Prairie Interlace

ART IN PROFILE

SERIES EDITOR:

Michele Hardy, Curator, Nickle Galleries, University of Calgary
ISSN 1700-9995 (Print) ISSN 1927-4351 (Online)

The Art in Profile series showcases the meaningful contributions of Canadian artists and architects, both emerging and established. Each book provides insight into the life and work of an artist or architect who asserts creativity, individuality, and cultural identity.

UNIVERSITY OF CALGARY
Press

Edited by
Michele Hardy,
Timothy Long,
and Julia Krueger

Prairie Interlace

Weaving, Modernisms, and the Expanded Frame, 1960–2000

Art in Profile Series
ISSN 1700-9995 (Print) ISSN 1927-4351 (Online)

University of Calgary Press
2500 University Drive NW
Calgary, Alberta
Canada T2N 1N4
press.ucalgary.ca

LIBRARY AND ARCHIVES CANADA CATALOGUING IN PUBLICATION

Title: Prairie interlace : weaving, modernisms, and the expanded frame, 1960-2000 / edited by
 Michele Hardy, Timothy Long, and Julia Krueger.
Names: Hardy, Michele A. (Michele Arlene), 1960- editor. | Long, Timothy, 1961- editor. | Krueger,
 Julia, 1978- editor.
Series: Art in profile ; 16.
Description: Series statement: Art in profile, 1700-9995 ; no. 16 | Includes bibliographical
 references.
Identifiers: Canadiana (print) 20230540430 | Canadiana (ebook) 20230540465 | ISBN 9781773854861
 (hardcover) | ISBN 9781773854878 (softcover) | ISBN 9781773854892 (PDF) | ISBN 9781773854885
 (Open Access PDF) | ISBN 9781773854908 (EPUB)
Subjects: LCSH: Textile crafts—Prairie Provinces—History—20th century. | LCSH: Textile artists—
 Prairie Provinces—History—20th century.
Classification: LCC NK8813.A3 P73 2023 | DDC 746.09712/09045—dc23

The University of Calgary Press acknowledges the support of the Government of Alberta through the
Alberta Media Fund for our publications. We acknowledge the financial support of the Government of
Canada. We acknowledge the financial support of the Canada Council for the Arts for our publishing
program.

This project has been made possible in part by the Government of Canada.

Copyediting by Andrew Goodwin and Brian Scrivener
All images by Dave Brown, LCR PhotoServices except where noted.
Cover image: Pat Adams, *Remember That Sunset We Saw from Here One Time?*, 1984 (cat. 2)
Cover design, page design, and typesetting by Melina Cusano

CONTENTS

MINISTER'S MESSAGE

Ministre
du Patrimoine canadien

Minister
of Canadian Heritage

Ottawa, Canada K1A 0M5

The arts have the power to transform us, expand our horizons, and help us to better understand the world around us.

The ambitious project *Prairie Interlace: Weaving, Modernisms, and the Expanded Frame, 1960 – 2000* highlights the ingenuity of Canadian artists and brings to life a period of importance in the history of art in our country.

Our government is proud to support this project that allows Canadians to explore our rich culture and heritage.

Congratulations and thank you to everyone involved.

Les arts ont le pouvoir de nous transformer, d'élargir nos horizons et de nous aider à mieux comprendre le monde qui nous entoure.

L'ambitieux projet *Prairies Entrelacées : Tissage, modernismes et cadre élargi, 1960 - 2000* met en lumière l'ingéniosité des artistes canadiens et fait revivre une période importante de l'histoire de l'art dans notre pays.

Notre gouvernement est fier de soutenir ce projet qui permet aux Canadiens d'explorer la richesse de notre culture et de notre patrimoine.

Félicitations et merci à toutes les personnes impliquées.

L'honorable / The Honourable Pascale St-Onge

Canada

ACKNOWLEDGEMENTS

Prairie Interlace: Weaving, Modernisms, and the Expanded Frame, 1960–2000 examines fibre-related connections across the Canadian Prairies (Alberta, Saskatchewan, and Manitoba) and reflects on the conditions that contributed to the rise and decline of this expansive textile movement. Central to this collaboration between Nickle Galleries, University of Calgary (Calgary, AB) and the MacKenzie Art Gallery (Regina, SK) was the desire to connect generations of artists, artists' groups, guilds, scholars, and collectors by facilitating the sharing of their inspiring artwork and stories. We were particularly keen to introduce younger generations to the fibre-related dynamism on the Prairies in the second half of the 20th century and to jump-start future related research. To achieve these goals, *Prairie Interlace* evolved into a travelling exhibition, symposium, website (www.prairieinterlace.ca), and publication. The exhibition featured 60 artworks by more than 48 artists and drew on public and private collections from across Canada; many of the works were shown for the first time or for the first time in decades. Building on the success of the tour and opening symposium, it is our hope that this publication and the related website will open space for a wider public to appreciate anew how beautifully the artists wove into every fibre of their extraordinary works what they value about art, craft, history, culture, politics, and the land.

This project, of course, is one that owes a debt to the many people who helped it flourish. To the many artists, friends, family members, and collectors who opened their hearts and homes to us, we express our deepest gratitude. Research and the locating of works for *Prairie Interlace* began in 2019 when institutions were closed due to the COVID-19 pandemic, but thanks to the extraordinary support of private and institutional collectors who worked from home and creatively problem solved, we were able to locate more than 350 Prairie works for consideration. We are especially grateful to the following individuals who assisted us during the research phase of this project and who facilitated loans or shared resources from their respective collections: Alberta Craft Council; Wendy Bakgaard; Melanie Berndt, Red Deer Museum + Art Gallery; Jacqueline Bell, Walter Phillips Gallery; Yohance Campbell, Athabasca University; Jillian Cyca, Remai Modern; Neil Devitt; Caroline Dugré, Canada Council Art Bank; Rhys Edwards, Surrey Art Gallery, Culture Division; Nicole Fletcher, Winnipeg Art Gallery; Patricia Grattan; Gale Hagblom; Kim Hallis, Public Art, City of Calgary; Belinda Harrow, SK Arts; Amy Jenkins, Canada Council Art Bank; Mackenzie Kelly-Frère; Alex King, University of Regina President's Art Collection; Robin Lambert, Red Deer College Permanent Art Collection; Gail Lint, Alberta Foundation for the Arts; Janet Lipsett, The Glencoe Club; Kathleen MacKinnon, Confederation Centre of the Arts; Daniel Matthes, University of Winnipeg Archives; Marcus Miller, Mann Art Gallery; Gail Niinimaa; Marie Olinik, MacKenzie Art Gallery; Cassandra Paul, Illingworth Kerr Gallery; Nick Radujko; Andrea Reichert,

Manitoba Crafts Museum and Library; Kevin Rice, Confederation Centre of the Arts; Laura Sanchini, Canadian Museum of History; Saskatchewan Craft Council; Brendan Schick, SK Arts; École Secondaire Beaumont Composite High School; Jack Severson; Danielle Siemens, Art Gallery of Alberta; Andrea Solaja, Imperial Oil; Cheryl Sonley, Levis Fine Art Auctions; Cydnee Sparrow, Mann Art Gallery; Kristin Stoesz, Alberta Foundation for the Arts; Mark Sylvestre, City of Regina; Jared Tiller, Heffel Gallery Limited; Nancy Townshend; Susan Sax Willock; and Janice Yates.

We would also like to acknowledge the following who generously facilitated image reproductions: Denver Art Museum; Gabriel Dumont Institute; Paul D. Fleck Library and Archives; Fondation Toms Pauli; Kaija Sanelma Harris Estate; La Guide's Archives; Manitoba Crafts Museum and Library; Minnesota Historical Society; Musée national des beaux-arts du Québec; Olds College; Daniel Paquet; Parker Gallery; Postmedia Network Canada Corp.; Musée de Saint-Boniface Museum; SK Arts; Libraries and Cultural Resources, University of Calgary; University of Regina Archives and Special Collections; and Margreet van Walsem Estate.

We wish to thank the teams at Nickle Galleries and the MacKenzie Art Gallery who worked tirelessly to realize this project from conception to finish. Thanks, in particular, go to Nickle Galleries' Christine Sowiak, Marina Fischer, Lisa Tillotson, John Hails, Doug McColl, Marla Halsted, and Aaron Sidorenko who (sometimes literally) moved mountains to make the magic happen; additional thanks go to the MacKenzie's dedicated team of John G. Hampton, Larissa Berschley MacLellan, Corey Bryson, Leevon Delorme, Anastasia Ferguson, Nikki Little, Jackie Martin, Crystal Mowry, Kara Neuls, Nicolle Nugent, Marie Olinik, Christina Prokopchuk, John Reichert, Christy Ross, Brenda Smith, Mackenzy Vida, and Allison Weed, among many others. We would like to thank those at Mann Art Gallery (Prince Albert, SK) and Art Gallery of Southwestern Manitoba (Brandon, MB) for enthusiastically hosting the exhibition and introducing us to their vibrant communities. For their expertise and dedication, we would like to thank textile conservator Gail Niinimaa, and students, Emily Croft and Camille LaFrance as well as City of Calgary Public Art conservators: Elisa Contreras Cigales, Sophia Zweifel, and Caitlin Young.

Thank you to all the researchers who contributed to the project and this publication. Curatorial Research Assistant Bailey Randell-Monsebroten was instrumental in researching the Indigenous artists in this exhibition and we are grateful for her research, openness, community driven approach, and curatorial eye. Research Assistant Yolande Krueger was instrumental in digitizing material for the exhibition, website, and publication, and for gathering all the documentation for this lavishly illustrated book ensuring that the publication moved forward in a timely manner. We are also thankful to everyone who worked on producing the publication, including Brian Scrivener, University of Calgary Press Director and his outstanding team. Photographic services were provided by Dave Brown and Andy Nichols, LCR Photo Services and Don Hall with design provided by Rhys Jolly, &Then, and University of Calgary's Melina Cusano.

Prairie Interlace: Weaving, Modernisms, and the Expanded Frame, 1960–2000 has been supported by several funding agencies and partners. Major funding for the project was provided by the Government of Canada through the Museum Assistance Program of the Department of Canadian Heritage. This support was essential for the success of the project. The MacKenzie would also like to gratefully acknowledge the ongoing support of its Board of Trustees, members, volunteers, donors, corporate sponsors, and public funders, the South Saskatchewan Community Foundation, Canada Council for the Arts, Sask Lotteries administered by SaskCulture, City of Regina, University of Regina, and SK Arts. The Nickle acknowledges with gratitude the ongoing support of the University of Calgary and Libraries and Cultural Resources, in particular: Mary-Jo Romaniuk, Vice-Provost (Libraries and Cultural Resources) and LCR Business Operation's Fola Okusami, Allison Olsen, and Jacky Law. We would also like to thank our many champions, community partners, university faculty and students.

In closing, we wish to thank all the artists and families of those artists who have passed for their creativity and vision, enthusiasm, and generosity. It has been an honour to learn from you. To our family and friends, thank you for your love and support and we ask forgiveness of those whom we have failed to mention.

Michele Hardy
Curator, Nickle Galleries

Timothy Long
Head Curator, MacKenzie Art Gallery

Julia Krueger
Independent Curator and Craft Historian

EXHIBITION ITINERARY

Nickle Galleries, University of Calgary, AB, Canada
September 9–December 17, 2022

Mann Art Gallery, Prince Albert, SK, Canada
April 14–May 27, 2023

Art Gallery of Southwestern Manitoba, Brandon, MB, Canada
July 6–September 10, 2023

MacKenzie Art Gallery, Regina, SK, Canada
November 4, 2023–February 18, 2024

www.prairieinterlace.ca

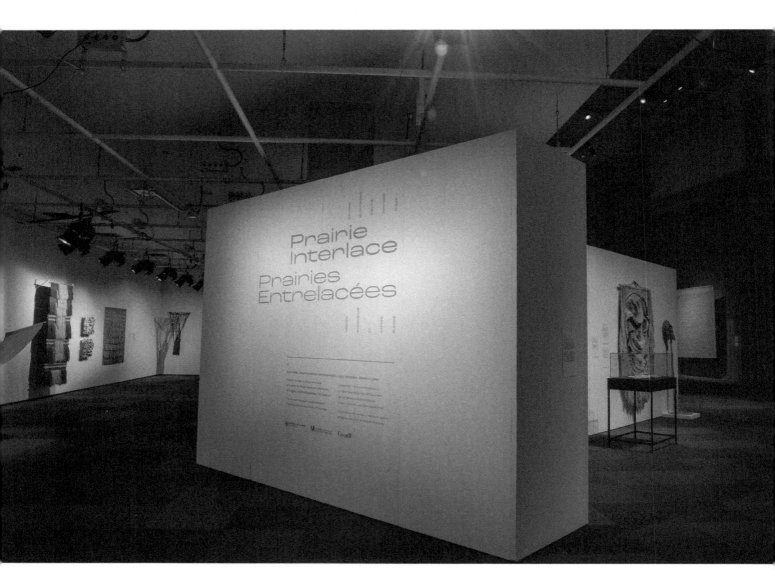

Installation view of *Prairie Interlace: Weaving, Modernisms, and the Expanded Frame, 1960–2000*, Nickle Galleries, 2022.

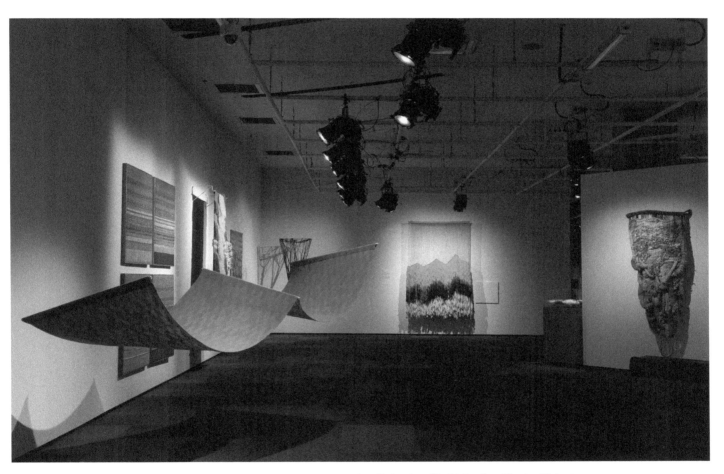

Installation view of *Prairie Interlace: Weaving, Modernisms, and the Expanded Frame, 1960–2000*, Nickle Galleries, 2022.

Left to right: Carol Little, *Furrow*, 1976 (cat. 29), Whynona Yates, *Hanging*, 1974 (cat. 59), Susan Barton-Tait, *Nepenthe*, c. 1977 (cat. 5)

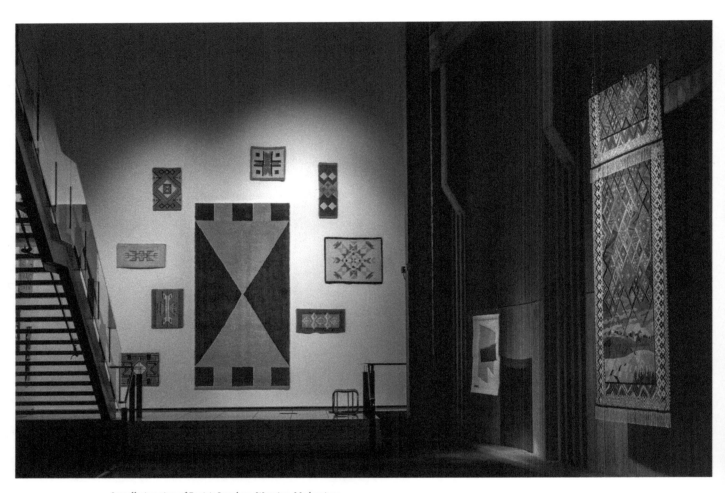

Installation view of *Prairie Interlace: Weaving, Modernisms,*
and the Expanded Frame, 1960–2000, Nickle Galleries, 2022.

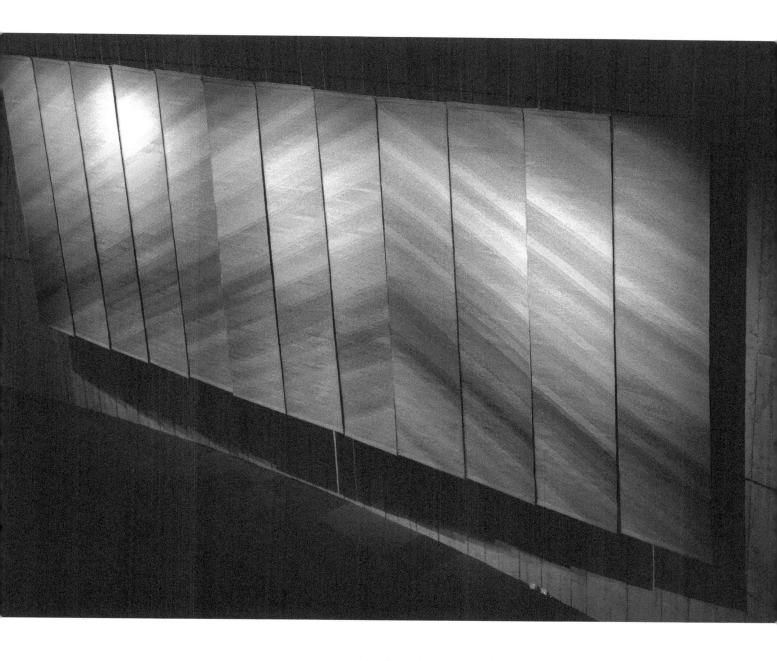

Installation view of *Prairie Interlace: Weaving, Modernisms,
and the Expanded Frame, 1960–2000*, Nickle Galleries, 2022.

Kaija Sanelma Harris, *Sun Ascending* (12 of 24 panels), 1985
(cat. 21)

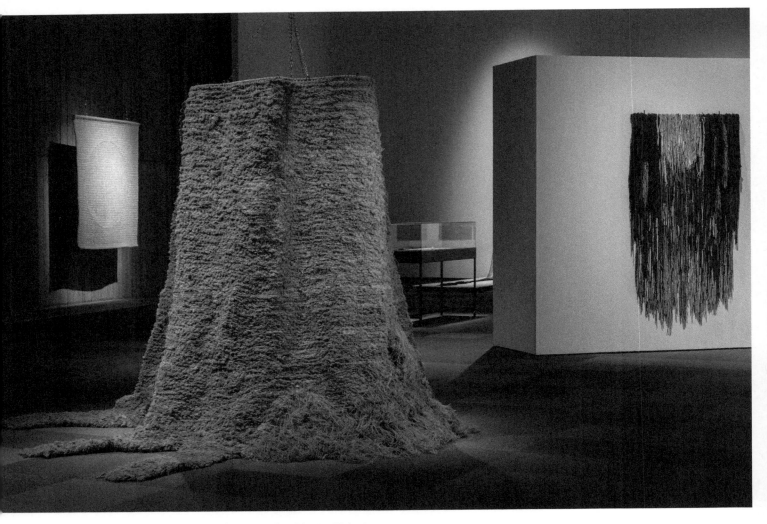

Installation view of *Prairie Interlace: Weaving, Modernisms, and the Expanded Frame, 1960–2000*, Nickle Galleries, 2022.

Left to right: Mariette Rousseau-Vermette, *Anne-Marie*, 1976 (cat. 47), Katharine Dickerson, *West Coast Tree Stump*, 1972 (cat. 11), Ilse Anysas-Šalkauskas, *Rising from the Ashes*, 1988 (cat. 3)

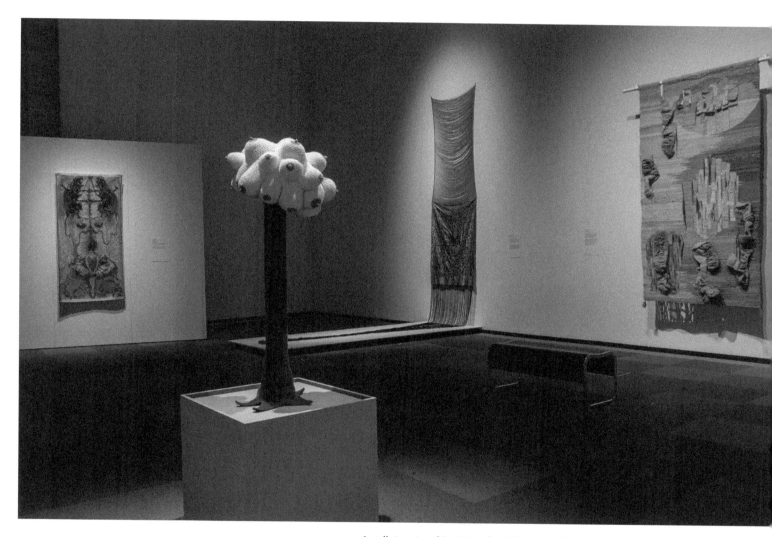

Installation view of *Prairie Interlace: Weaving, Modernisms, and the Expanded Frame, 1960–2000*, Nickle Galleries, 2022.

Ann Newdigate, *Then there was Mrs. Rorschach's dream/ You are what you see*, 1988 (cat. 39), Phyllis Green, *Boob Tree*, 1975 (cat. 18), Mary Scott, *Imago, (viii) "translatable" «Is That Which Denies»*, 1988 (cat. 52), Margreet van Walsem, *Inside Out*, 1977 (cat. 57)

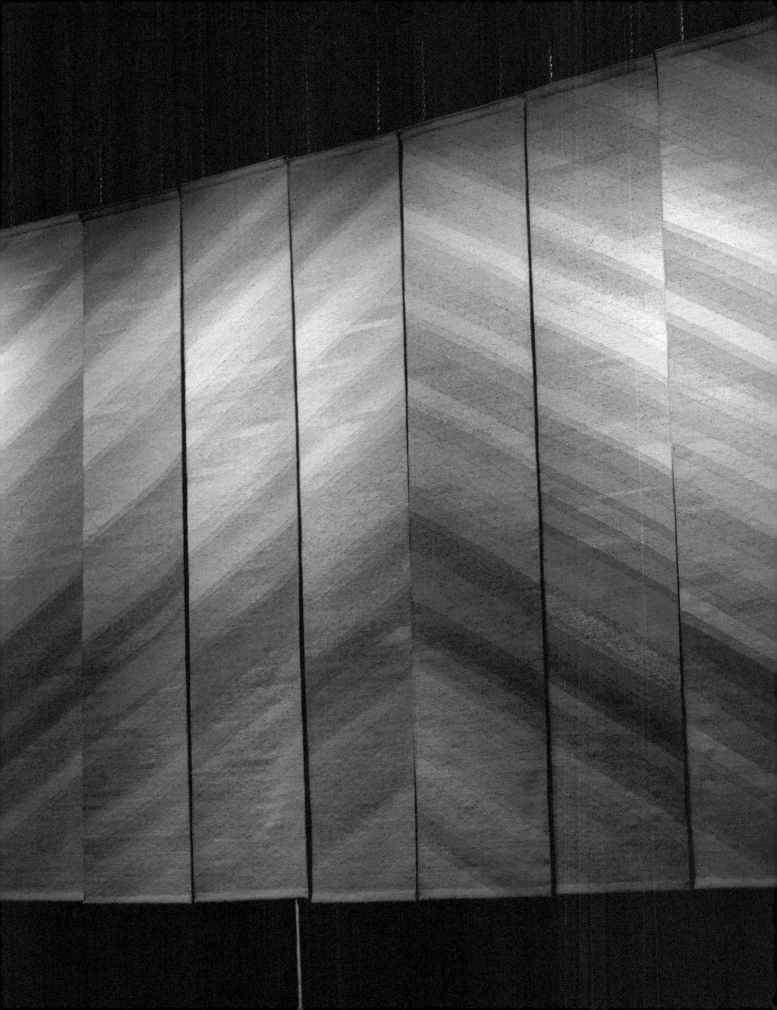

Introduction to *Prairie Interlace*: Recovering "Lost Modernisms"

by Julia Krueger, Michele Hardy, and Timothy Long

Prairie Interlace: Weaving, Modernisms, and the Expanded Frame, 1960–2000 looks back to the explosion of innovative textile-based art on the Canadian Prairies during the second half of the 20th century. With a focus on weaving and other interlace practices, such as rug hooking, macramé, knitting, and crochet, the project examines how artists of diverse backgrounds wove new histories of fibre during a period of intense energy and collective creativity. *Prairie Interlace* is set within the period 1960 to 2000, one of tremendous energy, opportunity, and experimentation across the Prairies and beyond. It was a period that, in Canada and particularly in Québec, developed out of a renewed interest in the textile crafts following the Second World War and the growing awareness and acceptance of tapestry weaving as a major art form rooted in Modernism.[1] As early as 1960, the National Gallery of Canada toured the works of two of Québec's best-known painter-weavers, Micheline Beauchemin and Mariette Rousseau-Vermette, across the country with the aim of enhancing awareness of their work, raising standards of weaving, and breaking down barriers between art and craft.[2] For Moncrieff Williamson, organizer of the Expo 67 exhibition *Canadian Fine Crafts*, the best Canadian craft displayed "excellence, inventiveness, [and] variety."[3] In 1979, the first Biennial of Contemporary Tapestry was launched in Montréal, an event that would champion experimentation in materials, scale, and form. Beyond Canada, the well-publicized Lausanne International Tapestry Biennials (Lausanne, Switzerland, 1962–1995),[4] The International Triennial of Tapestry (Łódź, Poland, 1975-),[5] and the Museum of Modern Art's *Wall Hangings* (New York, 1969),[6] along with publications such as Mildred Constantine and Jack Lenor Larsen's *Beyond Craft: The Art Fabric* (1972) and *The Art Fabric: Mainstream* (1981), proved to be internationally influential. Prairie artists were very much engaged in these events and experiments: many participated in the international exhibitions in Lausanne and Łódź, the Montréal Tapestry Biennials or travelled regularly to witness them. Others were introduced to the international fibre art movement though exhibitions in Canada, such as the solo shows

Kaija Sanelma Harris, *Sun Ascending* (detail), 1985 (cat. 21)

of the renowned Magdalena Abakanowicz at the Walter Phillips Gallery and Glenbow Museum (Banff/Calgary, 1982) and Musée d'art contemporain de Montréal (Montréal, 1983), as well as through the steady stream of international luminaries who led workshops at the Banff Centre, a major fibre hub. Like artists, craftspeople, and architects throughout Europe and North America, Prairie artists were drawn to the warmth, materiality, and experimental potential of innovative weaving processes.

Today little trace of the energy and activity of that period remains. The weavings which were once common in public buildings and corporate offices have all but disappeared. Records that may still be found in collections and archives are spotty at best. The looms at the Banff Centre sit idle in the basement, the result of changing program priorities. Despite the recent resurgence of interest in DIY crafts and fabric-based practices—a resurgence that makes the work of this earlier period look prescient—current activity falls well short of the scale and ambition of the modernist moment. *Prairie Interlace* represents an attempt to address this historical disappearance by discerning voices "silenced" by time and changing circumstances,[7] and by assessing the impact of Modernism on Prairie artists working with weaving and other interlace practices. The underlying challenges of curating textiles—another factor in the de-valuing and under-representation of the work of this period—are also discussed in Krueger and Hardy's "Curating *Prairie Interlace*: Encounters, Longings, and Challenges," which complements this introductory text. Through multiple access points—touring exhibition,

symposium, website, and this edited publication—*Prairie Interlace* contributes fresh research and new perspectives to craft histories on the Canadian Prairies (Alberta, Saskatchewan, and Manitoba) and sets these regional histories within national and international contexts. It is the first such project in recent decades to spotlight these makers, create space for their works, and, to borrow the words of craft historian Tanya Harrod, recover and record "lost modernisms."[8]

The warp and weft of this history are held taut by several creative tensions. Prairie weavers and other textile-based artists, like their ceramist counterparts, challenged traditional craft definitions as they engaged with painting, sculpture, and architecture. Yet, the story cannot be reduced to a simple modernist narrative of a break with tradition leading to new liberatory possibilities that began in the late 19th and early 20th centuries, or of regional artists uncritically responding to introduced *avant-garde* ideas—rather it is a nuanced tale of regional artists' varied engagement with Modernism and the international fibre art movement, a tale requiring an expanded frame. K. L. H. Wells asserts in *Weaving Modernism: Postwar Tapestry Between Paris and New York*, "Modern art and tapestry both reach unprecedented critical, economic, and institutional success during the same historical moment, the twenty-five years following World War II."[9] *Prairie Interlace* seeks to understand the connection between weaving and this particular phase of Modernism on the Prairies. The persistence of techniques as taught in art schools and weaving guilds, the cultural knowledge brought to the Prairies by European immigrants, and the renewed interest in traditional Indigenous practices,

are entwined with the modernist storyline. Modernism prefaced a move away from realistic representation towards abstraction, "honestly" emphasized visible physical processes and the materials used in art and architecture, rejected academic traditions in favour of the avant-garde, embraced the machine age, and questioned the distinction between art and everyday life.[10] With the early developments of Postmodernism in the 1970s, Feminist artists found in weaving, crochet, and other fibre arts a means to critique social and aesthetic hierarchies, expand the domestic frame, and insert narrative into their work. Postmodernism's eclecticism, pastiche, and fragmentation also made its way into Prairie weaving with references to magic carpets and Leonardo da Vinci. Indigenous artists found opportunities through rug hooking (both hooked and latch-hooked rugs)[11] and weaving to pursue economic opportunities while celebrating aesthetic and cultural traditions. Interest was diffuse and diverse, encompassing both academic institutions in large cities and weaving guilds in smaller centres, monumental commissions for modernist towers and small-scale works produced on table looms. Across the region, hubs of teaching and exchange emerged—the Alberta College of Art (now AUArts) in Calgary, the Banff Centre, the Saskatchewan Summer School of the Arts (1967–1991) held in Fort San near Fort Qu'Appelle, and numerous local guilds and clubs—where skills were honed, and modernist ideas tested and translated. *Prairie Interlace* retells this distinctive history through the interlaced narratives of art, craft, feminism, immigration, Indigeneity, regionalism, and architectural interior design.

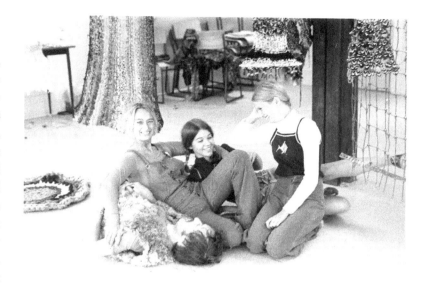

Evelyn Roth (second from left) with students attending her 1973 wearable art course at the Saskatchewan Summer School of the Arts, near Fort Qu'Appelle, Saskatchewan. Photo courtesy of SK Arts.

From its inception in 1928, the Crafts Guild of Manitoba has promoted the knowledge, interest and proficiency in crafts by offering a vast array of craft courses. In 1976 alone, they had 828 students. In this image from 1972, Shirley Tyderkie and Ruth Horner demonstrate weaving for the guild. Courtesy of the Manitoba Crafts Museum and Library.

Why Weaving?

Early in this project, it became apparent that research parameters were needed to deal with the immensity of the field of textiles. The decision was taken to narrow the curatorial focus to weaving along with the complementary interlace practices of macramé, rug hooking, crochet, and knitting. Aside from aligning with the curators' interests and institutional holdings, this decision took into account the specific histories of these practices on the Prairies, histories with roots going back to the first half of the 20th century, as Jennifer Salahub, Sherry Farrell Racette, and Cheryl Troupe reveal in their essays for this publication, and which continued to develop through a unique conjunction of grassroots and professional artistic activity during the period in question. The limited overlap between these textile methods and needle-based processes such as quilting and embroidery, and the interweave practices such as basketry, lay behind the decision to exclude them from the scope of this project. Their omission should be understood not as a value judgement but rather as an invitation for further curatorial exploration.

Even within these parameters, it became obvious that garments, yardage, and small-scale textiles for the home, such as napkins, placemats, and tablecloths, were something that could not be properly addressed in *Prairie Interlace*. Our curatorial curiosities were oriented toward artists who fell somewhere between a weaver-designer and a fibre artist.[12] For example, while we did not include the Expo 67 yardages by F. Douglas Motter or Whynona Yates, both currently in the collection of the Confederation Centre Art Gallery, we did include Yates' *Hanging*, 1974 (cat. 59) and Carol Little's *Furrow*, 1976, (cat. 29) which for all intents and purposes is a twill woven, warp ikat yardage, but is also something more due to its suspended installation. *Hanging* and *Furrow* posed questions that demanded a deeper investigation through their engagement with sculptural installation.

During the 1960s and 1970s, various labels such as *woven forms, new tapestry, wall hangings, fibre art, fibre constructions, fibre sculpture,* and *Art Fabric* were invented to describe non-utilitarian woven and off-loom works.[13] These labels and the fluid weaver-designer/fibre artist identities associated with them speak to the challenge of describing the large-scale convention-defying textile art of the period. An increase in scale was due in part to the economic boom of the 1970s, which saw record in-migration to oil-rich Alberta, spikes in the number of building permits, and broad opportunities for artists in all three Prairie provinces to create large textile works for corporate headquarters, office towers, banks, performance centres, and various government offices. It can also be argued that an increase in scale was a result of the minimum size requirements for the Lausanne Biennial: ten square metres for exhibited works.[14] Conceptually, it is important to note how weavers harnessed scale to challenge fibre's stereotypical associations with utilitarian craft and domesticity,[15] and to confound "the still-prevalent [at the time] stereotype of feminine modesty and passiveness,"[16] as Janet Koplos and Bruce Metcalf point out. It also brought to the fore invisible histories of marginalized communities. Marge Yuzicappi's monumental *Tapestry*

(Ta-hah-sheena), c. 1970, (cat. 60) is a bold statement, claiming space for Indigenous women and their creative works.

Expanding the Horizon

The need to know more, to understand better the contributions that Prairie textile artists made to wider narratives remains. How did this phenomenon emerge? How are we to assess the extraordinarily diverse and compelling artistic forms which they produced? And, after decades of attention and new opportunities for artists working with textiles, why by the late 1990s did interest dwindle? Consequently, this volume describes, assesses, and expands a Prairie textile horizon. As Kelly-Frère notes in his essay, the horizon "is a useful metaphor as we consider the interwoven legacies of weavers on the Canadian Prairie" (p. 124). We engaged scholars and artists to consider Prairie textiles and some of the most critical themes shaping the field. Their contributions are divided into three thematic groups. The first section, "Recovering Histories," brings together studies of specific developments. Historical narratives, many rescued from obscurity, are evaluated to show how the field of art textiles took form on the Prairies at both the high and low end of art spectrum: from the grassroots realities of Prairie farm women and Indigenous and Métis communities to the professional artistic enterprise of international fibre art and the incorporation of textiles within modernist architecture. In the second section, "Contextual Encounters," writers consider the phenomenon of weaving on the Prairies from broader theoretical perspectives, considering how

the artists engaged with the wider narratives of Modernism, Postmodernism, feminism, craft theory, and regionalism on the Prairies, thereby expanding our understanding of textile art practices. The third section, "Expanding the Frame," embeds a discussion of the works included in *Prairie Interlace* within critical theory, exploring how affect, art, and textiles function.

Jennifer Salahub leads off with a much-needed historical background in "Stand Back—Nothing to See—Move Along." Professor emerita from the Alberta University of the Arts, Salahub is a widely published textile historian who excels at reconstructing narratives through extensive archival research. Her essay focusses "not upon legacy, but rather ancestry, for the fibre art movement was a child of modern art and an active player in Modernism's grand narrative" (p. 18). Tracing that ancestry leads her to the period prior to 1960, an era of little interest at first glance. But like an episode of *Seinfeld*—a sitcom ostensibly about nothing—Salahub finds in the minutiae a rich and nuanced tale. She examines, for example, references to the influence of Modernism on textiles in Alberta newspapers of the 1910s and 1920s, craft revivals in the 1930s and 1940s, debates about Modernism during the formative years of weaving instruction at the Banff School of Fine Arts and Provincial Institute of Technology and Art in Calgary, and utopian weaving schemes for farm families propagated by the Roman Catholic Church and the Searle Grain Company. The narratives uncovered counter the simplistic characterization of modernist fibre art of the 1960s and 1970s emerging from a void. As Salahub argues, "the seeds for a robust,

regionally based, *modern* textile and textile art movement were being planted on the Prairies well before the fibre art movement took form," a conclusion that reminds us that history is written, knowledge is constructed, and amnesia is not as innocent as it seems.

Another essay concerned with neglected histories is Sherry Farrell Racette's "Marginalized Moderns: Co-operatives and Indigenous Textile Arts in Saskatchewan, 1960–1972." Racette is of Métis ancestry, a member of the Timiskaming First Nation, and a professor with the University of Regina. As a scholar, curator, and artist, she has a particular interest in Indigenous women's history, knowledge, and pedagogy. Her essay offers a parallel tale to Salahub's, examining not just a forgotten or unwritten history, but one that was often actively repressed. She notes how cultural expression, particularly the creation of regalia and ceremonial items, "the very heart of artistic expression" (p. 38), was suppressed by government policies. Ironically, those same federal and provincial governments found a new enthusiasm for Indigenous culture in the 1960s, resulting in various development initiatives, including the production of small finger-looped rabbit fur rugs in northern Saskatchewan, as seen in the work of Cree artist Anne Ratt, (cat. 44 & 45) and the production of latch-hooked rugs, called Ta-hah-sheena by the artists of the Sioux Handcraft Co-operative of Standing Buffalo Dakota First Nation in southern Saskatchewan (cat. 7, 15, 16, 17, 24, 33, 34, 54, 60, 61).

She recounts in detail the story of the Co-operative, chronicling the challenges the group members faced working on the margins and within a limiting co-operative structure. Despite notable successes—a National Film Board documentary, international exposure, and major commissions such as those produced for the library of the University of Regina—the project was short-lived in part because the textiles did not fit with received notions of Indigenous art, required expensive materials, and were labour intensive to produce. Critically, Racette demonstrates how the Co-operative functioned as a vehicle of knowledge transfer within the Dakota *tióšpaye*—"the complex network of extended families centered on women" (p. 45). Furthermore, she recovers from over-literal readings of the rugs' symbolism, the "unlimited creativity" contained in their "bold geometric language" (p. 46). Her essay reminds us that abstraction is rooted in Dakota/Lakota visual vocabulary and experience—not an imported form introduced by Modernism.

Cheryl Troupe's essay, "Métis Stories and Women's Artistic Labour in Margaret Pelletier Harrison's *Margaret's Rug*" offers a Métis perspective on the relationship between place, women, and textiles. Troupe is a citizen of the Métis Nation-Saskatchewan and a member of Gabriel Dumont Local #11 in Saskatoon. She is also an assistant professor of History at the University of Saskatchewan where her research focuses on Métis road allowance communities and the intersections of land, gender, and kinship. Troupe explains, "Agricultural settlement and Canadian government policy of the late 19th and early 20th century steadily displaced and dispossessed Prairie Métis, forcing them to relocate their families and re-establish themselves on land they didn't own, forming communities on newly surveyed unoccupied

Crown land reserved for roads, next to First Nations reserves, or on the correction lines which were adjustments to the Dominion Land Survey to compensate for the convergence of lines of longitude. These spaces, unique to the Prairie provinces, became known as road allowance communities."[17] Drawing on her long-standing community-based research, she offers an intimate account of the textile history of Margaret Harrison, an artist who grew up in the Katepwa Lake road allowance community in southern Saskatchewan's Qu'Appelle Valley. Troupe demonstrates how Modernism, in the form of settler colonialism and agrarian economy, marginalized Métis communities, particularly its men, and set the conditions for women's artistic production to become an important means of providing economic "stability and cultural continuity during a period of increasingly rapid economic, social, and political transition" (p. 57). It is worth reflecting on Métis women's limited choices for participation in Modernism, and how they did whatever was necessary to support their families. Furthermore, Troupe shows how hooked rugs continue to connect generations of family members to each other, their communities, and the land. For Harrison, in particular, rug hooking is a "mnemonic device" (p. 45) that encourages remembering and sharing details about place and kinship—a purpose beautifully realized in *Margaret's Rug*, a contemporary memory portrait of her family's community along the shores of Katepwa Lake (cat. 22).

If Salahub, Racette, and Troupe remind us of the complexity of received history—its blind spots and enduring legacies—the more recent story of the Banff School of Fine Arts

gives evidence of both the advancement and marginalization of textile art within the contemporary art scene. While traditional weaving had been taught at the school for decades, with the arrival of Mariette Rousseau-Vermette in 1977 the emphasis shifted towards experimental weavings on a grand scale. "The Gift of Time, The Gift of Freedom: Weaving and Fibre Art at the Banff Centre," explores the history of textiles at the school. Based not far from Banff, Mary-Beth Laviolette has been a keen observer of the school in addition to working as an independent art curator, researcher, and writer particularly attuned to fine craft in Canada. She describes how the Fibre Studio at Banff, under the leadership of Rousseau-Vermette and Inese Birstins, attracted students, instructors, and visitors from around the globe including many fibre-world luminaries: Mildred Constantine, Sheila Hicks, Magdalena Abakanowicz, Jack Lenor Larsen, Neda Al-Hilali, Joyce Weiland, among others. As Laviolette notes, the studio provided "space, energy, and freedom to create some of the most advanced art of its time" (p. 66)—a rare moment of progressive textile action. However, just over a decade after Rousseau-Vermette's arrival, the Banff School began to shift direction. It embraced a more interdisciplinary approach that tended to flatten—in the name of contemporary art—"anything related to craft-based skill or thinking" (p. 74). Laviolette's account points not only to the vicissitudes of institutional policy, but also it underscores the ongoing vulnerability of textiles within artworld hierarchies.

The concluding essay of *Recovering Histories*, "Living and Liveable Spaces: Prairie

Textiles and Architecture," by Susan Surette offers an examination of the potent relationships between Modernism, architecture, and textiles—a relationship which gave birth to the international phenomenon of textile art in the latter half of the 20th century. Surette is a ceramic artist, craft historian, and lecturer at Concordia University in Montréal who has written extensively on craft with a focus on the relationships between objects, makers, and consumers. A former weaver and basket maker, she continues to be passionate about all aspects of textiles. Her essay examines how Prairie artists translated "global perspectives into textile languages sensitive to regional concerns and interests" (p. 99)—perspectives that included those associated with modernist architecture. She notes that fibre works were needed to fill a deficiency in modernist buildings, making them liveable, infusing them with personal delight, and facilitating communication between people and between themselves and their spaces. That this project was enthusiastically taken up on the Prairies is due to the unique historical confluence of the oil boom, a dramatic increase in construction, and the alignment of "funders, developers, and architects" (p. 84) who created new opportunities for textile artists and their works. She notes further how Prairie artists took up the logistical and conceptual challenges of monumental architectural commissions, showing an adaptability that creators of utilitarian weaving often lacked. Many Prairie weavers maintained, for example, dual practices, producing both functional, utilitarian woven cloths as well as textiles that competed with other forms of modern art. Nearly every artist represented in *Prairie Interlace*

was involved with an architectural commission at some point in their career, and the list of national and international commissions which Surette examines is truly astounding: from office towers, to government buildings, to universities and arts centres, to embassies and consulates, to a Burger King in Medicine Hat. Wherever their work was located, it "performed complex roles within multiple social, cultural, political, and architectural contexts," and in the process "built bridges between institutions, the public, and artists" (p. 99). Surette concludes by drawing attention to the need to safeguard these treasures in the face of their continued disappearance.

"Contextual Encounters," the second section of *Prairie Interlace*, is introduced with the essay "Curating *Prairie Interlace*: Encounters, Longings, and Challenges" by Julia Krueger and Michele Hardy. Together, they examine the curatorial context of the project—one uniquely brought into focus by the COVID-19 pandemic. Researching a tactile medium during the closures and amidst complex restrictions was frustrating but highlighted critical and ongoing issues related to awareness of textiles, and issues surrounding access and preservation. For Krueger and Hardy, the dearth of archival records related to Prairie textiles and artists was particularly troubling.

The curators—none of whom are weavers—recognized the importance of including a weaver's perspective on the project and its varied goals. "Weaving at the Horizon: Encounters with Fibre Art on the Canadian Prairie" by Mackenzie Kelly-Frère offers a deeply personal account of learning to weave and how "contingent communities" of individuals approached weaving as an art

form. A weaver, educator, and scholar who teaches at the Alberta University of the Arts, Kelly-Frère in his essay builds on his extensive research into the social history of textiles, craft theory, and craft-based pedagogy. Following Glenn Adamson's idea that craft constitutes a "conceptual limit" for modernist art, Kelly-Frère demonstrates how the artists of *Prairie Interlace* "interrogated this conceptual limit both on and off their looms, weaving at the horizon where textile traditions are challenged by artistic innovations of form, materiality, and context" (p. 124). His detailed descriptions of the work of several artists in the exhibition—Pirkko Karvonen, Katharine Dickerson, Ann Newdigate, Jane Kidd, and Pat Adams—give valuable evidence of how their grounding in traditional textile knowledge and practices is coupled with an outward-looking, experimental attitude. The portraits of these weavers effectively dismantle what the writer describes as the typical narrative of artists "liberated from the restrictions of weaving traditions and even their looms" (p. 127) and replaces it with a nuanced story of reconnection, recontextualization, and the renegotiation of tradition and innovation. Kelly-Frère shows how the work of these artists, rooted in landscape, textile traditions, and lived experience, has helped us find our place within both Prairie and international horizons.

Concluding the section is Mireille Perron's feminist consideration of how Prairie textile artists "took up modernist key gestures . . . and intertwined activist, affective, poetic, and aesthetic purposes to suggest how textiles can be used to advance a political agenda as well as to make material engagement synonymous with community participation" (p. 161). Perron is professor emerita at the Alberta University of the Arts and an artist, educator, and well-respected scholar of craft. Her essay, "Contextual Bodies: From the Cradle to the Barricade," explores a surprisingly diverse collection of objects that span three decades: crocheted goddesses (Jane Sartorelli, cat. 50) and canine companions (Maija Peeples-Bright, cat. 41), birth image tapestries (Margreet van Walsem, cat. 56), knitted boob trees (Phyllis Green, cat. 18), and hooked rugs made of condoms (Nancy Crites, cat. 9), or latch-hooked rugs based on scrawled handwritten messages (Cindy Baker, cat. 4). As Perron demonstrates, these textile provocations challenge art world authority and patriarchy, explore the relationship of the handmade to body politics, and re-imagine relationships between makers and viewers. Other works take up the theoretical imperatives to challenge imposed definitions and categorical boundaries by embracing "in-between" states, a direction exploited with particular effectiveness by Ann Newdigate and Mary Scott. Perron's essay traverses generations, theoretical positions, materials, and methodologies to reveal the "new interpretive devices" that emerged from Prairie engagements with an expanded field of feminist and craft practices.

Alison Calder's essay introduces an interdisciplinary approach that underlines the multiple perspectives shared by both textile artists and writers from the Prairies. A renowned poet and scholar of Canadian Prairie literature, Calder is a professor at the University of Manitoba whose work explores perception, regionalism, and ecocriticism. In "Six Ways of Looking at *Prairie Interlace*,"

she evokes ways of knowing the Prairie land-scapes and bodies and how Prairie artists resist or complicate those conventions. For example, she notes how settlers have viewed the Prairies as a taken-for-granted site of resource extraction—a conventional view that writers, such as Tim Lilburn, and weavers, such as Jane Kidd and Pirkko Karvonen, both seek to counter. She notes further how the Prairies, despite their inherent geometric abstraction, are neither empty nor waiting to be filled, but already living, full, and deep. Turning to concerns associated with female identity, she links feminist writers, such as Lorna Crozier, with the playfully transformative objects of Phyllis Green, Aganetha Dyck, and Nancy Crites, complementing and adding to the discourse outlined by Perron. Finally, following the lead of Lakota Oglala writer Layli Long Soldier, Calder suggests that the Sioux Handcraft Co-operative latch-hooked rugs are "acts" rather than simply objects—records of traditional knowledge and making that connects bodies and spaces, time and identity. Through her own act of comparative reading, Calder explores resistance and complexity, arguing that textiles' potency, like writing's, is connected with "multiplicity, ambiguity, deferral, and mobility" (p. 177).

Co-curator Timothy Long concludes the volume in the third section of *Prairie Interlace*, "Expanding the Frame" with an original theoretical contribution. He notes "Prairie Interlace is but one part of the much larger story of how the flexibility of thread met the conceptual power of the frame in the post-Second World War era and unleashed a worldwide phenomenon the effects of which are still being felt" (p. 211). Long considers the relationship of weaving to art and the act of framing in an extended exercise of "thinking through craft" (Glenn Adamson). Textiles are (obviously) different from painting, but Long's analysis focuses less on what they are so much as how they are. A textile "outsider" with decades of curatorial experience as Head Curator at the MacKenzie Art Gallery where he has explored interdisciplinary dialogues involving art, sound, ceramics, film, and contemporary dance, Long offers a critical reconsideration of weaving as an art form with its own distinct frame. Expanding on Girardian theory, he argues that while the frame of art is excisional, the frame of textiles is umbilical: the former severs from the world in order to produce aesthetic presence; the latter cuts from the means of production (yarn, the loom) in order to touch the world and its foundational social structures. The frame of craft, he asserts, "is never far from the flesh" (p. 193). He articulates an important distinction, one that textile makers and scholars have rarely made with such precision and grounding in regional practice. His essay reminds us of the potential of weaving to critique established hierarchies and nurture interlaced connections of makers and communities.

The Interlace Continues

The sense of creative adventure, discovery, and endless potential experienced by the artists in this exhibition was almost palpable in the interviews conducted by the curators and writers for this project—several of which have been posted on the exhibition website. That enthusiasm, the product of a more optimistic time, is often tempered, however, by

the sense of loss which has accompanied the declining interest and prospects for weavers and other interlace artists over the past two decades. As a result of this shift, many of the artists switched to other media or continued to produce weavings within more limited horizons of opportunity. In every case, though, the artists welcomed the chance to share their memories and reflections about what was uniformly acknowledged to be a period of extraordinary production and activity within their oeuvres. The goal of this project, then, was not only to recover these lost histories, but also to connect generations of artists, artists' groups, guilds, scholars, and collectors and provide them with a forum in which to share artworks and stories. As a curatorial team, it is our belief that the works in this exhibition contain a generative power which will continue to inspire future production and research. The essays in this publication aid this effort with a long-overdue assessment of the theoretical and creative horizons opened by the artists during a period of intense creativity that engaged both new and historical forms. In filling this gap in Prairie art history, it is hoped that new light will also be shed on the many productive intersections of craft and art in Canada more generally. Together with the artworks in *Prairie Interlace*, which are but a small sample of a wide and diverse field of creative endeavour, this publication allows us to appreciate, once more, how artists of the period wove into every fibre of their extraordinary works what they valued about art, craft, history, culture, politics, and the land.

NOTES

1 Anne Newlands, "Mariette Rousseau-Vermette: Journey of a Painter-weaver from the 1940s through the 1960s," *Journal of Canadian Art History / Annales d'histoire de l'art Canadien* 32, no. 2 (2011): 74–107.

2 Newlands, "Rousseau-Vermette," 87.

3 Williamson cited in Sandra Alfody, "Excellence, Inventiveness, and Variety: Canadian Fine Crafts at Expo 67," in *Made in Canada : Craft and Design in the Sixties*, ed. Alan Elder (McGill-Queen's University Press, 2005), 55.

4 The International Lausanne Tapestry Biennials were held in Lausanne, Switzerland between 1962 and 1995. Founded by the artist Jean Lurçat, Pierre Pauli, Paul-Henri Jaccard, Georges-André Chevallaz, and René Berger, they aimed to "record, document and above all display the vitality and creativity of contemporary tapestry art." Fondation Toms Pauli, http://www.toms-pauli.ch/en/documentation/history/, accessed April 2, 2023.

5 The International Triennial of Tapestry at Łódź, Poland, began in response to the success of the Lausanne Biennials. Launched in 1972, the aim of the Triennial was to "promote artistic textiles and to strengthen its position in the world of modern art." The 17th International Triennial was held in 2022. Centralne Muzeum Włókiennictwa w Łódź, https://cmwl.pl/public/wydarzenie/wybrane/1-ogolnopolskie-trien-nale-tkaniny-przemyslowej-i-unikatowej-lodz-1972,89, accessed April 2, 2023.

6 *Wall Hangings* (February 25–May 4, 1969) was a ground-breaking exhibition (and publication) held at the Museum of Modern Art in New York. Curated by Mildred Constantine and Jack Lenor Larsen, they aimed to explore new developments in weaving and explore its relationship to art. "The weavers . . . are in no way concerned with the pictorial aspects of weaving, but are involved with extending the formal possibilities of the craft. They frequently use conventional weaves, but more and more often they work free of the loom, in complex and unusual techniques . . . their primary concern to extend the aesthetic qualities inherent in texture." The Museum of Modern Art, "Press Release," February 25, 1969, https://www.moma.org/documents/moma_press-release_326605.pdf, accessed April 2, 2023.

7 This project explores a constellation of practices, including weaving, tapestry, woven sculpture, rug hooking, knitting, and macramé, in which interlaced constructions of thread, yarn, and other materials are integral to the object's structure. While the curators acknowledge the many wonderful textiles made through other processes on the Prairies (especially quilting and embroidery), interlaced textiles produced between 1960 and 2000 were particularly experimental, bold, and aligned with Modernism.

8 Tanya Harrod, "House-trained Objects: Notes Toward Writing an Alternative History of Modern Art," in *Contemporary Art and the Home*, ed. Colin Painter (Oxford: Berg, 2002), 64.

9 K. L. H. Wells, *Weaving Modernism: Postwar Tapestry Between Paris and New York* (New Haven and London: Yale University Press, 2019), 9.

10 Marilyn Stokstad and Michael W. Cothren, *Art History: A Brief History*, 6th ed. (Upper Saddle River, NJ: Pearson, 2016), 513.

11 In this publication, hooked rugs refer to rugs produced with a hook which have a looped surface. Whereas latch-hooked rugs are those made with a latch hook where individual strands of wool are separately knotted to the base fabric.

12 Glenn Adamson states: "The questions that preoccupied artists in the 1960s and 1970s centered on the fiber artist's identity—craftsman or sculptor." Glenn Adamson, "The Fiber Game," *The Journal of Cloth and Culture* 5, no. 2 (2015): 171. Elissa Author discusses the two identities in Elissa Auther, "From Design for Production to Off-Loom Sculpture," in *Crafting Modernism: Midcentury American Art and Design*, ed. Jeannine Falino (New York: Abrams, 2012), 145.

13 Elissa Auther, *String, Felt, Thread: The Hierarchy of Art and Craft in American Art* (Minneapolis: University of Minnesota Press, 2010), 7.

14 Janet Koplos and Bruce Metcalf, *Makers: A History of American Studio Craft* (Hendersonville, NC: The Center for Craft, Creativity and Design, 2010), 259.

15 We are indebted to Elissa Auther's writing in *String, Felt, Thread* as it highlights the importance of scale in relation to the division of art and craft.

16 Koplos and Metcalf, *Makers*, 259.

17 Cheryl Troupe, email message to Michele Hardy, June 21, 2023.

Installation view of *Prairie Interlace: Weaving, Modernisms, and the Expanded Frame, 1960–2000*, Nickle Galleries, 2022.

Clockwise from left: Marge Yuzicappi, *Tapestry (Ta-hah-sheena)*, c. 1970 (cat. 60), Florence Maple, *Rug*, 1969 (cat. 33), Yvonne Yuzicappi, *Rug*, 1968 (cat. 61), Florence Maple, *Tipi Mat*, 1967 (cat. 34), Florence Ryder, *Untitled (lilac ground)*, no date (cat. 48).

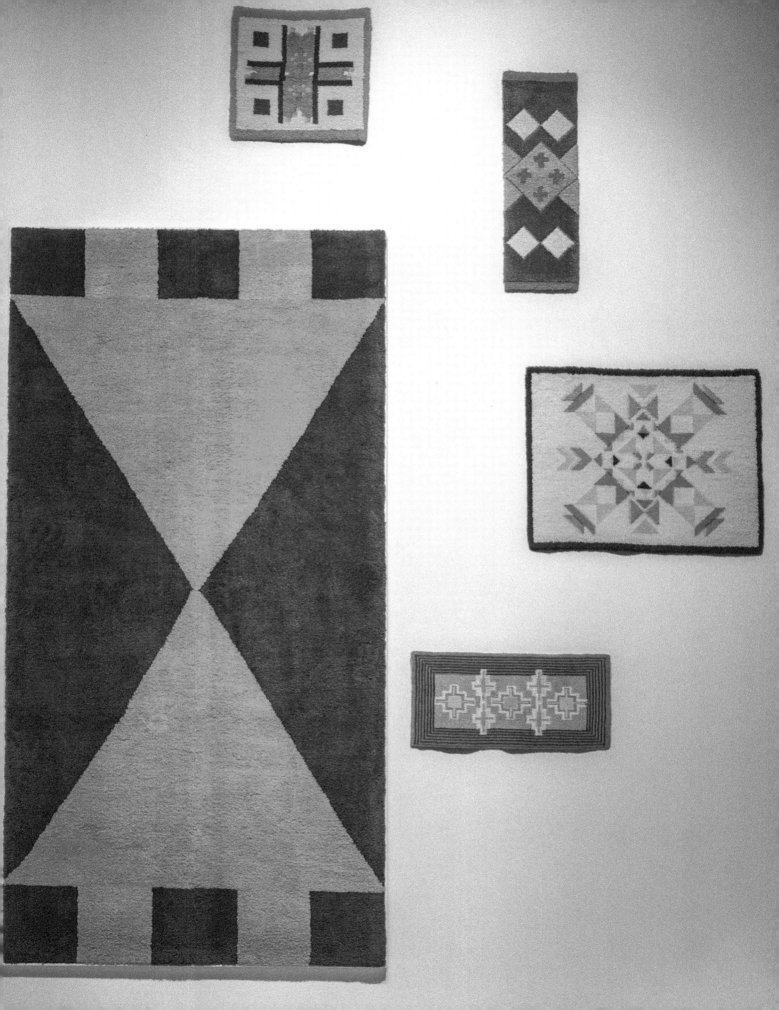

Recovering Histories

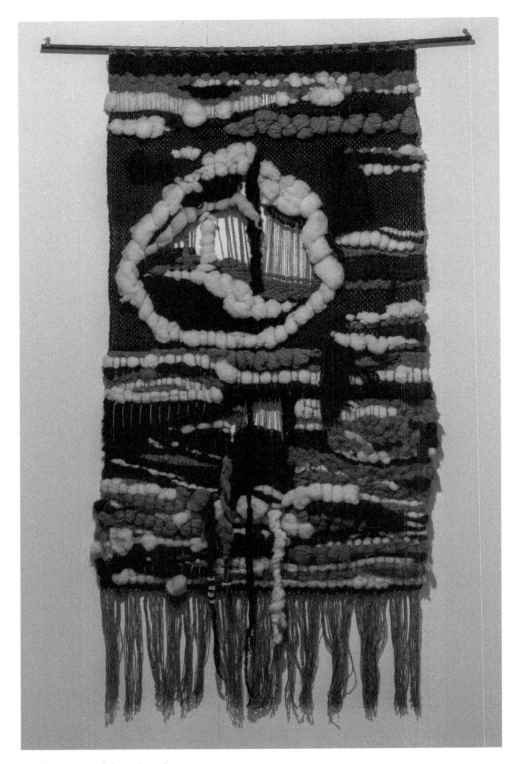

Hazel Schwass, *Untitled*, 1974 (cat. 51)

Stand Back—Nothing to See—Move Along

by Jennifer E. Salahub

And you didn't bring your spinning wheel or loom, Mrs. Mooney? Too bad, they would be great treasures in forty years or less. You would be asked to loan them for art exhibits and it would be a great source of interest for the young women to see how you made cloth, and set the patterns.

NELLIE MCCLUNG, 1936[1]

Western Canada, that is, the area west of Lake Ontario and east of the Canadian Rockies, has frequently been described as a 'cultural void,' and only within the past few months a writer in Canadian Art, a magazine which should know better, wrote that "there exists, between Ontario and British Columbia, something close to an artistic wasteland."

A. F. KEYS, 1961[2]

There is evidence of a kind of amnesia that is a part of contemporary culture. Macramé, for example, was not invented in the communes of the sixties flower children. . . . To deny, or even worse, to forget the traditional roots of fibre and fabric impoverishes us all.

JOHN VOLLMER, 1998[3]

And, Just What Textile Treasures Have We Lost on the Journey?

The curatorial intention behind *Prairie Interlace: Weaving, Modernisms, and the Expanded Frame* has been to recover and record lost modernisms—in this case, the curators have brought together (for the first time) a heady collection of modern and postmodern works of fibre art made in Manitoba, Saskatchewan, and Alberta between 1960 and 2000. The aim of this essay is to consider the implications that modernity and the critical success of the fibre art movement had on directing the extant Prairie textile narrative, in particular the history of the modern era (prior to 1960). The focus is not upon legacy, but rather ancestry, for the fibre art movement was a child of modern art and an active player in Modernism's grand narrative. When one turns to the critical literature—critical recognition being a much-coveted condition of modern and postmodern art—it appears that the fibre art movement, like Athena from the head of Zeus, was born fully formed, circa 1960, owing nothing to the past. The first generation of fibre artists is described by late-century art historians as 'modern' for not only appropriating the formal language of modern art but for *transcending* textiles' "humble craft origins" and for having "*liberated* the work from tradition and thus heightened their recognition by critics and the public."[4] As pioneers, they had no need to pay homage to the past, for the past is no guide in dealing with the new circumstances that make one a pioneer. The success of this strategy is reiterated in a 2022 article, "Textile artists: the pioneers of a new material world," by the arts editor of *Wallpaper*, Harriet Lloyd-Smith:

> In the 1970s, coinciding with the women's liberation movement, and the rise of feminist art, textiles underwent its own revolution. Fibre art was born: textiles was catapulted beyond the domestic space and unshackled from veiled art world snobbery. The medium took on a life beyond functional craft; it became textiles for textiles' sake.[5]

In one sense, these art historians are correct: the 1960s and 1970s did, indeed, see fibre art accepted into the fine art fold; however, that does not mean that handcrafted textiles produced on the Prairies prior to 1960 were as un-modern or unworthy of note as one might assume from the critical literature. The "Modern" was a complex phenomenon which gained traction in Canada in the early part of the 20th century and was promoted as a new mode of existence, a new art aesthetic, and perhaps more significantly, a force of social and cultural transformation. (This was the case for several Prairie handweaving initiatives.) By tracing this narrative through the critical art literature and then shifting the lens to focus on the digital archives of contemporary accounts (newspapers, magazines, newsletters, reviews of art and craft exhibitions, and school calendars) one begins to understand how it was that Prairie handweaving activities (no matter how modern) were not only denied a presence in the narrowing world of *fine art*—but also how their stories were lost.[6] This was furthered by what I call the *stand back—nothing to see—move along* school

of thought that continued to plague Prairie research, as it implied, "Why look for something when there is nothing to be found?"

In 1988, the textile historian John Vollmer lamented the lacuna, calling it a "kind of amnesia":

> Despite the relatively recent history of fibre art . . . and the explosion of the art form in the 1960s and 70s there is evidence of a kind of amnesia that is part of contemporary culture. Macramé, for example, was not invented in the communes of the sixties flower children. [T]o deny, or even worse, to forget the traditional roots of fibre and fabric impoverishes us all.[7]

However, so successful was the modernist campaign that even when Prairie artists of the 1980s and 1990s looked to history, it was to mine the history of past centuries rather than past decades.

It is helpful to remember that the Prairies experienced a late period of settlement, and the ability to craft goods out of local materials continued to have appeal as a matter of thrift, pride, and cultural identity well into the new century. As Dorothy Burnham, Canada's doyenne of textile history and the curator of the National Gallery of Canada (NGC) exhibition *The Comfortable Arts: Traditional Spinning and Weaving in Canada* explained in 1981, "In eastern Canada, except for isolated pockets, local production of textiles was finished by about 1900. In western Canada, the pioneering period was just getting started at that time."[8] Thus the "traditional" Prairie textiles in the

NGC exhibition were made between 1900 and 1950 with many reflecting a *modern* aesthetic.[9]

Even a cursory study of Prairie newspapers published in the early part of the 20th century reminds us that geographic isolation (or regionalism) should not to be equated with cultural isolation (as suggested by A. F. Keys above); nor, for that matter, should tradition be seen as being in diametric opposition to modern.[10] In 1914, just months before the Great War began, an article appeared in small town newspapers across southern Alberta. The article, "Modern Art Influence in Fabrics," informed readers that there was a new vogue for colour "spreading through every branch of the applied arts," and to underline this point it included an image of a modern textile by the Austrian architect and designer Joseph Hoffman. The author is adamant, not only about the future of modern textiles, but of their roots in tradition: "At first one may not like the new art, but that it has come to stay there is no doubt. It is the outgrowth of the seeds planted by William Morris."[11]

In 1927 the term "fabric art" appeared for the first time in the *Calgary Herald* to describe printed fabrics designed by modern artists. Readers were told, in no uncertain terms, how to recognize modern fabric's stylish signature with "the new spirit, the new coloring, the new technique" borrowed from the "futurist school" of art.[12] That same year, an article in *Maclean's Magazine*, "Woven Fabrics in Decoration: Canada provides a veritable wealth of material for following current mode," reveals how traditional handweaving was being repositioned as modern. It was to be a vehicle

for creativity—admired for its colours, geometric structure, and texture—an attractive blend of art and utility ready to take on a role in the modern *urban* interior.

> Now with so many imaginative weavers of all nationalities experimenting with the craft, and a younger generation of habitant women catering to the demand for color and smart effects, the possibilities for a really decorative covering have been increased. . . . There is a world of interest in investigating and utilizing the woven fabrics of today. They are rich in color, serviceable and original—warranting serious attention in new decorative schemes—and Canada, in particular, seems to provide a wealth of them.[13]

This journalist reiterates that these modern fabrics have their roots in the past—the product of a revival of "habitant weaving traditions." The commercially successful revivals of folk craft which took place in Eastern Canada in the 1920s and 1930s were initiated by the Canadian Handicraft Guild and provincial governments to promote tourism.[14] Under the guidance of Oscar Bériau (Director-General of Handicrafts for Québec), handweaving was positioned as an incarnation of French-Canadian heritage and an antidote to urban artifice and "the smoke and film of modernity, of hurried commerce."[15] Although it proved a successful marketing campaign, much of the rhetoric was immersed in "rural romanticism" with the "happy artisan" and the "cozy cottage" motif flooding the literature.

Bériau's characterization labelled both the production and the makers as old-fashioned, making them an easy target for derision by modernists.[16] Bériau, known best outside of Québec for his writing, would go on to be a significant force on the Prairies during the 1940s. His instructional text, *Home Weaving*, was in use across the Prairies and was described by *Craft Horizons,* the American Craft Council's journal, as "One of the Finest! . . . calculated to set a nation spinning and weaving at home!"[17]

In his 1931 lecture "The Value of Handicrafts," the new president of the Canadian Handicraft Guild, Wilfrid Bovey, advised that those in the West should consider stepping away from "the type of handicraft work which appeals mainly by reason of its *art value* or its curiosity value." This was in part a response to the economic devastation wrought by the 1929 drought that heralded the Dirty Thirties on the Prairies.[18] His advice: they should move towards a more practical commercial endeavour—as a viable home industry.

> There is no reason in the world why the Canadian countryside should not produce all the handmade tweeds and linens that Canadians wear. . . . The settlers of Hebridean and Ukrainian origin in Alberta and the French-Canadians of Québec have traditional skill in such work and a hereditary bent for it.[19]

In 1934 Bovey maintained that provincial governments had a pressing duty to "country folk" and advocated for a *modern* revival of handweaving as "one of the greatest hopes for the Canadian farmer in the future, both

economically and as a "means of regaining a contented and permanent rural life." He went on to urge the public, especially the "urban public," to purchase "tweeds made in rural districts."[20] He would explain, "Rural crafts are differentiated from these urban crafts not only because they are made in the country, but because, somehow or other they seem to breathe of the country, to have a country air."[21]

So successful was this characterization that when the political and social activist Nellie McClung (1873–1951) published *Clearing in the West: My Own Story* (1935), her identity as a *modern* woman was one who "wouldn't piece quilts or crochet, or knit."[22] Her autobiography reveals that McClung clearly envisaged the handmade as a resident of the rural past. She has a visiting teacher remark, "They are a symbol of an era in our history that is passing. Hand work is being superseded by machinery, and the fine creative household arts will be forgotten."[23] McClung unexpectedly provides insights into evolving attitudes regarding handweaving on the Prairies: first as a signifier of domestic skill and resourcefulness; then a source of creative pleasure; and finally, a site of some embarrassment. Mrs. Mooney (Nellie's mother) confides to their visitor that the younger generation "are a little bit ashamed of home-made stuff."[24] McClung's deliberate use of the descriptive "home-made" (with its overtones of the amateur and usefulness) rather than "handmade" (professional and bespoke) underscores the nascent *modernist* disdain for nostalgia, tradition, and rural and domestic values.

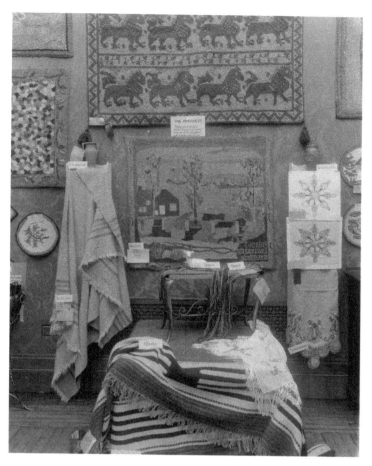

Handmade textiles from the nine provincial crafts guilds at *The Canadian Handicrafts Guild's Annual Prize and Competition Exhibition at the Montreal Art Association,* 1933. C11 D3 209 1933, La Guilde's Archives, Montréal, Canada.

Handweaving as a Contested and Negotiated Terrain

During the 1940s, handweaving was walking a cautious path, for an ambivalent, even antagonistic, relationship between modern art and *craft* was being constructed, with art critics and theorists contemptuous of craft's homey relationship with tradition. In "How Envy Killed the Crafts," Garth Clark contends that this relationship grew

"increasingly acrimonious as artists moved further away from the craft-based values of the mid-century and closer to post-1950 conceptualization and the dematerialization of the art object."[25] In 1939, the much-admired New York art critic Clement Greenberg theorized that as a modern artist either you belonged to the avant-garde, *challenging tradition*, or you produced *kitsch*. Within the decade, imputations of either the domestic or decoration were inherently damning to a would-be modern artist: "When the abstract artist grows tired, *he* becomes an interior decorator" and "decoration is the specter that haunts modernist painting."[26] In the semantics of cultural value, "decorative" and "domestic" were no longer neutral terms.[27]

Proponents of craft tried to extricate themselves from a cultural battle not of their making, as traditional values were to remain an integral element of modern craft. In 1942, Allen Eaton, the American craft revivalist, reviewed the *Exhibition of Modern British Crafts* at the Metropolitan Museum of Art in New York and felt it necessary to explain to the readers of the new journal *Craft Horizons* that there was a middle ground. When "modern" was used as a modifier of craft, it should not be feared. "It is modern in the best sense of that word, meaning that it is of today with a definite and pleasant relation to the past. [It is not] the indefinite, often confusing and sometimes freakish meaning which we attach to the word 'modern.'"[28]

In 1942, the American textile artist Ed Rossbach (1914–2002) wrote *Hand-Weaving as an Art Form*. Here, too, one sees tradition regarded as integral to a successful modern practice:

From their works we may conclude that the hand-weaver who would keep his craft a vital and significant art form must be thoroughly familiar with the medium, aware equally of its restrictions and its potentialities. He must have ideas to express—an aesthetic purpose, and he must use daring, patience, ingenuity, and sensitivity in continually exploring his medium for the best means of expressing those ideas.[29]

Looking back from the 1980s, Rossbach suggested that, while hand weavers might have followed different paths (the dreaded art/craft debate), it was this tacit understanding that fibre encouraged innovation and "stimulated experiments in new materials" that led some weavers to the fibre art movement of the 1960s.[30] In several articles in *American Craft*, he describes the separate, yet intersecting, paths taken by several eminent weavers who were practicing in the 1940s. Two stand out: the Bauhaus-trained weaver Anni Albers (1899–1994), whose "intellectually geometric" weavings and aesthetic theories spoke of her allegiance to modern art, modern design, and modern processes (manufacturing), and Mary Meigs Atwater (1878–1956), "the Dean of American Weaving," who was already well known having founded the Shuttle-Craft Guild in 1922 and published *The Shuttle-Craft Book of American Hand-Weaving. Being an account of the rise, development, eclipse and modern revival of a national popular art* in 1928.

Rossbach notes of Atwater that "By teaching her followers to value the traditional works and to appreciate them by copying and comprehending their structures, she

was responsible for a wider awareness of traditional weaving." He concludes, "To Atwater, the weaver experienced both the artist's job in creating and the craftsman's satisfaction."[31]

It is these values that inspired the Department of Extension at the University of Alberta to invite Atwater to teach weaving workshops at the School of Community Life in Olds, Alberta, in the summers of 1939 and 1940.[32] The success of this venture saw Atwater become the first instructor of "Weaving and Design" in the newly created Applied Arts program (1941) of the Banff School of Fine Arts (p. 66). A grant from the Carnegie Corporation "to establish and *maintain standards of craftsmanship* in the province" made Atwater a natural fit. Carnegie scholarships in handweaving were administered by the Canadian Handicraft Guild.[33] The prospectus assured potential students:

> The Banff School of Fine Arts considers itself fortunate in having as its first instructor in weaving Mrs. Mary Meigs Atwater, . . . She regularly conducts schools in various centres in the United States in addition to her school at Basin, Montana. Mrs. Atwater is recognized as an artist, designer and craftswoman who has done more to restore the art of weaving to its proper place in the country than any other single individual.[34]

Atwater set the guiding principles for the Banff workshops and was aided by Ethel Henderson of Winnipeg, already a graduate of Atwater's correspondence course. Both

ANNOUNCING

—THE—

Alberta School of Community Life

—AT—

School of Agriculture, Olds

JULY 3rd to 16th

COURSES OPEN TO ALL IN . . .
INTERNATIONAL AFFAIRS and CANADIAN PROBLEMS — RURAL SOCIOLOGY and COMMUNITY ORGANIZATION — PRINCIPLES of CO-OPERATION DRAMATICS — WEAVING — HOME-MAKING.

GUEST LECTURERS: Prof. Norman MacKenzie, University of Toronto; Prof. W. M. Drummond, Ontario Agricultural College; Mary M. Atwater, Basin, Montana.

Apply: Director, School of Community Life, Olds, Alberta.

Published in the *Calgary Herald*, a division of Postmedia Network Inc., June 29, 1940, 15. Courtesy of Olds College of Agriculture & Technology.

novice and advanced courses were offered at the Banff School with students meeting a series of objectives meant to raise standards, suggesting that not only a popular but also a critical interest in handweaving was being encouraged.[35] Donald Cameron, head of the university extension program, would gleefully remark, "Among the students was the millionaire head of a famous sewing machine company from California who was taking weaving."[36] Students attending the Banff School that summer would have been well aware of the ongoing debate regarding the direction modern handweaving was taking as the July/August issue of *The Weaver* had just published Atwater's indignant response to Anni Albers' "Handweaving Today: Textile Work at Black Mountain College." In the January/February edition, Albers had written:

> Unfortunately, today handweaving has degenerated in face of technically superior methods of production. Instead of freely developing new

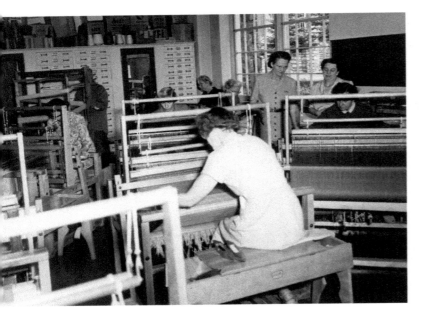

Weaving class at Banff School of Fine Arts, 1950. Courtesy of Glenbow Library and Archives Collection, Libraries and Cultural Resources Digital Collections, University of Calgary (CU1134332).

forms, recipes are often used, traditional formulas, which once proved successful. Freshness of invention, of intelligent and imaginative forming has been lost.[37] [The word "recipe" was a term regularly used by Atwater.]

Albers goes on to explain that there is a role handweaving might play: "[If it is] conceived as a preparatory step to machine production the work will be more than a revival of lost skill and will take responsible part in a new development." Further, she contends "if handweaving is to regain actual influence on contemporary life, approved repetition has to be replaced with the adventure of new exploring. . . . [To] become art it needs nothing but its own high development and adjustment in all its properties."[38]

Elsewhere, Atwater had taken Albers to task for her use of modern formalist language; what others interpreted as an intellectual approach to handweaving, Atwater described as "quaint notions."[39] In "It's Pretty but is it Art?" Atwater begins, "I disagreed . . . so heartily. It is stimulating to disagree," and continues, "Mrs. Albers suggests that handweaving 'may be Art' through what she calls 'free-forming,' without regard to 'fulfillment of demand,'—by which, I take, it means fitness for practical use. This sounds like the old and long since discredited principle of 'Art for Art's Sake,' and certainly holds little inspiration for the craftsman." She adds, "a 'free-formed' textile, so casually constructed that it will not hold together, is really not a fabric at all." At the same time, Atwater proposes that "'New exploring' is exciting, and is highly desirable *if* the explorer happens to be equipped with the technical knowledge and ability to take him somewhere."[40]

These articles must have encouraged serious discussions within the Banff cohort—perhaps sides were being taken—given that some were students or instructors in the Art Department of the Southern Alberta Institute of Technology (SAIT or 'The Tech"). The Tech had introduced weaving classes in the early 1930s as part of its popular three-year Applied Arts and Crafts Diploma, and by 1940 a designated weaving teacher was on the books.[41] Indeed, many of the fibre artists in *Prairie Interlace* found their *footing* at the Tech including F. Douglas Motter (cat. 36), who was both a student and an instructor, teaching weaving from 1963 through 1976. Others, such as Hazel Schwass (discussed below), Inese Birstins (cat. 6), and Katharine

Dickerson (cat. 11), attended the Banff School.

Atwater fully expected to teach at Banff the following year (July 28 to August 21, 1942); nonetheless, in early July she announced a sudden change in plan. "Due to Canadian government restrictions . . . visitors to Canada will not be permitted to purchase more than a total of twenty gallons of gasolene [sic] . . . It seemed advisable to give up the trip this year."[42] In his history of the school, Cameron would write that "Mrs. Henderson and Mrs. Mary Sandin of the U of A, who joined the staff in 1942, today are looked upon as two of the leading instructors in this field on the continent."[43] That some of the handweaving being produced at Banff also had currency within modern art practices of the 1940s and 1950s is revealed not only in the reviews of art and craft exhibitions in local newspapers, but also on the pages of *Loom Music* (1945–1965), a multi-page newsletter aimed at Canadian weavers and guild members, and edited and produced by Sandin and Henderson. With its patterns, instructions, and copious amounts of advice, *Loom Music* echoes Atwater's *Shuttle-Craft Bulletin* (1924–1954) and, like its American counterpart, provides a sense of the direction that handweaving on the Prairies was taking. For instance, the editors employed an excerpt from the British modern weaver Ethel Mairet's text, *Hand Weaving Today—Traditions and Changes*, to challenge readers. Mairet identified the modern nature of "small individual workshops" for "they are constantly experimenting with all sides of handweaving . . . they are the valuable and necessary laboratories . . . they always use a critical attitude . . . they are

Left to Right: Winnifred Savauge, Ethel M. Henderson and Mary Sandin at the Banff School of Fine Arts. "Program Calendar," *Applied Art* (c. 1947), 28. Courtesy of Paul D. Fleck Library and Archives, Banff, Alberta, Acc# 2003-10.

Loom Music IX, no. 1 (January 1952), cover.

Detail of *Automatic*, a free design technique. *Loom Music* IX, no. 2 (February 1952), 16.

always experimenting."[44] Of their readers, the editors of *Loom Music* asked, "Can we, as a company of weavers, pledge ourselves to do one extra yard on each warp we set up, to be used as an experimental piece? Let us learn to be weavers—not blind followers of a set of instructions."[45]

They were not blind followers. In 1945, Sandin and Henderson attended a Banff lecture given by the artist J. W. G. [Jock] Macdonald where they were introduced to automatic drawing.[46] Inspired, they went back to their looms and began to practice automatic weaving. "Our imperfect understanding of it was that one emptied the mind of conscious thought and gave the inner mind full sway. As this is exactly what we were to do in this weaving . . . [I]t made each row a real adventure, as we tried to let inspiration be our guide."[47]

Handweaving was being introduced on the Prairies through other initiatives, and in a throwaway line, in 1939, Atwater distinguished between the handweaving revivals

of Québec and the promotion of *modern* handweaving on the Prairies: "A great deal of simple weaving has been done in Québec province for a number of years, chiefly as a source of income for the people on farms. The interest in western Canada is more recent and is more along the lines of art and less for commercial returns."[48] The following year, after her experience teaching at Banff, she would write:

> In Alberta and in British Columbia—no doubt in other Canadian provinces—the State [sic] Universities are doing a great deal to promote handicraft. [. . .] Young women with skill in handicraft are sent out into the most distant and inaccessible parts of the country to teach the young people such crafts as weaving . . . I do not know of any similar work being done by universities in the United States. I wonder why not![49]

Not unexpectedly, Anni Albers was less than enthusiastic about such initiatives, identifying them as retrograde. "There is one other aspect of the work, one not intrinsically connected with the idea of future development; it is that of handweaving as a leisure-time occupation and as a source of income in rural communities, . . . [which is] often no more than a romantic attempt to recall a *temps perdu,* a result rather of an attitude than of procedure." She warned, "it is necessary to keep in mind that handweaving here takes on the character of a means to an end and is not in itself the center of interest."[50]

Only very recently some of the most important studies in education have revealed this; that the culture of the brain, the culture of life, the culture of the soul, begins with the culture of the finger tips. The neglect of the finger tips has led to the coarsening of the sense of touch and to the blunting of fine feelings.[51]

Sidestepping the critical debates and turning to first-hand documentation of the Prairie weaving culture (much available through digital archiving), one discovers that many hundreds of Prairie women (and it was mainly women) were introduced to handweaving through two rural educational initiatives that ran in the 1940s. One learns that many of these women took their new "traditional" skills and developed them further. These initiatives were described in contemporary accounts as modern—not only because they were introducing new materials and techniques—but because they were founded on the nuanced belief that they were a force of social and cultural transformation. Arguably, handweaving can be seen as a creative vehicle for modernist ideologies.

Both initiatives were inspired by the work done in Québec and followed a similar format—six weeks of structured classes saw each student complete a sample book. Janet Hoskins describes some extant sample books noting the unrelenting methodology not only over the duration of the class but over the years.[52] These books served two

A page from Grace Ethel (Stoner) Sundstrom's sample book. She learned to weave while living in Kennedy, Saskatchewan in the 1930s by enrolling in the Searle program. Photo by Dave Brown, LCR Photo Services and sample book courtesy of Gail Niinimaa.

important purposes—as the means of documenting progress and techniques, and as an *aide-mémoire* for future projects or teaching. The first program to bring handweaving classes to rural Prairie communities was established in Manitoba in 1941, and with its large Franco-Manitoban population it was natural that the school board would look to Québec and Oscar Bériau for guidance.

Mrs. Dorothy Rankine, Consultant, "Searle Farm Home Weaving Service" is shown at home, weaving a coat-length from blue poodle wool. The draw-drapes, 22 yards, were woven by Mrs. Rankine from turquoise cotton and gardenia-white nubby boucle. The next-to-glass curtains were woven by Mrs. Norman Lewis, from Ice-Gold white nubby boucle and metallic. The famous G.E.T. in Québec hooked the large picture. The wool warp on the loom is 15 yards long—enough for a top coat and matching suit. *Leclerc Present the Hand Weaving Looms*, no. 128 (May 1956): cover. Image courtesy of the Manitoba Crafts Museum and Library, 130.00-08.

The classes were administered by *La société Canadienne d'enseignement postscolaire du Manitoba* (the French Canadian section of the Manitoba Adult Education Association) and the Roman Catholic Church. Bériau sent for two French-speaking weaving instructors from the Sisters of the Holy Names of Jesus and Mary (SNJM) in Québec, and the first class was held at St. Joseph's Academy, St. Boniface, in July 1941.[53]

The press followed the progress of the scheme with great interest, mostly privileging the French-Canadian, Roman Catholic family values being espoused. In 1942, when the Ste. Agathe "farm home weaving circle" completed their course of study, an exhibition of the work was described in some detail in the *Winnipeg Tribune*.[54] Although the work was admired, neither the teacher nor the students were identified, and the spokesperson interviewed was the parish priest. And, reminiscent of a Victorian father, Father Clovis Paillé is effusive:

> We hope it will lead to sheep raising and the growing of flax. It's not just the fact that they have learned to make pretty and useful things for their homes that made the course so successful . . . It has taught them thrift, patience and perseverance. It has taught us older people that not all the young ones want to spend their time in idle pleasures.[55]

Along a similar vein, *Le tissage domestique en Saskatchewan*, 1943, finds L'abbé Maurice Baudoux describing handweaving as a means to address the vicissitudes of rural isolation and the war and goes on to speak of the role domestic textiles are playing in the

war effort. To his mind, handweaving had done much to elevate the taste for "home-made" items, and he argues that it will allow creativity to flourish in times of peace.[56]

The second scheme was secular and benevolent and is credited with teaching "over 1,000 rural women and girls to weave, free of charge to students, which enables them to make beautiful and useful materials for the home at a fraction of the cost at which the goods could be purchased."[57] Augustus L. Searle, of the Searle Grain Company, had watched in dismay as not only young men, but many young women had left the farm to join the war effort. His goal was to stabilize the farm family and prevent further migration to the cities. He, too, would turn to Bériau, who is described in the Searle publication, *Hand Loom Weaving*, as "undoubtedly the greatest authority on the American continent, and one of the greatest authorities of the world, on handicrafts including weaving."[58] In 1942 Searle established a weaving program that aimed, as the *Winnipeg Tribune* noted, "not to establish a new farm industry but merely to show farm women how to weave so they can improve their own individual surroundings."[59]

Oscar Bériau's daughter, Renée, herself a master weaver, travelled to Manitoba to recruit and train potential instructors for Searle. Four women were selected. All were accomplished weavers, fluent in English but each spoke at least one other language—two French, one Swedish, and one Ukrainian and Russian, which speaks to the ongoing Prairie handweaving traditions.[60] Upon completing the intensive three-month course the newly minted instructors were sent to rural communities in Alberta and

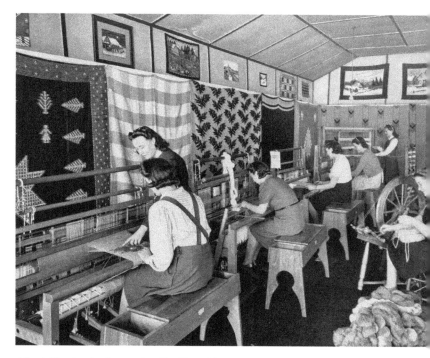

A Searle Weaving class in operation. *Hand Loom Weaving..... The story of the Searle Grain Company's Effort to Sponsor Hand-loom Weaving Among the Farm Women of the Prairie Provinces* (Winnipeg, 1944), n.p.

Saskatchewan where they met, according to Frank Kennedy the *Calgary Herald*'s agricultural editor, with "conspicuous success," partly because the company "bears all the expense, and materials used by the pupils for the instruction period are also provided free by the company."[61]

Classes were taught in towns with a Searle Grain Elevator, meaning the looms and other weaving equipment could be delivered by rail and then easily moved to another Searle location. Students signed a waiver agreeing "to carry out faithfully the detailed instructions of the teacher, and to weave only during the period of instruction

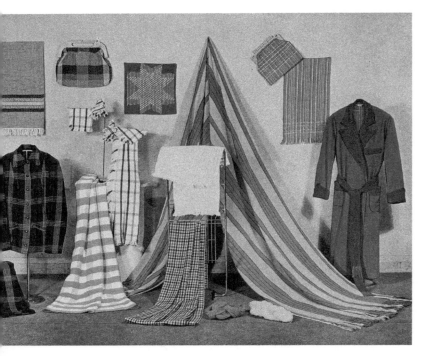

Handicrafts made by pupils of Searle Weaving classes. *Hand Loom Weaving.....The story of the Searle Grain Company's Effort to Sponsor Hand-loom Weaving Among the Farm Women of the Prairie Provinces* (Winnipeg, 1944), n.p.

such materials and such designs as the teacher shall approve, and which form part of the teaching course."[62] "The only obligation required of the pupils is that after they have graduated and formed a weaving circle, they in turn will teach free of charge farm women who desire to learn weaving."[63] Searle graduates continued to weave, to teach, to form guilds, to experiment, and to exhibit their work.[64] In "The World of Wheat," Searle Grain's research director would often provide updates on the weaving program. He was able to report in 1943 that 200 students had sent samples of their weaving to be adjudicated in Québec for an exhibition—where they were much admired and, according to Strange, "examined not without some jealousy."[65] The methodology was one that

would have been familiar to Atwater: "you learned weaving by weaving—and you started weaving *something*."[66] But where one took these skills after completing the class was another matter.

Hazel Schwass: A Graduate of the Searle Weaving Program

Saskatchewan-born artist Hazel [Pollock] Schwass, was eighteen when she embarked on the six-week Searle course, forty-nine when she created *Untitled*, 1974 (cat. 51), and sixty when she outlined the artistic path she had forged for the Alberta Culture Visual Arts' Personal Artist File in 1984. In it she credits her success as a fibre artist to the Searle's concentrated instruction on a four-harness loom, for it made her "self-sufficient in loom operation, 40 weaving techniques and practical application."

Her enthusiasm for weaving did not diminish, and over the years she continued to expand her textile skill sets—taking courses not only in various forms of weaving, but also in spinning and dyeing.

> I have woven in the traditional mode for twenty years. This grounding in technique and finish is the background I use in all my work. I feel weaving, be it practical or art piece, must be structurally sound and woven with those quality standards in mind.[67]

Admittedly proud of her functional work, one cannot help but wonder if a 1972 article, published in the *Calgary Herald*, served as a tipping point in the direction her practice would take. With a metaphorical pat

on her head, the journalist Ken Liddell mansplained,

> From a cottage industry that is a hobby and therapeutic occupation carried out in the basement of her home—in what is labeled the 'fun room'—Mrs. Schwass makes products that are warm and comfy: Saddle blankets for horses and little car seat covers for humans.[68]

Within two years Schwass had found her passion, "free-form woven art," and was creating and exhibiting conceptual *fibre art* pieces—such as *Untitled*. She was also creating large-scale public commissions. In 1979 Schwass won a scholarship to attend the Banff School of Fine Arts which saw her studying with Mary Snyder and focusing on multi-harness loom and three-dimensional weaving. And, as Augustus Searle had hoped, when he introduced the program, Schwass continued to inspire new generations of weavers through her teaching, much of it done in Lethbridge, Alberta.[69] Like many of the artists featured in *Prairie Interlace*, Schwass combined traditional and non-traditional skill sets,

> I feel my weaving has progressed from two-dimensional 'wall hangings' to concepts and designs for three-dimensional works suitable for office and public areas. I am constantly exploring and experimenting with materials other than fibre to incorporate in my work.[70]

Conclusion: Stand Back— Nothing to See—Move Along

Whereas the production of material culture through such schemes has been dismissed as acts of benevolence or romantic revivals, there should be no doubt that the history and legacy of modern handweaving on the Prairies is a rich one and requires much more scrutiny. Arguably, Prairie schemes promoting handweaving *were* modern, theorized in the day by socially utopian ideologies. But these weavers were also active within the world of art and craft, and it should be obvious that "community based and interactive projects that serve artisans, consumers and patrons" such as the Banff School of Fine Art, the Art Department of the Tech, and the Searle Grain Home Weaving Program also signal "artisan independence, agency and nascent resistance."[71]

The aim of this chapter has been to consider the role modernity played in the critical success of the fibre art movement and determine how this success directed the extant generational textile narrative. It did so by bringing a series of "lost" mid-century Prairie textile initiatives to the forefront. There is no doubt that the modernist art rhetoric of the mid-century was responsible for the elevation and critical acceptance of fibre art in the 1960s and 1970s, even as it perpetuated ongoing prejudices (gender, media, cultural, regional) that ensured that traditional textile practices, regardless of how modern, would continue to be relegated to a marginal position, if at all, in the literature.[72]

When John Vollmer called the gap in textile history a "kind of amnesia," we must

remind ourselves that amnesia is not inno-
cent; it is constructed just as all knowledge
bases are constructed. While benefiting from
the early modern tradition in the acquisition
of a knowledge base, the first generations of
fibre artists emphasized the conceptual ex-
citement of the transition to art. Eschewing
time-honoured sobriquets and traditional
relationships with handweaving, these *art-
ists* experimented with new media and tech-
niques and were welcomed as *pioneers* of the
new *art form*—the fibre arts.[73] It may even
be argued that adherence to tradition would
have only aggravated the ongoing hierarchi-
cal prejudices. By the late 1980s, fibre artists
were being positioned as postmodern rene-
gades who had creatively appropriated fibre
as a subversive medium. Nonetheless, so
successful was the modernist campaign that
even when these artists looked to history, it

was to the textile history of past centuries
rather than past decades.

As this research suggests, this is only
an initial foray into seemingly uncharted
waters with much more to discover about
innovative Prairie textile practices. Simply
by shifting the focus from art to craft, an
enriched textile narrative emerges from the
archives of Prairie social history. What is on
offer does not diminish but enhances the
significance of the work done on the Prairies
and represented in this exhibition. Each
work offers up another point of entry into
an alternative history that is waiting to be
told, for there is now substantial evidence to
argue that the seeds for a robust, regionally
based, *modern* textile and textile art move-
ment were being planted on the Prairies well
before the fibre art movement took form.

NOTES

1　Nellie McClung, "Visit from the Teacher," *Clearing in the West: My Own Story* (Toronto: Thomas Allen, 1935), 178.

2　A. [Archibald] F. Keys, "Introduction," *Alberta Artists, 1961* (Calgary: Calgary Allied Arts Council, 1961), n.p.

3　John Vollmer, in *Cinquième Biennale de Tapisserie Contemporaine de Montréal* (Montréal: Quebec Society of Contemporary Tapestry, 1988), 43. Vollmer was Senior Curator of Fine and Decorative Arts at the Glenbow-Alberta Institute, Calgary, 1984–86.

4　Karen Patterson, ed., *Lenore Tawney: Mirror of the Universe* (Chicago: University of Chicago Press, 2019); Mildred Constantine and Jack Lenor Larson, *Beyond Craft: The Art Fabric* (New York: Van Nostrand Reinhold, 1972), 7.

5　Harriet Lloyd-Smith, "Textile artists: the pioneers of a new material world," *Wallpaper*, March 24, 2022, https://www.wallpaper.com/art/contemporary-textile-artists.

6　Researchers from a variety of disciplines have taken up the challenge, although their findings have yet to be woven together to create a meaningful Prairie narrative.

7　Vollmer, *Cinquième Biennale*, 43.

8　Dorothy Burnham, "Multi-Cultural Traditions in Western Canada," *The Comfortable Arts: Traditional Spinning and Weaving in Canada* (Ottawa: National Gallery of Canada, 1981), 202.

9　The National Gallery of Canada exhibition identified Indigenous, settler, and immigrant textile traditions.

10　Virginia Nixon, "The Concept of Regionalism in Canadian Art History," *Journal of Canadian Art History* 10, no. 1 (1987): 30–41.

11　"Modern Art Influence in Fabrics," *Carlstadt News*, March 11, 1914, 11.

12　"Women to Wear Signed Works by Eminent Artists," *Calgary Daily Herald*, March 25, 1927, 11.

13　Anne Elizabeth Wilson, "Woven Fabrics in Decoration: Canada provides a veritable wealth of material for following current mode," *Maclean's*, August 15, 1927, 65–66.

14　Oscar Bériau, "Craft Revival in Quebec," *Craft Horizons* 2, no. 1 (November 1942): 25–26.

15　Louis Arthur Cunningham, "Among the Cottage Crafters," *Canadian Home Journal* (March 1933): 8, 34, 40.

16　T. J. Jackson Lear, *No Place of Grace: Antimodernism and the Transformation of American Culture, 1860–1920* (Chicago: University of Chicago Press, 1983).

17　Oscar Bériau, *Home Weaving* (Quebec: Department of Agriculture, 1939); "Book Review," *Craft Horizons* 2, no. 1 (1942): 27; "The Craft Revival in Quebec," *Craft Horizons* 2, no. 1 (1942): 25–27.

18　Given the Prairie provinces depended almost exclusively on raw materials and agricultural production, the drought heralded a decade historically recognized as the Great Depression.

19　Wilfrid Bovey, "The Value of Handicrafts," *Calgary Daily Herald*, February 6, 1931, 4. See also: "One Result of the Immense Tourist Traffic in Canada is a Revival of Home Industries," *Oyen News*, February 8, 1928, 5; "To Develop Home Art Industries: Canadian Handicraft Guild to Hold Exhibition in Regina," *Irma Times*, March 1, 1929, 2.

20　Wilfrid Bovey, "Future of Handicrafts: Means of Regaining Contented and Permanent Rural Life," *Crossfield Chronicle*, January 18, 1934, 6; *Redcliff Review*, February 1, 1934, 3.

21　Wilfrid Bovey, "'Colonel Bovey's Address' Art Reference Round Table," [Montreal Conference], *Bulletin of the American Library Association* 28, no. 9 (September 1934): 551–55.

22　McClung, "Visit," 242.

23　McClung, "Visit," 177.

24　McClung, "Visit," 178.

25　Garth Clark, "How Envy Killed the Crafts," in Glenn Adamson, *The Craft Reader* (London: Berg, 2010), 446.

26　Clement Greenberg, "Review of Exhibitions of Joan Miró, Fernand Leger, and Wassily Kandinsky," [1941] in *The Collected Essays and Criticism, Vol 1: Perceptions and Judgments, 1933–1944*, ed. John O'Brian (Chicago: University of Chicago Press, 1986), 64; "Milton Avery," [1957] in *The Collected Essays and Criticism, Volume 4: Modernism with a Vengeance, 1957–1969*, 43.

27　John Bentley Mays, "Comment," *American Craft* 45, no. 6 (December 1985/January 1986), in Adamson, *Craft Reader*, 430–40. The Canadian art critic, Mays, explained why art critics "will never be paying as much attention to crafts as craftspeople (and even some artists) think they should." "This is so not because craft or craft-as-art (as I have experienced it) are inferior to art, but because they are not art" (432).

28　Allen Eaton, "Exhibition of Modern British Crafts," *Craft Horizons* 2, no. 1 (March 1942): 8–10. From the Metropolitan Museum of Art in New York, it travelled to Ottawa, Montreal, and Quebec City in 1943.

29　Ed Rossbach, "Hand-Weaving as an art form," *Craft Horizons* 8, no. 23 (November 1948): 20–21.

30 Ed Rossbach, "Fiber in the Forties," *Craft Horizons* 42, no. 5 (November 1982): 15–19.

31 Ed Rossbach, "Mary Atwater and the Revival of American Traditional Weaving," *American Craft* 43, no. 5 (April–May 1983): 22.

32 "Handicraft Expert Flies to Olds for School. Noted Weaver. Olds School Agriculture," *Calgary Daily Herald,* July 4, 1939, 8.

33 Ralph Clark, *A History of the Department of Extension at the University of Alberta, 1912–1956* (Toronto: University of Toronto Press, 1985). In 1943 Alice B. Van Delinder was awarded a scholarship. She taught at Banff for ten years and at the Tech for fifteen. "Weaving Instructor Retires," *Calgary Herald*, May 16, 1962.

34 *Banff School of Fine Arts* [calendar], 1942, 17.

35 Early class lists reveal a surprising number of students from the United States.

36 Donald Cameron, *Campus in the Clouds* (Toronto: McClelland and Stewart, 1956), 36.

37 Anni Albers, "Handweaving Today: Textile Work at Black Mountain College," *Weaver* 6, no. 1 (January/February 1941): 1.

38 Albers, "Handweaving Today," 1, 5.

39 "Quaint Notions," cited in Rossbach, "Mary Atwater," 22; As Rossbach points out, "museum directors felt safe with the weavings of Anni Albers. They trusted her intellectual approach to fiber, her control, her absence of sensuous colour, her emphasis on the grid. With her work they avoided the artsy-crafty stigma." Ed Rossbach, "In the Bauhaus Mode: Anni Albers," *American Craft* 43 (December 1983–January 1984): 7–11; Ed Rossbach, "Fiber in the Forties," 15–19.

40 Mary Meigs Atwater, "It's Pretty—But is it Art?" *The Weaver* 6, no. 3 (July–August 1941): 12, 13.

41 Given that students were being prepared to enter the job market, handweaving classes were meant to support teachers, creative makers, and following the First World War, occupational therapy. Mrs. B. K. Benson (b. 1870 Iceland) taught spinning and weaving at the Tech in 1939 and in 1943 boasted "I have never copied from a pattern in my life." "Makes Clothing From Rabbit Wool," *Calgary Herald,* May 12, 1943, 8. In 1940, a recent hire at the Tech, J. B. McLellan, a graduate of the Glasgow School of Art (1937) with a background in craft (he would be the first to teach "Applied Art" at the Banff School of Fine Arts in 1941), was dismayed to discover that the looms had not made the trip to the new location. "Anxious to get his students started, Mr. McLellan made a small loom at home, and also some weaving boards, on which the first principles of threading a loom and color blending in design, could be learned." One can see his interest went beyond the utilitarian: "although weaving is tedious until the loom is threaded, it amply repays the worker, because such satisfactory color effects can be gained with threads, which give a richer and much clearer product than can possibly be obtained by mixtures of pigment on palette." Margaret L. Steven, "Healing by Handicraft: Classes Reflect Post-War Problems." *Calgary Herald*, January 18, 1941, 23.

42 Mary Meigs Atwater, *Shuttle-Craft Bulletin* (July 1942): 4.

43 Cameron, *Campus in the Clouds*, 36; Sandin was also a member of the Shuttle-Craft Guild, and mentioned in the April 1940 *Bulletin*.

44 Ethel Mairet, *Hand Weaving Today—Traditions and Changes* (London: Faber & Faber, 1939), cited in *Loom Music* 4, no. 9 (September 1947): 77. (Mairet's weaving was included in the Modern British Craft Exhibition).

45 *Loom Music* 4, no. 9 (September 1947): 77.

46 The Banff School of the Fine Arts, 1945 Calendar, 17. Biographical note: "James W. G. Macdonald D.A. (Edin) obtained a Diploma of Design at the Edinburgh College of Art in 1922; combined with practical design and spent three and one-half years as staff designer to a large textile factory in England, designing cretonnes, prints, damasks, carpets and embroideries."

47 *Loom Music* 9, no. 2 (February 1952): 15.

48 Mary Meigs Atwater, *Shuttle-Craft Bulletin* (September 1939): 4. "In the matter of weaving materials, however, Canada is far more fortunate than we. Cottons to be sure are more expensive than with us—but the beautiful linens, wools and worsteds, at prices far below the rates we pay were enough to make a weaver's mouth water."

49 *Shuttle-Craft Bulletin* (September 1940): 4.

50 Albers, "Handweaving Today," 7.

51 Dr. Jas. Robertson, C.M.G., founder of the Canadian Seed Growers Assoc., cited in "Introduction," *Hand Loom Weaving . . . The story of the Searle Grain Company's Effort to Sponsor Hand-Loom Weaving Among the Farm Women of the Prairie Provinces* (Winnipeg: Searle Grain Co., 1944).

52 Janet A. Hoskins, "Weaving Education in Manitoba in the 1940s" (master's thesis, University of Manitoba, 1982). In 2017 the Saskatchewan Craft Council asked contemporary weavers to respond to Bériau's text and extant samples, resulting in the exhibition, *Prairie Woven: From Utilitarian Roots to Contemporary Art*, Saskatoon, SK.

53 Sisters of the Holy Names of Jesus and Mary (SNJM) is a French-speaking teaching order founded in Quebec.

54 Works made were mainly domestic—scarves, baby shawls, curtains, tweed yardage, etc.—but also religious, such as altar mats. *Winnipeg Free Press*, March 9, 1943, 8.

55 Verena Garrioch, "Villagers of St. Agathe Present Display of Weaving," *Winnipeg Tribune,* November 17, 1942, 8.

56 L'abbé Maurice Baudoux (Secrétaire de la société Canadienne d'enseignement postscolaire, section française de la Saskatchewan), "Le tissage domestique en Saskatchewan," *La Liberté et le patriote,* January 20, 1943, 3.

57 "Grain Trade Answers C. F. A. Convention Charge," *Calgary Herald,* February 25, 1947, 3.

58 Searle Grain Company Ltd., *Hand-Loom Weaving,* Winnipeg, July 1944.

59 Alice McEachern, "Grain Firm Sponsors Weaving Instruction," *Winnipeg Tribune,* April 18, 1942, 3.

60 McEachern, "Grain Firm," 3.

61 Fred Kennedy, "Weaving Classes Popular on Farms: Project inaugurated by Searle Grain Co. Ltd. Providing of Great Value to West Farm Women," *Calgary Herald,* October 3, 1944, 13.

62 "Farm Home Weaving Circles Rules and Regulations," Searle Grain (Research Department), Winnipeg, February 1, 1943, cited in Hoskins, "Weaving Education," 108.

63 Kennedy, "Weaving Classes," 13.

64 D. Geneva Lent, "Folk Arts Exhibit Here Next Week," *Calgary Herald,* October 6, 1945, 8; Two years into the program, the company confirmed that "so far 246 forty-five inch looms had been purchased and estimated that over 10,000 yards of 45 inch material had been woven by graduates." *Hand-Loom Weaving.*

65 H. G. L. Strange, "The World of Wheat Reviewed Weekly," *Chronicle,* December 9, 1943, 1.

66 Rossbach, "Mary Atwater," 28.

67 "Hazel Schwass, Fibre Artist," Personal Artists File, Alberta Visual Arts, September 1984; National Gallery of Canada Artist file (30525), Textiles, December 15, 1987.

68 Ken Liddell, *Calgary Herald,* February 9, 1972, 5.

69 "Hazel Gladys Evelyn Schwass," obituary, November 12, 2011, Myalternatives, https://www.myalternatives.ca/acme/obituaries/2011-schwass-hazel-gladys-evelyn.

70 "Hazel Schwass, Fibre Artist," National Gallery of Canada Artist file.

71 Janice Helland, "Benevolence, Revival and 'Fair Trade': An Historical Perspective," in Janice Helland, Beverly Lemire, and Alena Buis eds., *Craft, Community and the Material Culture of Place and Politics 19th–20th Century* (Farnham, UK: Ashgate, 2014), 137.

72 Typically, Prairie production of the first half of the century was dismissed as traditional, aligned with gender, domesticity, and utility, and positioned as endangered keepsakes of interest only to antiquarians and social and cultural historians.

73 Catherine Roy (retired, Royal Alberta Museum) was invaluable in spurring me on and alerting me to the fact that these modern weavers had long been incorporating roadside grasses for wefts: See *Loom Music* 10, no. 6 (1953): 45.

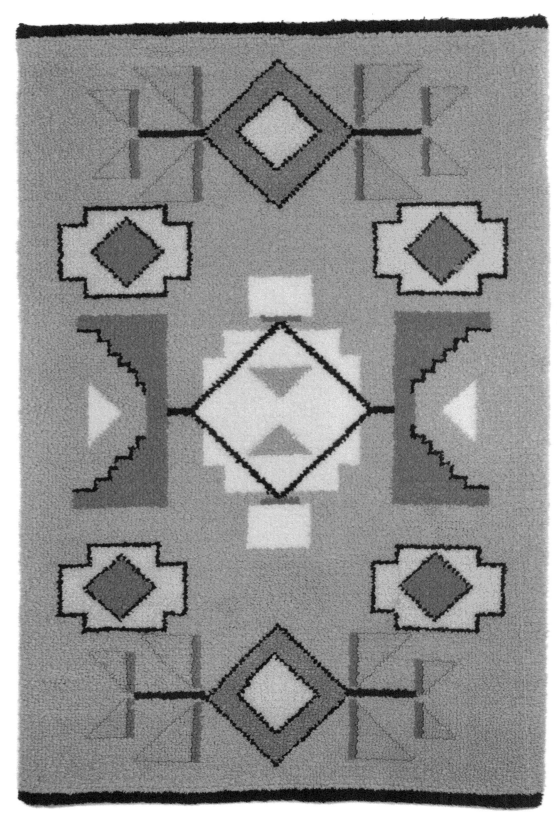

Evelyn Goodtrack, *Dakota Rug*, c. 1968 (cat. 16)

Marginalized Moderns: Co-operatives and Indigenous Textile Arts in Saskatchewan, 1960–1972

by Sherry Farrell Racette

She was a Native person exploring Modernism, that temporal and aesthetic other. But she was also Indigenous to the terrain of Modernism itself.[1]

PHILIP DELORIA

In 1969, *Maclean's* magazine named Dakota elder Martha Tawiyaka as one of the "Canadians You Should Know" with the caption declaring her "The Indian Grandma Moses of Rug Making."[2] She was described as the "spiritual head" of an artist co-operative on Standing Buffalo First Nation, and Lorna Ferguson as the "white woman" who conceived the idea. Like most media describing the Standing Buffalo rugs, the author emphasized the significance of Dakota oral histories and traditional designs but described rug-making as novel.

While the specific latch-hooked technique used by the Sioux Handcraft Co-operative to produce its Ta-hah-sheena rugs was introduced in 1967, Indigenous women in the Qu'Appelle Valley had been making rugs for decades. The majority were braided and hooked rugs. Preceded by buffalo robes, painted hides, Hudson's Bay blankets, and finger "woven" rabbit skin blankets, Indigenous women's use of cloth increased as they moved into settlements and onto reserves. These shifts were partially in response to the collapse of the buffalo herds and loss of political and economic power following the 1885 resistance and the signing of the treaties. During these difficult times, marketing rugs, quilts, baskets, and moccasins were important aspects of the annual economic cycle for both First Nations and Métis women.[3] Women's needles kept people alive. The products of sewing, accompanied by fish and berries, were often sold door-to-door. Rug-making was a family enterprise, and marketing could be highly competitive.

The critical feature in the longevity of hooked and braided rug-making is their essential frugality, recycling used clothing and other textiles into lengths of material. Frugality was at the heart of the weaving and sewing included in "Industrial teaching" for girls. The 1892 *Annual Report of the Department of Indian Affairs* provides descriptions of programs in Residential and Day Schools. The inspector visiting the Okanese school declared the girls "expert at carding wool," while other students knitted with yarn they had just spun. A "cloth hearth-rug" was among items on display.[4] The Qu'Appelle Industrial School had fully equipped sewing rooms, including spinning wheels and knitting machines. In the guise of education, girls played fundamental roles in the school economy. They sewed and mended *all* student clothing and made "door mats and hearth rugs" from clothing too worn for use.[5] The full life of every garment went through their hands.

In 1933, an array of artistic textiles from fifteen Prairie Residential and Day Schools was displayed at the Regina Fair. The reporter asked, "Where do they get their ideas?" and enthused, "Indian girls in the schools are talented seamtresses . . . they have a fine knowledge of colour combinations and are very quick to master new stitches in the various branches of sewing." Included in the display were "woven and hooked mats." Some of these talented children became the adult women of the Standing Buffalo co-operative. All the members, except possibly the eldest, had been taken to residential school. In the repeated narrative of "loss of culture," this was the unspoken reason why girls, recently returned from school, needed

support to reconnect with their own aesthetic traditions.

Government Policy and Indigenous Women's Art

Until 1951, Indigenous people living under the jurisdiction of the Indian Act were highly regulated and controlled. They could not travel without a pass from the Indian Agent, and important religious ceremonies were outlawed. It was illegal to gather, to dress in traditional garments, to dance, sing, or hire a lawyer. Indian Agents on each reserve had the power of Justices of the Peace. On the Prairies, "the dancing set" were viewed as a threat to assimilationist aims to destroy First Nations' cultures. The creation of regalia and ceremonial items—the very heart of artistic expression—was suppressed.

In 1951, a new edition of the Indian Act quietly removed most of the sections that outlawed ceremony and dance. Ironically, having spent eighty years actively repressing Indigenous creativity, federal government rhetoric in the 1960s bemoaned the loss of traditional knowledge and the resulting decline in cultural arts. The Department of Indian Affairs established its Cultural Affairs Section in 1965.[6] The new section's focus was developing special exhibitions and projects related to First Nations arts and culture, with an eye on the upcoming centennial. At the same time, Saskatchewan's Co-operative Commonwealth Federation (CCF) government embarked on a program of co-operative development in Northern Saskatchewan.[7] Following the CCF template, the Northern Handicraft Co-operative Centre at La Ronge was established in 1960

Anne Ratt, *Mat
(cross pattern)*,
c. 1971 (cat. 44)

Anne Ratt, *Mat
(radiating circle
pattern)*, c. 1971
(cat. 45)

Martha Tawiyaka, *Tipi Mat*, 1967 (cat. 54)

Theresa Isnana Sr.,
Rug, 1967 (cat. 24)

Jessie Goodwill, *Rug*,
1967 (cat. 17)

Nancy Goodpipe,
Rug, 1968 (cat. 15)

Florence Maple, *Tipi
Mat*, 1967 (cat. 34)

as an alternative to the trading post system.[8] The Saskatchewan Arts Board worked with the Department of Co-operatives to provide advice and support. In 1962, these efforts resulted in the inclusion of northern artists in a Canadian Handicraft Guild Exhibition in Italy.[9]

Anne Ratt's rabbit fur rugs (cat. 44 & 45) were created in this context. They may have been a "test product" marketed through the Northern Handicraft Centre at La Ronge. The small rug format was designed to appeal to tourists or a southern market, but the technique and skills were ancient northern Cree. Blankets and parkas were finger "woven" from lengths of rabbit fur cut from individual skins and dried into fur-covered cord. Rubbing and working the cord broke down the fibres in the skin, leaving a pliable length of fur. With a crooked index finger serving as a hook, women looped the fur into garments or blankets in a technique similar to crochet. The garments were lightweight and warm, with the open structure allowing heat and moisture to escape. Using the same technique, Anne Ratt "wove" alternating fur colours to create patterns. The average consumer may not have fully appreciated the process behind the soft little rugs, which may account for the small number produced.

The Sioux Handcraft Co-operative at Standing Buffalo was organized after Saskatchewan transitioned from a CCF to a Liberal government, and during a time of significant reorganization in the federal Department of Indian Affairs. Each level of government viewed Indigenous creativity as an untapped natural resource that if properly managed could address economic hardships. Having committed to Inuit co-operatives,

the federal government embraced "Eskimo Art" and promoted it to collectors. They were tentatively moving towards the idea of First Nations men as professional artists. However, in the bureaucratic vision of Indigenous arts, women would remain firmly tethered to craft production for a low-end tourist market. The Ta-hah-sheena rug-making project hovered between categories.

Ta-hah-sheena: the Sioux Handcraft Co-operative

The origin story of the Standing Buffalo co-operative comes from the intersection of two women's lives. Martha Tawiyaka was Sisseton Dakota, a descendant of Chief Standing Buffalo, a midwife and medicine woman, with deep knowledge of plant medicines. She abandoned her medicines when she became an Evangelical Christian, but whether practicing or not, the depth of her Dakota knowledge was profound.[10]

Lorna Bell Ferguson lived on Standing Buffalo for a short time as the wife of John Ferguson, a teacher who ran adult education programs from 1965 to 1967. The family's move to Standing Buffalo from Fort Vermilion, Alberta, in September 1965, was motivated by his acceptance into the University of Saskatchewan (Regina Campus) and an opportunity to teach an adult-education class at Standing Buffalo, part of a nationwide pilot project. The job came with a teacherage, ideal for a father with a growing family. In 1966, the Standing Buffalo adult education program was recognized as the only successful pilot site in the country.[11] Ferguson subsequently established a community advisory committee

and began organizing a range of training opportunities, but the following year his position was cut.[12] The family moved to Regina in 1969 where Lorna established and ran the first daycare for the university.[13]

In media reports and promotional literature, "Mrs. Ferguson" is credited with "conceiving and initiating" the Standing Buffalo project. It is sometimes suggested that she traveled to conduct extensive artistic research, but with three small children and the family's chronically precarious finances, that is unlikely.[14] However, she established a firm friendship with Martha Tawiyaka and became a student of Dakota visual traditions. She acted as the co-operative's spokesperson and served as "advisor and marketing consultant" from 1967 to 1968.

The initial two-week latch-hooked rug-making course coincided with John Ferguson's expanded training program. How Lorna Ferguson acquired the skills to teach and happened upon rug and tapestry production as a viable project remains a puzzle. Classes were offered at the teacherage at the cost of five dollars per participant, with the option of deducting the cost from the sale of rugs.[15] Dividing the twenty participants into morning and afternoon groups, Ferguson taught ten women at a time using a "kitchen table" pedagogy she was to replicate in her later literacy work.[16] Members joined the co-operative for a two-dollar fee, materials were provided, and further supplies were issued upon submission of a completed rug. The latch-hooked rug-making technique was labour intensive, with the Saskatoon StarPhoenix reporting "each square foot contains 1,600 hand-crafted knots which require three or more hours to complete."[17]

The project was consistently referred to as "a profit-sharing industry," but based on a "per square foot" model for both remuneration and sale, artists earned a dollar an hour, slightly below the Saskatchewan minimum wage—and only if the rug sold.[18]

Ferguson was adept at obtaining media coverage for the fledgling group. The initial press release was carried across the country with the headline "Sioux to Make Rugs," more accurately as "Sioux Co-Op Launched" in The Indian Record. Considering it was only a few years after restrictions on First Nations' movement were lifted, racism and social discomfort were significant realities. Ferguson's role as spokesperson and her strategy of focusing on the elderly advisors were effective. She reached out to prominent women, who at the time were western Canada's most effective arts advocates.[19] With a supportive and influential network, Ferguson organized displays and exhibitions in public venues, including government buildings, art galleries, Saskatchewan House in London, and the Musée de l'Homme in Paris.

Tióšpaye, Visual Grammar, and Female Abstraction

Although the Sioux Handcraft Co-operative was based on a Western co-operative model, the key role of elders was critical to its success. The five "design consultants" provided aesthetic and cultural support for younger artists. Martha Tawiyaka (cat. 54) is most frequently mentioned, but Jessie Goodwill (cat. 17), Mary Lasuisse (b. 1890), Lucy Yuzicapi (b. 1891), and Marina Goodfeather (b. 1901) were all important contributors.

The original grant proposed modest remuneration for their involvement. The advisors were active in the design process and made rugs themselves.

Perusing the list of co-operative members, kinship was clearly a factor. The importance of the *kunsi* or grandmother is obvious. It might be an overreading, but the co-operative appears to have overlapped with the Dakota *tióšpaye*—the complex network of extended families centred on women. Artists were often sisters, aunties, cousins, and sisters-in-law. These relationships would enhance the elder-advisors' capacity and comfort in transferring knowledge to younger members.

From the outset, Dakota/Lakota narrative was prioritized. Rugs were valued at "three dollars per square foot for ordinary designs and five dollars per square foot for story-telling designs."[20] While Lorna Ferguson appears to have been a keen and respectful learner, public representation of Ta-hah-sheena "story-telling" was somewhat romantic and simplistic.

The people of Standing Buffalo are descendants of several major bands of the Sisseton Dakota and Teton Lakota who moved north in the 1860s.[21] Dakota and Lakota imagery is based on a system of basic shapes. According to Lakota designer Sadie Red Wing, "all Lakota visual grammar originates in the line, the triangle, and the square."[22] Each basic shape in the vocabulary is a recognizable unit, but like letters of the alphabet, meaning is only created when shapes are combined. A single motif may have one literal meaning, but deeper meanings are formed by groupings, composition, and context. Meanings were often passed down through families and could vary significantly. "Feather" shapes (if grouped) could be a Whirlwind, Feathered Headdress, or Breath of Life.[23] The triangle, often representing the tipi, is much more than a shelter. A tipi could represent a home, a portal, or a unit in a camp circle (cat. 24). Different arrangements of triangles could represent mountains and hills.

A motif could be a mnemonic device for an entire story. One of Martha Tawiyaka's stories was represented by a stylized fish skeleton. A Whirlwind motif could represent the natural phenomenon or the character in a world-ordering, foundational story. Stars, including the morning and evening stars central to Dakota and Lakota cosmology, occur frequently in Ta-hah-sheena rugs. Stars were celestial beings, guides for those on earth, and their movements mirrored annual cycles.[24] The shape commonly identified as the "hourglass," clearly neither a Dakota nor Lakota term, is one of great significance. The *kapemni* represents cones—cosmic tipis—sky and earth worlds touching and aligning, with the bottom triangle representing the earth and the top the sky, with energy exchanged at the apex.[25]

Interpretation rested at the intersection of the viewer's knowledge, the maker's imagination, and the function of the object. Despite extensive study, most art historians are cautious about interpreting Dakota/Lakota art, because of its variations and the role of individual expression. Artists (in general) are reticent to explain due to protocols or the danger of appropriation or misuse. Within the artist collective itself, imagery was open and accessible. Photographs of the Standing Buffalo workspace show reference

Sicangu Lakota artist, *Robe*, about 1870, bison hide and glass
beads, 240.0 x 182.9 cm. Denver Art Museum: Native Arts
acquisition funds, 1948.144. Photography © Denver Art Museum.

Oceti Šakowiŋ artist, *Dakota Parflesh Bag*, c. 1900, 21.0 x 33.7
x 2.0 cm. Collection and photography: Minnesota Historical
Society, 9859.16.

drawings tacked to the wall. Christian con-
version and distance from their southern
homeland may have tempered meaning, but
James Howard, who spent time with Martha
Tawiyaka and others during this period,
commented that the northern "Sioux" had
maintained knowledge lost among their
southern kin. However, despite the potential
depth of knowledge embedded in imagery,
emphasis on literal readings of symbolic
meaning suggests a repetitive rigidity and
ignores key factors in female aesthetic prac-
tice: creativity and abstraction.

Women and men had separate, but
balanced, roles in all aspects of life, includ-
ing the aesthetic. Men painted sequential
narratives in arrangements of pictographic
images. Women worked with colour and
a bold geometric language. The *ta-hah-
sheena*, the ornamented robes from which
the co-operative's rugs took their name, is
a perfect example of that dichotomy. Men's
robes were covered with pictographic nar-
ratives of significant events in their lives,
while women's were geometric. They could
be painted, quilled, or beaded. Designs
could be gendered: some for men, others for
women.[26] Designs were born in dreams and
the imagination, invented, and modified to
suit the purpose of the object. Within a spe-
cific geometric vocabulary, women exercised
unlimited creativity. This was only restricted
if there was a specific function that required
particular imagery or colours, and even
then, there was room for subtle variations.

Descriptions in the Ta-hah-sheena in-
ventory frequently reference parfleche bags
and other rawhide containers. Painting on
rawhide was a female practice, and it was a
space of excellence and innovation.[27] Of the

hundreds of surviving painted parfleche containers, no two are the same. In the same way, by 1969, the co-operative produced 182 unique designs, working with the same visual grammar. As Kiowa artist Terri Greeves so aptly commented, "women were busy abstracting the world."[28]

Making and Marketing

When the co-operative was invited to the prestigious New York Gift Show in 1968, the Regina *Leader-Post* covered their departure, featuring a photograph of a smiling co-operative member Joan Ryder wearing beaded moccasins as she boarded a plane with Lorna Ferguson.[29] The article informed readers that the co-operative had grown from twelve to forty-eight members, who ranged in age from eighteen to ninety-two. The forthcoming National Film Board documentary, *Standing Buffalo,* was also mentioned.

In its first year of operation, the co-operative produced eighty-five rugs and tapestries.[30] The second year was buoyed by the New York Gift show, the release of the NFB documentary, and inclusion in an exhibition of Canadian craft that toured Europe, Japan, and Australia. Despite this promise, ta-hah-sheena rugs were never fully embraced by the Department of Indian Affairs' arts and crafts program. The 1967–1970 Annual Reports of the Department of Indian Affairs do not mention the Standing Buffalo co-operative, although the federal government purchased the rugs that toured with the Canadian craft exhibition (currently housed in the Indigenous Art Centre collection in Gatineau). The *Indian News* reported the "most productive display to date has

Joan Ryder and Lorna Ferguson seen departing for New York to demonstrate and display rugs at the New York Gift show. Far right is Mrs. W. Brass who was also leaving that day to attend an Indian Affairs meeting in Toronto. Published in *The Leader-Post* (Regina, SK), a division of Postmedia Network Inc., "Rugs shown in New York," August 20, 1968, 10.

been at the Lippel Art Gallery in Montréal. The display was promoted by Miss Alanis Obomsawin of the Abenaki Indian tribe near Montréal."[31]

The co-operative's aspirations for acceptance in the art market, or at least by discerning interior decorators, was never fully embraced. Despite a grant from the "vocational and special training division" of the Department of Indian Affairs, its sporadic funding was largely through the provincial Department of Co-operatives and the Saskatchewan Arts Board.[32] In 1968, when a promised Department of Indian Affairs loan was denied, Lorna Ferguson

Florence Maple, *Rug*, 1969
(cat. 33)

Rose Buffalo,
Ta-Hah 'Sheena, 1968
(cat. 7)

Yvonne Yuzicappi, *Rug*,
1968 (cat. 61)

Florence Ryder, *Untitled (pink ground)*, no date (cat. 49)

revealed the co-operative's fragile finances: "It really is a shoe-string operation with no adequate capital . . . We have never been able to maintain continuous production."[33] By late 1969, Ferguson's marriage ended, and she returned to Fort Vermilion with her children. The co-operative carried on, with the Saskatchewan Arts Board assisting in promotion and marketing, but the number of active artists declined.

Despite this, Ta-hah-sheena artists' most significant accomplishments occurred during the final years. In 1968, Seneca artist and curator Tom Hill was appointed director of the Cultural Affairs Section of the Department of Indian and Northern Affairs. Women had not been included in The Indians of Canada pavilion at Montréal's Expo 67, but Hill proposed works by two women for Expo 70 at Osaka, Japan: a tea set by Mohawk Potter Elda Smith and a tapestry by Bernice Bear. The works were destined for the Discovery Room of the Canadian Pavilion.

Their selection was based on "the status they have achieved in the Canadian art world and for their ability to best portray native Canadian art."[34] Bernice Bear's composition and colour palette were described as "a classic example of the Canadian Indian's feel for symmetry and colour." Bear's untitled rug can be identified in the Indigenous Art Centre's collection through a media photograph and a rather indifferent description in a Ta-hah-sheena inventory: "designs without meaning (except the flint arrowheads) purely decorative."[35] For Hill, however, Bear, then twenty-two years old, working in pure colour and abstraction, represented the new generation of Indigenous artists.

Two large latch-hooked tapestries were commissioned by the University of Saskatchewan (Regina Campus) in 1970 where they are installed in public spaces. Three selected designs submitted by Marge (Marjorie) Yuzicappi (cat. 60), Martha Tawiyaka, and Bernice Runns were chosen, and execution was a collaborative effort, with co-operative members (often family) working together. The geometric patterns are both subtle and dynamic, serving the ancient purpose of beautifying a shared communal space.

In 1972, Lorraine Yuzicappi, president of the co-operative, informed a patron that Marge Yuzicappi had a rug that was almost finished, but "Margaret Ryder and her girls are the only ones interested in making large rugs at the present time."[36] The labour-intensive process, low remuneration, and cost of materials that had been chronic challenges, combined with movement and life changes among key members, led to Ta-hah-sheena's quiet demise.

But its impacts continue. Standing Buffalo, for its small size, is one of the most artistically vibrant First Nations in Western Canada. Women shifted to beadwork and star blankets, art forms with deep meaning and immediate relevance to their families and community. Rather than trying to accommodate the shifting interests of an outside market, their focus turned inward.

A new textile artist emerged in the 1970s. Florence Ryder, a child during the co-operative's lifetime, learned rug-making from her mother, Elizabeth Ryder. A prolific artist, Ryder returned to the affordable hooked rug, a much more sustainable medium. Influenced by Ta-hah-sheena's

aesthetic (cat. 48 & 49), her work has been widely collected. She had a solo exhibition *Florence Ryder: Hooked Rugs* in 1989 at the Dunlop Art Gallery in Regina and was included in the gallery's contemporary group exhibitions *Indian Summer,* 1990 and *Here and Now,* 1999.

It is important to see the structures that limited Indigenous women artists of this time to truly appreciate the importance of their work. With only six years of tentative inclusion in the Canadian body politic, the women of Standing Buffalo organized decades before the inclusion of Indigenous artists into arts funding streams. The co-operative structure, the sole source of available funding, emphasized profit distribution and job creation. It reflected prevalent government attitudes to view Indigenous art solely through an economic lens. It was a wildly inappropriate vehicle for an artist collective seeking inclusion as fine craft. Ta-hah-sheena's labour-intensive, intergenerational creative process was a refusal to take the proffered niche as manufacturers or suppliers for a low-end tourist market. This was a bold, brave venture as witnessed by the enduring visual power of their work.

NOTES

1 Philip Deloria, *Becoming Mary Sully: Toward an American Indian Abstract* (Seattle, WA: University of Washington Press, 2019), 21. Author's note: This essay began with a directed study of Ta-hah-sheena rugs in the SK Arts Permanent Collection with University of Regina Media, Art, and Performance (MAP) graduate students Larissa Ketchimonia and Bailey Monsebroten that led to our quest to identify the locations of surviving rugs.

2 "Canadians You Should Know," *MacLean's Magazine*, October 1, 1969, 97.

3 See Samuel Buffalo Interview 1, IH-115, August 30, 1977; Joe Moran Interview, IH-SD.104, August 22, 1983, Saskatchewan Archives Board. Transcripts available on oUR Space, University of Regina Archives and Special Collection, https://ourspace.uregina.ca/.

4 *Annual Report of the Department of Indian Affairs for the Year 1892* (Ottawa: Government Services, 1893), 244.

5 *Annual Report*, 177, 178.

6 For a discussion of the Cultural Section, see Barry Ace, "Reactive Intermediates: Aboriginal Art, Politics, and Resonance of the 1960s and 1970s, in *7: Professional Indian Artists, Inc.*, ed. Michelle LaVallee (Regina: MacKenzie Art Gallery, 2014), 200–204.

7 See David M. Quiring, *CCF Colonialism in Northern Saskatchewan: Battling Parish Priests, Bootleggers, and Fur Sharks* (Vancouver: UBC Press, 2004).

8 "Indian Handicraft Sold at Cooperative Centre," *Leader-Post* (Regina), June 18, 1960, 15.

9 "European Markets for Indian Crafts," *Leader-Post* (Regina), February 2, 1962, 7.

10 Martha Tawiyaka told James Howard she buried her medicines, and put aside her practice in James Howard, *The Canadian Sioux* (Lincoln NE: University of Nebraska Press, 1984), 48.

11 "12 Indians Receive Diplomas as Education Course Finishes," *Leader-Post* (Regina), March 5, 1966, 1.

12 Ferguson announced his job loss at a United Church Conference in Regina. "Indian Worker Losing Position: Job being abolished," *Leader-Post* (Regina), June 1, 1967.

13 "Day Care Centre Seeks Quarters," *Leader-Post* (Regina), November 6, 1969, 4.

14 Two of their sons became authors, describing their mother's courage throughout their family misadventures in Ian Ferguson, *Village of the Small Houses: A Memoir of Sorts* (Vancouver: Douglas & McIntyre, 2003) and Will Ferguson, *Beauty Tips from Moose Jaw* (Toronto: Knopf Canada, 2010).

15 Dear – from Lorna Ferguson (unsigned), Sioux Handicraft Industry, Fort Qu'Appelle SK, July 26, 1967, Ta-hah-sheena research file, folder 23, Dunlop Art Gallery archives.

16 Lorna Bell was referred to as "The Grandmother of Literacy" and credited with launching Alberta's literacy movement. See Deborah Morgan, *Opening Doors: Thoughts and Experiences of Community Literacy Workers in Alberta* (Camrose: Augustana University College and Alberta Association of Adult Literacy, 1992), 99.

17 "Tapestries Feature Sioux Designs," *StarPhoenix* (Saskatoon), March 28, 1968, 6.

18 A grant application described the cost per square foot as $6, and the sale price calculated at $9 per square foot.

19 See Ann Whitelaw, "Professional/Volunteer: Women at the Edmonton Art Gallery, 1923–70," in *Rethinking Professionalism: Women and Art in Canada*, ed. Kristina Huneault and Janice Anderson (Montreal: McGill-Queen's University Press, 2012), 357–90.

20 Lorna Ferguson, Submission re Teepee Mat Makers (Proposal for Cottage Industry Rugmaking Project), n.d., Ta-hah-sheena research file, folder 15, Dunlop Art Gallery archives.

21 Martha Tawiyaka was one of James H. Howard's important sources of information during his fieldwork in the 1970s. James H. Howard, *The Canadian Sioux* (Lincoln, NE: University of Nebraska Press, 1984).

22 Sadie Red Wing, "Learning the Traditional Lakota Visual Language Through Shape Play" (master's thesis, North Carolina State University, 2016), 31.

23 Carrie Lyford, *Quill and Beadwork of the Western Sioux*, reprint of 1940 original (Boulder, CO: Johnson Publishing Co., 1979), 74 & 77.

24 Sinte Gleska College, *Lakota Star Knowledge: Studies in Lakota Stellar Theology* (Rosebud, SK: Sinte Gleska College Publishing, 1990).

25 Julie A. Rice-Rollins, "The Cartographic Heritage of the Lakota Sioux," *Cartographic Perspectives* 48 (Spring 2004), 43.

26 Rice-Rollins, "Cartographic Heritage," 78.

27 American Meredith, "Parfleches: How Native Women Pushed the Envelope of Abstraction," *First American Art Magazine* 26 (Spring 2020): 34–39.

28 Teri Greeves, "Women Were Busy Abstracting the World," in *Hearts of Our People: Native Women Artists*, ed. Jill Ahlberg Yohe and Teri Greeves (Minneapolis, MN: Minneapolis Institute of Art in association with the University of Washington Press, 2019), 101.

29 "Rugs shown in New York," *Leader-Post* (Regina), August 20, 1968, 10.

30 "Handcraft group meets: Bylaws approved," *Leader-Post* (Regina), January 16, 1968, 10.

31 "Tah-hah-sheena," *Indian News* 12, no. 1 (April 1969), 6.

32 The article reported sales worth two million dollars, but that must be an error.

33 "Native co-op's hopes dashed by refusal," *Leader-Post* (Regina), Sept 6, 1968, 11.

34 "Canadian Indian Art Forms at Expo '70", *The Indian News* 12, no. 8 (November 1969), 7.

35 Rug no. 68031C, Bernice Bear, Inventories and lists of rugs, Ta-hah-sheena research file, folder 35, Dunlop Art Gallery archives.

36 Mrs. Lorraine Yuzicappi to Mrs. Collins, Fort Qu'Appelle SK, 16 May 1972, Ta-hah-sheena research file, folder 30, Dunlop Art Gallery archives.

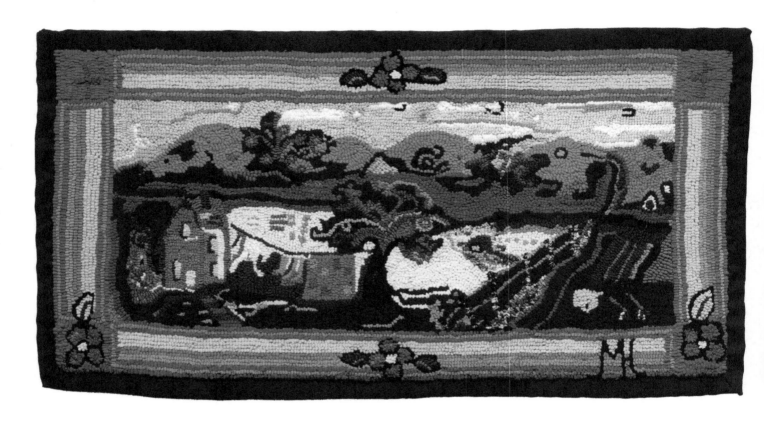

Margaret Harrison, *Margaret's Rug*, c. 2005 (cat. 22)

Métis Stories and Women's Artistic Labour in Margaret Pelletier Harrison's *Margaret's Rug*

by Cheryl Troupe

Margaret Harrison is an accomplished seamstress and traditional art practitioner. She practices Métis-style floral embroidery and is one of a few remaining Métis women who continue to make hooked rugs. She grew up in the Katepwa Lake road allowance community in Southern Saskatchewan's Qu'Appelle Valley and is a member of the extended Racette, Pelletier, and Cardinal families. These families descend from buffalo hunters in the Qu'Appelle Valley region in the mid-to-late 1800s. By the early 20th century, many of these families lived on land they did not own, having been displaced by the failure of the Federal Government's scrip system and Dominion Lands Act to secure Métis land title. These families relocated to land owned by settler farmers with whom they found seasonal labour opportunities and unoccupied Crown land, next to First Nations reserves, or on the land set aside for the creation of roads in the Dominion Land Survey. These spaces formed across the Prairies and have since become known as road allowance communities. Margaret's mother, Adeline Pelletier dit Racette, and her mother's sisters, Florence, Agnes, and Louise, were well-recognized in the Qu'Appelle Valley for their sewing work and hooked rugs. They passed their cultural teachings, sewing knowledge, and rug-making expertise on to her: these teachings and the legacy of Métis women's artistic labour guide Margaret's contemporary art practice.

While rug making in the Qu'Appelle Valley is no longer performed at the scale it once was, Margaret continues to practice the art form and pass on these teachings, often through community art workshops. In 2013 she gifted me one of her hooked rugs that I have titled *Margaret's Rug* (cat. 22). It is not in the typical floral pattern taught to her by her mother, grandmother, and aunts but is a pictorial rendering of their family home on the road allowance along the shores of Katepwa Lake. It is an exceptional example of historical and contemporary art practice, a map of Margaret's experience that ties her to the Qu'Appelle

Margaret Pelletier Harrison with *Margaret's Rug*, 2013. Photo courtesy of Cheryl Troupe.

Vitaline Cardinal and Josue Pelletier, circa 1950. Photo courtesy of Margaret Harrison.

Valley, and a mnemonic device that allows her to remember and share. With each element depicted on the rug, she shared stories about her experiences growing up in the Valley, specific places, women's work, and the foods they grew, harvested, and prepared. Margaret's community was tight-knit, and all families were closely related. They shared resources and spent time working and socializing together. Although her home is the only one depicted on the rug, she shared many stories about her grandparents, Josue Pelletier and Vitaline Cardinal, who lived next to Margaret and her parents, and stories about her aunts, uncles, and cousins, who also lived along the lake.

The scene on her rug depicts where they lived "snugged in close along the lakeshore" at the end of Katewpa Lake.[1] Margaret's childhood home is in the foreground of the rug, complete with a clothesline strung with blankets and clothes hanging to dry. Next to the house are flowers, trees, and vegetable gardens that were planted and harvested by women. Margaret has also included the garden tools that the family used to work the land. In the background are the Valley roads and coulees, lined with plants and trees, including chokecherry and saskatoon berry bushes they harvested annually. Bordering the rug are two white crosses, symbolic of the importance of the Catholic Church in Margaret's life, and in the life of the Qu'Appelle Métis community. Also present are two floral designs, like those that her mother, aunts, and grandmothers used to decorate their own rugs. Lastly, if you look closely, you will see an infinity symbol, an important marker of Métis identity and symbol of nationhood.

Métis women, like those from the Qu'Appelle Valley, have a long history dating to the early years of the fur trade, of producing clothing and material goods for sale or trade to fur company posts, settlers, and newcomers.[2] Indigenous scholar and artist Sherry Farrell Racette argues that Indigenous women adapted their work during the fur trade to emerging rural economies, finding avenues to continue producing and selling hand-crafted and often decorative items.[3] First Nations and Métis women commonly marketed their handmade goods to local fur posts, traders, and later settlers. Métis buffalo hunter and trader Norbert Welsh recalled that in the late 1880s he regularly bought products, particularly moccasins, made by local Métis and First Nations women to sell in his store at File Hills, located just north of the Qu'Appelle Valley.[4]

Women's artistic production and traditional sewing and handwork skills were essential to supporting Métis families well into the early 20th century. The practice continues today, often with the help of social media and the internet. As settlement across the Prairie provinces increased in the early 20th century, so did Métis' involvement in the developing agrarian economy. Displaced by the failure of Canadian government policies to secure Métis land tenure, many struggled to hold on to the plots of land on which they lived. They faced racism in everyday interactions with settlers and challenges in the evolving new social order that privileged the settler economy and Euro-Canadian laws and institutions. Within road allowance communities there was little economic opportunity. For a time, men found work as seasonal or day labourers for settler farmers, picking rocks, clearing fields, and planting and harvesting crops.

In contrast, women worked as domestics in settler homes or sometimes alongside their husbands, helping with farm work. They also netted fish, harvested berries, and dug seneca root that they sold or traded to bring income into the family. In many instances, Métis women marketed their traditional artistic and sewing skills, taught to them by their mothers and grandmothers, to bring additional income and necessary food and supplies into the home. This artistic labour provided stability and cultural continuity during a period of increasingly rapid economic, social, and political transition. Women's artistic labour was a critical component of the family economy. Margaret's mother, Adeline, echoed the importance of women's artistic and economic activity, remarking, "you didn't have to worry about anything once you have a rug like that."[5] Many Valley women, including Margaret's mother and aunties, used their sewing, beading, embroidery, and other decorative art skills passed on to them by their mothers and grandmothers to make and sell items of clothing and decorative household objects into the 1930s and 1940s. Celine Amyotte Poitras recalled that during this period, and increasingly during the Depression, "there wasn't a speck of work for men" in the Qu'Appelle Valley. So, it was often women's labour that supported the family.[6] She recalled doing a lot of sewing for people and that it was the "one thing [she] had to fall back on." Sewing was often done by the light of a coal oil lamp late at night once she had finished her work for the day and put the children to bed. Sewing work was generally

Adeline Pelletier dit Racette with one of her rugs, May 2002.
Photo courtesy of ©Gabriel Dumont Institute, GDI.RS.0990.

done by hand, as few had access to sewing machines until after the Second World War.

Adeline worked and sewed for several farm families. Her brothers also worked for farmers on the north side of the Valley around the town of Abernethy. When harvest time came, Margaret's family and grandparents would join her uncles, taking field work where they could. The women sometimes helped in the fields, but more often they would help butcher cattle and pigs. Margaret remembers her mother and grandmother bringing home the leftover meat and innards to clean, cook, and make blood sausage. She also recalls that her uncle Raoul would often say a good word to farmers and their wives about how hard his sister Adeline worked, so word got around about Adeline's sewing skills and work ethic. In return for her sewing work, she often received boxes of old clothes and fabric that she would

take apart, making clothing and blankets for the family. She would also save the fabric for making hooked rugs.

Adeline's sisters Florence, Agnes, and Louise were also recognized for their sewing skills. Agnes lived in nearby Indian Head and worked mending uniforms for the Royal Canadian Mounted Police. Louise lived in South Qu'Appelle and worked at the hospital as a seamstress and in the laundry, while Florence, like Adeline, took on sewing work for neighbouring farm families. Florence's son, Bob Desjarlais, recalled his mother sitting at her sewing machine from when she got up in the morning until well after dark, making all the family's clothing and blankets. She regularly sewed for settler families and even sewed wedding gowns and bridesmaid dresses.[7] Both Margaret and Bob recalled that their mothers worked in exchange for food, including meat that farmers had butchered. Their labour helped support the family and reduced what they needed to hunt, fish, or purchase, which was important because working for farmers often took them away from their food-harvesting activities. Bob Desjarlais echoed the importance of women's work to the family economy, remarking that his "Mother made it all with the needle."[8]

These women recycled almost every piece of clothing they could. They got old clothes from farmers they worked for and re-made clothes into new pieces. They mended, darned, and patched, and when clothing was no longer wearable, they took pieces apart, sorted, saved, and cut them into strips for rug making.

Hooked rugs are historically utilitarian and domestic objects with roots dating back

to the mid-18th century in North America.[9] While rug hooking was a widespread art practice among Métis women in the early 20th century, it is unclear how or who introduced this art form in the Qu'Appelle Valley region. Likely, it was carried with the Métis as they moved across the Prairies. Rug hooking was a common practice in the Red River parishes in the mid-to-late 19th century and was most likely taught to young women by the nuns in the convent schools. There is a rug in Le Musée de Saint-Boniface in Winnipeg, Manitoba, made by Marie Rose Breland for one of her sons in the 1880s. Marie Rose was the daughter of Cuthbert Grant and Marie Desmarais, and in 1836, at age fifteen, she married Pascal Breland. In 1869–70, the Brelands wintered north of the Qu'Appelle Valley to hunt buffalo and regularly opened their home to extended family and community members throughout the winter.[10] Marie Rose had two siblings, James and Julie, who were already married into the large extended Desjarlais, Blondeau, and Fisher kinship networks in the Valley. Measuring 185 x 200 cm, *Le Tapis Breland* would have been a considerable undertaking to make as well as transport. While the Museum indicates that Breland is the rug's maker, it was likely a collaborative effort between Marie Rose and other women in her family.

These hooked rugs, like the one made by Breland, became popular in Métis and settler homes in the early 20th century. Also popular were braided rugs made from strips of fabric braided and then sewn together into a circular or oval form. As hooked rugs increased in popularity, burlap embossed with rug patterns became available through

Marie Breland (nee Grant), *Le Tapis Breland*, c. 1890, hooked rug; wool, jute, cotton, 185 x 200 cm. Collection of le Musée de Saint-Boniface Museum, Manitoba, DA-330.

mail order catalogues. However, Métis rug makers continued to create their own rug designs because the pre-made patterns were out of their price range.

According to Margaret, her mother and aunties, "The Racette girls," as she called them, were the rug hookers who, like several Métis women, made and sold hooked rugs throughout the Valley.[11] Scraps of old clothes were saved, sorted, and then dyed in different colours, in preparation for them to be cut into about 2.5 cm strips. A piece of burlap recycled from a potato sack was stretched on a wooden frame and then decorated with the rug design, drawn with a piece of charcoal. A hook was made from a filed-down nail head embedded in a round wooden handle that fitted securely in the palm of the maker's hand. The fabric was pulled from behind,

Margaret Harrison, *Margaret's Rug* (detail), c. 2005 (cat. 22)

through the holes of the burlap, forming small, consistent loops. Hooked rugs were made in all different sizes and most often were square or rectangular because making a round or oval rug on a square frame would waste burlap.

Métis floral beadwork and silk embroidery patterns influenced rug designs. Margaret and her cousin Bob recalled their mothers using a distinctive rose pattern. Adeline often created a large floral pattern in shades of pink and red with large green leaves and vines. She would plan out her design and then try to save fabric in those colours. If she did not have the colour she wanted or needed, she would dye her fabric using crepe paper, used in box socials and at Church, that was readily available. Adeline mixed the crepe paper with boiling water and soaked the cloth in the mixture, adding salt at the end to set the colour; otherwise, the fabric's colour would run when the rugs were washed. Margaret also remembered her mother using fabric dye to colour her fabric strips, but only when customers ordered rugs in specific designs and colours and provided her with the scrap fabric and fabric dye to complete the project.

Métis women sold their rugs to neighbours and local farm families, often for three or four dollars each, or traded them for food items like butter, eggs, or meat that Métis families did not produce for themselves.[12] These sales provided much-needed income and food to feed hungry families. The three or four dollars a rug brought in was a lot of money; according to Desjarlais, "at that time, five dollars was enough to feed a family of four for at least a week."[13] Joseph Moran, also from the Qu'Appelle Valley,

recalled that his mother's handmade rugs enabled her to bring income into the family, often its sole support.[14] He describes her entrepreneurial spirit and tenaciousness in selling her rugs. For many years she took the train from Lebret to Regina (a distance of about 80 kilometres / 50 miles), where she marketed her rugs in exchange for clothes or money. She conducted quite a prosperous trade, eventually attracting the interest of the local police. This attention was perhaps because she was selling her goods without the required license or formal business establishment, or because she was Indigenous. The attention she received, Moran suggests, forced her to sneak around in conducting her business and avoid the watchful eye of the authorities. Evident is Mrs. Moran's drive to support her family despite challenges she may have faced, even potential confrontation with the law. Mrs. Moran was acting out of necessity, filling an economic role not filled by her blind husband. As the sole or primary breadwinner in their families, women like Mrs. Moran are examples of the efforts of Métis women in devising strategies to do what was necessary to support their families.

In Margaret's family, her mother Adeline and auntie Florence were not the only rug makers. These skills were practiced across extended families and passed on to younger women within their kinship networks. Margaret's paternal grandmother, Vitaline Cardinal, made hooked rugs, as did Vitaline's sisters La Rose and Octavie. In an oral history interview held by the Gabriel Dumont Institute, Josephine Tarr recalled that Emma Amyotte, Octavie Cardinal's daughter-in-law, worked hard to provide for her family by making and selling hooked

and braided rugs and by picking and selling berries.[15] She was even able to save enough money from these sales to buy herself a milk cow. Women on both sides of Margaret's family were rug makers and were part of an interrelated network of Métis women who did this work. Most likely, many other women, even within this family, also produced and sold hooked rugs.

The extended family system in which these women made their rugs translated into informal sales territories. Margaret's paternal grandfather, Josue Pelletier, sold his wife Vitaline Cardinal's rugs. Josue, Margaret recalled, was a fish peddler, selling fish, berries, and rugs throughout the Valley. He spoke little English, using mostly Cree or Michif, but he knew which farm families were likely to purchase his wares. He would peddle Vitaline's rugs from the Katepwa road allowance community to the south side of the Valley and then out of the Valley to Indian Head, where he and Vitaline did their business. The family considered this his territory, while the north side of the Valley towards Abernethy was where Margaret's parents Alfred and Adeline and her uncle Michel and Aunt Cora did their business, generally selling Adeline's rugs. Being on opposite sides of the Valley ensured that the family could cover a large territory and that their sales did not overlap. Similarly, Florence sold her rugs starting at the top of the hill on the north side and moving down into the Valley, careful not to cover the same territory as Adeline. This strategy of disseminating Métis hooked rugs across the Qu'Appelle Valley region "so their patterns or their rugs never met," as Margaret remarks, helped reduce potential competition between makers and maintained family cohesion.[16]

From the late 19th century to the mid-20th century, Métis increasingly integrated into the settler economy across the Prairies. Often living on the road allowance, their integration was not as landowners but as temporary or seasonal farm labourers. Identifying opportunities within the settler economy, they also sold berries, fish, and other products harvested from the natural environment. They lived within a complex barter economy where they traded their labour for the goods, supplies, and many of the foods they relied upon.

Women's labour as domestics or selling the products of their labour helped families maintain their economic independence. In the Qu'Appelle Valley, many Métis women like Margaret's mother, aunts, and grandmothers marketed the traditional artistic and sewing skills taught to them by their mothers and grandmothers to bring additional income and necessary food and supplies into the home. They took advantage of the economic opportunities that presented themselves and, in doing so, adapted to the growing settler agrarian economy in ways that recognized Métis family systems and art forms. It is the legacy of these women that Margaret carries with her as she continues to practice, preserve, and promote this distinctly Métis art form.

NOTES

1 Margaret Harrison, interview with the author, February 12, 2010.

2 Sherry Farrell Racette, "'Sewing Ourselves Together': Clothing, Decorative Arts and the Expression of Métis and Halfbreed Identity" (PhD diss., University of Manitoba, 2014).

3 Sherry Farrell Racette, "Nimble Fingers and Strong Backs: First Nations and Métis Women in Fur Trade and Rural Economies," in *Indigenous Women and Work, From Labor to Activism*, ed. Carol Williams (Chicago: University of Illinois Press, 2012), 148–162; Sherry Farrell Racette, "Sewing for a Living: The Commodification of Métis Women's Artistic Production," in *Contact Zones: Aboriginal and Settler Women in Canada's Colonial* Past, ed. Katie Pickles and Myra Rutherdale (Vancouver: UBC Press, 2005), 17–46.

4 Mary Weekes, *The Last Buffalo Hunter* (Saskatoon: Fifth House Publishers, 1994), 172–73.

5 Adeline Pelletier dit Racette, interview by Leah Dorion-Paquin and Anna Flaminio with Adeline Pelletier dit Racette and Margaret Harrison, May 23–24, 2002, transcript, Virtual Museum of Métis History and Culture, Gabriel Dumont Institute, https://www.metismuseum.ca/media/document.php/05849.Adeline%20Racette.pdf.

6 Celina Amyotte Poitras, interview by Sharon Gaddie and Margaret Jefferson with Agnes Amyotte Fisher and Celina Amyotte Poitras, August 3, 1982, transcript, Virtual Museum of Métis History and Culture, Gabriel Dumont Institute, https://www.metismuseum.ca/media/document.php/01010.Fisher,%20Agnes%20(S.%20Gladdie%20)10.05.2021.pdf.

7 Bob Desjarlais, interview by Leah Dorion-Paquin and Cheryl Troupe, July 3, 2002, transcript, Virtual Museum of Métis History and Culture, Gabriel Dumont Institute, https://www.metismuseum.ca/media/document.php/05848.Bob%20Desjarlais%20two.pdf.

8 Desjarlais, interview.

9 For a comprehensive article regarding the origins of rug hooking refer to Sharon M. H. MacDonald, "'As the Locusts in Egypt Gathered Crops': Hooked Mat Mania and Cross-Border Shopping in the Early 20th Century," in *Material History Review* 54, no. 3 (2001): 58–70.

10 Isaac Cowie, *The Company of Adventurers: A Narrative of Seven Years in the Service of the Hudson's Bay Company During 1867-1874* (Lincoln: University of Nebraska Press, 1993), 381.

11 Joseph Moran, interview by Sharon Gaddie, August 22, 1983, transcript, Virtual Museum of Métis History and Culture, Gabriel Dumont Institute, https://www.metis-museum.ca/media/document.php/00992.Moran,%20Joe%20(Sharon%20Gaddie).pdf; Bob Desjarlais, interview, December 6–7, 2003; Bob Desjarlais, interview by Cheryl Troupe and Calvin Racette, May 15, 2002, transcript, Virtual Museum of Métis History and Culture, Gabriel Dumont Institute, https://www.metismuseum.ca/media/document.php/05847.Bob%20Desjarlais.pdf; Bob Desjarlais, interview, July 3, 2002; Margaret Harrison and Adeline Pelletier dit Racette, interview, May 23–24, 2002; Margaret Harrison, interview, February 24, 2014; Margaret Harrison, interview, July 9, 2014.

12 Margaret Harrison and Adeline Pelletier dit Racette interview, 23–24 May 2002; Margaret Harrison, interview, February 24, 2014.

13 Desjarlais, interview, May 15, 2002.

14 Moran, interview, August 22, 1983.

15 Josephine Tarr, interview by Victoria Racette, February 27, 1984, transcript, Virtual Museum of Métis History and Culture, Gabriel Dumont Institute, https://www.metismuseum.ca/media/document.php/01025.Tarr,%20Josephine%20M.%20(V.%20Racette).pdf.

16 Margaret Harrison, interview, July 9, 2014.; Margaret Harrison and Adeline Pelletier dit Racette, interview, May 23–24, 2002.

Ann Hamilton, *Untitled*, 1979 (cat. 19)

The Gift of Time, The Gift of Freedom: Weaving and Fibre Art at the Banff Centre

by Mary-Beth Laviolette

Introduction

"It was the most exciting place you could ever imagine," recalled Calgary-based fibre artist Inese Birstins (cat. 6).[1] The place was the Banff Centre and its celebrated weaving and fibre art program. The period was the late 1970s/early 1980s when fibre was a burgeoning and exuberant sphere of creative practice—especially for women artists—and the very best in the field travelled to the scenic "Campus in the Clouds."[2] They came as participants, as faculty members, and as guest artists for the annual Fibre Interchange (1979–1988), or for other fibre-related workshops in Weaving/Textile Arts. Serving as a bridge between international developments in the field and the Prairie scene as represented by *Prairie Interlace*, the weaving and fibre art program at the Banff Centre is an episode long overdue for an assessment.

One of the faculty members was Mildred Constantine (1913–2008). "Connie," as she was commonly known, had become a familiar face, attending nine of the ten sessions in Banff. She was a powerhouse thinker and writer who as curator at the Museum of Modern Art (MoMA) (1948–1971) in New York City had organized or co-curated more than twenty-six exhibitions. Her most "important"[3] was *Wall Hangings,* 1969,[4] in which thirty-nine pieces by contemporary weavers from nine different countries were presented on the main floor as *original art*. It was a first for the august institution, which was better known for its championing of modernist painting and sculpture.[5] Working with her on this mid-century reassessment of weaving was the innovative textile designer Jack Lenor Larsen (1927–2020).[6]

Larsen was celebrated, as *The New York Times* later recounted, for blending "ancient techniques and modern technology to weave fabrics that are now in the collection of MoMA and the Louvre."[7] Significantly, he also bridged the worlds of design, industry, and art and was a champion of craft. In 1980, the Seattle-born designer appeared as a guest lecturer at the

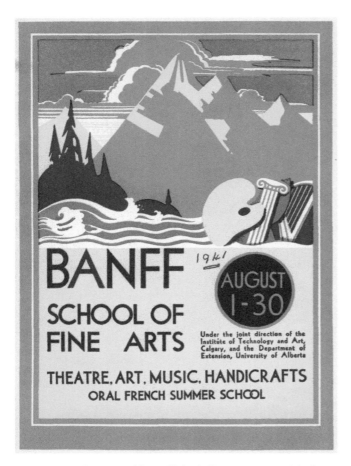

Cover page of the Banff School of Fine Arts Program Calendar, c. 1941. Paul D. Fleck Library and Archives, Banff, Alberta, Acc# 2003-10.

Banff Centre's Fibre Interchange alongside Brooklyn-born Constantine. Despite his association with the fabric industry, Larsen could see a different, more expressive role for weaving, including working off-loom.

Off-loom work comprises a myriad of techniques, such as knotting and braiding, crocheting and knitting, looping and netting, coiling and twining, or hooking and punch needle. Constantine, in an interview with *Calgary Herald* art critic Nancy Tousley, noted how "art fabric," as she preferred to describe such artwork, had emerged in the

pluralistic 1970s "as one of the strongest forms of contemporary art."[8] As curator-historian Glenn Adamson observes, the result of this wider practice was more room for improvisation and spontaneous action—all without the preplanning needed for weaving a pictorial tapestry.[9] More to the point, the opportunities for large-scale and site-specific sculptural installations, often made with rougher fibres like jute and sisal, were endless. All that was needed was the space, energy, and freedom to create some of the most advanced art of its time, and the Campus in the Clouds in Banff, Alberta, with its annual international Fibre Interchange gathering, provided the venue, fed the ambition, and facilitated the gift of freedom and time.

A Framework for Weaving at the Banff Centre

Established as a summer school in the early 1930s,[10] the Banff Centre first featured a weaving program (as part of a new Division in Applied Arts and Handicrafts[11]) in 1941. With a new and ambitious policy of inviting "leading artists of the world to develop a richer Canadian culture in the friendly atmosphere of the Canadian West,"[12] the date of 1941—just for perspective—puts the Banff Centre a full decade ahead of the Ontario College of Art (now OCAD University) in Toronto, which established its textile department in the mid-1950s.[13] Initiated with aid of the American weaving revivalist Mary Meigs Atwater (1878–1956) and supported by the efforts of her assistants Winnipeg's Ethel M. Henderson (d. 1966) and Edmonton's Mary I. Sandin (1901–1991) (p. 25),[14] the alpine summer school helped

to nurture "the idea of teaching textiles *as art*"[15] in postwar Canada.

By the 1960s, weaving at the school had morphed into a well-respected, albeit conservative program with Master Weaver Mary Garnham Andrews (1916–2018) also providing formidable instruction and mentorship. Born in Montréal, Andrews began her own journey—with spindle-shaped shuttle in hand—as a Banff Centre student in 1948. In the following decades, Andrews represented history and continuity as she taught a myriad of weaving techniques, encompassing primitive, plain tabby or taffeta weave, basket, corded, two-block patterns or two harnesses, tapestry, and so on. At Andrews' passing at the age of 102 in Banff, participant Jane Stafford, now herself a highly experienced weaver, wrote in her blog: "I would not be the teacher I am today if she had not been my weaving master."[16]

If Mary Andrews provided a sense of tradition, then Mary E. Snyder (dates unknown) of the popular *Lace and Lacey Weaves*[17] brought new courses and created a reinvigorated environment for the newly named Weaving/Textile Arts Department.[18] With a floor plan drawn-up by the Kansas-educated weaving instructor,[19] looms, equipment, and supplies were moved from Lloyd Hall to the more light-filled facility of the recently opened Glyde Studio Building. The year was 1976 and, as head of the department, Snyder established the first "Winter Diploma Course in Weaving"[20] with the ambition (short-lived as it turned out) of offering a two-year diploma program.[21]

Intent on offering an all-around textile education in a *non-academic setting*, which had always been one of the attractions of the Banff Centre, the courses were both technical and artistic with the study of colour and design, directed reading, and art history. Practical concerns were also addressed in the program, such as how to set up and operate a studio, the preparation of a portfolio, and exhibition display.[22] Two studios were at the service of the participants: a large weaving studio on the third floor, and a print studio in the basement where working with a range of dyes and fibre media was possible and, to a certain extent, papermaking could be accommodated. Based on available information, the diploma program likely ran from 1976 to sometime in 1980.

During her thirty-five-year professional career in handweaving, Mary E. Snyder had exhibited widely, written several how-to books, and given summer workshops since 1973 in Banff. She was also listed in the Who's Who of Women in Education.[23] Although a first-rate weaver, the American met her match with the appearance of the internationally known Mariette Rousseau-Vermette of Québec (cat. 47).

A Canadian Textile Superstar Arrives

Just as experienced and just as respected as Snyder, Mariette Rousseau-Vermette was regarded by many as a "visionary."[24] Textile artist Patricia (Pat) Askren worked as an instructor and studio coordinator at the time. "[Rousseau-Vermette] saw the direction craft was moving in the world. She, like Les Manning in the Ceramics Studio at Banff, brought craft to a new, exciting place."[25] On a more personal level, Jane Stafford considered herself fortunate to have met the Québec

Fibre arts with Magdalena Abakanowicz. Visual Arts Photographs, Photographic Services [Technical Services] fonds, Paul D. Fleck Library and Archives, Banff, Alberta, VS.1982.4_18.

artist because she offered the young weaving enthusiast a full-time position in the winter cycle with full tuition. "If it hadn't been for [Rousseau-Vermette], I would not have been there [from 1981 to 1988]."[26]

First invited by the Banff Centre in 1977 to teach a three-week "Art in Architecture"[27] course, the school's weekly *Centre Letter* later described how "students were electrified by [Rousseau-Vermette's] own work and by her generosity towards participants. She returned the next year to teach the same course and began planning the first Fibre Interchange, for the following year [1979]."[28] For this special six-week intensive which ran until 1988, many of the looms were moved out of the studio area.

Rousseau-Vermette was a product of the Quiet Revolution[29] and a witness to the emergence of abstract painting in Québec; as a "painter-weaver,"[30] she was a member of the New Tapestry movement which "saw tapestry emerge as an autonomous art form,

on par with painting."[31] Her idea for Banff was to bring emerging and professional artists together in an open studio format in Glyde Hall: in other words, to create a hothouse environment for self-directed learning with *no* required courses, only the stimulation of optional workshops, lectures, and discussions by critics, curators, and artists. Selected by submission, the emerging artist would propose a project or body of work with the opportunity to confer with an international faculty of professionals and knowledgeable support staff in one-on-one critiques, demonstrations, and optional workshops. In the school's literature, Fibre Interchange was described as a program unique in North America.[32]

Giving the first lecture for the 1980 Fibre Interchange was Elsa Sreenivasam (–2017), a teacher at Iowa State University and president of the international Surface Design Association. Her talk was titled, punfully, "Dyeing to Know, Knowing to Dye."[33] Some of the other guest artists were fibre/textile rebels, such as: experimental weaving fiend Sheila Hicks (American, b. 1934; attended Fibre Interchange in 1981); figurative sculptor, Magdalena Abakanowicz (Poland, 1930–2017; attended Fibre Interchange in 1982); installation artist, Neda Al-Hilali (Czechoslovakia, b. 1938; attended Fibre Interchange in 1980); knotting and braiding master, Claire Zeisler (American, 1903–1991; attended Fibre Interchange in 1981[34]); and the *Reason Over Passion* feminist quilter Joyce Wieland (Canadian, 1930–1998; attended Fibre Interchange in 1982). The full list is much longer and equally impressive. Suffice it to say that the Banff Centre facilities, with the exception of ventilation issues

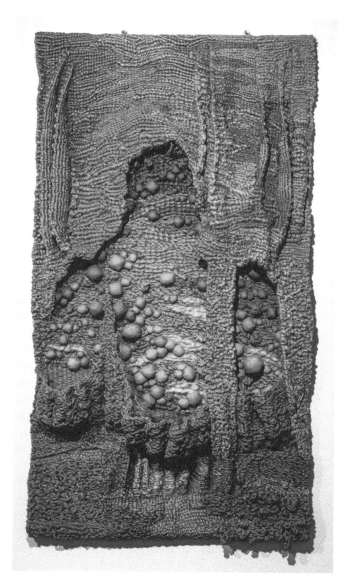

Inese Birstins,
Mindscape, 1978
(cat. 6)

Inese Birstins,
Mindscape (detail),
1978 (cat. 6)

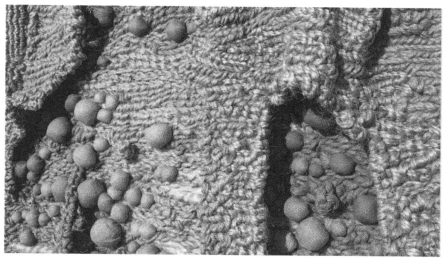

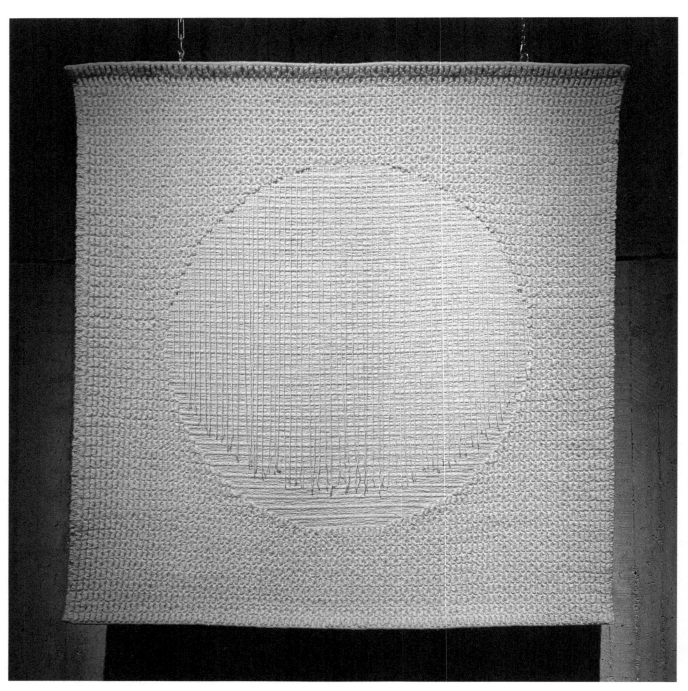

Mariette Rousseau-Vermette, *Anne-Marie*, 1976 (cat. 47)

in Glyde Hall, excelled as a base for creative explorations, with its support staff, workspaces, selection of harness and tapestry looms, print studio for textiles, darkroom, and rudimentary papermaking area.

Aside from Fibre Interchange, other activity also caught the attention of textile participants. In the *1980 Summer Program*, for instance, there was information about a seven-week "Woven Fibres, Multiharness, Sculptured, Manipulated" course instructed by Mary Snyder and fellow Americans Warren Seelig and Rai Senior.[35] At that point, Snyder was described in the Program as experimenting with several looms with one piece involving eight looms.[36] Doing more also included offering courses in "Ukrainian Folk Weaving," which began as a co-operative partnership between the Banff Centre and Ukrainian Museum of Canada in Saskatoon and ran from 1976 to 1987.[37]

With the two-year success of Fibre Interchange, Rousseau-Vermette was now listed in the *1980–81 Winter Program*[38] as the Acting Head of the Fibre Studio with Pat Askren as the Program Coordinator. As for Mary Snyder, no mention is made of her again in Banff Centre material[39] with the Latvian-born Inese Birstins recalling an unhappy departure,[40] a fate which Rousseau-Vermette would also experience when she quit in 1985.[41]

In the meantime, it was the golden era of fibre art at the Banff Centre. Leading an enthusiastic group of participants, professional guests also appeared in both the summer and winter cycles and the aforementioned six-week summer Fibre Interchange. John Bentley Mays, a high profile Canadian art critic for the *Globe and Mail* was *not* a guest

in the fibre arts area, but on a 1984 summer sojourn[42] to the Banff Centre he let it be known that, as a casual observer, the most innovative and interesting work was being done in the fibre area of the school.[43] No doubt, this was unsettling news for some visual art faculty members not involved in the contemporary fibre/textile world and still unused to its status as a largely female-centred, feminist-driven disruption in what was then a largely male artistic preserve.

By all indications, Rousseau-Vermette, upon assuming the role of Studio Head in 1982, led a dynamic Weaving/Textile department with Mary Andrews still in the picture with her expertise at "Multi-Harness Weaving." In addition, Kaija Sanelma Harris continued to push the envelope with "Multi-Harness Architectural Weaves." Working on samples such as double weaves, Finnweaver, warp and weft overshot, satin weaves and combined weaves, Harris introduced participants to the creative use of traditional weaves for large, structurally sound woven works displayed in buildings (cat. 20). In that same summer, Inese Birstins introduced "Feltmaking," while Joan Livingstone in "Image in Non-Woven Structures" explored with participants the use of markmaking, language, and the development of images in non-woven structures. For Livingstone's workshop, Poland's acclaimed fibre sculptor Magdalena Abakanowicz gave the final critique.

There was no doubt that Rousseau-Vermette's international reputation and direction only furthered the mountain school's attraction as a place geared for the mentorship and development of young women artists. Speaking in broader terms,

Inese Birstins dyeing wool in Banff, c. 1978. Photo courtesy of Inese Birstins.

Arts Planner Michael Bawtree wrote in the *Winter Cycle 1980–81* Program, "Banff can and should offer to the artists what no one else can provide, either within the constraints of formal education or in the harsher world outside: *the gift of time*, and *the gift of freedom*."[44] More to the point: "Everything was taken care of and you could work *overnight*."[45] Or, in the case of Patricia Oleszko (b. 1947, American), meet with the Detroit-born artist in the dead of night to stage a performance either body-painted or dressed in ritual clothing created by the participants in her "Costume, Fantasy, Performance" workshop.[46] The location: the popular jewel-like Grassi Lakes above Canmore, east of Banff.

By 1986 both Rousseau-Vermette and Birstins were gone, the latter only brought back as acting head for the summer programs of 1986 and 1987. Despite weaving and other fibre art practices being validated as contemporary art over a more than ten-year period, a perusal of the Banff Centre programs from 1989-on indicates fibre art

as a singular discipline has faded into the background. What happened? Unlike the Ceramics Studio and Photography Studio, Fibre was absorbed into the Visual Arts program—done, supposedly, for its own good and out of concern in the larger visual arts faculty that the sisterhood of weavers and off-loom fibre artists were too insular.[47] Too caught up in their own thing, worse, too much on its own trajectory to fully absorb the *new* thinking at the Banff Centre, which had become all about the *interdisciplinary*. It was a curious perception, given the sculptural/installation/performance record of the Rousseau-Vermette years.

For some, like Montréal artist Ruth Scheuing, who worked as Assistant Head of Fibres (1989–91), the new arrangement was all to the good. "Banff was truly hoping to break down the disciplines and have people work interdisciplinarily."[48] From the point of view of Ingrid Bachman, who succeeded Scheuing[49] but now only as Residency Assistant, "Fibre was becoming more and more accepted as a fine art practice. I think feminism and post colonialism had something to do with that."[50]

Under the new leadership of President Dr. Paul Fleck (1982–1992) and the 1989 hiring of Lorne Falk as the Art Studio Program Director, three ten-week residencies a year were established, each with a *thematic* approach. Residency themes evoked conceptual rigour and attention to the socio-political, as well as the cultural and artistic: in Summer 1990 the residency theme was "Border Culture," followed by "Fluxus" in Fall 1990, then "Neomythism" in Winter 1991, and, always a critical favourite any time and any place, "Mass Culture and Art"

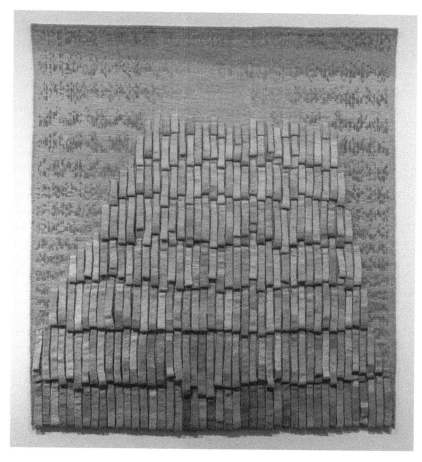

Kaija Sanelma
Harris, *Stubble Field*,
1984 (cat. 20)

Kaija Sanelma
Harris, *Stubble Field*
(detail), 1984 (cat. 20)

in Summer 1991. That was the brave new world to which weaving and off-loom artists were expected to conform. Now, more than thirty years later, themed residences are still *de rigueur* at the Banff Centre with the intent that everyone has access to the artmaking facilities, including whatever is left from the glory days of fibre art at the centre.

Jane Stafford is less in accord regarding what happened to the fifty-year legacy of weaving/textiles and fibre art at the Centre. She describes its incorporation into Visual Arts as "disastrous" and "tragic."[51] Despite any number of artists who wanted to lead the program, Birstins points out how, after Rousseau-Vermette and she left, no serious attempt was made to fill that position.[52]

In Sandra Alfoldy's "Canada's Textile Arts: A Brief History," she observes how "Canada's textile history is analogous to the illusion of unity provided by draping cloth— the surface may be smooth but underneath

disconnected parts co-exist."[53] The situation she describes is similar to the divide and disconnect between visual arts and craft at the Banff Centre. What happened at Canada's unique Campus in the Clouds is clear: in the name of what was considered "contemporary" at *that moment in time*, history and past practices were quickly dispensed with and the theoretical trajectory of contemporary art allowed to level and flatten anything related to craft-based skill or thinking. A few years later, a similar fate would befall ceramics, the other craft-based object-making activity at the Banff Centre, which had flourished under the energetic leadership of Les Manning (1944–2020). Here today, gone tomorrow. Thirty years later, the question now is: what was lost in that transformation?

With its span of artwork from the 1960s to the late 1990s, *Prairie Interlace* might provide some insight into that lingering question.

NOTES

1 Inese Birstins, interview with the author, January 7, 2022, Calgary, AB. From 1980 to 1989, Birstins held several positions at the Banff Centre, including: Programme Assistant; Assistant Studio Head; Associate Studio Head; Acting Studio Head/ Artistic Director; Studio Head/ Artistic Director; and lastly, Consultant for Fibre Programme. The author wishes to thank the following for their contributions to the preparation of this essay: Jessica Zimmerman and Lois Quail, Paul D. Fleck Library and Archives, Banff Centre; Michele Hardy and Julia Krueger, Nickle Galleries, University of Calgary; and artists Pat Askren, Ingrid Bachmann, Inese Birstins, Katharine Dickerson, Ruth Scheuing, Jane Stafford, and Barbara Todd for their comments and assistance.

2 Donald Cameron, *Campus in the Clouds* (Toronto: McClelland and Stewart, 1956).

3 Jenni Sorkin, "Way Beyond Craft: Thinking through the Work of Mildred Constantine," *Textile: The Journal of Cloth and Culture* 1, no.1 (January 2003): 30, DOI: 10.10 80/17518350.2003.11428630.

4 *Wall Hangings* was on view from February 25 to May 4, 1969.

5 Sorkin observes, "the [Museum] of Modern [Art] is distinguished by its distance from arts and crafts." Sorkin, "Way Beyond Craft," 32.

6 It is known that Larsen was a guest artist in 1980 and 1985. No information could be found about the specifics of his visit.

7 "Larsen, 93, Textile Designer With an Architect's Touch Dies," *New York Times*, December 24, 2020, B11.

8 Nancy Tousley, "Battle for art fabric being slowly won," *Calgary Herald*, August 2, 1980, D8.

9 Glenn Adamson, "The Fiber Game," *Textile: The Journal of Cloth and Culture* 5, no. 2 (2007): 154–77, DOI:10.2752/175183507X219434.

10 Briefly, the Banff Centre for Arts and Creativity has been training artists in the Canadian Rockies since 1933. It was founded by the University of Alberta Extension Department with funds provided by the Carnegie Foundation. This continued until 1966 when the University of Calgary assumed responsibility for the then named Banff School of Fine Arts. In 1978 the Banff Centre was granted autonomy as a non-university institution.

11 David and Peggy Leighton, "From Craft to Art," in *Artists, Builders and Dreamers: 50 Years at the Banff School* (Toronto: McClelland and Stewart, 1982), 93–98.

12 Ken Liddell, *Calgary Herald*, quoted in Pearlann Reichman and Karen Wall, *Uplift: Visual Culture at the Banff School of Fine Arts* (Vancouver: University of British Columbia Press, 2020), 174.

13 Sandra Alfoldy, "Canada's Textile Arts: A Brief History," in *Art Textiles of the World: Canada* (Brighton, UK: Telos Art Publishing, 2009), 11.

14 M. Sandin left the school in 1961; E. Henderson retired in 1963.

15 Alfoldy, "Canada's Textile Arts," 11. Author's emphasis.

16 "Remembering Mary Andrews," janestaffordtextiles. com/blog/July-2018 newsletter.

17 Originally published in 1960, a paperback edition was released in 1986. No information about the publisher was found.

18 The department was also described in the Centre's programs as "Weaving/Fabric Arts"; by 1979 the term used is "Fibre Arts," followed by simply "Fibre" or "Fibre Studio" in the early 1980s.

19 From the University of Kansas, Mary Synder earned a BFA 1970 in Textile Design in Weaving and an MFA 1971 in Design.

20 *1978 Weaving/Textile Arts Program*, 78, Fibre Arts Program Files, Media and Visual Arts fonds, Paul D. Fleck Library and Archives, Banff Centre for Arts and Creativity, Banff, AB.

21 Although former participant and instructor Barbara Kreutter attended the two-year diploma program beginning in 1976, she is uncertain how long it continued after she left in 1978. Email interview with the author, March 1, 2022. The diploma program is listed in the 1978 and 1979 program calendars, but in the 1980 calendar, it states: " The studio program is not a diploma course, and no credits or grades will be assigned." No other information could be found by the author.

22 *1978 Summer Program*, 78, Fibre Arts Program Files, Media and Visual Arts fonds, Paul D. Fleck Library and Archives, Banff Centre for Arts and Creativity, Banff, AB.

23 *1979 Winter Program*, 67, Fibre Arts Program Files, Media and Visual Arts fonds, Paul D. Fleck Library and Archives, Banff Centre for Arts and Creativity, Banff, AB.

24 Pat Askren, email interview with the author, March 9, 2022.

25 Askren, interview.

26 Jane Stafford, email interview with the author, March 21, 2022.

27 As an example of Rousseau-Vermette's work in this area, in the Fall of 1982, the artist's woven tubed ceiling for the new Roy Thompson Hall was greeted with

enthusiastic applause on opening night. A collaboration with the architect Arthur Erickson, the unusual ceiling was designed for the acoustics. With a speciality in woven art for public spaces, Rousseau-Vermette's structure (fabricated by a Montreal company) was yet another triumph for the artist already known for her theatre curtains at the National Arts Centre in Ottawa (1966) and the Kennedy Center in Washington, D.C. (1971).

28 "She Led Development of Exciting Fibre Program; A Tribute to Mariette Rousseau-Vermette," *Centre Letter* (newsletter) 5, no. 16 (August 1984), Newsletters-Centre Letter, Marketing & Communications, Paul D. Fleck Library and Archives, Banff Centre for Arts and Creativity, Banff, AB.

29 The Quiet Revolution in the 1960s signaled the end of Quebec's church-based education system and a move towards a secular society with no interference from the clergy. Government replaced the Catholic Church in this largely francophone society. A popular slogan was "Maîtres chez nous" ("Masters of our own house").

30 Anne Newlands, "Mariette Rousseau-Vermette: Journey of a Painter-weaver from the 1940s through the 1960s," *Journal of Canadian Art History / Annales D'histoire De L'art Canadien* 32, no. 2 (2011): 74–107.

31 "Mariette Rousseau-Vermette: 1926–2006," artpublic-montreal.ca/en/artiste/66589.

32 *The Banff Centre School of Fine Arts Summer 1982*, 40, Fibre Arts Program Files, Media and Visual Arts fonds, Paul D. Fleck Library and Archives, Banff Centre for Arts and Creativity, Banff, AB.

33 *Centre Lettre* 1, no. 28 (July 11, 1980), Media and Visual Arts fonds, Paul D. Fleck Library and Archives, Banff, AB. Elsa Sreenivasum was involved with the Weaving/Textile program and Fibre Interchange. Her years at the Banff Centre as an instructor and guest artist: 1978–1984.

34 Zeisler, known for her large totemic works, taught a two-week "Sculptural Forms" course.

35 *Summer Program 1980*, 50, Fibre Arts Program Files, Media and Visual Arts fonds, Paul D. Fleck Library and Archives, Banff Centre for Arts and Creativity, Banff, AB.

36 *Summer Program 1980*, 52.

37 The instructors were Patricia Olsen, Rose Dragan, Nell Pawlik, Marie Kischuk, Alice Nicholaichuk, Olga Semchuk, Patricia Pelech, Jean Meketiak, Nadia Kreptul. Jane Stafford provided technical assistance. The very existence of this centuries-old practice was a testament to an artistic tradition deeply rooted in the Prairie soil.

38 *Winter 1980–81 Program*, 9, Fibre Arts Program Files, Media and Visual Arts fonds, Paul D. Fleck Library and Archives, Banff Centre for Arts and Creativity, Banff, AB.

39 Due to the ongoing closure of the Paul D. Fleck Library and Archives from 2020 to 2022, the author was only able to access materials first-hand in mid-March of 2022 and again later that year in July.

40 Inese Birstins, interview with the artist, November 1, 2021, Calgary, AB.

41 Birstins, interview, November 1, 2021.

42 John Bentley Mays appeared as faculty in the Visual Arts Art Studio program. May's comment about Fibre Interchange remains a strong recollection of Inese Birstins, and also of the author, who as a member of the public attended one of the critic's talks that summer.

43 Birstins, interview, January 7, 2022.

44 *1980–81 Program*, 7, Fibre Arts Program Files, Media and Visual Arts fonds, Paul D. Fleck Library and Archives, Banff Centre for Arts and Creativity, Banff, AB.

45 Birstins, interview, January 7, 2022.

46 *Summer/Winter Program 1986–87*, Fibre Arts Program Files, Media and Visual Arts fonds, Paul D. Fleck Library and Archives, Banff Centre for Arts and Creativity, Banff, AB.

47 Birstins, interview, January 7, 2022.

48 Ruth Scheuing, email interview with the author, March 1, 2022; telephone interview with the author, October 23, 2021.

49 Bachman was at the Banff Centre from 1991 to 1993.

50 Ingrid Bachman, email interview with the author, March 11, 2022.

51 Jane Stafford, email interview with the author, March 21, 2022.

52 Birstins, interview, January 7, 2022.

53 Alfoldy, "Canada's Textile Arts," 9. Author's emphasis.

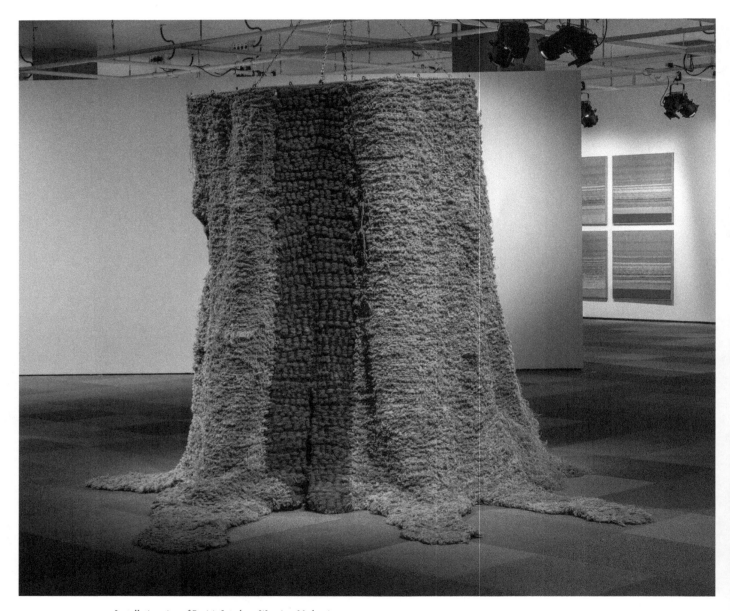

Installation view of *Prairie Interlace: Weaving, Modernisms,
and the Expanded Frame, 1960–2000*, Nickle Galleries, 2022.

Katharine Dickerson, *West Coast Tree Stump*, c. 1972 (cat. 11)

abstract woven and off-loom work in fiber."[27] Extensively toured in North America, this exhibition encouraged makers to creatively engage with fibres on a large scale, and to experiment with techniques and a variety of materials. Two seminal American publications by curator Mildred Constantine and textile designer Jack Lenor Larsen, one a catalogue of the exhibition and the other published a decade later, featured full-page illustrations of monumental contemporary fibre works and insightful analyses, intensifying interest in and acceptance of these hangings as a new kind of art.[28] The American *Fiberarts Magazine*, first published in 1976, became an influential aesthetic, technical, and marketing resource for many weavers as it disseminated the emerging innovative approaches to fibres. Experimental techniques and materials highlighted in these exhibitions and publications are reflected in two texturally evocative Prairie loom-based works from 1974, *Untitled Wall Hanging* by Hazel Schwass (cat. 51) and *Large Tapestry Weave* by Gayle Platz (cat. 43), suggesting how weavers enthusiastically incorporated found objects such as branches, bones, and beads, along with unspun fleece, into their woven structures. Susan Barton-Tait's *Northern Lights*, 1978, for the Manulife offices in Winnipeg brings to mind Le Corbusier's tapestry designation, muralnomad, as it integrated the interlacing techniques of weaving and knitting, so that it jumped off the wall, while cleverly invoking a sense of total enclosure through its reflections on the surfaces of the mirror-tiled walls and ceiling of the elevator lobby. Similarly, with their encircling walls, *West Coast Tree Stump*, 1972 (cat. 11), and the vast *West Coast Forest*

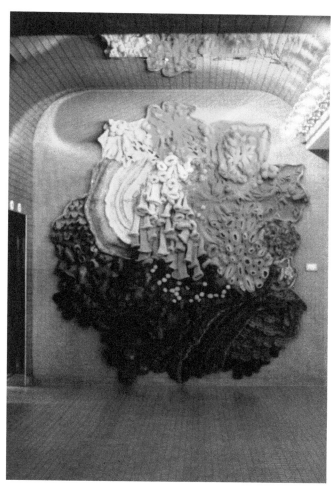

Susan Barton-Tait, *Northern Lights*, 1978, crocheted/felted; wool. Installed in the Manulife Building, Winnipeg, Manitoba. Photo courtesy of Susan Barton-Tait.

envelop a person as they move through them. One of Dickerson's students observed that "[s]he teleported our minds into these amazing installations within architectural settings, transforming rooms into magical places surrounded by wool,"[29] illustrating how monumentality describes not only the physical size but also the emotional effect of an architectural work and the ornament that

completes it.[30] Fibre art like this made for powerful and exciting encounters.

Production on such a large scale could be daunting for handweavers of the studio craft movement as they were often limited in studio space, loom sizes, tools, materials, people power, and even the know-how to interpret architectural drawings and building specifications. Some architects and clients questioned "craftspeople's professionalism, saying they can't cost work efficiently, can't work to a brief, can't draw clear and detailed drawings, can't handle complicated and large contracts, can't collaborate well with the varying groups of people inevitably involved on public projects and can't meet deadlines."[31] Canadian architect Hazen Sise was adamant that the architect "must have the final word . . . [as] the architectural design process demands this control."[32] Complaints were made that many artists who received commissions for monumental public art were "surprisingly unaware of the aesthetic determinants of architecture and the theoretical base of architectural form" that should inform their contributions.[33] Textile artists often had to acquire new skills such as reading architectural designs and building specifications, becoming aware of fluctuating light levels, researching lightfast dyes and fibre longevity, and learning to use fireproofing. A few were already exposed to these issues through their educational institutions, or, in the case of Dickerson, had the advantage of a mother who had studied architecture.[34] Such challenges facing artists and the potentially fraught relationships that could ensue during the commissioning process were recognized by allied arts advocate Anita Aarons, who worked tirelessly throughout the 1960s to provide some training through her columns in the journal *RAIC Architecture Canada* and in her *Allied Arts Catalogue, Vol. 1* and *Vol. 2*. Aarons traveled throughout Canada, was aware of the expertise of Prairie textile artists and their projects, and offered aesthetic, business, and production guidelines for clients, architects, and craftspeople alike.

Fibre projects that involved virtuosic combinations of inspiration, technical proficiency, and aesthetic innovation were only possible when funders, developers, and architects created opportunities for their realization. In Canadian post-secondary institutions, many fibre art programs enthusiastically introduced requisite courses that taught design and fabrication skills and exposed their students to commission procedures.[35] Indeed, government programs were instrumental in commissioning works, often from these students. Between 1964 and 1978 the Canadian federal government's program to designate one per cent of the cost of a federal building project towards the purchase of art for that building[36] facilitated the integration of tapestries into architectural spaces, and many provinces and corporations informally or formally adopted similar programs. Dickerson's 1977 *Northern Lights* for the Cottage Hospital in Watson Lake, Yukon,[37] was acquired in this spirit, as were the *Ta-hah-sheena* rugs for the University of Regina's Dr. John Archer Library (cat. 60). Two decades after Aarons had initially advocated for such commissions, their ongoing popularity inspired Alberta Culture to engage Alberta College of Art professor Dickerson to produce *Commissioning Visual Art: A Guide for Artists and Patrons,*

a concise and informative booklet to help artists negotiate the complex steps of the commissioning process.[38]

Commissions for such spaces could be acquired in various ways: through direct contacts between the weavers and architects; through interventions by interior designers or art consultants acting as expert intermediaries; through cultural institutions that mediated between client, architect, and artist; and even through personal contacts. Sometimes, without jury selection, a direct invitation was issued to a specifically chosen artist; at other times, a select group of artists were approached who subsequently were juried by a committee; a third approach was to issue a public call, often circulated by provincial and federal craft or art councils. In all cases, participating artists needed to submit initial designs, maquettes, samples of materials, design rationales, and a timetable.[39] For *Sun Ascending* (cat. 21), Harris was initially approached by design consultant Eve Baxter, who had previously narrowed the field of potential artists, but then Harris underwent a jury selection that included corporate and architectural firm representatives. Baxter remarked that consultants had to be familiar with "what was going on in the field and who was doing what."[40] Another commissioning method was experienced by Barton-Tait, who acquired her contract for *Northern Lights* through a general public call.[41] For his first tapestry order, *Passages*, 1985, Murray Gibson was directly connected to his client by a consultant, and Brenda Campbell benefitted from the support of art consultant Carolyn Tavender, who regularly approached her during the late 1960s and throughout the 1970s regarding wall

Tapestry (*Ta-hah-sheena*) (cat. 60) by Marge Yuzicappi (left), c. 1970 and *Tapestry* (*Ta-hah-sheena*) by Bernice Runns (right), c. 1971. Installed in the Dr. John Archer Library, designed by Minoru Yamaski. Photo courtesy of University of Regina Archives and Special Collections, 90-70, Slide 109.

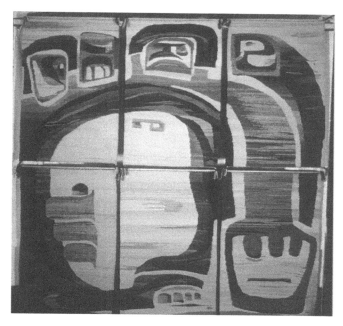

Margreet van Walsem, *Palaver*, 1973, tapestry; wool, natural dyes, 250 x 260 cm. SK Arts Permanent Collection, C72.11. Photo courtesy of the Margreet van Walsem Estate.

Murray Gibson, *Passages*, 1985, wool, silk and rayon, 90 x 183 cm. Installed in a primary suite bedroom. Photo by Larry MacDougal and courtesy of Murray Gibson.

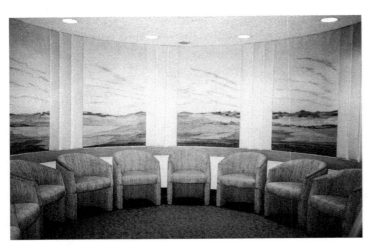

Elaine Rounds, *Prairie Vistas*, 1992, Swedish Inlay on six linen panels, 1.6 x 9.1 meters. Commission for and installed in Dr. Jay Winburn's circular reception area in his Optometry office, Brandon, Manitoba. Photo courtesy of Elaine Rounds.

hangings for corporate offices.[42] Tavender went on to act as an art consultant for the decoration of Alberta House in London, England,[43] a space in which several Alberta weavers, including Campbell, were consequently represented (p. 115).[44] Pirkko Karvonen recalled that her earth-toned weaving, *Westward,* c. 1980, for Westcan Bulk Transport's Edmonton boardroom, was her first of many art-consultant commissions. Acting as consultant for the furnishing of provincial government offices and for public art commissions and purchases, the Saskatchewan Arts Board facilitated the acquisition of several monumental tapestries, including the three Ta-hah-sheena wall rugs in the Dr. John Archer Library,[45] Margreet van Walsem's woven *Whites,* 1975, and her earlier immense six-panel tapestry *Palaver,* 1972, initially installed in the modernist Saskatchewan Centre of the Arts (1970), a design emerging from her concern about political and moral "justice/injustice" within Saskatchewan government practices.[46] Rather than working through an intermediary, a practice that she had found costly, Elaine Rounds preferred to receive most of her commissions for corporate spaces by means of personal contacts with the client, such as the woven multi-panel *Prairie Scene,* 1992, executed for Dr. Jay Winburn's office in Brandon, Manitoba.[47] As a 1984 British publication involved in promoting public art noted: "the institution's first task is not to choose the art but the person or persons who are going to do the choosing . . . whoever does the choosing must know a lot about current [art] and has to avoid not only the fashions but the vested interests of the art world."[48]

Prairie weavers were certainly keen to tackle the commission challenges of design, materials, and fabrication to encourage living and liveable spaces. At a time when immense paintings were a sign of professional excellence, architectural weavings opened a path for textile artists to be taken seriously by the art world, thereby distancing themselves from functional domestic production that often pigeonholed them as amateurs. In the interwar years, women of the Bauhaus weaving studio and Americans such as Dorothy Liebes and Gertrude Strengell had led the way as professional weavers, who teamed up with textile manufacturers to industrially produce their texturally and materially innovative handwoven designs that were often included as functional elements in large modernist corporate spaces.[49] However, for both Liebes and Strengell, weaving's role in architectural spaces was ultimately utilitarian, a "dependent expression,"[50] "functioning architecturally—for dividing rooms, controlling light, providing insulation."[51] Indeed, wall hangings and imaginative enclosures were not part of either Liebes' or Strengell's vision for the alliance of textiles and architecture. Reflecting this philosophy, Liebes referred to herself as an "artist-designer."[52]

Prairie textile artists proved to be more flexible in their relationships with architecture than were Liebes and Strengell. Calgary's F. Douglas Motter, handweaver and founder of Douglas Motter and Associates (1961), in conjunction with weavers such as Gerd Poulsen and Brenda Campbell, wove functional yardage, including draperies, men's suiting, place mats, and lamp shades, but also embraced the opportunity to create wall hangings that enlivened public (cat. 36)

and corporate spaces across the Prairie provinces.[53] Harris and Karvonen, both mid-century immigrants from Finland, had formally studied textiles after initially learning to weave domestic articles from their family members, and consequently went on to work in industry with northern European designers before immersing themselves in wall hangings after arriving in Canada.[54] Karvonen, like Motter, continued to maintain a functional handweaving practice for which she was very much respected while simultaneously creating architectural weavings.[55] Heller, known in Canada for her large-scale tapestries such as *Heat*, 1983 (cat. 23), began her career working in a Polish government factory as an industrial rug designer, where most of her production was exported to the "West."[56] Not bound by ideologies that confined textiles to a limited role in architectural spaces, these Prairie weavers collaborated extensively with architects and designers to develop one-of-a-kind monumental tapestries—Canada's own muralnomads.

Rousseau-Vermette, who had worked for Liebes in 1948–49, called herself a "painter-weaver,"[57] rather than adopting Liebes' self-designation as an artist-designer. This new label highlighted that contemporary weavers created art by designing *and* making the hanging, in opposition to historic tapestry fabrication, which relied on a two-step process involving a painter who provided the design and a weaver who executed it. In the Prairies, most fibre artists worked as "painter-weavers," a statement of artistic professionalism recognizing that the weaver controlled all aspects of the process as an artist and craftsperson, an approach

in line with the Lausanne Biennials. An exception to this trend was the 1974 project initiated by Fay Loeb of Toronto, who commissioned Canadian painters to supply designs for a numbered edition of hooked rug wall hangings, with the punch-hooking process undertaken by anonymous craftspeople in Mexico.[58] This pan-Canadian initiative involved several Prairie painters, including William Perehudoff (cat. 42), who supplied designs for a limited production.[59] Loeb's marketing approach asserted that this was the first time Canadian painters were accorded the prestigious honour of having their designs made into tapestries as had previously been undertaken in France with works by European and American painters.[60] However, the comparison was not quite accurate; in the Loeb project the yarn was hooked into an existing canvas backing, a very different technique from the European practice of weaving tapestries on high- or low-warp looms. Unremarked, as well, by Loeb was the practice of American 20th-century rug hooking enterprises that had often relied on painters to supply them with modern designs, especially during the interwar years.[61] The popular limited-edition Loeb tapestries were installed in office buildings throughout Canada.

As Prairie weavers realized, monumentality is not simple to achieve aesthetically or materially; the "seepage of monumentality" leaked into every aspect of their projects. Aesthetic considerations included composition, colour, physical scale, subject matter. Just blowing up a drawing or a small-scale maquette was not adequate; as modernist sculptor Anthony Caro advised, "an appropriate dynamic, a logic of enlargement must prevail."[62] Successful textile projects acknowledged audience viewpoints to ensure legibility of their textures and motifs from the requisite viewing distances; they considered the sizes, shapes, and configurations of walls so they would not be dwarfed by or overwhelm the space, would fit around unconventionally shaped walls, and would emphasize appropriate directionality. Colours that worked on a small scale would not necessarily translate into a large one, and for monumental spaces, bold and vibrant colours were often needed to offset the vast voids. Material considerations for weavers included securing adequate and consistent supplies of synthetic or local dyes along with natural and synthetic fibres, the appropriate equipment and tools, and, importantly, adequate studio space. Many of the designs for these immense architectural commissions had to be tailored to accommodate the size of the available looms, and so were woven in sections that were then assembled on the wall as panels. Karvonen, for example, wove the three-panel tapestry *Ekokanee*, 1977 for a Medicine Hat Burger King, while Harris included eleven panels in her 1989 monumental tapestry commissioned by Moriyama & Teshima for Ottawa City Hall.[63] Van Walsem's impressive *Palaver* included six panels distributed in two rows of three. While the weavers often worked from isolated home studios with restricted space, on a social level they engaged in multidimensional interactions with designers, clients, and architects. The correspondence in their archives documents the thoughtfulness required in these business relationships and financial transactions. For example, in talking about her commission *Ribbonways*,

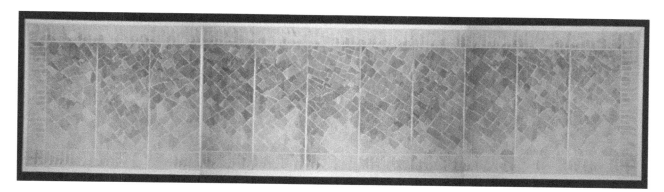

Kaija Sanelma Harris, *Ottawa-Carleton Mural Commission Drawing*, 1989. Photo courtesy of the Kaija Sanelma Harris Estate.

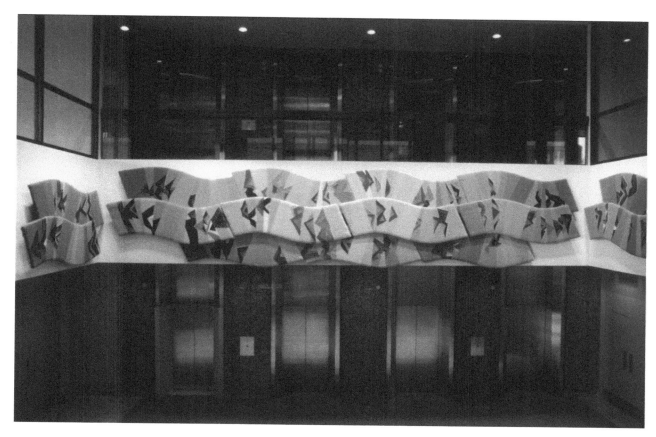

Jane Kidd, *Ribbonways*, 1982, shaped woven tapestry; wool, cotton and rayon, 2.1 x 15 meters. Installed in Eau Claire Place II, Jecco Development, Calgary, Alberta. Photo courtesy of Jane Kidd.

Kaija Sanelma Harris' Saskatoon studio while while weaving *Sun Ascending*, 1983. Photo courtesy of the Kaija Sanelma Harris Estate.

1982, for Eau Claire Place II in Calgary, Jane Kidd succinctly observes that she made a commitment from the beginning to a clear overall idea "so that my client is secure in terms of its end result."[64] On top of aesthetic, material and spatial concerns, the seepage of monumentality into human relations involved developing clear communications and efficiently negotiating social relations among all the key players.

Creating such monumental works entailed organization and re-organization of the lives and spaces of the makers. The immense Ta-hah-sheena hooked rugs on the walls of the Dr. John Archer Library were executed in a studio that had been converted from an old schoolhouse, as such large projects would have been impossible in busy family homes.[65] While producing the twelve-foot-high *West Coast Forest*, Dickerson realized the height of her studio fell well short of the height of her project and thus the vertical loom had to be modified so the ends could be lowered as the weaving progressed. Her studio's permeability to rain, less concerning when short-term and smaller weaving projects were undertaken, was also a worry for this year-long venture.[66] When Harris' contract was signed for *Sun Ascending*, she already had the space and the requisite looms, and "enough yarn to start and studio organized." However, the scale of work required her to empty her space of everything external to this contract and store it elsewhere, and to rearrange her two looms so that the weavers worked back-to-back and maintained very regular nine-to-five weaving workdays.[67] Having competent weavers to help with architectural commissions of all sorts, whether one-of-a-kind tapestries or functional products, such as draperies and upholstery materials, was an important consideration. Motter regularly engaged Alberta College of Art graduates who had learned to weave, such as Paulsen, Campbell, and later Carol Little. Campbell worked with Douglas Motter and Associates for four years (1966–70) where she received

her first rya wall hanging commissions for office buildings through Tavender, who particularly appreciated her art education.[68] Such examples emphasize that, whether in terms of the monumental size of a work or its production, human expertise and professional relationships were key to a project's success.

During the later decades of the 20th century, Calgary's booming oil industry significantly impacted weaving commissions. Gibson's wool and silk *Prairie Carpet,* 1990 (cat. 14), commissioned by Esso Resources for its University of Calgary research centre, cleverly brings together Alberta's oil patch with Middle Eastern oil production. Gibson referenced kilim weaving, a technique associated with tribal weaving in the Middle East that he was researching, and the romantic concept of a magic carpet flying through the night sky over Alberta.[69] The tapestry's whimsical and abstract but subject-specific design may have helped assure its retention in the Esso collection after it was removed from its original location.[70] Another petroleum-based site-specific commission, Gibson's *Remembering the Future,* 1988, was woven for an elevator lobby in Amoco Corporation's Calgary office.[71] Gibson knew in advance where his tapestry would hang and conceived a horizontal format that responded to the hallway space but also referenced the proportions of the elevator doors. Responding to the requirement in the commission brief to reference the petroleum industry, Gibson represented the seismic waves produced in petroleum exploration and their abstracted movement through the geological strata of the earth, up through the planet's habitable layer, and into the sky. In its elevator lobby

Brenda Campbell working at Douglas Motter and Associates in Calgary, Alberta, c. 1968. Photo courtesy of Brenda Campbell.

space, the tapestry celebrated the petroleum industry while critically reminding it of "the balance between contemporary economic needs and responsible stewardship for the future of the planet."[72] Produced at a time when the petroleum industry was, and subsequently continues to be, under pressure because of climate change and environmental degradation, Gibson's tapestry skillfully weaves together architectural setting,

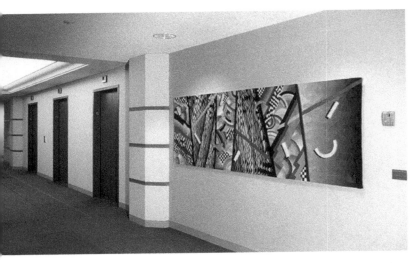

Murray Gibson, *Remembering the Future*, 1988, tapestry; wool, silk and metalic fibres, 91 x 266 cm. Commissioned by and installed in the Amoco Canada Building, Calgary, Alberta. Photo by Ken Woo and courtesy of Murray Gibson.

corporate message, and design content with insightful social commentary.

Clearly, integrating this art form into architectural spaces is a complex task involving metaphorical and symbolic considerations. According to art historian and curator Miwon Kwon, the term "in situ" embraces not only a physical condition of the art, but also social, political, and cultural conditions,[73] as the physical location of the artwork, together with its own materiality and motifs, creates a space of social interaction that encourages conversations. The fusion of these conditions is evident in many of Gibson's Prairie tapestries, including *Chinook Medley*, a privately funded commission for the Calgary Civic Art Collection as part of the Canada 125 celebrations in 1992 and originally hung outside the mayor's office in the old part of Calgary City Hall.

The carefully chosen motifs reference the historic importance of both ranching and petroleum to the economic development of Calgary by tracing the history of Southern Alberta, beginning with herds of buffalo and including well-chosen motifs such as cattle brands, barbed wire fencing, and oil and gas symbols to form the "notes" on the musical staves.[74] Narrative tapestries such as those by Gibson, or multi-panel familiar landscapes such as Elaine Rounds' 1999 *Prairie Scene* woven for the boardroom of Meyers Norris Penny, Accountants, are often best appreciated over time, whether in a series of shorter encounters or one longer viewing. Rounds proudly recalls this tapestry invariably instigated friendly conversations among those present.[75] However, when social, political, and cultural conditions shift, the conversations the tapestries evoke can become dated and the tapestries seen as irrelevant, a condition leading to a nomadic life for some works.

Landscape abstraction, a subject easily apprehended by a large audience, and perhaps more amenable to changing contexts, was especially appropriate where a harmonious and ideologically neutral integration with an interior was desired. Rounds created several landscape commissions for offices in which each room's colour palette was carefully coordinated with the tapestry, including her multi-panel *Prairie Vistas* for an optometry office waiting room. The distribution of panels across a curved wall ensures that all who sit in the chairs placed against the wall have a view of several sections of the landscape, a perspective that Rounds conceived as a view from a porch with white pillars interrupting the landscape's continuous horizontal flow.[76]

Likewise, her five-panel Prairie landscape for Meyers Norris Penny skillfully integrates the colours of the chair upholstery and table surface.[77] Equally architectonically harmonious are other large tapestries, such as Harris' multipaneled *Fields*, 1981, in the Canadian embassy in Varsovie (Warsaw), Poland, and Karvonen's *Ekokanee* and *Westward*.[78]

Jane Kidd, a weaver who has tackled many public tapestry commissions, explained their important role: "Commissioning is about putting really exciting, vibrant art in public places that stimulates people, does something for these spaces, and does something for the people who see it every day."[79] Geometric forms accomplished this efficiently and were, like landscape, accessible to a large audience. In Kidd's *Ribbonways*, woven panels stretched on a curvilinear framework and hung on three walls of the foyer of Eau Claire Place II in Calgary enlivened the space through their wave patterns and animated geometric coloured motifs. They effectively countered the grid of the building and brought attention to the main doors, invigorating this "streamlined office tower entrance."[80] Similarly, Carol Little and F. Douglas Motter's vibrantly coloured *This Bright Land*, 1976 (cat. 36), creates a rhythmical sequence of polygons that both reference and contradict the geometric regularity of the modernist architecture characteristic of Calgary at that time. An important interface between abstract geometries and specific cultural motifs occurs in the Sioux Handcraft Co-operative's *Ta-hah-sheena* installation in the Archer Library. For many people, the geometric forms in these hooked rugs were recognizable as both modernist art and as symbols aesthetically grounded within First Nations culture. But for the Sioux makers, they had very particular meanings, often referencing specific designs passed down intergenerationally by Sioux women, with many representing a maker's personal narrative.[81] In this latter example, geometric forms were not only visually dynamic; they codified community and family stories.

In some cases, weaving a history of place into a hanging enhanced its site specificity. Ann Newdigate executed a conceptually rich tapestry for Moshe Safdie's postmodern addition to Ottawa City Hall. *Many Voices/Miltunkasik*, 1994, woven in silk and mounted on canvas, integrated into its design submission instructions to the architects to respect the diverse population of Ottawa; to reinforce the point, Newdigate translated these instructions into five First Nation languages.[82] Harris' 1989 Ottawa City Hall tapestry, commissioned by Moriyama & Teshima Architects for their modernist building, was designed to remind Ottawa civic administrators about the smaller political entities that had recently been amalgamated into the expanded Ottawa region. By interlacing the geometric forms of each municipality's shape with abstractions of the Rideau and Ottawa rivers among a grid of roads and streets, her eleven-panel weaving referenced the eleven smaller municipalities.[83] Despite its specific symbolic content, the tapestry, although received by the architects, was never installed in City Hall and its present location remains unknown.[84] Clearly, a great deal of conceptual thinking went into many site-specific works, making it even more unfortunate that the current locations of several impressive Prairie mural-nomads are unknown.

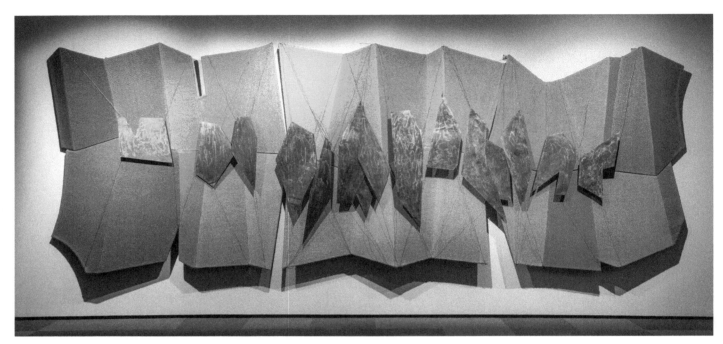

F. Douglas Motter, *This Bright Land*, 1976 (cat. 36)

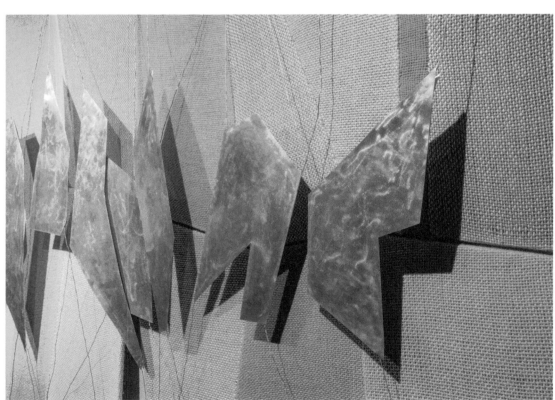

F. Douglas Motter, *This Bright Land* (detail), 1976 (cat. 36)

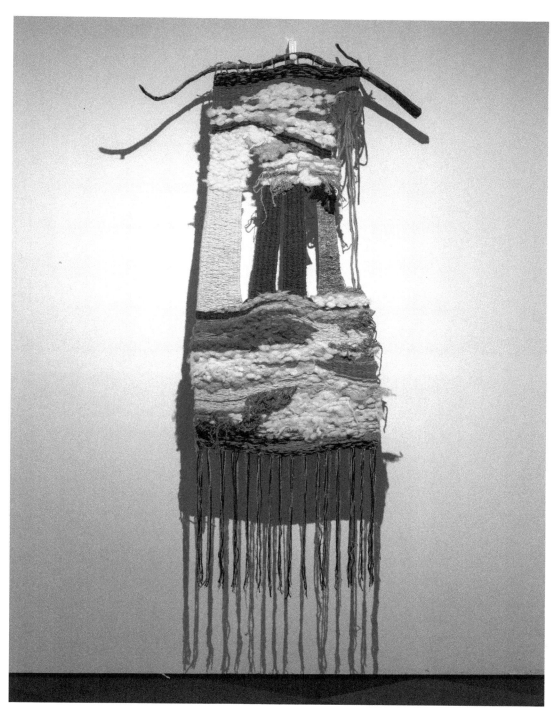

Gayle Platz, *Large Tapestry Weave*, c. 1974 (cat. 43)

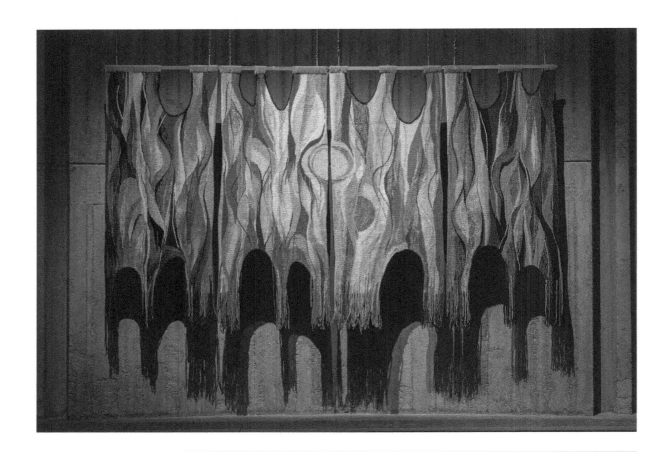

Installation view of *Prairie Interlace: Weaving, Modernisms, and the Expanded Frame, 1960–2000*, Nickle Galleries, 2022.

Eva Heller, *Heat*, 1983 (cat. 23)

Installation view of *Prairie Interlace: Weaving, Modernisms, and the Expanded Frame, 1960–2000*, Nickle Galleries, 2022.

William Perehudoff, *Untitled Tapestry (Loeb Commission)*, 1976 (cat. 42)

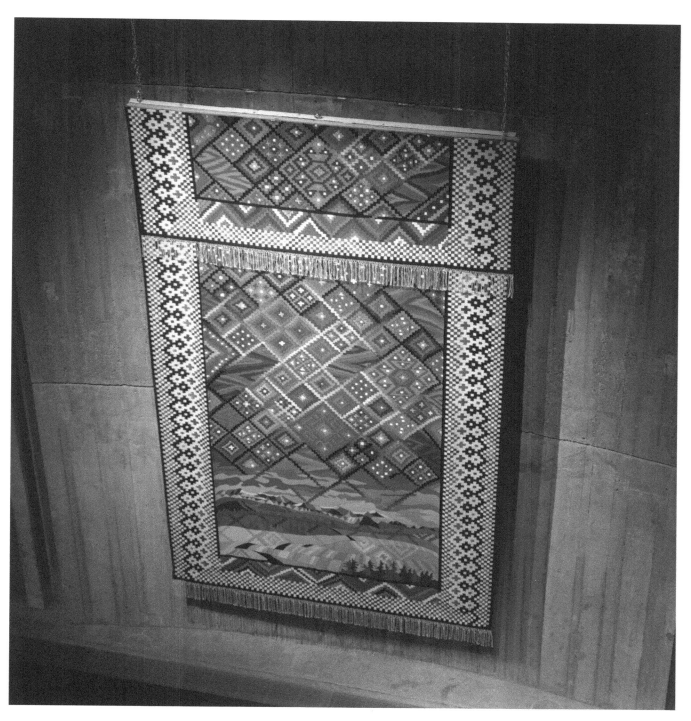

Installation view of *Prairie Interlace: Weaving, Modernisms, and the Expanded Frame, 1960–2000*, Nickle Galleries, 2022.

Murray Gibson, *Prairie Carpet*, 1990 (cat. 14)

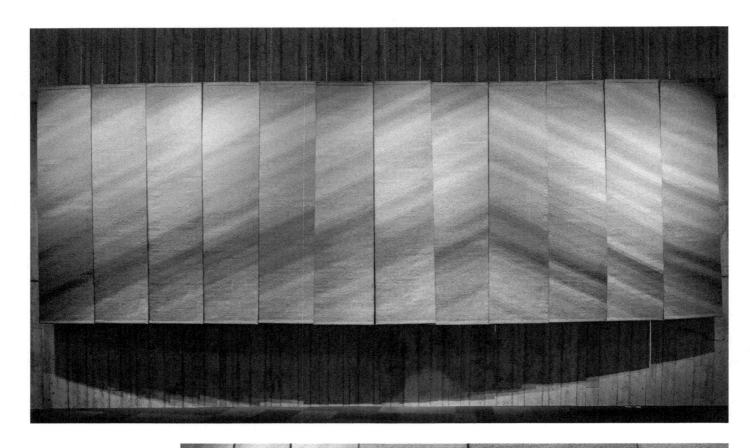

Installation view of *Prairie Interlace: Weaving, Modernisms, and the Expanded Frame, 1960–2000*, Nickle Galleries, 2022.

Kaija Sanelma Harris, *Sun Ascending* (12 of 24 panels), 1985 (cat. 21)

Kaija Sanelma Harris, *Sun Ascending* (detail), 1985 (cat. 21)

73 Miwon Kwon, *One Place After Another: site-specific art and locational identity* (Cambridge, MA: MIT Press, 2002).

74 Murray Gibson, email to the author, March 20, 2022.

75 Rounds, interview.

76 Rounds, interview.

77 This tapestry was woven for Myers Norris Penny, Accountants, 1999.

78 Julia Krueger, telephone conversation with the author, March 9, 2022.

79 Jane Kidd, quoted in Tousley, "Unusual Work," A11.

80 Tousley, "Unusual Work," A11.

81 Hensen, "Standing Buffalo"; Probe, *Ta-Hah-Sheena*, 7.

82 Ann Newdigate, *Many Voices/Miltunkasik*, artist's website, http://www.annnewdigate.ca/archives/pages/BACKGROUND_details/ottawa.html. This tapestry remains in the City of Ottawa art collection.

83 Kaija Sanelma Harris Archives, Ottawa Carleton Mural, Ottawa Carleton Proposal. Kaija Sanelma Harris papers, Saskatchewan Craft Council, Saskatoon, SK.

84 Letter to Harris from Moriyama and Teshima Architects, December 7, 1989, Kaija Sanelma Harris works documentation, Kaija Sanelma Harris 89 Ottawa Carleton Mural, Proof of Purchase, Kaija Sanelma Harris papers, Saskatchewan Craft Council, Saskatoon, SK; Julia Krueger, March 9, 2022.

85 Petherbridge, "Exaggerations," 49.

86 Susan Barton-Tait, email to the author, March 27, 2022.

87 Julia Krueger, email to the author, July 14, 2022.

88 Rounds, interview.

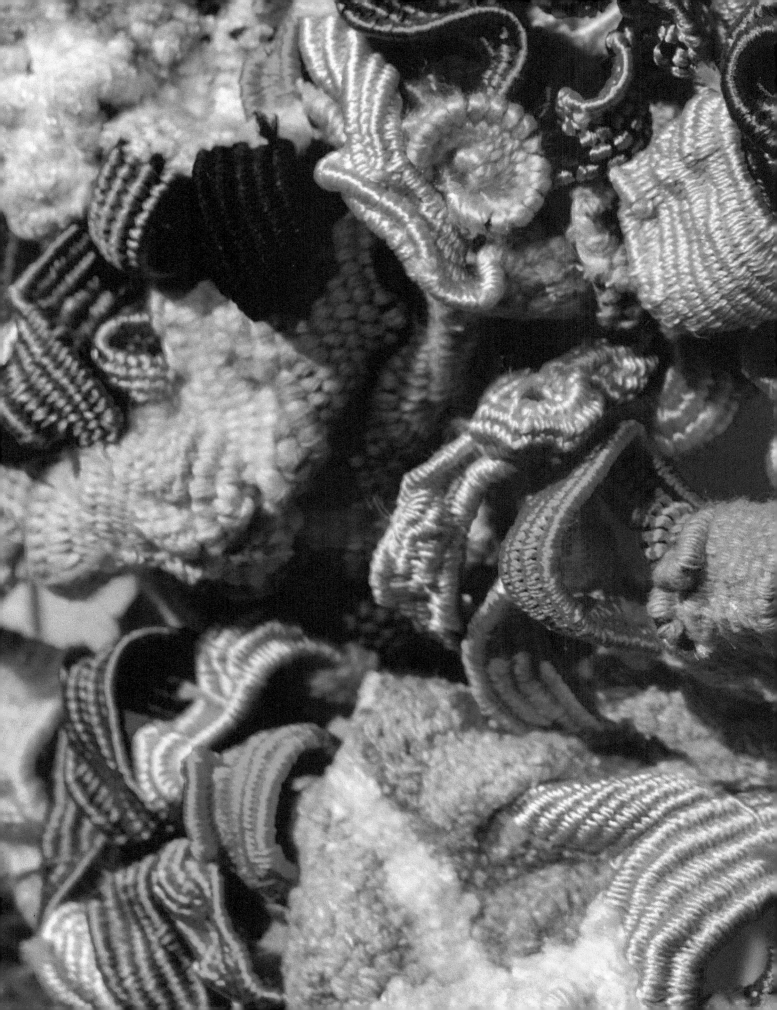

Contextual Encounters

Pat Adams, *Prairie Sunset*, 1983 (cat. 1)
Photo: Don Hall

Curating *Prairie Interlace*: Encounters, Longings, and Challenges

by Julia Krueger and Michele Hardy

Prairie Interlace provides an opportunity to reflect not only on the explosion of innovative interlace practices on the Canadian Prairies, but also on the specific joys and trials attached to curating textiles. Working virtually on this multi-faceted project during the COVID-19 pandemic brought into focus several of the considerations and requirements, often impossible to meet, of curating an essentially tactile medium. The pandemic also made more precious those moments of encounter with woven works, both in the past and in the course of our research, which inspired our deliberations. From the initial breathtaking encounters with pieces of exceptional skill and aesthetic impact, to the ordeal of locating artists and information, to the unique strategies needed for installing textiles, this essay gives expression to some of the specific concerns which we, as a curatorial team, faced in developing *Prairie Interlace*.

Wondrous Encounters and Resonant Longings

Foundational to *Prairie Interlace* are the sixty woven and interlaced objects which illustrate the breadth of textile-based work that occurred in the second half of the 20th century on the Prairies. Among these objects are a number that had long resonated in the minds of our curatorial team, composed of Michele Hardy (Curator, Nickle Galleries, University of Calgary), Timothy Long (Head Curator, MacKenzie Art Gallery), and Julia Krueger (Independent Curator and Researcher).[1] Literary historian Stephen Greenblatt explains that a "resonant" object is one with the power to pull "the viewer away from the celebration of isolated objects and towards a series of implied, only half visible relationships and questions . . . [and] to evoke in the viewer the complex, dynamic cultural forces from which it has emerged."[2] These "resonant relationships,"[3] as Krueger describes them, often begin with a wondrous encounter with an object. Greenblatt defines wonder "as the power of the object displayed to stop the viewer in his [or her] tracks, to convey an arresting sense of uniqueness, to evoke an exalted attention."[4]

The dialogue that ensues between object, history, community, and researcher has the capacity to enlarge our horizons.

When wonder strikes, a curator or researcher cannot always follow up due to the constraints of time, capacity, or other commitments. A resonant longing often ensues, one lodged in the recesses of memory where it continues to tug at the unconscious. Krueger, for example, vividly remembers seeing her first Pat Adams weaving. While assisting with the installation of an exhibition at the Moose Jaw Museum & Art Gallery in 2011, she was tasked with unrolling the textile in preparation for hanging. The slow unfolding of the weaving was like watching the morning light spread over a honey-coloured swath of land below a brilliant mauve sky: a wondrous encounter with land and yarn. She recalls noting colours that perfectly echoed the seemingly unreal hues of a Prairie sky and a window-like view that stopped time and grounded within her the particulars of place. She can't remember much else from that exhibition because her attention was so entirely transfixed. She wanted to learn more about Adams and his deft use of yarn, but she couldn't as her focus at the time was on Prairie ceramics. By happenstance, a few years later Krueger climbed the stairwell of the MacKenzie Art Gallery in Regina and came face-to-face with Adams' *Prairie Sunset*, 1983 (cat. 1).

Looking at its sky of brilliant pink and violet, she once again found herself overcome by wonder—for the Prairies, for Adams' skill, for the calm and quiet in the work, and for a woven rendering of light unlike anything she had seen before. Her desire continued to build as she worked with

Timothy Long on exhibitions which sought to expand the history of clay in relation to late Modernism and early Postmodernism in Regina. After co-curating *Victor Cicansky: The Gardener's Universe* in 2019, a window opened as they asked themselves, "What's next?" In that moment, the resonant longing for a history of textile art that would encompass craft, Modernism, and Postmodernism on the Prairies emerged from their mental recesses. For Krueger, there was a longing to understand the work of Prairie weavers such as Adams; for Long, the desire was to explore and expand the context of Kaija Sanelma Harris' monumental architectural weaving *Sun Ascending*, 1985 (cat. 21), something he was unable to do at the time of its acquisition by the MacKenzie in 2014. Long and Krueger then approached textile curator Michele Hardy, who eagerly joined the project bringing a knowledge and passion that would be foundational to the project.

Troubles with Textiles

Research for this exhibition has met with more than its share of troubles. At the onset of the research phase, the COVID-19 pandemic hit, disrupting our plans to visit archives and private collections and undermining efforts to view public textile collections in person. Inconvenient as they were, the pandemic restrictions shone a spotlight on the challenges of storing, documenting, and exhibiting textiles—challenges that have tended to stifle and suppress textile research even when there isn't a pandemic. Outside of our own institutions, we found access to museum collections next to impossible due to closures. Reduced staffing at many

institutions further impacted what could be accessed and when. For some institutions, collections staff had only sporadic in-person access to otherwise closed facilities. Hence, most of the research to select the artworks for *Prairie Interlace* was conducted through online databases or by collections staff who could access files remotely. In situations where records were meagre or photographs absent, we simply could not consider the works. In many cases, photographs were available but at such low resolution as to make study difficult. For some works, we did not fully understand their structure until they were unpacked at Nickle Galleries over the summer of 2022. While the textile selections we made are representative of the tremendous creativity and experimentation that characterized textile works of the Prairies between 1960 and 2000, just *how* representative is a question for future scholars.

Physical artist files, today increasingly rare, were difficult and in some cases impossible to access; holdings of archival materials related to fibre art are sporadic at best. Ironically, for a digital age, the Nickle's hard copy artist files (files that have not been maintained for over a decade and linger in deep storage) proved an important resource. Once upon a time, librarians clipped newspaper articles and filed exhibition catalogues—fortunately for us, their efforts coincided with the period of investigation. Krueger identified the importance of provincial craft council publications, overlooked and difficult to search, and coordinated the digitizing of past newsletters of Alberta and Saskatchewan's craft councils.[5]

Throughout the research phase, we began to postulate that these challenges—though exposed by COVID-19—have been major contributing factors to why the story of weaving on the Canadian Prairies has not been more thoroughly researched, exhibited, or written about. Collectively referred to here as "Troubles with Textiles," our list of challenges helps to describe the inherent complications in researching textiles, complications that impact how, when, and where textiles are accessed, viewed, researched, and, ultimately, understood. The following is a brief synopsis of those troubles.

Lexical Lack

M. Anna Fariello has argued that there is a need for craft to have its own discipline-specific language.[6] The same is true for the fields within craft such as textiles. While there are numerous words to describe textiles, these words are often misunderstood, used inconsistently, or appear like arcane jargon to those without specific textile knowledge. For example, to purists, "tapestry" is a discontinuous weft-faced pictorial textile like Murray Gibson's *Prairie Carpet*, 1990 (cat. 14). Confusingly, when researching *Prairie Interlace*, Marge Yuzicappi's latch-hooked rug, *Tapestry (Ta-hah-sheena)*, c. 1970 (cat. 60), and William Perehudoff's punch-hooked *Untitled Tapestry (Loeb Commission)*, 1976 (cat. 42), not only have "tapestry" in their titles, but they were also categorized as such in their respective databases. These aren't necessarily errors as "tapestry" is often used to describe pictorial fibre-based works that are hung on a wall. To further confuse matters, the free-form macramé pieces by Jane Sartorelli and the

pieced and knotted leather work by Ilse Anysas-Šalkauskas have "tapestry" included in the "materials" fields of their respective databases. Needless to say, this lexical inconsistency fosters confusion and makes it hard to articulate the parameters of a research inquiry. In some cases, the catch-all term "mixed media" concealed the identity of textiles altogether. Lexical confusion acts as a barrier when searching through databases and muddies questions posed to staff who might have limited familiarity with textiles. A simple task, like a search for specific holdings, can easily become "too much trouble."

Intransigent Baggage

Historically, and stereotypically speaking, textiles are associated with the domestic, hobby craft, and women's work. Frances Borzello notes in *At Home: The Domestic Interior in Art* that the domestic interior as a subject has been invisible to the history of art and has "no official existence."[7] By extension, it would be safe to say the objects found within those interiors, such as Annabel Taylor's rug *Ten Shades of Sheep*, 1983 (cat. 55), are largely invisible to curators because they are not considered art. Except in cases when they critique art world hierarchies (e.g., the work of Nancy Crites, cat. 9 & 10, and Cindy Baker, cat. 4), textiles are frequently "not at home" within the white cube of the art gallery and art publications.

Julia Bryan-Wilson notes in *Fray: Art and Textile Politics* that textile production across cultures, while not "uniformly considered feminized labor," retains a feminized association that clings to "textiles across the spheres of applied art, everyday fashion design and industry."[8] During the 1970s, part of the period covered by *Prairie Interlace*, textiles and the labour associated with fibre-based arts were appropriated by feminist artists to reframe "women's work" from the domestic sphere as high art.[9] Since the 1970s, this reframing has become the default for textiles and has tended to reinforce the intransigent feminized associations (to borrow from Bryan-Wilson) that cling to textiles, meaning that unless one wishes to engage with feminist sexual and gender politics, the object holds no interest. In other words, textile projects come with a baggage of expectations that researchers may not want to engage or may not provide an appropriate frame for the objects under consideration.

Architectural Servitude

Elissa Auther explains that the weaver-designer of the 1950s adhered "to the notion of woven textiles as utilitarian products subordinated to interior design or architecture."[10] In the 1960s and 1970s, architects and interior designers started to commission larger, more expressive textile pieces that were as far from drapery as could be imagined. The notion of textiles being in service to architecture remained, however, undermining appreciation of them as art objects. As Surette points out in her essay, referring to the monumental tapestries shown at the Lausanne Biennials, Le Corbusier famously termed them "muralnomads," acknowledging their potential removal from walls, a gesture that weakened, but did not altogether dissolve, the lingering association with architecture. Apart from the physical, logistical, and aesthetic challenges of creating textiles to suit and serve architectural settings (never the other way around), their

servitude does not end with their removal from architectural spaces. Unlike a piece of furniture or painting, they can't simply be moved, particularly if created to fit within a certain complex dimensional space. For example, Kaija Sanelma Harris' *Sun Ascending*, 1985 was made specifically to warm the austere modernist interior of Mies van der Rohe's TD Centre in Toronto (p. 82). Each of the twenty-four panels is almost four metres tall, making it next to impossible to install this work anywhere other than the TD Centre lobby—only half its panels could be included at Nickle Galleries and its height precluded inclusion at two *Prairie Interlace* venues altogether! Architectural textiles are typically created to complement a specific interior space and they tend to follow prevailing trends in interior design. Tastes and styles change, building interiors are renewed and renovated; what once looked modern can look embarrassingly dated years later.

When the decision is made to retire architectural textiles, the question arises, what to do with them? Many works the curators learned about have disappeared, having vanished into remote storage, private collections, or possibly landfills. Those tasked with dispersing large textiles do not always think to call a collecting institution to see if there is interest in acquiring the piece. Compounding this difficulty, not all institutions collect textiles or have the capacity to house large works. Transfer of ownership can be a long, drawn-out process making donation a nuisance for all but the most dedicated. Another critical factor is that the longer a textile is installed the more damage it is likely to have received from light, dust, pests, and wear. While museum recommendations

suggest displaying textiles for only a few months,[11] architectural textiles typically remain on display for years. In other words, the conditions attached to architectural textiles are so specific that it makes it exceptionally hard to find other homes for them.

Fear-Based Avoidance

Striking fear into the heart of any museum professional working with textiles is the Canadian Conservation Institute's ten "Agents of Deterioration," a list developed in the 1980s. It identifies the ten biggest threats to the preservation of historic objects with suggestions on how to mitigate those risks.[12] Because textiles are vulnerable to all ten agents, their conservation is particularly fraught. The special care and handling textiles require can be a serious challenge for institutions and may result in fear-based avoidance. Textile donations, including architectural donations, can be turned down for any number of reasons: if appropriate storage space is unavailable, if the costs of conservation are deemed too high, if staff expertise is lacking. In many cases, it is easier to avoid these objects altogether rather than take on the challenge of bringing them into a collection. In the end, this means that textiles are not collected as widely as other forms of fine craft.

Hidden Away in Plain Sight

Because they are particularly susceptible to damage from light, temperature, humidity, and pests, textiles tend to be stored in secure, dark, environmentally controlled rooms. Visible storage arrangements in museums, a trend since the 1970s, have excluded textiles.[13] Flat textiles are often stored in

Textile conservator Gail Niinimaa and Nickle Galleries' preparator Doug McColl examining the plywood backing of *Prairie Barnacles* (cat. 32) by the Crafts Guild of Manitoba. Photo courtesy of Nickle Galleries.

map-drawers; larger flat textiles are rolled, suspended, and covered with cotton sheeting; three-dimensional textiles are hung or stored on shelves, typically wrapped or boxed to protect them from dust and light. This means that textiles tend to be shrouded from view—inaccessible except to a privileged few.[14] This also means that textiles tend to be out-of-sight and out-of-mind. Textile scholar and curator John Vollmer once noted that "Unlike a painting, it's easy to roll up a tapestry and forget about it."[15]

If a collections staff member is asked—"Do you have any rugs with green stripes?"—it may be a challenge for them to answer what is contained in those wrapped rolls, especially if the works have not been photographed. Whereas libraries once consisted mainly of books you could peruse on shelves, digital libraries and museum collection management systems streamline and direct inquiries and inhibit casual searching and serendipity. This was a significant issue for *Prairie Interlace* as we didn't always know precisely what we were looking for.

Demands on Human Resources

Museums and art galleries are frequently overstretched and understaffed. The pandemic's restrictions on how many people could occupy a closed space highlighted the number of staff needed to care for and provide access to textile artifacts. In the case of *Prairie Interlace*, if more than one person was required to inspect a work, to be the eyes for the researchers who could not visit the facility, or to take a photograph of it, the request was often denied. Beyond the pandemic restrictions, it is important to note the extra work required by the sheer size and weight of many works, particularly architectural textiles. At the Canada Council Art Bank in Ottawa, it took several preparatory staff to hoist Katharine Dickerson's *West Coast Tree Stump*, 1972 (cat. 11), from its flattened state in a crate. For both public and private collections, large tables or clean floor spaces were required to view textiles. For example, Murray Gibson's *Prairie Carpet*, 1990 (cat. 14), designed specifically for the Esso Research Centre on the University of Calgary campus but since removed (p. 114), had to be rolled out in a boardroom in Imperial Oil's Quarry Park offices in southeast Calgary, and William Perehudoff's *Untitled Tapestry (Loeb Commission)*, 1976 (cat. 42), was

spread on a plastic-covered floor in the main lobby space of the Confederation Centre Art Gallery in Charlottetown. There is a cost to the institution when several staff are required for a researcher to access or photograph a rolled textile. As might be expected, when budgets are tight or capacity limited, access can be restricted as a result.

Salvage over Curatorial Intent

The fact that most of the artworks included in *Prairie Interlace* were loaned from government collections is not accidental and is not due solely to COVID-19 closures. These collections are the main repository for these types of textiles on the Prairies, a reality that raises questions about their role in the composition of the historical record. As mentioned above, textiles through the 1960s, 1970s, and 1980s were used to embellish government and corporate offices. When these facilities closed, their contents were often saved for posterity. A case in point is Alberta House in London, England, which was decorated by interior designer Carolyn Tavender[16] with commissioned textile works that included Whynona Yates' *Hanging*, 1974 (cat. 59), and Brenda Campbell's *Lava*, 1974 (p. 115). When the facility was permanently closed in 1995, these works were transferred to the collection of the Alberta Foundation for the Arts.[17] While any effort to preserve textiles is welcome, the resulting inventory of artworks is rather like a historic or ethnographic collection; it reflects a salvage paradigm rather than curatorial intention that takes into account the field of contemporary production or an artist's career. This lack of curatorial intent is evident in the textile holdings of many government collections,

The SK Arts Permanent Collection textile wall in Regina, SK. Photo courtesy of SK Arts.

and even in some art gallery collections, suggesting an entrenched de-valuing of textiles. With few exceptions (e.g., Aganetha Dyck and Ann Newdigate), textiles are collected piecemeal and opportunistically. Any sense of the development of a fibre artist's oeuvre is lost within the scattered remains found in

Preparatory staff from Nickle Galleries and the City of Calgary Public Art Collection begin the installation process for *This Bright Land* (cat. 36) by F. Douglas Motter. Photo courtesy of Nickle Galleries.

public collections. Compounding this situation is the often scant information about the artists and their commissions. A case in point is *This Bright Land*, 1976 (cat. 36), by Motter and Associates. It was commissioned for the entrance to the Calgary Convention Centre, but in 1983 it entered the collection of the City of Calgary where it has been in storage ever since. No installation photographs or instructions are to be found, and it was only recently discovered that the work, though designed by F. Douglas Motter, was woven by Carol Little. It is next to impossible to build a comprehensive understanding of the work of artists such as Little, Campbell, and Yates through their salvaged holdings in public collections.

||||

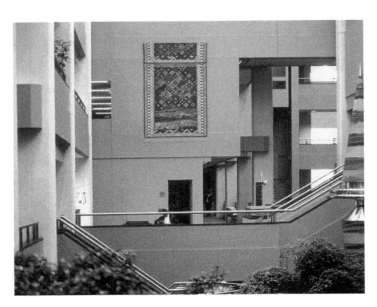

Murray Gibson, *Prairie Carpet*, 1990 (cat. 14). Commissioned by Esso Resources for its research facility at the University of Calgary, Alberta. Photo by John Dean and courtesy of Murray Gibson.

Textiles are ephemeral. Frequently made for domestic use, they are often thrown away or recycled when no longer useful; hence old textiles are rare. Examples of ancient textiles are rarer still; their existence is predicated on their chance preservation in peat bogs, permafrost, or extremely dry conditions. But the perpetual absence of modern textiles is neither the result of disposal after use nor a lack of proper storage conditions but rather a compounding, continual loop of the seven points above. What we know about recent Prairie textiles is based on what may have been collected, may have been recorded, and may have been accessible on any given day. Textiles' perpetual absence is a result not just of a series of inconvenient or unfortunate "troubles," but of models and priorities antithetical to textiles that have reduced, if

not outright negated, their presence within Prairie art and craft history and discourse.

The point of this reflection on the vicissitudes of textile curation is not to complain about the efforts of collecting institutions—indeed, the curators are indebted to them—but to point out the difficulties of curating textiles, suggesting reasons why they are seldom researched and exhibited. An exhibition of oil paintings, ceramics, or ancient coins poses its own challenges but none as restrictive or hidden as textiles. The hope is that by sharing these struggles, other curators, researchers, artists, and collections professionals will be inspired to address the specific needs of textiles and to no longer see them solely as sources of trouble.

Textile-centric Installation Strategies

Michele Hardy took the lead on the installation of *Prairie Interlace* at Nickle Galleries, which was the first venue and institution responsible for administering the major touring project grant from the Museums Assistance Program of Canadian Heritage. Her textile-centric approach focused on the selection of metatextiles and deployment of textile-specific installation strategies. A metatextile is an object with self-referential qualities that highlight the unique characteristics of the medium. For example, the selection of a work like *Close Knit*, 1976 (cat. 13), by Aganetha Dyck highlights the manipulable qualities of cloth because the placement and folding of each shrunken sweater's arms varies with each installation. Other works embody the rich history and global reach of textiles: Murray Gibson's

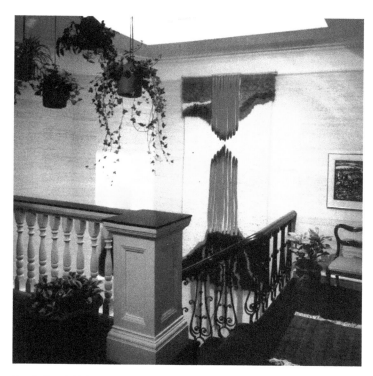

Brenda Campbell, *Lava*, 1974, tapestry; wool, 365 x 145 x 13 cm. Installed in the upper stairwell landing of Alberta House in London, England and now in the Collection of the Alberta Foundation for the Arts, 1997.013.001. Photo from Andrea Lang, "Artistic Interiors: Fine Art and Interior Design," *Artswest* 6, no. 6 (June 1981): 20.

Prairie Carpet, 1990 (cat. 14), self-consciously embeds transcultural weaving references in both its process and patterning. Other artists index the material foundations of weaving in their work. Annabel Taylor's rug *Ten Shades of Sheep* (cat. 55) derives its pattern and colour palette from variations in the wool harvested from specific sheep. Similarly, Kate Waterhouse's archive of dye-samples, the product of years of experimentation with different Prairie plants (cat. 58), provides a master key to foundational textile knowledge. Specific installation strategies also contributed to Hardy's textile-centric curation. The installation

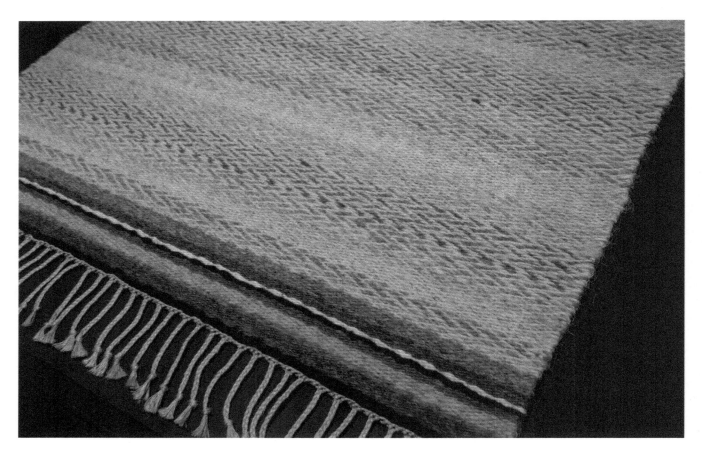

Annabel Taylor, *Ten Shades of Sheep* (detail), 1983 (cat. 55)

Annabel Taylor, *Ten Shades of Sheep*, 1983 (cat. 55)

116 PRAIRIE INTERLACE

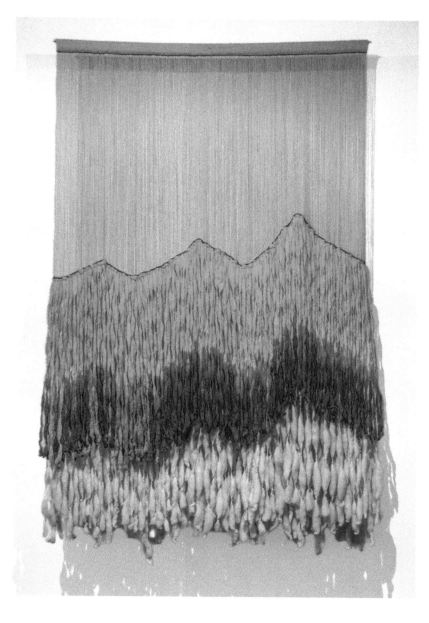

Whynona Yates, *Hanging*,
1974 (cat. 59)

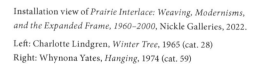

Installation view of *Prairie Interlace: Weaving, Modernisms,
and the Expanded Frame, 1960–2000*, Nickle Galleries, 2022.

Left: Charlotte Lindgren, *Winter Tree*, 1965 (cat. 28)
Right: Whynona Yates, *Hanging*, 1974 (cat. 59)

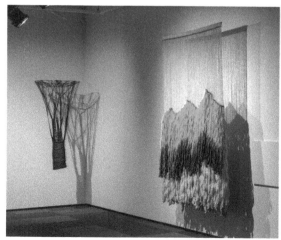

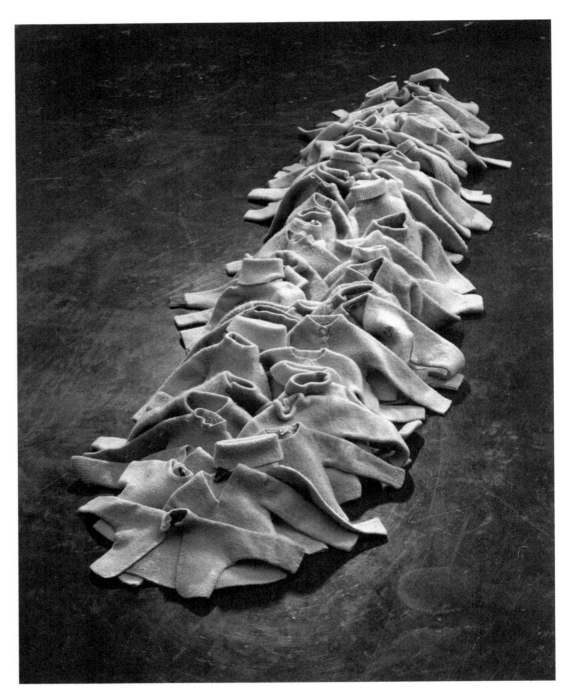

Aganetha Dyck, *Close Knit*, 1976 (cat. 13)

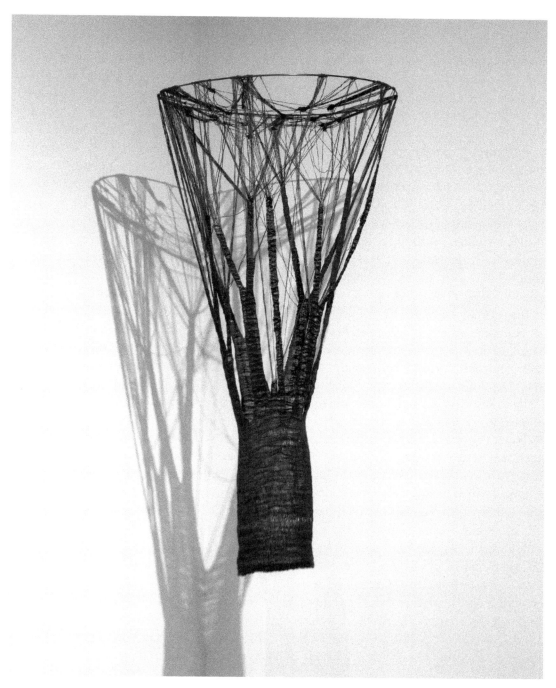

Charlotte Lindgren, *Winter Tree*, 1965 (cat. 28)

plan was anchored by free-hanging works that recalled the decisive movement of fibre art into three-dimensional space during the 1960s and 1970s. Leading the way historically was Charlotte Lindgren; the very material and structure of *Winter Tree*, 1965 (cat. 28), a suspended lace-like tube of dark woven thread, extends into space through the dance of shadow on the walls. In *Furrow*, 1976 (cat. 29), with a nod to gravity's effects upon textiles, Carol Little transforms a rather unassuming piece of yardage into a mid-air ballet by draping it over dowels suspended from the ceiling. One of the most significant decisions Hardy made was to suspend works at a distance from the wall, even if they would normally hang flush against its surface. This strategy enabled key textile qualities to come to the forefront, such as the independence of woven wall hangings from the frame of painting, a topic addressed by Long in his essay. Unlike a painting, the reverse side of a textile holds secrets to its fabrication; the complex construction of works such as Whynona Yates' *Hanging*, 1974 (cat. 59), can only be understood through an inspection of its reverse side. Separation from the wall also brings attention to the previous life of certain works as architectural commissions. In this, the raw concrete walls of Nickle Galleries' exhibition space, once the brutalist exterior of the University Theatre, provided an impressive and appropriate backdrop for those works made for architectural spaces, such as Harris' *Sun Ascending* (cat. 21). In another instance, the scale of

Nickle Galleries' space allowed for the elevation of the small, domestically scaled rugs of the Sioux Handcraft Co-operative to a monumental register, as they were installed in a salon hang alongside Marge Yuzicappi's colossal *Tapestry (Ta-hah-sheena)*, c. 1970 (cat. 60). These engagements with space and scale provided a counterpoint to the intimate textural qualities that invited long and leisurely close looking.

Beyond the Exhibition

The resonant, wondrous, troublesome nature of textile art accounts for its widespread appeal *and* general invisibility. This exhibition, website, and publication attempt to address both sides of the equation, by amplifying textile's visceral and conceptual appeal while mitigating the factors that often lead to its omission from display and discourse. Reflecting on the curation of textiles is part of our strategy, one which we hope plants the seeds of future projects. The hope is that collectors, museum professionals, archivists, building managers, and others will be attentive to the specific needs of textile art, and will collect, conserve, and document these remarkable works with intention and care. Ultimately, we hope this publication conveys something of the wondrous encounters we experienced in researching and producing *Prairie Interlace*, and stirs resonant longings that will foster future creation, study, enjoyment, and understanding.

NOTES

1 For Julia Krueger in addition to the work of Pat Adams, it is Katharine Dickerson's *West Coast Tree Stump*, 1972 and the work of Margreet van Walsem that have resonantly beckoned to her for almost two decades. For Timothy Long, a resonant longing began with the MacKenzie Art Gallery's acquisition of Kaija Sanelma Harris' *Sun Ascending*, 1985.

2 Stephen Greenblatt, "Resonance and Wonder," *Bulletin of the American Academy of Arts and Sciences* 43, no. 4 (January 1990), 19–20, 23.

3 Julia Krueger, "Indisciplined Ceramic Outhouses and Blob-like Glass Bunnies: Four Case Studies on Canadian Prairie Ceramics and Glass" (PhD diss., University of Western Ontario, 2020), 2–3.

4 Greenblatt, "Resonance and Wonder," 19–20.

5 For the Saskatchewan Craft Council's *The Craft Factor*, visit: https://saskcraftcouncil.org/the-craft-factor-archive/; The Alberta Craft Council's *Alberta Craft*, visit *https://issuu.com/albertacraft*.

6 M. Anna Fariello, "Making and Naming: The Lexicon of Studio Craft," in *Extra/Ordinary: Craft and Contemporary Art*, ed. Maria Elena Buszek (Durham: Duke University Press, 2011), 23.

7 Frances Borzello, *At Home: The Domestic Interior in Art* (London: Thames & Hudson, 2006), 26.

8 Julia Bryan-Wilson, *Fray: Art and Textile Politics* (Chicago: University of Chicago Press, 2017), 10 & 12.

9 Glenn Adamson, "The Fiber Game," *The Journal of Cloth and Culture* 5, no. 2 (2015): 169.

10 Elissa Auther, "From Design for Production to Off-Loom Sculpture," in *Crafting Modernism: Midcentury American Art and Design*, ed. Jeannine Falino (New York: Abrams, 2012), 145.

11 Renée Dancause, Janet Wagner, and Jan Vuori, "Caring for textiles and costumes," *Preventive Conservation Guidelines for Collections* (Canadian Conservation Institute), https://www.canada.ca/en/conservation-institute/services/preventive-conservation/guidelines-collections/textiles-costumes.html#a34, accessed December 27, 2022.

12 Canadian Conservation Institute, "Agents of deterioration," https://www.canada.ca/en/conservation-institute/services/agents-deterioration.html, accessed December 18, 2022.

13 UBC's textile collections were not regularly featured in visible storage until the completion of a major Renewal Project in 2010, https://www.wikiwand.com/en/Museum_of_Anthropology_at_UBC, accessed December 18, 2022.

14 Michele Hardy and Joanne Schmidt, "Radical Access: Textiles and Museums," Textile Society of America Symposium Proceedings (2008), https://digitalcommons.unl.edu/tsaconf/1089/, accessed March 17, 2023; Fiona Candlin, "Don't Touch! Hands Off! Art, Blindness and the Conservation of Expertise," *Body and Society* 10, no. 1 (2004): 71–90.

15 John Vollmer, "Tamara Jaworska: Tapestry weaver was a Canadian cultural treasure," *Globe and Mail*, November 22, 2015, https://www.theglobeandmail.com/arts/art-and-architecture/tamara-jaworska-tapestry-weaver-was-a-canadian-cultural-treasure/article27434364/, accessed March 18, 2023.

16 Andrea Lang, "Artistic Interiors: Fine Art and Interior Design," *Artswest* 6, no. 6 (June 1981): 18–27.

17 Textiles transferred from Alberta House to the AFA collection after its closure in 1995 include 1997.013.00 and 1997.051.001 by Brenda Campbell; 1997.116.001 and 1997.116.002 by Lavoine McCullagh; 1997.085.001 and 1997.118.001 by Whynona Yates; and 1997.117.001 by Elisabeth Vander Helm. Gail Lint to Julia Krueger, "Textiles from Alberta House London," email, October 14, 2021.

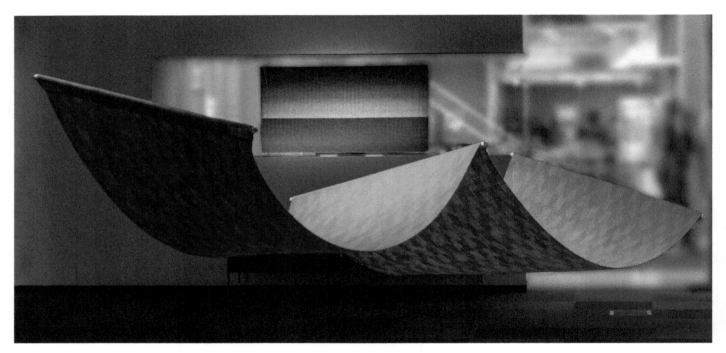

Installation view of *Prairie Interlace: Weaving, Modernisms,
and the Expanded Frame, 1960–2000*, Nickle Galleries, 2022.

Foreground: Carol Little, *Furrow*, 1976 (cat. 29)
Background: Pat Adams, *Prairie Sunset*, 1983 (cat. 1)

Weaving at the Horizon: Encounters with Fibre Art on the Canadian Prairie

by Mackenzie Kelly-Frère

. . . textiles are the receptacle for so many conflicting preconceptions,
emotions, traditions and investments, people are often uncertain
about what label to apply. Yet it seems that this very undefinableness is
increasingly being claimed as a positive space between, around, and away
from labels that normalize such hierarchies as high and low art.

ANN NEWDIGATE[1]

For me, the Prairie shaped my weaving and I deliberately ignored any other
influences.

PAT ADAMS[2]

I learned how to weave at the Alberta College of Art[3] in 1994, a year before the final instalment of the Lausanne International Tapestry Biennial. At the time I was only vaguely aware of the influence of the Biennial on the fibre art movement and its role in the "transformation of classical tapestry to a new form of artistic expression."[4] My weaving teachers, Katharine Dickerson and Jane Kidd, introduced us to artists who exhibited at Lausanne, encouraging us to look beyond our local context. The work of Lenore Tawney, Sheila Hicks, and Magdalena Abakanowicz inspired us to experiment both on and off the loom, to investigate unusual materials, and to engage with weaving as a form of personal expression. We incorporated dye techniques and process-intensive approaches made popular by contemporary Japanese textile artists such as Hiroyuki Shindo, who visited the Alberta College of Art in the mid-1990s. As

an enthusiastic student of textiles, I began to understand that fibre art was international in its scope. At the same time, I also noticed that the network of artists working in fibre-based media was a small one. Claiming a space on the timeline of fibre art as a perennial student of weaving and a descendant of settlers on Treaty Seven Territory, I acknowledge the influence of my teachers and in turn the cumulative influences of their own mentors and teachers.

These artists and their weaving are the focus of *Prairie Interlace: Textiles, Modernisms, and the Expanded Frame*. With them I share a sense of place, here between the foothills of the Rocky Mountains and the east country of Alberta where I grew up. I experience a deep sense of recognition when looking at Pirkko Karvonen's *Rapeseed Fields* (cat. 25). Its hand-spun yarns are dyed in shades of gold and green, evoking the fragrant, cultivated fields experienced from an open car window driving from Trochu to Drumheller, Alberta. Like Pat Adams (cat. 1 & 2) of Saskatchewan or Elaine Rounds (cat. 46) of Manitoba, I understand that the vast flatness of this agrarian landscape invites textile abstraction, with a horizon line as flat as the *fell*[5] of handwoven cloth as it accumulates on the loom. The horizon is also a destination to which one may never arrive—a kind of nonplace and an elusive site for becoming.[6] As such it is a useful metaphor as we consider the interwoven legacies of weavers on the Canadian Prairie during a period of radical changes to weaving practice. Glenn Adamson argues that craft is a horizon that constitutes a "conceptual limit active throughout modern artistic practice."[7] The artists of *Prairie Interlace* have interrogated this conceptual limit both on and off their looms, weaving at the horizon where textile traditions are challenged by artistic innovations of form, materiality, and context.

The work that resulted from this process offers a unique parallel record of the struggle for art world legitimacy undertaken by weavers and curators who instigated and sustained the fibre art movement in Europe and the United States. In her book *String, Felt, Thread: The Hierarchy of Art and Craft in American Art*, Elissa Auther contextualizes this struggle as it happened within "three spheres of practice . . . fiber art; process or postminimalist art; and feminist art."[8] Throughout her text, Auther complexifies the narrative of the fibre art movement by highlighting the overlapping subjectivities of its participants. In similar fashion, this essay will consider the work of several artists in *Prairie Interlace* and explore how contingent communities of weaving practice approached the notion of weaving as an art form. This text will also attempt to unpick overlapping contexts that informed the work, including early 20th-century efforts towards the revival of handweaving, the push for the professionalization of fine craft, and the Prairie landscape itself. While many of the artists in this exhibition have exhibited their work around the world, some of their weaving evokes a kind of made-on-the-Prairies sensibility in which landscape and the Prairie horizon are enmeshed with various subjectivities related to place and identity.

The transformation of weaving practice enacted between 1960 and 2000 is remarkable considering handweaving's pathway

to revitalization in North America with its focus on the preservation of weaving traditions. Commonly credited to Mary Atwater, the revival of American handweaving favoured colonial era weaving drafts[9] and utilitarian textiles. These she featured in the *Shuttlecraft Guild Bulletin*, a self-published weaving periodical distributed widely across North America.[10] Decades later these drafts were still in use at the Banff School of Fine Arts where Ethel Henderson of Winnipeg and Mary Sandin of Edmonton taught weaving from 1942 until the early 1960s.[11] While teaching in Banff, the two weavers also collaborated on a periodical of their own. *Loom Music* was published for more than twenty years and regularly featured what was taught in Banff in those early days. Anecdotes of summer activities in the mountains were also included with designs inspired by the colours of glacial lakes.[12] Advice and even drafts from Atwater's earlier publications were regularly included. *Loom Music*'s editorial content was minimal, with most pages dedicated to educating the home weaver with clear and friendly instructions for useful domestic articles. When the authors of *Loom Music* encountered the weaving of Anni Albers in a 1952 travelling exhibition at the University of Alberta,[13] they pointed to the modernity of the weaving as proof that handweaving holds an "important place in the textile world of today." At the same time, it is telling that these educators focused their report on technical aspects of Albers' upholstery and drapery materials, revealing a bias towards the traditional utility of cloth.[14] Indeed, one must look very hard at the writing and teaching records of these weavers to discern the seeds for the experimental

Reproduction of the linen *Peyto Lake Towel* woven by Mackenzie Kelly-Frère based on draft and instructions in the November 1951 issue of *Loom Music*.

weaving which was to follow at Banff. In the decades following Henderson and Sandin's tenure, the weaving workshop at Banff was to become a generative site for fibre artist-in-residence programming under the leadership of Mariette Rousseau-Vermette, an artist from Québec who initiated the Fibre Interchange in 1979, attracting artists from around the world.[15]

The development of programs for weaving instruction on the Canadian Prairies occurred in the decades following the First World War. As early as the 1930s,

Calgary weaver F. Douglas Motter. Photo by Jack De Lorme and courtesy of Libraries and Cultural Resources Digital Collections, University of Calgary, 1954-02 (CU1140342).

the summer program at Banff, would go on to teach weaving at the Provincial Institute of Technology and Art from 1948 until her retirement in 1962.[19] F. Douglas Motter—one of the artists of *Prairie Interlace*—was hired to teach in the program at the newly named Alberta College of Art the next year.[20] Following the Second World War, weaving guilds, associations, and community-based workshops were initiated across the Prairie provinces.[21] In 1947, the Guild of Canadian Weavers was founded by Mary Black, Ethel Henderson, and Mary Sandin with the express purpose of raising the standard for handweaving through the establishment of a new testing program by mail.[22] All of this activity began as a project with shared goals—to elevate the technical standards of weaving along with its theory and critical reception. These initiatives were encouraged by a broader movement to professionalize the crafts across the country. In her book *Crafting Identity: The Development of Fine Craft in Canada*, Sandra Alfoldy notes that "Canadians were highly influenced by the modernist perspectives put forward at the first World Conference of Craftsmen [in 1964] and taken up by the American Craft Council's journal *Craft Horizons*."[23] As some chose to align themselves with the art world, key values that had previously united weavers, such as function, finish, and fit for purpose, were directly challenged by new priorities like innovation with unusual materials, originality, and, above all, artistic self-expression. Alfoldy notes that many were left out of this new future for craft. "Frequently, marginalized craftspeople reflected approaches to craft considered outdated, for example those who practiced and

the Provincial Institute of Technology and Art in Calgary (later the Alberta College of Art)[16] offered weaving classes as part of their art program "provided there was sufficient demand."[17] The Banff School of Fine Arts weaving course was started in 1941 as part of the University of Alberta's Department of Extension.[18] Although initially there was no credential offered for the summer program, this was perhaps the first complete course for weaving available in Canada—and an influential one. Alice VanDelinder, a student of

preserved traditional skills, or those who avoided neat classification, like First Nations craftspeople."[24] The split between weavers with a more traditional focus and those eager to align themselves with fibre art eventually coalesced into two distinct yet contingent communities of practice—weavers in guilds and weavers in art schools. This is, of course, a broad generalization. Given the scale of the overall weaving community on the Prairies, overlap was inevitable. It is not surprising, given this smaller context, that many of the artists in *Prairie Interlace* either taught or were taught by other artists in the exhibition.[25] Beyond art schools, workshops were how most weavers learned to weave. Weavers also taught one another and traveled to conferences hosted by the Handweaver's Guild of America or the World Craft Council to take workshops from international weavers such as Lily Bohlin,[26] Jagoda Buić, or Ritzi Jacobi.[27]

The typical narrative of this period given by curators and critics (notably not by weavers) is one of rupture where artists were liberated from the restrictions of weaving traditions and even their looms. In their text accompanying the 1969 exhibit *Wall Hangings* at the Museum of Modern Art in New York, curators Mildred Constantine and Jack Lenor Larsen heralded this new era in which weavers were able to experiment "free of the loom."[28] The truth, however, was more complicated. In many cases weavers were looking to ancient weaving and traditional structures for inspiration. Writing recently about *Wall Hangings*, Glenn Adamson notes that weavers "adopted off-loom techniques such as knotting, wrapping, and plaiting, as well as ingenious 'hacks' of

the loom itself. Their motivation was to find new vocabularies for the discipline, which ironically led them to techniques that were deliberately anachronistic. They borrowed ideas, for example, from ancient Peruvian textiles: the shock of the old."[29] Katharine Dickerson's 1972 work *West Coast Tree Stump* (cat. 11) demonstrates how weavers recontextualized traditional weaving structures while adopting the sculptural strategies of fibre art. Dickerson studied at the Art Institute of Chicago with Else Regensteiner, herself a student of Marli Ehrman and Anni Albers.[30] She counts artists like Magdalena Abakanowicz and Claire Zeisler as early influences on her practice and worked for a time as Zeisler's studio assistant.[31] In the early 1970s Dickerson immigrated to Canada to pursue weaving in an entirely different context. Living on Vancouver Island, she met Salish weavers who taught her twining techniques.[32] In *West Coast Tree Stump*, Dickerson used an adapted twining technique in concert with an overshot structure commonly used in loom-woven, settler-colonial coverlets. The twining comprises an integral part of the structure, holding the entire form together, while the overshot floats over the surface of the form, providing a textural effect of charred wood. The work was woven off loom from the top down using a custom-fabricated support. In this monumental piece Dickerson has instrumentalized the structural vocabulary of cloth, intentionally enmeshing the cultural referents of each. For the artist, *West Coast Tree Stump* was both an homage to the Salish people and a social commentary on the destruction of culture and nature by settler loggers.[33] A sculptor of textiles with

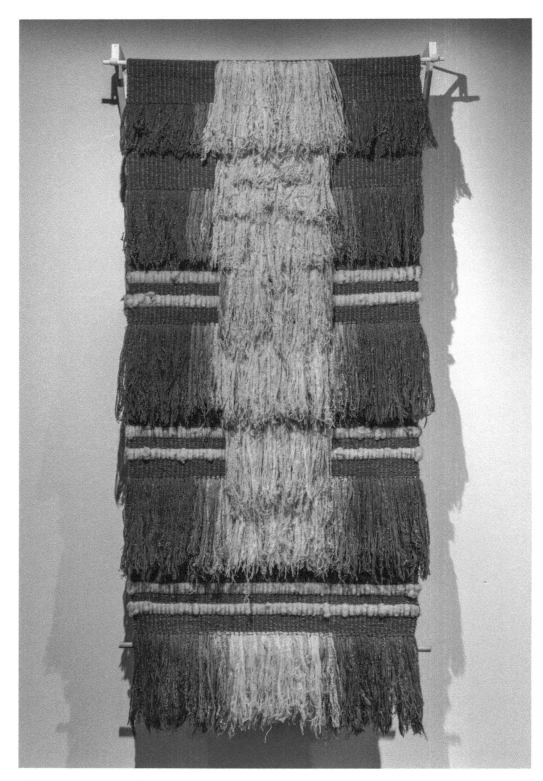

Pirkko Karvonen, *Rapeseed Fields*, 1974 (cat. 25)

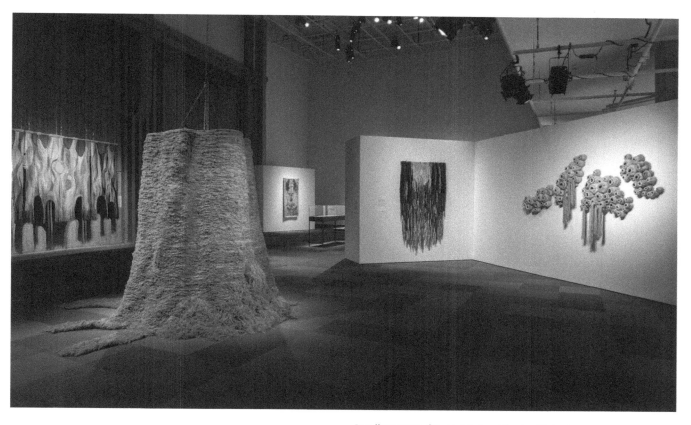

Installation view of *Prairie Interlace: Weaving, Modernisms, and the Expanded Frame, 1960–2000*, Nickle Galleries, 2022.

Left to right: Eva Heller, *Heat*, 1983 (cat. 23), Katharine Dickerson, *West Coast Tree Stump*, 1972 (cat. 11), Ann Newdigate, *Then there was Mrs. Rorschach's dream/ You are what you see*, 1988 (cat. 39), Ilse Anysas-Šalkauskas, *Rising from the Ashes*, 1988 (cat. 3), Crafts Guild of Manitoba, *Prairie Barnacles*, 1979 (cat. 32)

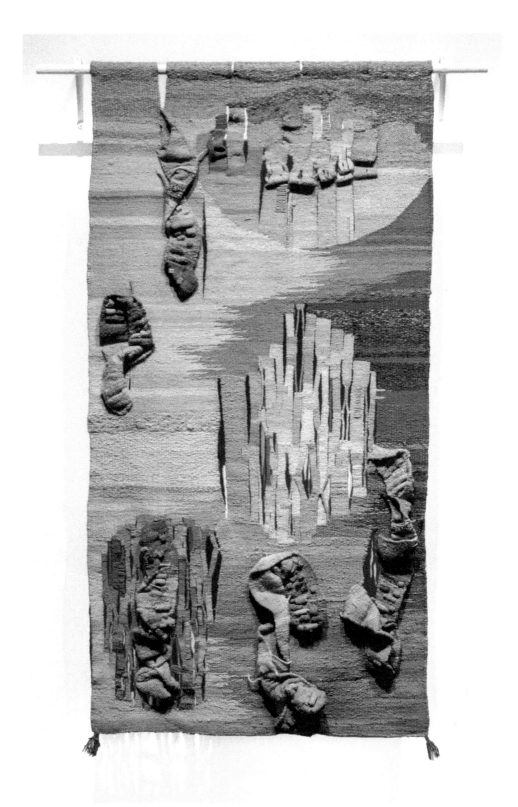

Margreet van Walsem,
Inside Out, 1977 (cat. 57)

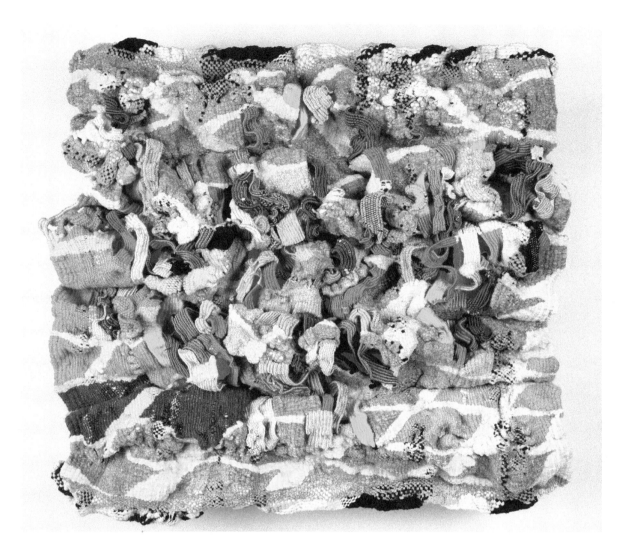

Jane Kidd, *Landslice #1*, 1988 (cat. 26)

Jane Kidd, *Landslice #1* (detail), 1988
(cat. 26)

Ann Newdigate, *Collage Preparatory Sketch For Wee Mannie,*
1980 (cat. 37)

Ann Newdigate, *National Identity, Borders and the Time Factor, or, Wee Mannie*, 1982 (cat. 38)

Pat Adams, *Remember That Sunset We Saw from Here One Time?*,
1984 (cat. 2).

Elaine Rounds, *Prairie Twill Seasons (Ode to Spring, Summer, Fall and Winter)*, 1985 (cat. 46)

an affinity for woven structures, Dickerson is deliberately anachronistic in her approach and utilizes these structures with startling fluency—the path of each yarn is a lexical gesture to be interpreted.

In 1977, Dickerson undertook her own handweaving revival project at the Alberta College of Art where she took over from F. Douglas Motter. At the time she was advised to rejuvenate the program, or it would be closed.[34] She would go on to teach weaving to many students in her thirty years at the institution, myself included. Throughout her career, Dickerson's research has focused on cloth structures and their relationship to making meaning in different cultures. A sabbatical in the mid-1990s found Dickerson on New Zealand's Te Ika-a-Māui / North Island, learning about *harakeke* (New Zealand flax) and Maori weft-twining techniques with weaver Eddie Maxwell.[35] More recently, Dickerson has investigated the particularities of the Flesberg weave structure,[36] a type of bound weave unique to her maternal ancestral homeland. Dickerson has shared her research broadly, publishing articles and monographs for the benefit of her students and colleagues.

Even in an art school setting like the Alberta College of Art, weaving curricula drew from technical source materials also referenced by weaving guilds or community workshops. Old-fashioned weaving drafts and loom set-ups circulated between students like recipe cards. *Craft Horizons,* with its focus on re-envisioning craft as art, was just as likely to be on a weaver's bookshelf as a copy of Mary Atwater's *Shuttlecraft Book of American Handweaving.*[37] What differed were the critical contexts in which

the weaving was conceived and shown. In addition, there was an implicit bias towards art making as opposed to practical weaving that persisted even in the mid-1990s. As a young weaver in my twenties, I made work for a gallery setting almost exclusively. The processes of weaving and its materiality were foregrounded as I aligned myself with post minimalism. Influenced by Jane Kidd, I also became deeply invested in textile history and the social history of weaving across different cultures. Considering myself an artist first, I confess that I did not weave a tea towel until I was forty-six years old but have always admired the weavers who did.

Immigrants to Canada brought with them textile traditions from Ukraine, Poland, Latvia, Lithuania, and Finland and provided another key influence on weaving across the Prairies. In *Prairie Interlace,* artists like Eva Heller (cat. 23), Inese Birstins (cat. 6), and Pirkko Karvonen (cat. 25) share their unique perspectives in woven form. Their works exhibit the dual influence of textile traditions and the revolutionary fibre art movement celebrated at the Lausanne Biennials. Pirkko Karvonen learned how to weave in Finland as a teenager. In the early 1970s she would return to Finland for a summer course to learn how to weave "the right way."[38] This she did in preparation to teach a weaving course for the Edmonton Public School Board's Extension Services and later weaving workshops around the province for Alberta Culture. Karvonen travelled with other Albertans to several World Craft Council Conferences and counts F. Douglas Motter as a colleague who supported and influenced her weaving.[39] She was also a founding member of the Hand Weavers, Spinners

and Dyers of Alberta and a past president of the Guild of Canadian Weavers.[40] When I first met the artist in 2021, we discussed her association with weaving guilds. Karvonen explained that it was not always a perfect fit as she questioned the rules for appropriate materials and conventions for finishing and displaying textiles.[41] At the same time it is very clear that she holds a profound respect for weavers of the past—especially weavers in her home country of Finland. Finnish textile artist Eva Anttila was a particular inspiration.[42] As a result of her broad knowledge of textile structures, Karvonen was able to develop a weft inlay technique with linen to produce a series of tapestries that feature grain elevators. For Karvonen, grain elevators were like the "cathedrals of the Prairie" and a symbol for industry and the persistence of agricultural industry. At the time she wove this series, grain elevators across the Prairies were being replaced by centralized depots. In a sense Karvonen felt as if she were acting to preserve the elevators.[43] The sensitivity with which the artist renders late summer light on the sun-faded paint of the elevators is remarkable. Her self-developed method using variable weights of dyed linen threads (some dyed with plants) allowed her to blend colours impressionistically, stranding multiple colours to get the particular result. In conversation with Karvonen, one gets the sense of an artist who remains intensely curious about the world around her. She is currently working to complete a book on Finnish mats based on her interviews with Finnish weavers about their rag rugs.[44] Like her contemporaries in *Prairie Interlace*, Karvonen has travelled and taught throughout her life in such places as

Pirkko Karvonen, *Grain Elevators*, c. 1985, Linen, 142 x 175 cm. Collection of The Glencoe Club, Calgary, Alberta. Photo: Andy Nichols, LCR PhotoServices.

Sweden, Denmark, Australia, and the United States[45]—metabolizing the influences of the fibre art she encountered along the way.

Ann Newdigate immigrated to Saskatchewan from South Africa in 1966 and completed a Bachelor of Fine Arts at the University of Saskatchewan in 1975. She credits Margreet van Walsem with introducing her to tapestry. Her fascination with Gobelin[46] tapestry persisted, and in 1981 she was granted funding by the Saskatchewan Arts Board (now SK Arts) to undertake a year-long course in tapestry at the Edinburgh College of Art, studying with Maureen Hodge and Fiona Mathison. It was here that she wove *National Identity, Borders and the time factor, or, Wee Mannie* (cat. 38). At this time the artist was engaged with interpreting the quick and free gestures of drawings with "the systematic quality of the tapestry process."[47] The tapestry department at the Edinburgh College of Art was founded

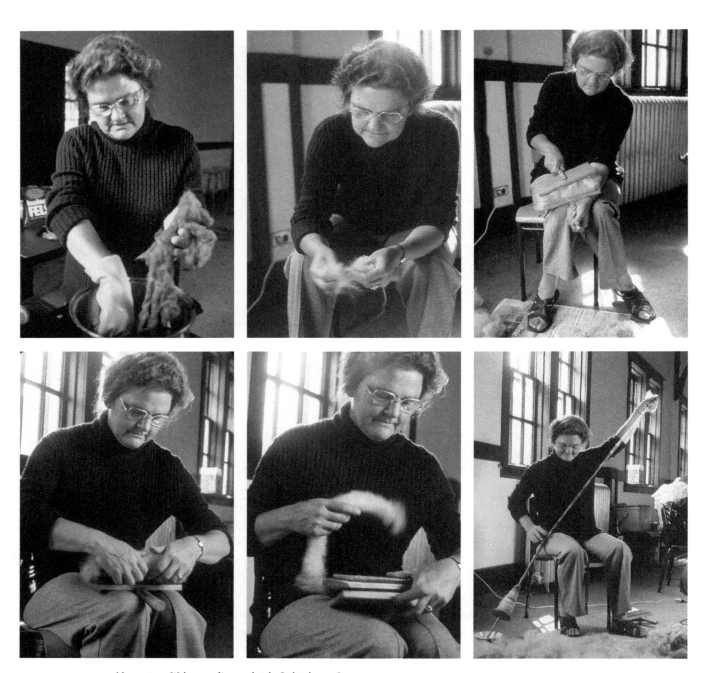

Margreet van Walsem carding wool at the Saskatchewan Summer
School of the Arts, Fort Qu'Appelle, Saskatchewan, 1973. Photos
courtesy of the Margreet van Walsem Estate.

by Archie Brennan, who was also the director of Dovecot, which produced tapestries in collaboration with artists like Louise Nevelson and David Hockney.[48] In this context, Newdigate became keenly aware of the interrelationship of craft, art, and the subordination of the tapestry artist—particularly women who work in tapestry—to those working in other media. In her 1986 MFA thesis "Love, Labour and Tapestry: Unravelling a Victorian Legacy,"[49] Newdigate examines the gendered boundaries of high and low art in the methodical manner one may imagine the artist weaves her tapestries. If we return to Glenn Adamson's notion of craft as a conceptual limit,[50] we may conjecture that Newdigate's work in tapestry traverses this boundary thread-by-thread as the artist continually redefines her position as a tapestry weaver in relation to dominant visual art forms. In *Then there was Mrs. Rorschach's dream/ You are what you see* (cat. 39) the artist intentionally enacts a painterly approach to tapestry with masterful blending of colour throughout. The work's title references Rorschach ink blots, wherein what one perceives reflects somehow on one's state of mind. However, in this case it is with Mrs. Rorschach that Newdigate contends. In her text from the exhibition *Look At It This Way,* Lynne Bell notes Newdigate's reference to Mrs. Rorschach and writes, "[w]ith the figure of Mrs. Rorschach, the artist points to the historian's neglect of both women and tapestry."[51] In this tapestry that imitates the painting (p. 158) while also referring to psychoanalysis, Newdigate calls attention to the viewers' own biases in relationship to what they perceive. Is it a painting or a tapestry? Of tapestry itself, Newdigate writes,

"The medium, belonging everywhere and nowhere, is everything and nothing. It is what you think, and it conjures what you don't know and can't remember—it has no certainty."[52] It would seem that for the artist tapestry is not only a *métier* but an unfixed form to which she may enmesh innumerable theoretical positions.

Like Ann Newdigate, Jane Kidd's trajectory as an artist parallels the shifts and changes in fibre art along with the rise of theories of craft and the handmade. In her own writing Kidd has articulated her commitment to tapestry and her belief in its potential as a contemporary form. She writes, "I have come to value the handmade as a human-centered activity and site for tacit knowledge, process as a means to reconnect skillful making with skillful thinking, time investment as a reflection of generosity and willingness to take care and pay attention."[53] Jane Kidd taught at the Alberta College of Art from 1980 until 2011. Taking care and paying attention are hallmarks of Kidd's approach to her work in tapestry and as an educator. As a tapestry weaver, Kidd has always been attuned to an international context. She describes her *Landslice* series from the late 1980s as transitional work in which she attempted to create woven work like Peter and Ritzi Jacobi or Sheila Hicks whom she admired.[54] *Landslice I and III* (cat. 26 & 27) in *Prairie Interlace* are artifacts from a series of experiments enacted on the tapestry form. Using a pulled-warp technique, Kidd added tension to what was initially woven as a flat piece. Strips woven with discontinuous weft are separated in places by slits in the web. By slowly and deliberately pulling and securing different warp threads,

Jane Kidd, *Land Sentence: Arbour*, 2009, woven tapestry: wool, cotton, rayon and silk, 81 x 203 cm. Collection of the Aberta Foundation for the Arts, 2009.057.001. Photo by John Dean and courtesy of Jane Kidd.

the artist created ridges and texture across the surface. By the intentional manipulation of warp threads, the transformed textile looks much like a landscape with furrows of scraped or plowed earth forced into sharp relief. In a medium intrinsically intertwined with historicism and allegory, Kidd evokes geologic time and the shifting of tectonic plates, all at a very small scale. These works reference earth and landscape without quite representing it.[55] In her long career following these experimental pieces, Kidd has produced entire bodies of work that ponder what it is to collect, to make things by hand—in essence, to be human. With her *Land Sentence* series begun in 2009, Kidd's focus turned to the impact humans make on the land itself. Referencing aerial and satellite photographs of ecological devastation, Kidd meticulously weaves patterns of drought and

deforestation at once beautiful and terrible. In her own words, Kidd uses "the slow and intimate process and flawed language of tapestry weaving . . . to refocus on our complicity in the sentencing of the world we live in." With *Inheritance,* a new series of sculptural tapestries woven between 2020 and 2022, Kidd continues her focus on our impact on the natural. Referencing the body with garment-shaped forms at the scale of children's clothing, Kidd personalizes the plight of the land, rendering its devastation intimate as we negotiate with ecological destruction on the horizon.

In Pat Adams' work, the horizon line is a literal focus for his woven abstractions of the Saskatchewan landscape. Pat Adams first encountered weaving in Halifax, taking extension courses at the Nova Scotia College of Art and Design in 1974. At the time Adams

was a professional working in community development. He was drawn to weaving as he felt it might give him a sense of finishing something in a more tangible way than he had experienced in his professional life.[56] He began weaving rugs in a set dimension, working out his designs in bands of natural, undyed grey wools. Interestingly, Adams deployed a strategy for composition in these pieces in which each grey shade was to be used once before repeating. He would write out a sequence in advance and then weave it. Using an algorithmic approach to composition, Adams was able to "take his perception out of it."[57] Although Adams claims to have ignored the art world intentionally,[58] it is compelling to consider how weaving lends itself easily to systems for composition used by contemporary artists. Adams' approach was not unlike those enacted by artist Sol LeWitt, whose "structures, based on squares and cubes, fabricated using industrial materials and processes, eliminated the hand of the artist through a rule- and system-based conceptual approach."[59] In his own community, Adams was an advocate for the crafts working for the Saskatchewan Craft Council and various other organizations including the Saskatoon Weavers and Spinners Guild. Commenting on the reception of his work Adams noted that the people who collected it were most often other craftspeople showing at the same craft shows who would buy the rugs using the money they had made at the shows.[60]

His weavings in *Prairie Interlace* are from a series of rug format pieces that capture a sense of shifting light on the horizon (cat. 1 & 2). Utilizing a pick-on-pick technique in which alternating wool yarns of different shades are passed across the warp, producing vertical bands of changing colour. Not unlike furrows of a cultivated field, the stripes in this work shift and change depending on the viewing angle. Devoid of figuration or landmarks, Adams' weaving is as much about light at a particular moment of time as it is about the land. There is something of the sublime here as one encounters the ephemeral, transitory nature of existence when faced with the vast Prairie landscape. It is a theme shared by weaver Elaine Rounds whose multi-panel work *Prairie Twill Seasons (Ode to Spring, Summer, Fall and Winter)*, (cat. 46) also takes advantage of the flatness of the weft line to enact a mimetic textile response to land and sky. In Adams' later work, a connection to the land would continue as he shifted to a weaving practice that connected him to his Métis culture. He learned to finger weave in the 1990s and later discovered that he could reproduce a Métis sash on the loom.[61] The Métis sash evolved from the traditional sashes of French Canadian and Indigenous hunters and trappers. Three metres in length, the sash had many practical purposes. "It was tied around the waist of the *capote*[62] for warmth and could also be used as a tumpline for carrying packs or as rope to haul canoes during a long and difficult portage. The sash also served as an emergency bridle when the Métis were out on the hunt."[63] Today, the sash has become a symbol for Métis identity, culture, and connection to the land. A specially commissioned Métis sash woven by Adams now sits alongside the official regalia of the Saskatchewan Legislature in Regina.[64] In both his weavings of the Prairie horizon and Métis sashes Adams says he is working

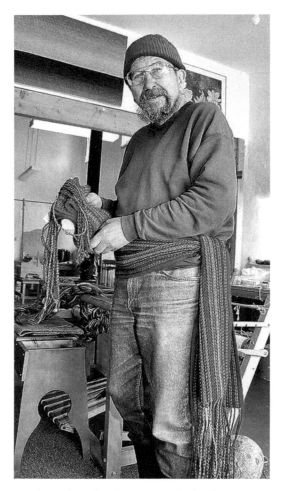

Pat Adams in his studio. Photo courtesy of Sask Valley News.

with identity.[65] To the weaver both applications of his weaving in art and for cultural regalia enmesh traditions with concept and personal expression.

I began this writing with the horizon as a metaphor for the perpetual negotiation between tradition and innovation undertaken by the artists of *Prairie Interlace*. The weavings of Pat Adams and Pirkko Karvonen are deeply rooted in the landscapes that inspired them and are nourished by textile traditions. Katharine Dickerson employs a complex lexicon of textile structure and pattern to speak to her personal lived experience. Tapestry artists Jane Kidd and Ann Newdigate have worked with a view towards the broader art world and their place in it, tackling complex ideas with discipline and intellectual rigour. Like the meandering threads in a handwoven tapestry each artist has taken their own path and committed to a *métier* uniquely suited to explore narrative, embody care for the world, and convey tacit, inherited knowledge. Whether the horizon is reached or not, it remains important. For, as Glenn Adamson writes, a horizon "is nonetheless intrinsic to any sense of position."[66] Or as my father, a man born and raised on the Prairie, has reminded me on more than one occasion, "If you go that way, you'll be over there."[67]

NOTES

1 Ann Newdigate, "An Essay," in *Annabel Taylor: New Works in Fibre*, exhibition brochure (Prince Albert, SK: Little Gallery, 1993).

2 Pat Adams, interview with Timothy Long, June 25–26, 2020.

3 In 1995 the institution was renamed the Alberta College of Art & Design and again in 2019 as the Alberta University of the Arts. https://www.auarts.ca/why-auarts/history-and-mission, accessed March 17, 2022.

4 Giselle Eberhard Cotton and Magali Junet, *From Tapestry to Fiber Art: The Lausanne Biennials 1962–1995* (Milan: Skira/Fondation Toms Pauli, 2017), 133.

5 The *fell* is the leading edge of handwoven cloth as it is woven on the loom.

6 Here I acknowledge the influence of queer theorist José Esteban Muñoz's conceptualization of queerness as an unreachable horizon in *Cruising Utopia: The Then and There of Queer Futurity* (New York: New York University Press, 2009), 2.

7 Here Glenn Adamson builds on Johanna Drucker's argument that Modern art is "an infinitely varied field defined by a series of contingent horizons." *Thinking Through Craft* (London: Berg/Victoria & Albert Museums, 2007), 2.

8 Elissa Auther, *String, Felt, Thread: The Hierarchy of Art and Craft in American Art* (Minneapolis: University of Minnesota Press, 2010), xxi.

9 A weaving draft is a kind of preparatory notation used in planning a piece of weaving. Atwater and other weaving educators popularized these drafts by reproducing them and sharing them with students.

Traditional weaving drafts continue to be revived in different ways in contemporary periodicals and guild newsletters. As such these relics of a colonial past persist in contemporary weaving practice.

10 The *Shuttlecraft Guild Bulletin* was initiated in 1924 and was published until the early 1950s. Atwater retired in 1947 but continued to contribute articles to the publication. http://www.mmawg.org/Bulletin.htm, accessed March 18, 2022.

11 David and Peggy Leighton, *Artists, Builders and Dreamers: 50 Years at the Banff School* (Toronto: McLelland & Stewart, 1983), 93.

12 A regular "Banff Report" was typically included in September issues of *Loom Music*. A design for "Peyto Lake" towels using the "M's and O's" structure featured pattern bands in turquoise, red, green, and grey in the November 1951 issue of *Loom Music*. Ethel Henderson and Mary Sandin, *Loom Music* (November 1951): 68–70.

13 *Anni Albers: Textiles* was first exhibited at the Museum of Modern Art in New York in 1949 and travelled to twenty-six museums in the United States and Canada. https://www.albersfoundation.org/alberses/chronology, accessed September 18, 2023.

14 Henderson and Sandin, *Loom Music* (April 1952): 24–28.

15 In her introduction to *From Tapestry to Fiber Art*, Janis Jefferies writes about Ruth Scheuing's observations regarding the Fibre Interchange at Banff and its impact on fibre art in Canada and internationally. Janis Jefferies, "Introduction," in *From Tapestry to Fiber Art*, 11.

16 Now the Alberta University of the Arts.

17 Jewellery, pottery, wood carving, and weaving are listed under "Craft Work (Special)" as topics for which a course may be requested in the 1932–33 Annual Announcement, for the Provincial Institute of Technology and Art in Calgary. It is also noted that "Students will be given every encouragement, and where possible a market will be found for their production," 61.

18 Mary Atwater was hired to establish the weaving program at the Banff School of Fine Arts in 1941 and taught with Ethel Henderson as her assistant. The following year Atwater decided not to return. By her account this was due to Canadian government's wartime rationing of gasoline and the fact that alternative travel was "uncomfortable and crowded." *Shuttlecraft Guild Bulletin* (July 1942), http://www.mmawg.org/Bulletin.htm. Another account of Atwater's reason for resigning is given in *Artists, Builders and Dreamers: 50 Years at the Banff School*. David and Peggy Leighton note that Atwater was "very concerned about her personal security, and it was rumored that she carried a revolver wherever she went." This was reported to have caused trouble at the border when Atwater crossed from her home state of Montana. "Faced with having to give up the gun or her teaching job at Banff, she chose to give up the latter," 93, 95.

19 *Calgary Herald*, "Weaving Instructor Retires," May 16, 1962, 43.

20 Motter also taught at the Banff School of Fine Arts in the 1970s. Brian Brennan, "Weaver's Life was a Rich Tapestry of Experience," *Calgary Herald*, December 9, 1993, B2.

21 Two of the earliest weaving guilds on the Prairies were founded by Ethel Henderson, who founded the Manitoba Branch of the Guild of Canadian Weavers in 1947, and Mary Sandin who formed the Edmonton Weaver's Guild in 1953. Joanne Tabachek, 1997, http://

www.mbweavers.ca/about-us/our-history/ accessed March 15, 2022; https://albertaonrecord.ca/edmonton-weavers-guild-fonds, accessed March 15, 2022.

22 https://www.thegcw.ca/about, accessed March 15, 2022.

23 Sandra Alfoldy, *Crafting Identity: The Development of Fine Craft in Canada* (Montreal and Kingston: McGill-Queen's University Press, 2005), 6.

24 Alfoldy, *Crafting Identity*, 7.

25 F. Douglas Motter and Margreet van Walsem have several students represented in *Prairie Interlace*.

26 Jane Kidd, interview with the author, March 1, 2022.

27 Margreet van Walsem took workshops with Jagoda Buic and Ritzi Jacobi in 1974, possibly at the World Congress of Craftsmen in Toronto.

28 Constantine and Larsen, *Wall Hangings*, 2.

29 Adamson, "Experiencing The Shock of the Old, Fiber Artists Rediscover Shows Like MoMA's Pivotal 1969 'Wall Hangings,'" *Art in America*, June 23, 2020, https://www.artnews.com/art-in-america/features/wall-hangings-moma-rediscovered-fiber-art-1202692079/.

30 Christa C. Mayer Thurman, "Else Regensteiner and Julia McVicker," *Art Institute of Chicago Museum Studies* 23, no. 1 (1997): 18–95, https://doi.org/10.2307/4104389.

31 Katharine Dickerson, interview with the author, March 11, 2022.

32 Dickerson, interview.

33 Katharine Dickerson, email to the author, March 16, 2022.

34 Dickerson, interview.

35 Katharine Dickerson, "Aho Tapu: The Sacred Weft," in *Craft Perception and Practice: A Canadian Discourse*, ed. Paula Gustafson, vol. 1 (Vancouver: Ronsdale Press, 2001), 162.

36 Katharine Dickerson, "Flesberg Bound Weave System," *Norwegian Textile Letter* 12, no. 2 (February 2006): 1–8, https://norwegiantextileletter.com/wp-content/uploads/2014/05/ntl12-2-1.pdf.

37 Originally published in 1928, the book was reprinted several times and re-issued as recently as 2008 with a special biography of its author included. Another of Atwater's influential publications was "Byways in Handweaving," which has taught many artists Central and South American techniques for band weaving. Drafts reproduced from this book appeared in photocopied handouts in Katharine Dickerson's 1994 weaving class in which the author learned to weave.

38 Pirkko Karvonen, interview with Julia Krueger, September 7, 2021.

39 Karvonen, interview.

40 Pirkko Karvonen, email to the author, March 3, 2022.

41 Pirkko Karvonen, interview with the author, December 4, 2021.

42 Karvonen, interview.

43 Pirkko Karvonen, interview with the author, March 15, 2022.

44 Karvonen, email.

45 Karvonen, email.

46 Gobelin tapestry refers to a style of tapestry woven in Gobelin, France, popularized by such artists as Archie Brennan. Often referred to as upright or "high warp" tapestry.

47 Ann Newdigate, "Tapestry, Drawing and a Sense of Place," in *Ann Newdigate: Tapestry, Drawing and a Sense of Place*, exhibition catalogue (Regina: Norman Mackenzie Art Gallery, 1982), 5.

48 Newdigate, "Tapestry, Drawing and a Sense of Place," 5

49 Ann Newdigate, "Love, Labour and Tapestry: Unravelling a Victorian Legacy" (master's thesis, University of Saskatchewan, 1986).

50 Adamson, *Thinking Through Craft*, 2.

51 Lynne Bell, "Look At It This Way," in *Ann Newdigate Mills: Look At It This Way*, exhibition catalogue (Saskatoon: Mendel Art Gallery, 1988), 4.

52 Ann Newdigate,"Kinda art, sorta tapestry: tapestry as shorthand access to the definitions, languages, institutions, attitudes, hierarchies, ideologies, constructions, classifications, histories, prejudices and other bad habits of the West," in *New Feminist Art Criticism: Critical Strategies*, ed. Katy Deepwell (Manchester: Manchester University Press, 1994), 174

53 Jane Kidd, "To Practice in the Middle," 2008, http://www.janekidd.net/?pageid=07 accessed March 18, 2022.

54 Jane Kidd, interview with the author, March 1, 2022.

55 A parallel may be found in the work of Eva Hesse whose sort of abstraction Elissa Auther characterizes as "highly allusive without being symbolic." Auther, *String, Felt, Thread*, 73.

56 Adams, interview.

57 Adams, interview.

58 Adams, interview.

59 Kirsten Swenson, *Irrational Judgments: Eva Hesse, Sol LeWitt, and 1960s* (New York and New Haven, CT: Yale University Press, 2015), 4.

60 Adams, interview.

61 Adams, interview.

62 A *capote* is a thigh-length winter coat worn by Métis men.

63 Louise Vien and Lawrence Barkwell, "History of the Metis Sash," 2012, 6, https://www.metismuseum.ca/media/document.php/14789.History%20of%20the%20Metis%20Sash.pdf, accessed July 31, 2022.

64 John Lagimodiere, "Metis Sash at Home in the House," *Eagle Feather News*, December 2010, 1.

65 Adams, interview.

66 Adamson, *Thinking Through Craft*, 2.

67 Ed Frère.

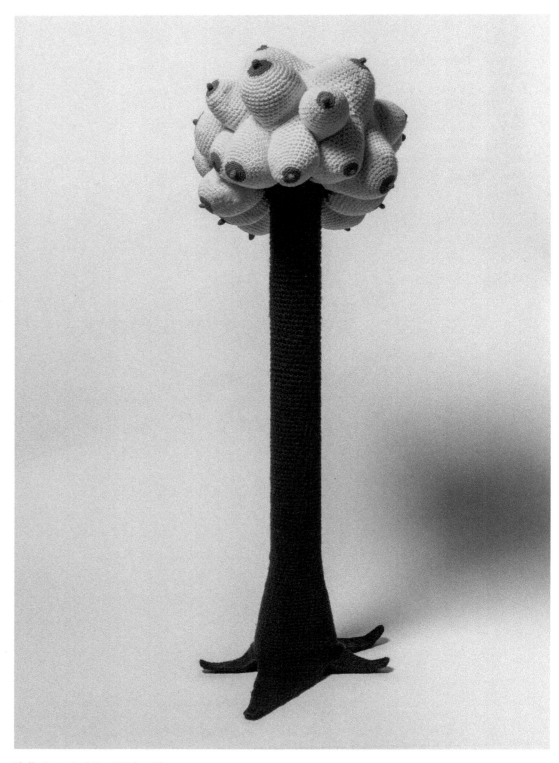

Phyllis Green, *Boob Tree*, 1975 (cat. 18)
Image courtesy Winnipeg Art Gallery. Photo: Ernest Mayer.

Contextual Bodies: From the Cradle to the Barricade

by Mireille Perron

A crocheted tree with boobs, an interspecies "beasty," two activist hooked rugs, a macramé conjuration by a Welsh enchantress, a modernist weaving of birthing, and three intertextual tapestries manifest the prevalence of the body and importance of feminism in Prairie textile practices. The latter half of the 20th century witnessed a vast expansion of Feminist and Craft practice, theory, criticism, and curatorial methods.[1] While many artists in *Prairie Interlace: Weaving, Modernisms, and the Expanded Frame* identify or identified as textile or fibre artists, and as feminists, not all do or did. These divergences reflect a textile and/or feminist identity navigating an artistic and social space where the very notion of identity was being questioned.[2]

Phyllis Green wears with confidence many hats. An early feminist, she is a celebrated mixed-media sculptor with a keen knowledge of fibre and ceramics. *Boob Tree*, 1975 (cat. 18), was a breakthrough for the twenty-four-year-old art student. Green recalls:

> I had loved making things for as long as I can remember, but I was astonished when my sculpture *Boob Tree* was accepted for inclusion in the exhibition *Woman As Viewer* at The Winnipeg Art Gallery in 1975. It was the first juried show that I had entered. A few months earlier, I had carried my art piece into the yard of my rented apartment in Vancouver, loaded my 35mm camera with Kodachrome film, and shot my first slides. I identified as a feminist, but not as an artist. I was too shy to travel to the opening, but I enjoyed from afar the stir that the exhibition, and my entry in particular, created.[3]

Boob Tree is a crocheted palm tree with pink breasts and crimson nipples. It was selected as the poster image for the all-female survey organized by The Committee for Women Artists at the Winnipeg Art Gallery. The exhibition was a feminist riposte to the in-house exhibition *Images of Women*, ostensibly celebrating the International Women's Year but dominated by images of women created by men.[4] *Boob Tree* encapsulates many feminist strategies of the time. It invalidates the modernist canon of abstraction by being figurative. Using crochet, it ironically

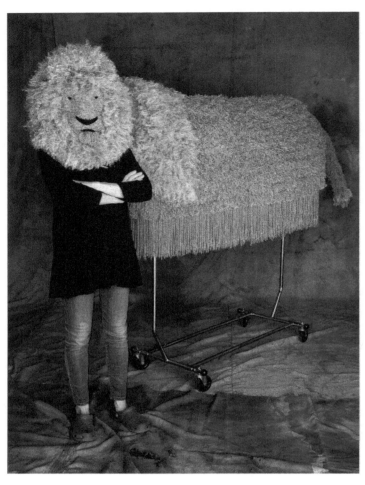

Phyllis Green, *Lion/Lamb*, 2020, steel, resin, fiber, 177.8 x 271.8 x 91.4 cm. Photo by Ave Pildas and courtesy of Phyllis Green.

expands the modernist tenet of experimenting with materials and forms, and playfully reclaims female anatomy, while parodying masculine tropes. It absurdly exaggerates the western view of nature as female. *Boob Tree* is the precursor of Green's multifarious self, where she performs in hybrid fibre constructions to produce contextual subjectivities.

She makes a comparison with *Lion/Lamb*, 2020.

> Though more than forty years separate the completion of *Boob Tree* and *Lion/Lamb*, years in which my technical skills increased and my career as an artist and teacher developed tremendously, I find similarities between the two sculptures. Both are inspired by objects in the natural world and both appear as constructions of fiber, establishing their relationship to craft.[5]

Maija Peeples-Bright crocheted *Sunny Snail Woofish*, 1970 (cat. 41), a cross between a fish, a snail, and a dog, as one of her many "beasties." Her other crocheted "beasties," dresses, sweaters, and cardigans share non-hierarchical titles and are simply referred to as *Knits* followed by a number.[6] When Peeples-Bright wears her textile creations, she integrates fully her exuberant zootopias: her reality is a matter of worlding and inhabiting the worlds she creates. Kathleen Stewart's definition of worlding refers to the "affective nature" of the world in which "non-human agency" comprising of "forms, rhythms and refrains" reaches a point of "expressivity" for an individual and develops a sense of "legibility."[7] Donna Haraway describes "companion species" as engaged in relentless processes of "becoming with" a world in which "natures, cultures, subjects and objects do not preexist their intertwined worldings."[8]

Peeples-Bright specifies: "Beasties are EWEniversal ambassadors of interspecies & stellhare selections, who create a world without judgement." She also declares that "Godliness is next to Woofiness."[9] Woof W.

Woof, a shaggy black cocker-dachshund, made regular appearances, starting in 1968, in a fresco in *The Rainbow House*, the home Peeples-Bright shared with her husband, David Zack, in San Francisco.[10] Woof notably provided the artist with a surname, between changing her name for her husbands' names (three times). A founder of Nut Art, Peeples-Bright fully incarnates its belief in creating phantasmagorical and humorous worlds reflective of the artist's idiosyncrasies. Even if she was the only female founding member in a group of white male artists, she sees herself as "Totally UN-Political."[11] Nut tenets invalidate identity politics (most notably gender, race, and class) by claiming a position beyond hierarchies.

Nevertheless, the artist's persistent celebration of decoration, ornament, and domesticity deviates from Modernism and its negative association with the feminine. Miriam Schapiro's notion of *Femmages* would help to better situate Peeples-Bright's paintings as textile collages or as paintings of sewn objects. "Femmage," or feminist/female collage, was defined as an activity "practiced by women using traditional women's techniques to achieve their art—sewing, piecing, hooking, cutting, appliquéing."[12] *Femmages* undermine art hierarchies through domestic strategies very often used by Peeples-Bright. Haraway's question, "Whom do we touch when we touch a dog? How does this touch shape our multi-species world?" seems to be addressed by Peeples-Bright's crocheted *Sunny Snail Woofish* (cat. 41).[13]

Sunny Snail Woofish shares with Green's *Lion/Lamb* a concern with how humankind can understand differently relationships with non-human animals. The former performs

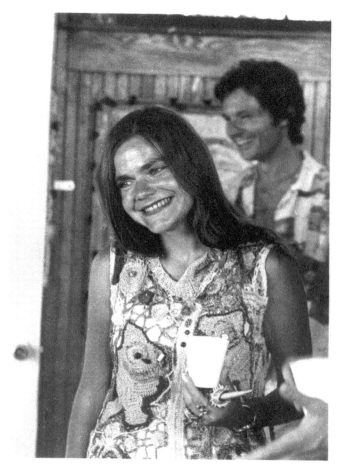

Maija (Peeples-Bright) Woof at the opening of her exhibition at The Candy Store Gallery, Folsom, California, 1971. Photo by Tom Rippon and courtesy of Parker Gallery.

cross-breeding among non-human species, while the latter enacts a more profound métissage; Green becomes the *Lion/Lamb* when she puts on the wearable sculpture.

Nancy Crites is a recognized fibre artist who has lived in many Prairie locations, including Edmonton, Saskatoon, Regina, Prince Albert, and now Calgary. She inherited her passion for textile practice from her mother, who taught her knitting, sewing, and embroidery at an early age.

Nancy Crites, *Threshold: No Laughing Matter* (current state), 1991 (cat. 9). Photo by Don Hall.

It was through an extension class with Pirkko Karvonen that she first learned to weave while at the University of Alberta. For multiple years, Crites participated in the summer workshops at the University of Saskatchewan's Kenderdine Campus located at Emma Lake, and she also attended the Saskatchewan Summer School of the Arts in the Qu'Appelle Valley.[14] Crites lived in Prince Albert in the 1980s where she was an active member of the arts community, including the Prince Albert Weavers and Spinners Guild, a lively and supportive society with amazing facilities and equipment. The back-to-the-land ethos of the times promoted self-reliance and self-sufficiency, which included learning all processes linked to weaving such as shearing, carding, spinning, and dyeing wool.[15] She credits her artistic development to individual artist grants from the Saskatchewan Art Board (now SK Arts). The late Jane Turnbull Evans of the Saskatchewan Arts Board was a strong

influence on Crites' development as an artist which saw her move from traditional fibre methods to employing found objects as well as mylar, ribbon, wood, metal, and paper in her weavings.[16]

Threshold: No Laughing Matter, 1991 (cat. 9), and is a hooked rug composed of latex condoms that was made in response to the AIDS epidemic. Crites, a self-taught rug hooker, created it as a conceptual "welcome mat"; it was exhibited the same year at the Mendel Art Gallery in Saskatoon as part of an all-female exhibition titled *Laughing Matters.*[17] Now in the permanent collection of SK Arts, it is accompanied by a second welcome mat titled *Threshold: No Laughing Matter II,* 2022 (cat. 10), which was donated to SK Arts as a companion to the more ephemeral latex version. Both rugs share a similar design, but the materials differ and dictate a shift in content. Made during the COVID-19 pandemic, the second welcome mat is hooked using natural, traditional materials: wool, silk, and mohair. If both mats address welcoming as a concept that implies respecting personal space, they differ in how they convey the effect of uncertain times. During the 1990s AIDS epidemic, Crites was a mother of pre-teens. She recruited them by asking them to unwrap and wipe the blue and pink condoms. This maternal hands-on teaching ensured that her children would be comfortable with condoms in the context of sexual security and self-respect when it came to sexuality.[18] During the COVID-19 pandemic, Crites came to the conclusion that to be a relevant update her companion version of the condom rug needed to stand the test of time and be more publicly accessible. Welcoming is fraught with difficulties

during our era of pandemic uncertainty; Crites believes that stability and care are what we need.[19] Like her welcome mats, Crites' recent rugs favour "schematic, symbolic and simplified imagery to tell a story."[20]

Cindy Baker is a performance and interdisciplinary artist, LGBTQ2+ and fat activist, university art teacher, and cultural worker with a love, since her childhood, for all that is crafted. In all her work, she excels in skewing/queering contexts to allow for deviations from social norms that expand identity politics. All materials and techniques in Baker's practice are performative.[21] *I know people are stealing my things*, 1998 (cat. 4), is part of a larger series of latch-hook *Welcome Mats* for those who are not necessarily welcome. The artist explains:

> While traditional rug hooking enjoys a position of honour among traditional craft forms, latch-hooking as an activity (as well as the finished product) for the most part is seen by the craft and mainstream communities as an amateur form evocative of a 1970s aesthetic. It is actually for these reasons that I am attracted to latch hook; the potential for emotional and aesthetic baggage carried by the medium itself is the perfect platform for my work. It is a craft form within the field described by the artist and cultural theorist Allyson Mitchell as "abandoned craft," and as such, most of the materials for these works have been found in secondhand shops and at garage sales.[22]

Cindy Baker, *Don't Open the Knife Drawer*, 2017. Photo courtesy of Cindy Baker.

The pseudo-paranoid voice in *I know people are stealing my things* is a precursor to *Don't open the knife drawer*, her ongoing series of etched knives warning the viewer not to open the knife drawer after the fact.[23] Both series create what Claire Bishop describes as "relational antagonism" in which the impetus for transformation is provoked by unease and sustained tension, leading to negotiation, thus defining democratic spaces.[24] Baker queers materials, processes, and contexts to shift meaning through unease and to reveal another possibility of being. Using the latch-hook grid, more suitable to symmetry, she imposes a handwritten text with a careless slant; this intervention on the modernist grid effects an inescapable change.[25] The artist accumulates deviations from modernist canons, not only through the use of hobby crafts but by adding text. Using text is antithetical to art for art's sake, the modernist motto that, among many things, invalidates body and identity politics.[26]

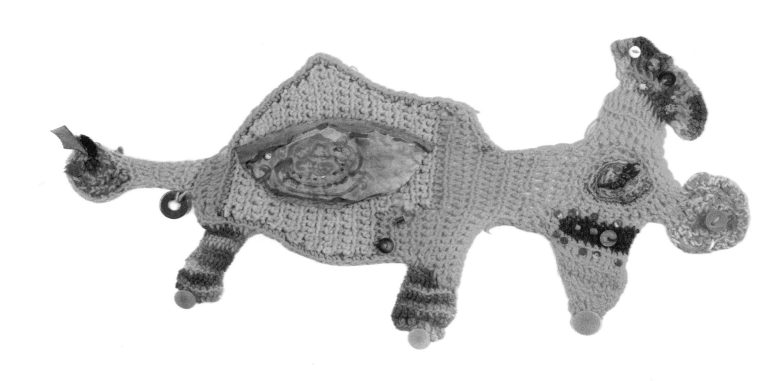

Maija Peeples-Bright, *Sunny Snail Woofish*, c. 1970 (cat. 41)

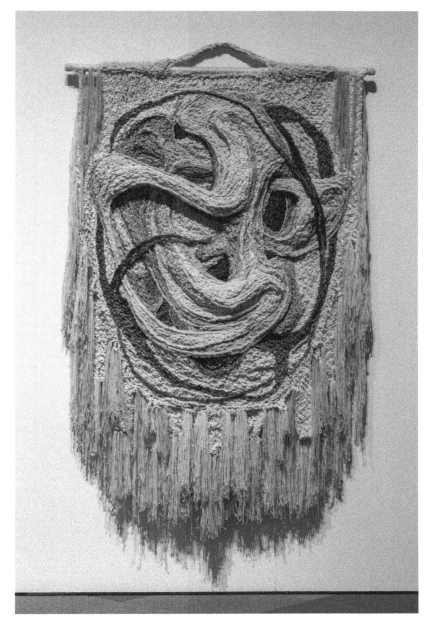

Jane Sartorelli, *Cerridwen*, c. 1975
(cat. 50)

Jane Sartorelli, *Cerridwen* (detail), c. 1975
(cat. 50)

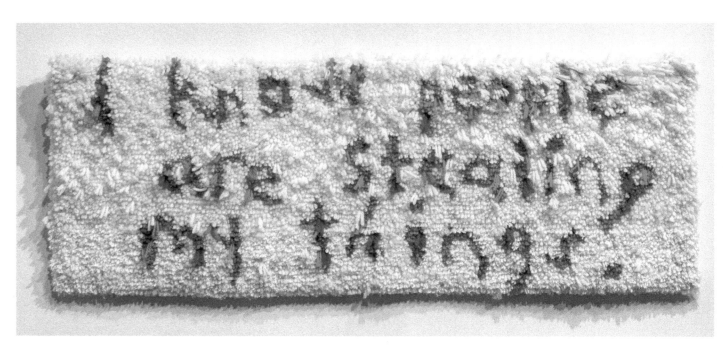

Cindy Baker, *I know people are stealing my things*, 1998 (cat. 4)

Nancy Crites, *Threshold: No Laughing Matter II*, 2022 (cat. 10)

Nancy Crites,
*Threshold: No
Laughing Matter*,
1991 (cat. 9) Image
courtesy of SK Arts.

Many artists engaged in craft express a pervasive social commitment. By making rugs with an activist intent, both Crites and Baker critically activate the potential of domestic textiles to explore relationships between handmade and body politics.[27]

Jane Sartorelli's *Cerridwen,* 1975 (cat. 50) takes its title from the Welsh enchantress of the same name. Sartorelli studied anthropology, a field of study that might account for her attraction to understanding belief systems across cultures. Cerridwen is the goddess of rebirth and transformation, and her cauldron signifies knowledge and inspiration.[28] I envision Sartorelli as one of Cerridwen's descendants; the attributes of invention and transformation distinguished her fibre practice. Sartorelli invented her own material practice. In 1971 she began to experiment with cloth cards and yarns in the construction of large wall hangings in high relief.[29] A variation on macramé, her new language transformed ways of tying, wrapping, knotting, weaving, binding, and braiding: old stories were made anew by her novel manipulation of fibre. Sartorelli reclaimed mythology and artmaking as processes of "becoming" through transformative states. In a similar vein, feminist witchcraft has reclaimed the figure of the witch as a positive symbol of suppressed female knowledge, power, and independence.[30] *Cerridwen* is an impressive wall hanging that reads as a larger-than-life-size mythological being in a womb. Or is it a mask? Or an abstract jumble of lines and tubular fibre forms? However, all possibilities recall the Goddess' myths; from ingesting a being to create another, to her ability to shape-shift into various animals, to brewing life-altering potions.

Margreet van Walsem had a short but prolific career as a fibre artist, cultural and craft advocate, and teacher.[31] Ann Newdigate recalls: "What Margreet taught was absolute professionalism. . . . She demonstrated that within the pleasure and sensuousness of the medium resides a very serious time-honoured pursuit."[32] Originally from the Netherlands, van Walsem came to Canada in 1956 with her husband Jan van Walsem and a young son. It is in Saskatchewan that her career as an artist began when she was forty-six years old. Her first foray into textiles was with batik, followed by weaving. Van Walsem embraced and taught all aspects of the medium from carding, spinning, and dyeing from natural sources, to constructing "primitive" looms, before finally weaving.[33]

One tenet of Modernism is "truth to materials." The return to natural materials was textile's modernist equivalent, while controlling one's means of production extended the artist's agency. In 1996, the Prince Albert Spinners and Weavers Guild created a collaborative tapestry to honour the life and work of Margreet van Walsem and Kate Waterhouse (cat. 40).[34] The celebratory tapestry was made with natural hand-dyed fleece resulting from the numerous experiments left behind by each weaver. Waterhouse and van Walsem were extensively known throughout Saskatchewan for their natural dyeing processes. They both taught spinning, dyeing, and weaving. Van Walsem contributed to the progress of Waterhouse's book about her experiments (cat. 58).[35] The act of caring about materials and processes linked to nature generated a new form of consciousness: "Weaving involves a sense of harmony and rhythm—one's understanding

and use of time changes, when trying to find the essential link with growth and decay, light and darkness, sun and rain, warmth and coldness."[36] Van Walsem's tapestries indicate a strong relationship between working with the land as a journey into self-reliance.

Van Walsem's practice also exemplified what craft theorist Peter Dormer describes as "a workmanship of risk": a process that celebrates variations every step of the way.[37] By 1973, when van Walsem made a study trip to the Lausanne International Tapestry Biennial, fibre art had generated many new directions. As Dormer notes, new possibilities in weaving "go back to very ancient techniques used by Peruvian and Pueblo, Egyptian and Eastern European weavers, and inspire limitless possibilities and special qualities in modern work."[38]

Birth, 1971 (cat. 56), is exemplary of the artist's themes and modernist designs.[39] Van Walsem states: "Legends are important, as are old sayings, embodying old truths. It also involves being surprised with and wondering about familiar things: birth, death, dance, giving, taking, justice and injustice."[40] *Birth* is quintessentially modernist in its rejection of a realistic depiction and tendency to abstraction with its reductive, flat shapes, expressive, sleek, clean, simplified lines, and natural colours that emphasize the surface. Conversely, *Birth* is a feminist view of childbirth in its exploration of vaginal imagery, the naked goddess figure, and material defiance. *Birth* is a public representation of birthing as an imaginary female construct that makes the mother and child equivalent partners in action. Both figures slip off the modernist flat picture plane screaming with wide-open mouths.

Margreet van Walsem, *Birth,* 1971 (cat. 56) Image: Michele Hardy.

Ann Newdigate, *Then there was Mrs. Rorschach's dream*, 1988, watercolour crayon, acrylic on canvas, 182 x 93 cm. SK Arts Permanent Collection, 2000-004. Photo by Don Hall.

Ann Newdigate, *Then there was Mrs. Rorschach's dream/ You are what you see* (detail), 1988 (cat. 39)

Ann Newdigate, *Then there was Mrs. Rorschach's dream/ You are what you see* (detail), 1988 (cat. 39)

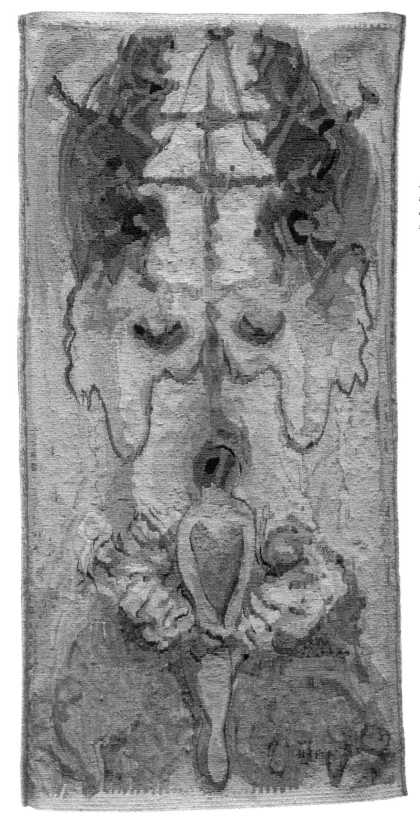

Ann Newdigate, *Then there was Mrs. Rorschach's dream/ You are what you see*, 1988 (cat. 39)

Sartorelli and van Walsem opted for weaving and a "workmanship of risk" in order to assert birth-giving as metaphorically equivalent to the women's creative process. Both precede Judy Chicago's acclaimed *Birth Project*, 1980–1985, in which the birthing process is likewise seen as a metaphor for creation. Chicago enlisted the domestic textile practice of needlepoint with over 150 needleworkers stitching her wide-ranging images of birth.[41]

Joan Borsa asks, "How do we make space for stories and lives for which the central interpretative devices of the culture don't quite work?"[42] Ann Newdigate's practice makes that space primarily through weaving tapestry. She states, "I work in tapestry primarily for its materiality and its capacity to shift within traditions, to shuttle between theoretical positions, to hover around borders, to challenge hierarchies, and to connect with many different resonating imperatives."[43] In particular, Newdigate's tapestry and preparatory sketch titled *National Identity, Borders and the Time Factor, or, Wee Mannie*, 1982 (cat. 38 & 37), illuminates the artist's investigations.[44]

> With assistance from the Saskatchewan Arts Board, I was able to spend an intensive year at the Edinburgh College of Art working with Maureen Hodge and Fiona Mathison. Through my self-directed studies, and from many catalogues, I had realised that this was, at the time, the only place to study tapestry within the rigorous dictates of a contemporary art school. I needed to learn to translate my drawings on paper into tapestry with enough accuracy to satisfy myself.[45]

The tapestry and drawing are heavily layered surfaces. Newdigate's layering makes apparent the ways in which official history layers over other stories and their voices. The haunting figure of Louis Riel inhabits the scene. The Métis leader was hung for treason but later revered. This interest in layering multiple voices favours a feminist stance outside binary configurations, one that favours conflicting or unresolved voices and appeals to the body through its materiality. Mary Scott's *Imago* series shares the exploration of transient bodies and locations in a perpetual state of becoming (cat. 52). Scott's unraveled silk presents frayed and shredded surfaces that invoke the impossibility of locating unconscious, idealized psychological constructions.

Newdigate has always been aware of coming from there (South Africa) and living here (Canada). The need to shift, shuttle, and hover around borders and margins are states of being she expresses through a medium that embeds similar paradoxes and ambiguities. Newdigate, like Scott, weaves the possibilities of being in transit or existing in between states.[46]

Then there was Mrs. Rorschach's dream/ You are what you see (cat. 39) is the third of seven tapestry panels titled *Look At It This Way*. It makes a parallel between the invisibility of Mrs. Rorschach and Tapestry in official history.[47] Based on the Rorschach inkblot test, it conveys "that tapestry as a medium acts as a projective test producing different reactions in different people depending on the presuppositions they brought to the work."[48] Ann Newdigate explains:

Having become aware of the way in which a medium or process affects readings of visual art, I decided to make a series that would be an intervention in the dominance of painting conventions. Each work had two titles. The first title addressed the initial response of the viewers on seeing the work installed in a gallery, and the second echoed the adjusted reception that was made on realising that the images were in a woven form.[49]

To conclude, a feminist crocheted tree with boobs, a Nut Art interspecies "beasty," two activist hooked rugs, a macramé conjuration by a Welsh enchantress, a modernist weaving of birthing, and three intertextual tapestries interlace Prairie textile to body politics. These works are or were a material manifestation of a desire for connections, smooth or snagged. They took up modernist key gestures such as truth to materials and abstraction, and intertwined activist, affective, poetic, and aesthetic purposes to suggest how textiles can be used to advance a political agenda as well as to make material engagement synonymous with community participation. In every act of making there is an expectation for meaning, but it is rarely an explanation or a proposition. At best, it is an insinuation that opens up a space for complicity, contrast, equivalence, confirmation, or conflict. These textile works invented new interpretative devices to foretell other ways to tell stories, lives, subjectivities, and bodies from the cradle to the barricade.

NOTES

1 To mention just one unique feminist Prairie collective, see MAWA (Mentoring Artists for Women's Art) https://mawa.ca, and for textiles the many Prairie Weavers and Spinners Guilds; The Prince Albert Weavers and Spinners Guild is credited by Nancy Crites, Margreet van Walsem, and Ann Newdigate.

2 *Textiles sismographes : Symposium fibres et textiles 1995* (Montreal: CATQ/Conseil des arts textiles du Québec, 1995). Of note, intersectional feminism, a term coined in 1989 by Kimberlé Crenshaw, was not yet part of the discourse for most of the selected artists.

3 Phyllis Green, email to the author, March 22, 2022.

4 Doug Harvey, "The Contrarian's Engagement: Current Figuration in the Art of Phyllis Green," *Border Crossings* (December 2018): 54–59.

5 Green, email.

6 *Maija Peeples-Bright/Sam Spano: Dinner for Two*, Guerrero Gallery, Los Angeles, January 20–February 17, 2018, https://www.guerrerogallery.com/maija-peeplesbright-sam-spano.

7 Kathleen Stewart, "Worlding Refrains," in *The Affect Theory Reader*, ed. M. Gregg and G. Seigworth (London: Duke University Press, 2010), 339–53.

8 Donna Haraway, *When Species Meet* (Minneapolis: University of Minnesota Press, 2008).

9 Maija Peeples-Bright, *Maija Peeples-Bright: beautiFOAL*, exhibition catalogue (Los Angeles: Parker Gallery, 2020).

10 Peeples-Bright, *beautiFOAL*.

11 Julia Krueger, "A Feminist Lens on Six Female Ceramists in Regina," in *Regina Clay: Worlds in the Making*, ed. Timothy Long (Regina, SK: MacKenzie Art Gallery, 2005).

12 Miriam Schapiro and Melissa Meyer, "Waste Not Want Not: An Inquiry into What Women Saved and Assembled—FEMMAGE," *Heresies* 1, no. 4 (Winter 1977–78): 66–69.

13 Haraway, *When Species Meet*.

14 Nancy Crites, telephone conversation with the author, April 2022; and email to the author, May 12, 2022. It was in these sessions that she mentored with artists such as Judith Mackenzie and Jane Kidd (also in this exhibition), Deborah Forbes, George Glenn, Martha Townsend, Joan Borsa, and Richard Gorenko.

15 Crites, telephone conversation and email.

16 Crites, telephone conversation and email.

17 Crites, telephone conversation and email.

18 Crites, telephone conversation and email.

19 Crites, telephone conversation and email.

20 Nancy Crites, artist's website, https://nancycrites-fibreartist.com. Note: She designs these narrative rugs herself and at times in collaboration with her husband, the artist Richard Gorenko.

21 Cindy Baker, artist's website, http://www.populust.ca/cinde/wp/2009/05/bait/.

22 Cindy Baker, artist's website.

23 Cindy Baker, artist's website.

24 Claire Bishop, "Art of the Encounter: Antagonism and Relational Aesthetics," *Circa*, no. 114 (2005): 32–35, https://doi.org/10.2307/25564369, accessed May 3, 2022. Ted Hiebert needs to be credited for this reading of Baker's work. Ted Hiebert, "Introduction," in *Casual Encounters: Catalyst: Cindy Baker*, ed. Ted Hiebert (Victoria, BC: Noxious Sector Press, 2021). This publication is also highly recommended for an informal biography of the artist and her work.

25 Baker, artist's website. Note: in her famous essay "Grids," Rosalind Krauss explains: "Yet it is safe to say that no form within the whole of modern aesthetic production has sustained itself so relentlessly while at the same time being so impervious to change." Rosalind Krauss, "Grids," *October* 9 (1979): 51–64, https://doi.org/10.2307/778321.

26 "Art for art's sake," *Encyclopedia Britannica*, January 23, 2015, https://www.britannica.com/topic/art-for-arts-sake.

27 Anthea Black and Nicole Burisch, *The New Politics of the Handmade: Craft, Art and Design* (London: Bloomsbury Publishing, 2020).

28 "Ceridwen," Wikipedia, https://en.wikipedia.org/wiki/Ceridwen.

29 Candas Jane Dorsey, "Textures of Her World: The work of fibre artist Jane Sartorelli," exhibition catalogue (Edmonton: Lefebvre Galleries, 1983).

30 Wendy Griffin, "The Embodied Goddess: Feminist Witchcraft and Female Divinity," *Sociology of Religion*, 56, no. 1 (1995): 35–48, https://doi.org/10.2307/3712037, accessed May 3, 2022.

31 Margreet van Walsem had five exhibitions (two solos) from 1969 to 1979; made a study trip to Lausanne in 1973 for the 6th Tapestry Biennial; was one of the three delegates from Saskatchewan to the World Craft Conference held in Toronto in 1974; and taught numerous workshops and courses all over Saskatchewan. From Jan van Walsem's CD compilation "Margreet van Walsem Artist SK Canada 1969–79, 2006, Mann Art Gallery archives, Prince Albert, SK.

32 Ann Newdigate, "Weavings by Margreet van Walsem," *The Craft Factor* (Saskatoon, SK) 4, no. 2 (June 1979); reprinted in n.paradoxa, online issue 4 (August 1997).

33 Jan van Walsem, CD compilation.

34 Ann Newdigate, "Kinda art, sorta tapestry: tapestry as shorthand access to the definitions, languages, institutions, attitudes, hierarchies, ideologies, constructions, classifications, histories, prejudices and other bad habits of the West," in *New Feminist Art Criticism: Critical Strategies*, ed. Katy Deepwell (Manchester: Manchester University Press, 1995): 174–181.

35 Jan van Walsem, CD compilation. See also Kate Waterhouse, *Saskatchewan Dyes: A Personal Adventure with Plants and Colours* (Prince Albert, SK: Write Way Printing, 1977), and the Waterhouse dye samples collection in this exhibition.

36 Marg Jasper, "Tapestries, Batiks reflect Nature," *Daily Herald* (Prince Albert, SK), December 2, 1974.

37 David Pye, *The Nature and Art of Workmanship* (Cambridge: Cambridge University Press, 1968).

38 Pye, *Nature and Art*.

39 It was exhibited in 1979 at the Norman Mackenzie Art Gallery in Regina in the solo exhibition, *Margreet van Walsem: Fabric Artist*. Jan van Walsem, CD compilation.

40 Jasper, "Tapestries."

41 "The Birth Project," Judy Chicago Research Portal: Learning, Making, Culture, https://judychicagoportal.org/projects/birth-project; and "Birth Project," Through the Flower, https://throughtheflower.org/project/birth-project/.

42 Joan Borsa, *Making Space*, exhibition catalogue (Vancouver: Presentation House, 1988).

43 Newdigate, "Kinda art, sorta tapestry."

44 It was exhibited in 1982–83 in the solo exhibition, *Ann Newdigate Mills: Tapestry, Drawings and a Sense of Place* at the Norman Mackenzie Art Gallery in Regina, and later toured Western Canada.

45 Ann Newdigate, "Edinburgh Work," artist's website, http://www.annnewdigate.ca/archives/pages/JOURNEY_details/Journey_2detail.html, accessed April 2022.

46 Newdigate, "CV/Bio," artist's website, http://annnewdigate.ca/cvbio/

47 Mrs. Rorschach was a practicing psychologist, just like her more famous husband, Swiss psychologist Hermann Rorschach, who gave his name to the inkblot test.

48 Lynne Bell, *Ann Newdigate Mills: Look At It This Way*, exhibition catalogue (Saskatoon: Mendel Art Gallery, 1988).

49 Ann Newdigate, "The Look At It This Way series," artist's website, http://annnewdigate.ca/archives/pages/JOURNEY_details/journey.html.

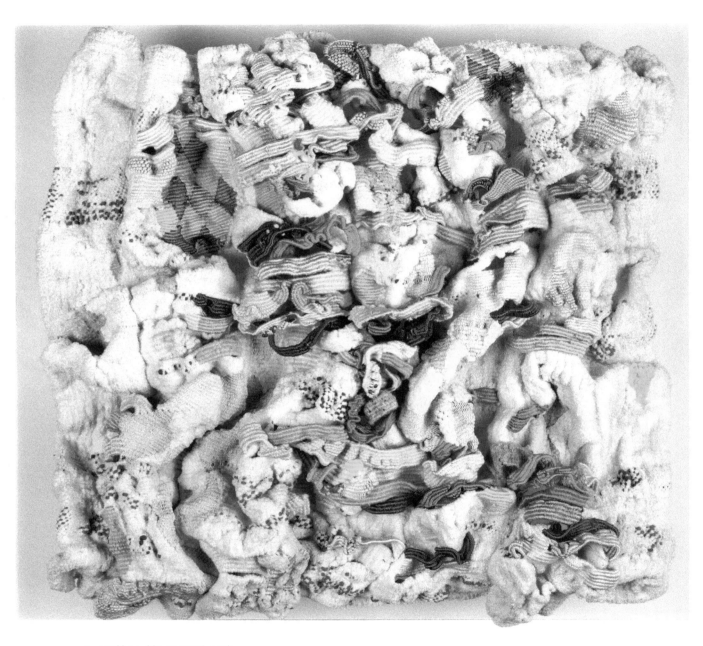

Jane Kidd, *Landslice* #3, 1989 (cat. 27)

Six Ways of Looking at *Prairie Interlace*

by Alison Calder

The View

> *Looking at wolf willow bloom,*
>
> *streaming through plushlands of scent towards the feeling of its yellow, self*
>
> *breaks up, flaring in stratosphere.*
>
> *Looking undermines us.*
>
> *The world and its shining can't hold our evaporating weight.*

<div align="right">TIM LILBURN, 2007, "HOW TO BE HERE?"[1]</div>

The Prairie landscape only looks like it would be easy to turn into art. Writers who first tried to use their imported English to describe the place ignored the Indigenous languages and knowledge that might have helped them to get their bearings. This alienation wove its way into the best-known Prairie realist novels, which were read, like the landscape itself, as being transparent or self-evident. Much writing from the Prairie provinces in the last fifty or so years has been engaged in the act of *un*writing. As Karina Vernon points out in *The Black Prairie Archives*, that Prairie literary history reflects a white settler/colonizer perspective is no accident.[2] I would add that it's also no accident that Prairie literary history largely reflects a view that the *raison d'être* of the Prairies is resource extraction, whether agricultural products, mining, oil, or even art. In this mindset, its value centres on its usefulness in the generation of wealth; land that cannot be exploited is a waste of space.

The works in *Prairie Interlace* interrupt this narrative of regional use-value, in terms of both place and art. As recent Prairie writing turns towards environmental awareness, deep history, and Indigenous knowledge, readers are invited to look again at a landscape taken

for granted. This looking, as Tim Lilburn writes, undermines us, unsettling ideas of ownership and mastery. So, too, viewers of *Prairie Interlace* are challenged by works like Pirkko Karvonen's *Rapeseed Fields* (cat. 25). Here the perspective is unexpectedly aerial: instead of seeing the usual horizon, we look down on a crop that spills out of its fields, swamping grid roads or tunneling beneath them. The piece's title invites speculation: in what ways is this a field? It has become a cliché to talk about a Prairie experience in terms of land and sky, but here the viewer may be actually *in* the sky, looking down on fields that can be experienced purely as shape and colour. The horizontal/vertical relation, emphasized in Henry Kreisel's oft-quoted vision of a "giant in the landscape" silhouetted against the sky,[3] is disrupted. Similar revisioning occurs in *Landslice #1* by Jane Kidd (cat. 26), which presents as a cross-section of soil, here constructed by pulling the warp threads after weaving to create a bunched fabric. If *Rapeseed Fields* takes the viewer above the earth, *Landslice #1* suggests a need to look below it. The colourful fabric, reading as scraps or discards even though it is one solid piece, serves an almost archaeological function, reminding viewers of the land's deep history as layers of human occupation are revealed. It also suggests a manufactured landscape, not only by showing a landslice that has been itself constructed, but also by presenting the spectacle of the artist's labour. While the labour that goes into farming, for example, is amply represented in canonical Prairie novels such as Martha Ostenso's 1925 *Wild Geese*,[4] the labour that goes into producing those novels is largely masked by the finished product. So, too, with domestic textile crafts, largely made by women, where the maker's time and skill are eclipsed by the use-value inherent in a product like a dishtowel or a pair of hand-knit socks. Through use, these products become ephemeral, and the labour held in rugs, clothing, blankets, towels, and even rags dissolves and disappears. In *Landslice #3* (cat. 27), the viewer is particularly confronted with "wasted" productivity, as Kidd's laborious action of pulling the warp threads transforms the flat woven textile into a sculptural art object. The *Landslice* pieces call into view multivalent questions about the relationship of settler/colonizer culture to the place, the cost to the earth of such settlement, the erasure of women's labour in home-making, and the need to engage in both literal and figurative excavations of buried history.

The Body

Let's stand up for breasts
any size, any colour,
breasts shaped like kiwi
* fruit,*
like mandolins, like pouter
* pigeons,*
breasts playful and shameless as
* puppies.*
Breasts that pop buttons,
breasts with rose tattoos.
Let's give them the vote.
Let's make them mayor for the
* day.*

LORNA CROZIER, 2009, "NEWS FLASH FROM THE FASHION MAGAZINES"[5]

Thus writes poet Lorna Crozier in an extract from "News Flash from the Fashion Magazines." Crozier's poem—playful, feminist, political, a little ridiculous—works with imagery and language to break the silence surrounding women's bodies and to highlight the ways in which the fashion industry, and capitalism in general, seeks to control them. Ostensibly a response to an article claiming that breasts are out of fashion, the poem has a sister expression in Phyllis Green's *Boob Tree* (cat. 18), where Crozier's description of breasts "shaped like kiwi fruit" are literalized in Green's sculpture. Like Crozier, Green makes breasts the centre of attention, turning them into fruit or leaves, both animating them and leaving them strangely unmoored. Disembodied, Green's crocheted breasts are shocking, but only because the cultural fixation on women's bodies is unmasked. Does Western culture treat women as boob trees? Where Crozier presents breasts as independent entities, giving them a parodic power—"Let's give them the vote"—Green's crochet treatment renders them curiously passive. At the same time, her use of crochet adds to potential scandal by linking a craft most commonly associated with grandmothers to an open sexuality. The cartoonish quality of Green's work, accentuated by her bright colours, suggests and comments on the juvenile nature of the male gaze—a gaze which, Crozier's poem points out, women also turn on themselves.

Concern with female identity links Green's fructified body to Aganetha Dyck's vertebral sculpture *Close Knit* (cat. 13). These felted sweaters are simultaneously different and the same, with their anthropomorphic attitudes suggesting that they're looking around curiously, perhaps crowded together for comfort—or because they're unable to leave. It's tempting to read into this piece the kind of exploration and exposé of Prairie Mennonite communities that poet di brandt undertook her 1987 *questions i asked my mother* or novelist Miriam Toews showed in her 2004, *A Complicated Kindness*.[6] Dyck's use of felted sweaters, with the pun on clothes/close, literally softens her critique as the medium allows ambiguous interpretation. What is the cost of the uniformity she depicts? Dyck's wordless art permits contradictory situations to be true simultaneously, managing to show complex social identities without assigning blame. The medium also presents Dyck with a kind of plausible deniability perhaps not available to Nancy Crites, whose use of condoms in the welcome mat in *Threshold—No Laughing Matter* (cat. 9) makes it impossible to consider the piece apolitically. Like Kidd's scrap-like aesthetic in her *Landslice* works, Dyck's use of felted sweaters in *Close Knit* also evokes questions about sustainability, waste, and labour. Are these garments spoiled in their transformation into art, or are these waste items usefully repurposed? What kind of costs are being examined here—and who is paying the bill?

The Depths

"On that monotonous surface with its occasional ship-like farm, its atolls of shelter-belt trees, its level ring of horizon, there is little to interrupt the eye. Roads run straight between parallel lines of fence until they intersect the circle of the horizon. It is a landscape of circles, radii, perspective

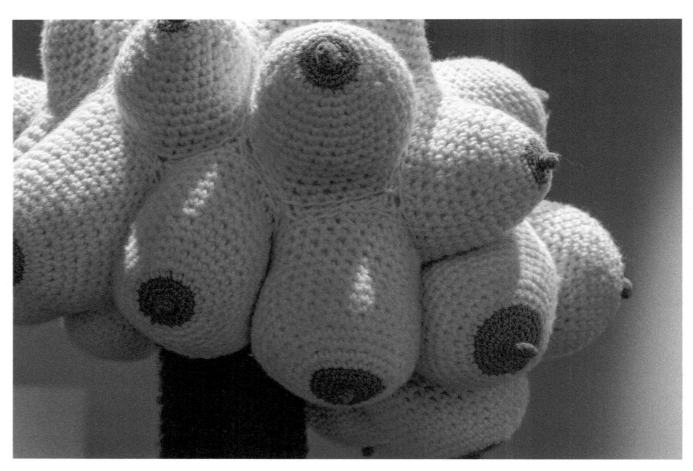

Phyllis Green, *Boob Tree* (detail), 1975 (cat. 18)

exercises—a country of geometry."[7] So writes Wallace Stegner in the 1962 *Wolf Willow*, his iconic memoir of growing up in southern Saskatchewan. Such geometry might seem to define people's relation to the place, as in the title of Laurence Ricou's 1973 study of Prairie literature, *Vertical Man/Horizontal World*.[8] But as the subtitle of Stegner's book suggests—"A History, a Story, and a Memory of the Last Plains Frontier"—the seemingly definite lines mask a complex intersection of time, place, and human response. The land's transparency is a disguise, hiding different realities that are perhaps best connected through metaphor or art.

An insistence that place is important is present even in the title *Prairie Interlace*, and many of the works included here engage directly with a geometric settler imagination. Amy Loewan's *A Mandala "The Circle and the Square"* (cat. 30) and *A Peace Project* (cat. 31) are obvious examples, as are Margaret Sutherland's *The Seed* (cat. 53) and Pirkko Karvonen's *Rapeseed Fields* (cat. 25). But, as with the Prairie itself, all is not as it seems. Pat Adams' *Prairie Sunset* (cat. 1), with its minimalist representation of horizon and light, looks like it fits into Stegner's model perfectly. But what then does one do with Adams' *Remember That Sunset We Saw From Here One Time?* (cat. 2) While on the one hand viewers now see two landscapes, through the postmodern duplication and layering of images they are also confronted with the fact that neither of these rectangles is actually a landscape at all. Stegner's natural geography is here refigured as a highly stylized representation that looks increasingly unnatural as Adams' work raises questions of colour and scale. And is the Prairie really this flat? That both layered images seem plausible suggests that neither might be, as Adams' work draws attention to the art rather than the subject. This insistent problematizing of representation, also epitomized in genre-blurring written texts such as Kristjana Gunnars' 1989 *The Prowler* or Aritha van Herk's 1990 *Places Far from Ellesmere*,[9] speaks again to a desire to unwrite Prairie clichés. In juxtaposing the landscape of Ellesmere Island with the setting of Tolstoy's novel *Anna Karenina*, van Herk produces a double vision that creates a space to consider the "rules" of representation of both environment and gender. Adams' piece functions similarly, as viewers are invited to carry questions about the construction of the tapestry into a consideration of the construction of the landscape itself.

Further complications of place are suggested in Brenda Campbell's *Woodlands Undercover* (cat. 8). Its topographical imagery, reminiscent of *Rapeseed Fields* (cat. 25), appears ripped out of a larger frame, the lighter border against the black evoking both a shredded map, and a lakeshore seen from above. Strands of field and furrow dangle and unravel into a texture that evokes the woodlands of the piece's title. To be undercover is to be subversive, hidden: what does it mean to unmake a landscape, particularly one that has been so consciously made? The piece's two straight edges accentuate the lack of framing elsewhere. Not only does the material seem to drip off the work's ripped edge, but in the use of spaces between the woven cords, the work also allows the viewer's gaze to go beyond the surface (undercover?) to the wall behind.

Striking here also is the use of colour. Where *Rapeseed Fields* (cat. 25) employs familiar green and gold to invoke its subject, Campbell's use of grey means that viewers need to find another way to understand how what they see represents a woodland. Meanwhile, in *Ten Shades of Sheep* (cat. 55), Annabel Taylor uses colour to promote a different kind of engagement. Paradoxically, by turning her work into a colour study, she draws a direct line to materials usually taken for granted.

Consumer culture suggests that textiles and clothing are endlessly available, appearing as the product of unseen hands and coming from invisible sources. *Ten Shades of Sheep* (cat. 55) literally makes these sources visible as the distinct shades of wool work together to create a cohesive texture. Both sampler and showcase, it links both to highly conceptual works and to the earthy beauty of Kate Waterhouse's dye archive (cat. 58). Showing local plants like fleabane and nettle in what is perhaps an unexpected light, Waterhouse's archive invites a redefinition of the surroundings, as plants that viewers thought they knew are revealed to have unexpected dimensions. In these ways, viewers are prompted to step outside of well-trodden paths as they consider the underpinnings of their surroundings.

The Flat?

Everyone knows that the Prairie is made for farming. Or is it? One result of viewing the Prairie primarily in terms of resource extraction is that it is now one of the world's most altered landscapes. Following other imaginative roads requires a recentering, an ability to reframe and see a place without literal or symbolic horizons. This essay began with a consideration of the disorienting aerial view offered by Karvonen's *Rapeseed Fields.* (cat. 25) and Carol Little's *Furrow* (cat. 29) adds another dimension to that top-down perspective. *Furrow* turns the line upon its axis, simultaneously evoking a furrow seen lengthwise, as the long strip of fabric replicates the straight line of the plow, and crossways, as the zig-zagging of the fabric calls to mind a cross-section of a furrowed field. If we think about the Prairie having two dimensions—Stegner's landscape of circles, radii, perspective exercises—then *Furrow* bursts into 3D with the dynamism of a flying carpet. The vibrant colour further defamiliarizes the agricultural landscape, redefining a furrow in terms of aesthetic possibility rather than agricultural byproduct. What is the purpose of this airborne furrow, caught mid-launch? We might consider it beside Cathryn Miller's *Winter Sun* (cat. 35), whose sharp angles capture frozen light and ice crystals. *Winter Sun* is all about stillness, while *Furrow*, like Dyck's *Close Knit* (cat. 13), invites animation. While some pieces suggest thoughtful contemplation, *Furrow* looks like a viewer might have to chase it around the gallery. The Prairie is imagined by many to be unchanging, a timeless, motionless agricultural landscape, always in the past. Little uses this piece's title as a hinge to swing representation from one mode to another, raising questions about both the art and its putative subject, and giving settler geometry a reboot.

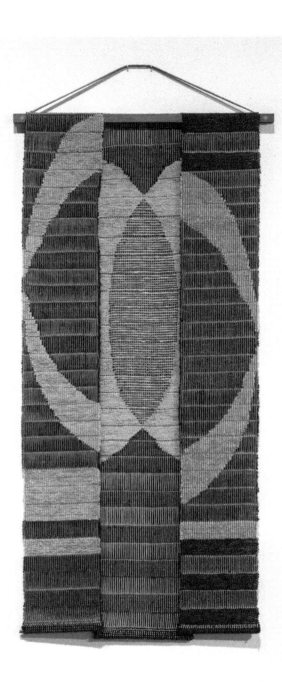

Margaret Sutherland, *The Seed*, c. 1984 (cat. 53)

Margaret Sutherland, *The Seed* (detail), c. 1984 (cat. 53)

Amy Loewan, *A Peace Project*, 2000 (cat. 31)

Amy Loewan, *A Peace Project* (detail), 2000 (cat. 31)

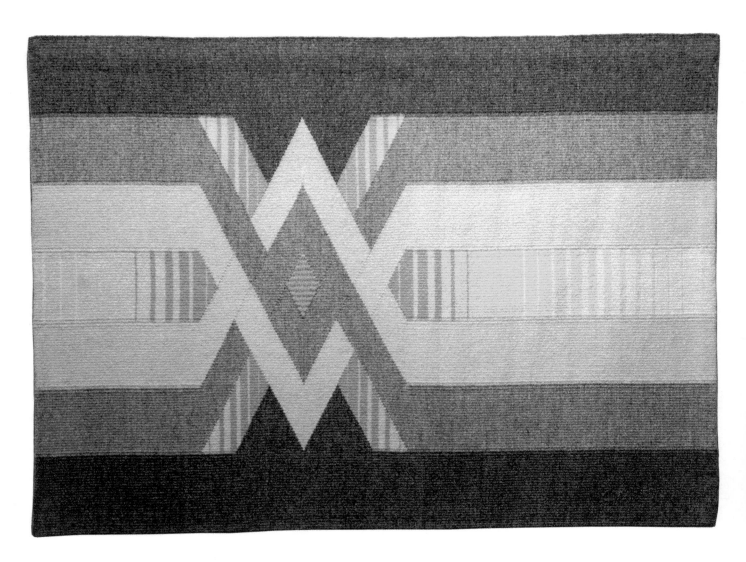

Cathryn Miller, *Winter Sun*, c. 1977 (cat. 35)

Kate Waterhouse, *Kate Waterhouse Archives—Dye Sample Chart*,
1977 (cat. 58)

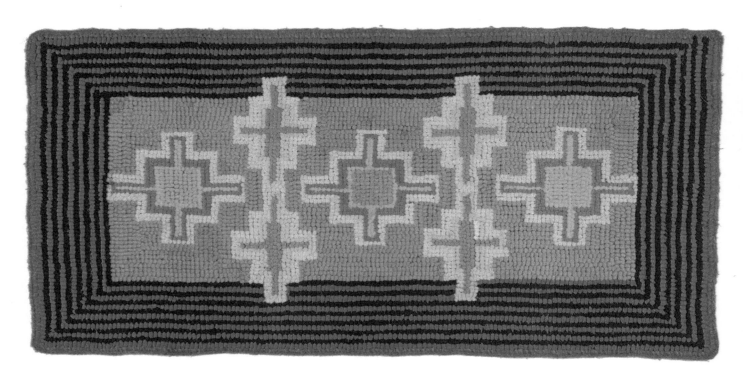

Florence Ryder, *Untitled (lilac ground)*, no date (cat. 48)

now

make room in the mouth

for grassesgrassesgrasses

<div align="right">

LAYLI LONG SOLDIER,
2017, *WHEREAS*[10]

</div>

In "38," her poem about the thirty-eight Dakota men hanged in 1862 for their resistance to starvation-induced genocide caused by the American government's failure to honour treaties made with the Dakota Nation, Oglala Lakota poet Layli Long Soldier brings together art, history, memory, aesthetics, resistance, and Indigenous resurgence. The annual memorial ride commemorating the thirty-eight men hanged for their part in the Sioux Uprising, she writes, "is not an object inscribed with words, but an *act*."[11] When I look at the works made by Florence Ryder (cat. 48 & 49) and by the artists in the Sioux Handcraft Co-operative (cat. 7, 15, 16, 17, 24, 33, 34, 54, 60, 61), I want to think about the making of art as an act of memorializing, an act which does not locate Indigenous culture in the past but insists on it as a continuing strength in the present. Making this art is an act of resistance that adapts colonial craft practices by incorporating traditional knowledge. In making the rug, the artist animates that knowledge, as a storyteller animates through speech. This is to say that these pieces are not artifacts. Describing the Sioux uprising, Long Soldier writes that "'Real' poems do not 'really' require words."[12] If I think of these rugs as acts rather than as objects, then I can understand them not only as records of Sioux decorative

art and the traditional knowledge associated with it, but I can also understand the labour that went into them as an ongoing resurgent practice. In that the rug becomes the record of its own making, it becomes, as Long Soldier suggests, "an *act*." This is a different kind of geometry that speaks to plenitude, not emptiness, and whose lines are paths written by the land itself.

The Thread

Even a tightly woven fabric contains space. Conventional essay writing states that you need an introduction, a body, and a conclusion. But, like the interlacing suggested in this exhibition's title, the works in *Prairie Interlace* refuse a straight line, instead insisting on multiplicity, ambiguity, deferral, and mobility. If there is a commonality here, it may be the invitation to the viewer to reconsider not only the artwork and its parameters, but also the ways in which modes of representation work to create particular narratives of place and identity. These narratives include the designs that humans make on the Prairie landscape itself, as artists work against and through the colonial grid to suggest depth and dimension. A textile's materiality can motivate a recognition of the ways that bodies imprint themselves on place, and are themselves marked by social and historical forces. The refusal of these pieces to be easily corralled into one summary shows both complexity and strength.

NOTES

1 Tim Lilburn, "How to Be Here?," in *Desire Never Leaves*, ed. Alison Calder (Waterloo, ON: Wilfrid Laurier University Press, 2007), 20.

2 Karina Vernon, ed., *The Black Prairie Archives* (Waterloo, ON: Wilfrid Laurier University Press, 2020).

3 Henry Kreisel, "The Prairie: A State of Mind," in *Contexts of Canadian Criticism*, ed. Eli Mandel (Toronto: University of Toronto Press, 1971), 254–66.

4 Martha Ostenso, *Wild Geese* (Toronto: McClelland & Stewart, 2008). First published 1925.

5 Lorna Crozier, "News Flash From the Fashion Magazines," in *The Blue Hour of the Day: Selected Poems* (Toronto: McClelland & Stewart, 2009), 66.

6 di brandt, *questions i asked my mother* (Winnipeg: Turnstone, 2015); Miriam Toews, *A Complicated Kindness* (Toronto: Knopf, 2004).

7 Wallace Stegner, *Wolf Willow: A History, a Story, and a Memory of the Last Prairie Frontier* (Toronto: Penguin, 2000), 7. First published 1962.

8 Laurence Ricou, *Vertical Man/Horizontal World* (Vancouver: University British Columbia Press, 1973).

9 Kristjana Gunnars, *The Prowler* (Red Deer, AB: Red Deer Press, 1992); Aritha van Herk, *Places Far From Ellesmere* (Red Deer, AB: Red Deer Press, 2003).

10 Layli Long Soldier, *Whereas* (Minneapolis: Graywolf Press, 2017), 5.

11 Long Soldier, *Whereas*, 52 (italics in original).

12 Long Soldier, *Whereas*, 53 (italics in original).

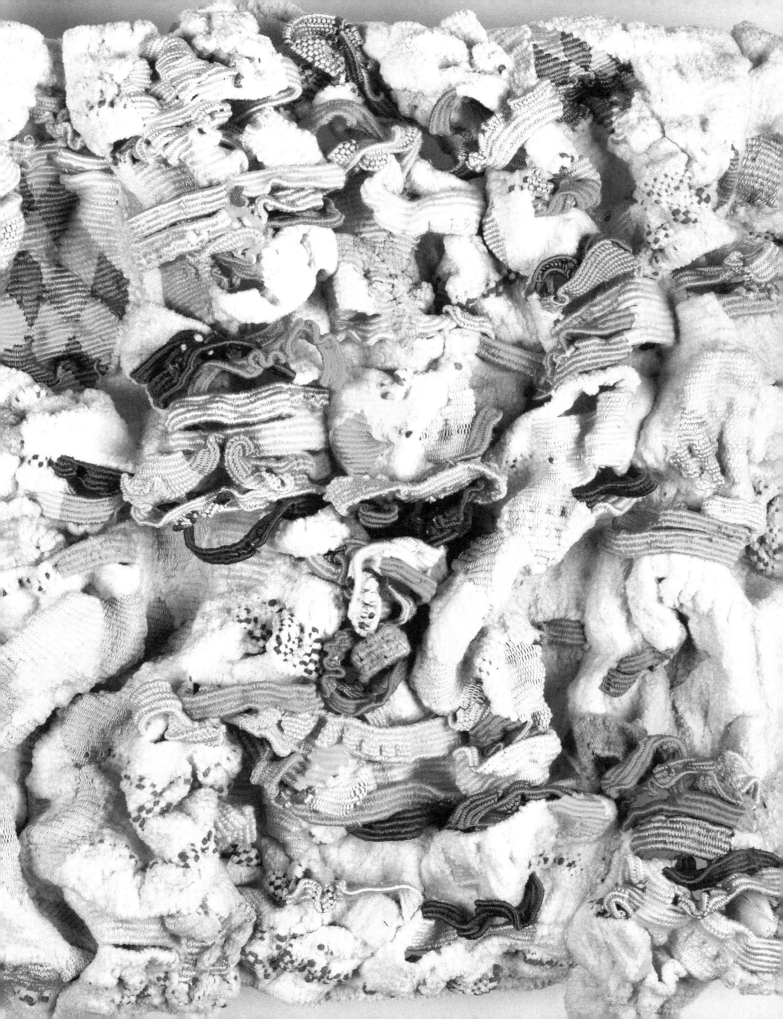

Expanding the Frame

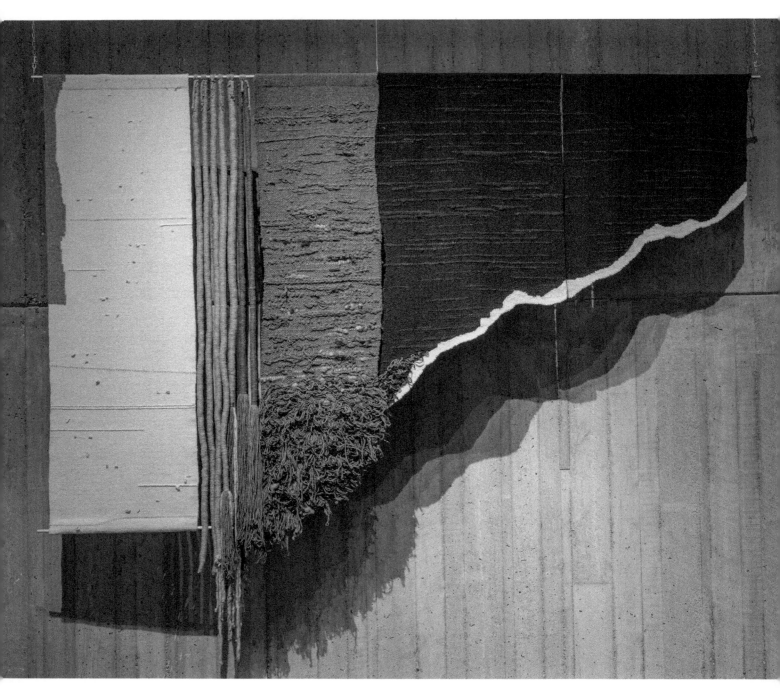

Brenda Campbell, *Woodlands Undercover*, 1975 (cat. 8)

Weaving in an Expanded Frame

by Timothy Long

What is the frame appropriate to weaving and other interlace practices?[1] The answer, more often than not, is none. Framing as a physical device is an unnecessary addition. An interlace of woven fibre, which we consider here to include hooked rugs, macramé, and knitting, among other practices, is strong and supple. It holds its own place without the need for an external support. More than that, the frame has an energy which seems foreign to weaving, an edge that is hard rather than softly looped or tied. Take, for example, Brenda Campbell's *Woodlands Undercover*, 1975, one of the expansive architectural tapestries in *Prairie Interlace* (cat. 8). Its dialogue with the edge is a masterclass in complexity and nuance: borders reflect off its perimeter like ridgelines in a rearview mirror, coil in hanging cords that divide scrolls of charcoal and cream, and fray in rya knots that frustrate the clean ascent of its earthside boundary. Ridges punctuate its surface and ripple across a landscape of natural wool and cotton. Shaped canvases of the 1960s and 1970s look contrived by comparison

And yet, whenever weaving is shown in an art gallery or museum, the frame of art is there, in the architecture, the institution, the conventions of display and ways of appropriating images that go back to the origins of modernity. A frame is unavoidable if we are to call a weaving a work of art. The question of frames and their role in the production of aesthetic presence has been a central concern of my curatorial practice and writing over the past two decades. In my engagement with practices ranging from painting, to ceramics, to lens-based installation, to dance, I have been spurred by the cultural anthropology of René Girard to reconsider the source of the frame's power and its role in mediating viewers' interactions with the art object. *Prairie Interlace*, with its proliferation of practices that revel in an independence from the frame of high art even as they appropriate it, provides an unexpectedly rich opportunity to consider afresh the specificities of the frame of weaving, a generally overlooked and underestimated medium.

This exploration joins a growing body of textile theory that, since the 1990s, has articulated what an expanded frame might look like—one that allows weaving to breathe, to operate

on its own terms, without the confining edge of frame or plinth. Recent surveys such as *The Handbook of Textile Culture*, 2017, demonstrate the extraordinary versatility of weaving within the wider field of textiles to engage a host of cultural, social, political, historical, and aesthetic concerns and their intersections.[2] Writing about the renewed interest among international curators in contemporary textile art, Christine Checinska and Grant Watson list some of the current directions: "Towards formal concerns with abstract or soft sculpture, to the serial process of textile construction, to feminism, woman's work and artisanal labour, to the hierarchies between art and craft, applied and fine art and on to architecture and design, to trade, industry and globalization."[3] As we shall see, this list could have been written about the works in *Prairie Interlace*. While the language of debates may have shifted, the material lineages established by artists working in the latter half of the 20th century have continued relevance today. This essay takes up the challenge of articulating the frame of their production, both as an overdue historical assessment and as a theoretical foray with contemporary application.

The Umbilical Frame

Imagine a studio by a river where an artist sits on a box working at her loom. Looking out the window, she sees bits of the world bobbing in the water. One day a wooden prosthetic leg floats by. She thinks of her past, of her home in South Africa, of the colonial battle that took her grandfather's life. On another day, she receives dried flowers from friends far away. She thinks of her new home by a prairie river in Saskatchewan, of Métis leader Louis Riel, and of another life lost to a colonial war. She has made a drawing, a collage, of quickly recorded impressions. She picks up her shuttle and begins to weave. She is rethinking the nature of tapestry. She is making a new prosthetic, a phantom limb of recollections whose ache is held in woven tapestry. [4]

The artist is Ann Newdigate, who for many years has been one of weaving's most articulate and clearsighted critics. With tapestries such as *National Identity, Borders and the Time Factor, or, Wee Mannie*, created at Dovecot by the Water of Leith while studying at the Edinburgh College of Art in 1982, Newdigate began a decades-long reconsideration of weaving's potential for critical inquiry (cat. 38). In 1995, she addressed the theoretical uncertainties facing weavers on the Prairies with a succinct and pointed summary that was included in the collection *New Feminist Art Criticism* edited by Katy Deepwell. The title for her essay states

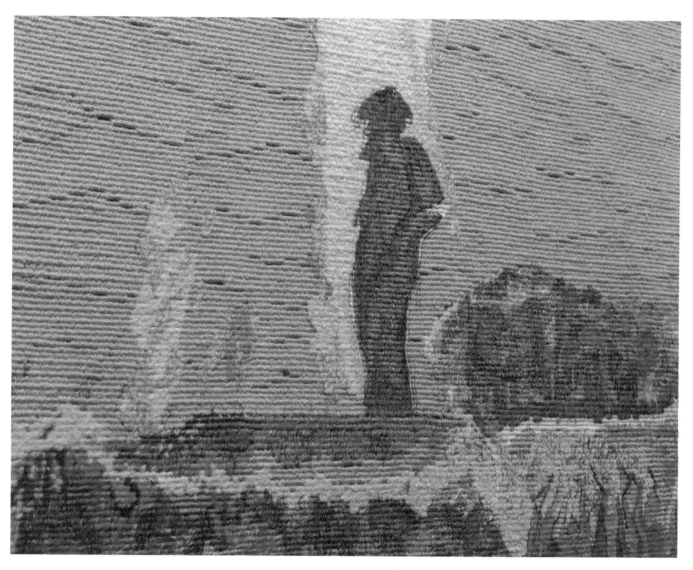

Ann Newdigate, *National Identity, Borders and the Time Factor, or, Wee Mannie* (detail), 1982 (cat. 38). At the centre of this detail is the silhouette of Louis Riel, a reference to the historic photograph of the Métis leader taken after his capture at Batoche in 1885.

the situation with wry candour: "Kinda art, sorta tapestry: tapestry as shorthand access to the definitions, languages, institutions, attitudes, hierarchies, ideologies, constructions, classifications, histories, prejudices and other bad habits of the West."[5] Newdigate situates tapestry in an undefined territory between art and craft, between centre and region, between privileged white male hegemony and marginalized communities based in class, gender, and race. While acknowledging tapestry's subaltern status in the art world, she does not despair. Rather she values its location on the edges as a uniquely productive position from which to erode cultural oppositions:

> I work in tapestry primarily for its materiality and its capacity to shift within traditions, to shuttle between theoretical positions, to hover around borders, to challenge hierarchies and to connect with many different resonating imperatives. The medium, belonging everywhere and nowhere, is everything and nothing. It is what you think, and it conjures what you don't know and can't remember—it has no certainty.[6]

Newdigate's statement captures the creative and critical conundrum experienced by many of the artists working in this medium, of the freedom as well as the challenges of operating outside and against established theoretical frameworks and value systems. Although written over twenty-five years ago, it describes a situation which continues to resonate today. After viewing *Prairie Interlace*, Calgary artist Mary Scott, who is represented in the exhibition by a work

which itself traverses material and conceptual boundaries (cat. 52), commented on the curatorial challenge of delving into "a discipline whose edges and limitations are hard to capture (firm up), one that reveals a level and quality of invention quite astounding."[7] Scott's reaction would seem to bear out Newdigate's assertion that tapestry, and by extension weaving, has "no certainty." As curators seeking to articulate the theoretical horizons which opened up for weavers on the Prairies post-1960, as well as the edges they confronted, the task remains exhilarating, if at times vexingly elusive.

Uncertainty about edges, however, points back to the question of frames. Newdigate's assessment of the situation comes from her own hard-won experience of engaging with the frame of modernist painting through the medium of tapestry. After finding her initial bid for critical acceptance rebuffed, she entered the lengthy process of coming to terms with a medium which did not fit this aesthetic frame. Tapestry, she eventually concluded, provides "shorthand access to institutionalized European attitudes."[8] Her studio practice makes use of this theoretical understanding in a thoroughgoing rejection of the frameworks of authority that underpin modernist art: her work is postmodern in its dissolution of hierarchies of genre and of centre and margin, postcolonial in its understanding of her own privilege as a middle class white Canadian woman from South Africa, and feminist in its embrace of an art form practiced primarily by women that fits neither the definitions of high art (painting) or low art (craft).

The question remains, though, what is the frame appropriate to weaving if not

the frame of painting and sculpture? What may be proposed in its place other than a frameless uncertainty? If Newdigate is to be believed, to attempt a theory of weaving would be to assemble its fragmentary edges into an illusory and necessarily coercive whole. Interestingly, her position aligns with the proposition made by textile theorist and fellow South African émigré Sarat Maharaj just a few years earlier: that the larger category of textile art is, to borrow Derrida's term, "undecidable": "something that seems to belong to one genre but overshoots its border and seems no less at home in another. Belongs to both, we might say, by not belonging to either."[9] However, rather than settle for this description of weaving as a perpetual nomad, we will press deeper to understand how the borders of both art and weaving were established, what they mean on a socio-anthropological level, and, ultimately, how they intersect in the work under consideration. What we will propose is that weaving, as an art form, is connected to the world via a thread *and* a frame, a simple yet profound insight that explains its astounding capacity for shifts of form and intention along its spun shaft. In this I hope to expand the frame of weaving and discover the key to the medium's extraordinary proliferation at a critical juncture in art history both on the Prairies and elsewhere.

Glenn Adamson in his illuminating study *Thinking Through Craft* provides a constructive starting point for considering the frame of weaving, a point of entry embedded within his more general consideration of the frame of craft.[10] In setting up his argument, he begins by addressing a fundamental tension within the modernist artwork: between its claim to autonomy as described by Theodor Adorno and its contextual dependencies as articulated by Jacques Derrida. Pointing to Derrida's concept of the *parergon* or frame (literally "that which is next to the work"), Adamson notes that the autonomy of the artwork is always contingent on a frame. "The *parergon*, if functioning properly, seems to cut the work clean off from the world. Like a freshly cut flower, Derrida writes, when art is severed from its surroundings it does not bleed."[11] However, this cut is performed by an object, a frame, which is itself a work of craft. Craft, Adamson goes on to argue, is a supplement which is necessary to the art object's claim to autonomy. If this conceptualization of craft would seem to reinforce its subordinate status, Adamson, like Newdigate, views it differently. He argues that art and craft are bound together in a relationship of mutual dependence, and that craft's so-called inferiority constitutes its strength. For if the art object's autonomy is dependent on the contingency of the frame, only through craft can art's unacknowledged relationship to its context be understood and critiqued. Using the concept of the supplement, Adamson provides a host of examples of what "thinking through craft" might mean for a diverse array of practices, from ceramics, to jewelry, to furniture, to glass, to weaving and fibre art.[12]

In elucidating the host of contextual relationships in which art is implicated, Adamson deftly dismantles the hierarchies

Ann Hamilton, *Untitled* (detail), 1979 (cat. 19)

that have disadvantaged weaving and other craft media. Those contextual relationships include its materiality, haptic intelligence (skill), relationship to time and land (pastoral), and connection to the disadvantaged poles of social hierarchies (amateur, feminist, and BIPOC). However, while articulating craft's supplementary relationship to art, his explanation for the existence of this dynamic remains incomplete. In support of his argument, Adamson quotes Derrida's memorable line from *The Truth in Painting*: "the *parergon* is a form which has as its traditional determination not that it stands out but that it disappears, buries itself, effaces itself, melts away at the moment when it deploys its greatest energy."[13] Adamson uses this insight to underline how craft must disappear so that the work of art may come into view. Simply put, the frame must die so that art may live. While this is no doubt true, what is unaccounted for by both Adamson and Derrida is the socio-anthropological location of the power by which the frame operates.

As I have argued elsewhere, to account fully for the frame's energy we must look to its sacrificial origins.[14] According to the theory of the scapegoat elaborated by cultural anthropologist René Girard, the supplement (frame/craft) and the victim of violence (scapegoat) are one in the same.[15] Viewed through a Girardian lens, the frame operates in a way that replicates the pattern of scapegoating violence. Just as the violent mob encircles its victim, expelling it from the social body, so a frame excises a small parcel of reality and expels it from our mundane existence. The motivations for these expulsions are linked. Both the scapegoat and the

artwork are the objects of collective, rivalrous desires—desires which are not original but rather rooted in the mimetic contagion of "I want what they want." When expulsion is achieved, those conflicting desires are suddenly unified. For the scapegoating mob, the result is a collective recognition of a miraculous peace. The victim, which was once the source of all evil, now returns as the divine presence of the god, the source of all good for the newly reconciled social body. Similarly, the artwork, initially held at a distance by the frame, returns its excised section of the world with the quasi-divine aura of aesthetic presence. As Andrew McKenna argues in his comparative study of Girard and Derrida, every cultural form, language and art included, is a surrogate of the original victim and is in turn dependent on another stand in, writing or craft, as the case may be.[16] According to this substitutionary logic, the frame is a supplement of a supplement of the scapegoat. Viewed from this perspective, the cut that separates the art object from the world is yet another expression of the sacred violence by which the social order is maintained—hardly a bunch of freshly cut flowers placed in a vase!

How the sacred presence which formerly pertained to the god, and later to the idol or icon, came to inhabit the artwork as aesthetic aura is the result of a historical transformation that has been described in detail by art historian Hans Belting in his magisterial study *Likeness and Presence*.[17] By applying Girard's anthropology of violence to Belting's account, we may see that frames, beyond their role as generators of aesthetic presence, mediate between the art object and the world, reconciling the competing and

Aganetha Dyck, *Rope Dance*, c. 1974 (cat. 12)

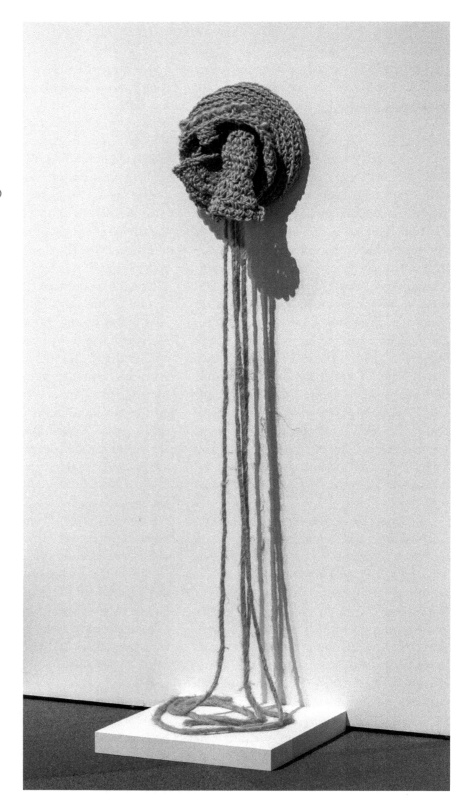

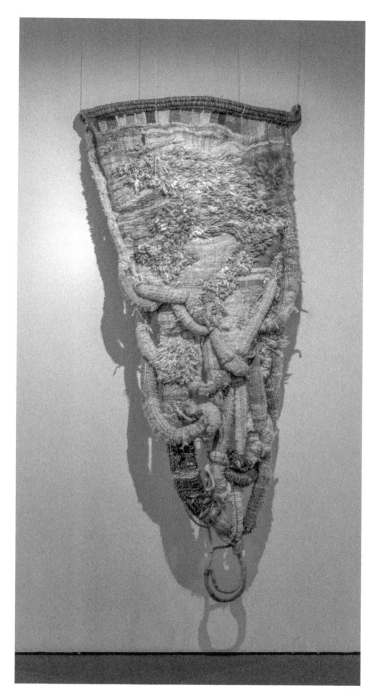

Susan Barton-Tait, *Nepenthe*,
c. 1977 (cat. 5)

Susan Barton-Tait, *Nepenthe* (detail), c. 1977 (cat. 5)

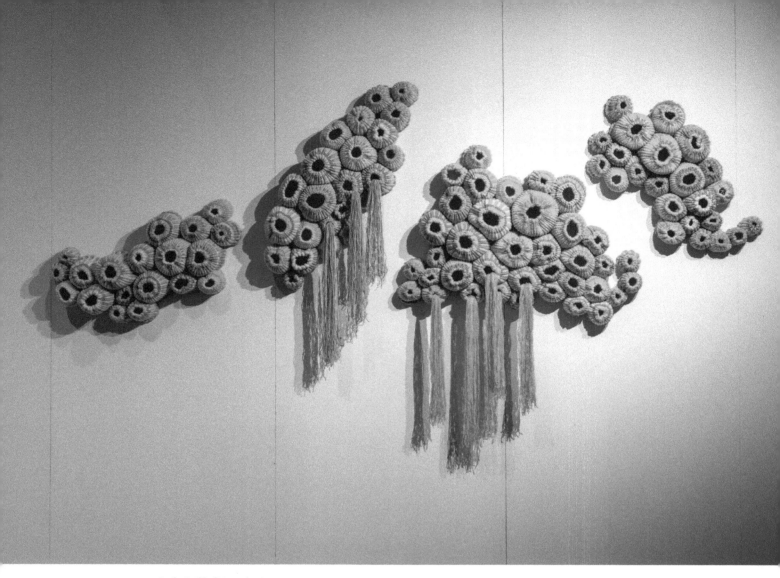

Crafts Guild of Manitoba, *Prairie Barnacles*, 1979 (cat. 32)

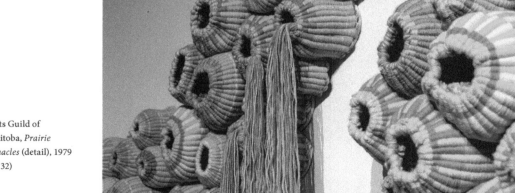

Crafts Guild of Manitoba, *Prairie Barnacles* (detail), 1979 (cat. 32)

mimetic desires of the viewers' intersubjective gazes. The frame also stands in for the hand of the artist, whose priest-like genius is responsible for the transformation of artisanal craft into the inspired work of art. Thus, the frame unites in its form artist, artwork, and viewer in a recreation of the sacrificial scene. Of course, the history of Western art, from early modern times to today, has involved a progressive questioning of the frame that has exposed the sacrificial contract between artist, artwork, and viewer. As I have argued elsewhere, the effect of this questioning has produced not iconoclasm, but rather "theatroclasm," or the breaking of the place of the viewer.[18] From Giotto to Rembrandt, from Manet to Warhol, the viewer has become increasingly aware of their privileged position, of their implication in the exclusions which the artwork either tacitly or overtly sustains. At the same time, the artwork has activated through its questioning of the frame an identification with the victim of violence, the hidden subject of the work of art.[19]

If painting and sculpture's relationship to the sacred is missing from Adamson's account, so also is craft's. Whereas art gestures to the original victim through a chain of substitutions, craft attends the scene, holding the robes, metaphorically speaking, like Paul at the stoning of Stephen. Cloth covers the body; ceramic and glass contain the libation; furniture holds the offering. Rather than serve as the object of the cult, craft embellishes religious rituals through the ministrations of food, drink, and clothing, and thus maintains a contextual adjacency which carries over into the era of art. Thus, both art and craft have a relationship to the victim of violence. However, while the frame which excises art from the world is "bloodless", to borrow Derrida's term, the frame of craft is never far from the flesh. From the perspective of Girard's theory of the scapegoat, the question of contact is significant. The collective must not touch the scapegoat if the transference of social ills is to be successful; if contact is made, the social body may be contaminated by violence and the desired peace never attained.[20] This fact explains why the art object, with its disappearing frame, has a particular efficacy in producing presence, and why the craft object remains supplemental. What distinguishes craft from art is whether it touches the victim or not.

Desacralization, the long process initiated by the recognition of the innocence of the victim, makes these relationships visible. When craft meets the theatroclastic energies of the modernist avant-garde and its concern for identification with the victim of violence, it meets the viewer with an embrace quite different from the mirror strategies of visual art. It creates a point of contact between viewer and victim, not through a mediating frame, but rather as a "servant object."[21] However, this distinction also explains the significance of craft's distinguishing features: its character as an object bound inextricably to the conditions of its production—material, corporeal, temporal, geographical, and social. These are the locations where craft meets suffering flesh. At the same time, the critical frame of art helps craft to see its own relationship to the sacred and participation in the production of violent unanimity. Craft's role then is not so much to critique high art through a

shadowy rivalry, but rather to join forces in a multi-dimensional critique of scapegoating violence through and against a diverse range of cultural forms.

What, then, is weaving's particular relationship to the sacred? Unlike painting, weaving attains its autonomy when it leaves the frame, at the moment when it is removed from the loom. Weaving's primary separation, then, is not from a reality which it represents, but from the material which is its means of production. Its cut is umbilical, rather than excisional. Touch a weaving's edge and you will feel knots, not the heads of nails. Turn a weaving over and you will see its technique of production, not how it was stretched over a cross-braced wooden frame. Turning to mythology, the Moirai or Fates of ancient Greece provide an illustration of the violence inherent in the umbilical cut.[22] In performing their daily tasks of spinning and weaving, they determine the fate of humanity: Klotho, who spins the thread of mortal life; Lachesis, who measures its length; and Atropos, whose final cut determines the moment of death. The umbilical cut is thus ambivalent, signifying both the beginning and end of life. Even the gods of Olympus are subject to the Fates, who represent the underlying forces of order and hierarchy,[23] an order that is established at a cost. The etymology of "moirai" is "to apportion",[24] a description that locates the actions of the goddesses within the sacrificial realm; their cut determines inclusion and exclusion, who receives life and who does not.[25] This message is woven into every piece of cloth and carried on the body from cradle to grave.

As we shall see, the works in *Prairie Interlace* make contact with viewers within the expanded frame of modernist weaving through their materiality, temporality, corporeality, and alterity. When touched by the desacralizing energy of the modernist avant-garde, weaving, which had been largely static since its flowering as Renaissance tapestry, released an umbilical energy that moved in a multitude of destabilizing directions—exposing the many deterministic threads on which our civilization hangs.[26] That energy was ambivalent, pointing both toward the established order, but also to its dismantling. This understanding is useful not only for articulating weaving's engagement with the frame of art, but with frames outside of Western culture. In this, perhaps, we may find the elusive "edges and limitations" of a discipline.

Contexts: Material and Temporal

Imagine a hall full of tapestries.
The scale is large, impressive.
Here the pictorial inventions
of cubism are warmed on the
great looms of Gobelin and
Aubusson. The cutout birds of
Henri Matisse take wing in one,
the architectural traceries of Le
Corbusier cavort in another.
Then you encounter a work with
no image, no designer-painter
passing his cartoon to translator-
weaver. Over human height and

nearly four arm-spans-wide, it is a panorama of colour sensation, cool yet vibrantly alive. It moves in vertical chords from deep browns of forest humus, to chill bands of marine blue, through intermediaries of ice and sky, to the frozen reaches of outer space. It is a cross-section of winter on its side. Only the textural inventions of the wild Polish looms come close to its woven intentions.

Animated by a cut that is umbilical rather than excisional, weavers of the 1960s opened up new material and formal possibilities along the contingent edges of the medium. Taking as their point of departure the structural logic of weaving, they advanced an exploration of embodied colour, knotted edge, pendent form, and measured time. Already, at the initial Lausanne International Tapestry Biennial in 1962, artist-weavers such as Mariette Rousseau-Vermette from Canada stood out from better known French names such as Le Corbusier, Henri Matisse, and Henri Lurçat, who as cartoon-painters remained at one remove from the actual process of weaving. In *Hiver canadien*, 1962, Rousseau-Vermette uses the underlying structure of warp and weft and the naturally variable intensities of dyed wool to order and animate fields of colour, rather than translating designs produced on paper. Its pictorial energy, its presence, is contained

Mariette Rousseau-Vermette, *Hiver canadien*, 1961, tapestry low-warp, 213.3 x 540.7 cm. Collection of the Musée national des beaux-arts du Québec, Purchase (1963.70). © Succession Mariette Rousseau-Vermette et Claude Vermette. Photo by MNBAQ, Jean-Guy Kérouac.

within the very fibres from which it is made. Unlike painting, colour in weaving is not additive but rather derives from chemical bonds with thread and yarn. Dyes themselves are often made from the extracts of plants and animals; like living tissues, fibres take into their matrix the liquid substance of the land.[27] Rousseau-Vermette's tapestry speaks to the potential of weaving to expand its frame beyond the opticality of painting by exploring its own structural possibilities and material lineages.

For Charlotte Lindgren, who got her start as a weaver in Winnipeg and was another early Canadian participant at Lausanne, it was structure rather than colour that took precedence: "I use colour and texture only to strengthen the image and to clarify the structure."[28] Suspension is inherent in wall tapestry, which hangs without a frame, resulting in a gravitational pull that is distributed thread-to-thread across the textile. When it moves into three-dimensional space, tapestry's pendent quality contrasts to the gravity denying thrust of plinth-based works. In *Winter Tree*, 1967,

Charlotte Lindgren, *Aedicule*, 1967, 245 x 245 x 180 cm. Photo by Gilles Alonso and courtesy of © Fondation Toms Pauli, Lausanne.

created for the craft exhibition at Expo 67, Lindgren exploits textile's dialogue with gravity by creating a flat, single-piece weaving that only takes spatial form when hung (cat. 28). That same year at the Lausanne Biennial, Lindgren's *Aedicule*, 1967, was one of the first tapestries to extend from the wall. Shown in a separate section reserved for three-dimensional entries,[29] the work uses the language of draped canopies and backdrops to create an architectural structure, as suggested by its title. Lindgren builds on the logic of internal slits and openings, first seen at the 1965 Biennial, to articulate a fully

realized portal and throne. Furthermore, fringes, a decorative edge that marks the knotted boundary of tapestry, are lengthened into soft and penetrable columns. By 1969 three-dimensional approaches, led by Magdalena Abakanowicz, proliferated at Lausanne, paralleling the gravitational orientation of minimalist sculpture represented by Robert Morris and Eva Hesse and their experiments with hanging felt, thread, and latex.[30]

These seismic shifts within the material expression of weaving continued to be registered in works from the 1970s and 1980s. On the Prairies, designs were often oriented towards landscape. Eschewing pictorial tapestry, artists built on the umbilical materialism of Rousseau-Vermette, who transmitted her knowledge of international developments in her role as head of Fibre Arts at the Banff Centre. In responding to one of the most disturbed ecosystems on the planet, artists were able to draw on a range of techniques to conceptualize land as felt reality rather than colonial pictorial construct. If the harmonic resonance between the survey grid of the Prairies, the modernist grid of 20th-century art, and the ordered grid of the loom seemed destined to reinforce the work of the colonial "Fates" in apportioning the Prairies, then weaving retorted with tactile resistance. Rousseau-Vermette, along with Inese Birstins, Kaija Sanelma Harris, Eva Heller, Pirkko Karvonen, Jane Kidd, Gayle Platz, Ilse Ansyas-Šalkauskas, Margreet van Walsem, Whynona Yates, and others, brought a response to Prairie which probed deeply into the meaning of its folds and vegetation. Other weavers embraced the free-standing hang, such as Susan Barton-Tait, Katharine

Dickerson, Aganetha Dyck, and Carol Little, as artists across the Prairies experimented with interventions into three-dimensional space. Sensing the limitations of weaving's bound edge, a number of these artists abandoned weaving altogether by the end of the decade, finding more fruitful avenues for creation in felt (Birstins, Dyck) and paper (Barton-Tait, Miller).

The umbilical cut of spun fibre signals the creation of a weaving, but also the beginning of its eventual demise through fading or decay; birth and death are contained in this gesture. Time is always implicated. The significance of the cut derives, in no small part, from the time devoted to harvesting, cleaning, spinning, and dyeing fibre, all in preparation for the time-intensive process of weaving itself. During the 1960s and 1970s, many weavers invested themselves in processes such as sourcing local wool and plant fibres, creating dyes from native plants, and studying traditional and Indigenous weaving techniques. While these artisanal practices can be seen as part of the back-to-the-land movement, or the broader category of the "pastoral", as Adamson situates it,[31] the ultimate commitment is to time. This temporal investment stands in contrast to the ideal of progress which annihilates time through the application of "time-saving" technologies, as well as the aesthetic pursuit of the sublime, a quasi-eternal presentness that is the legacy of the sacred in Western art.[32] When comparing the large-scale abstractions of late Modernism with those produced by Mariette Rousseau-Vermette (cat. 47) and Ann Hamilton (cat. 19) at the Banff Centre in the late 1970s, for example, absorption in their colour fields is continually interrupted by the intrusion of knots and bound elements. Modernity, which is grounded in a sense of the new that is produced by the continual expulsion of the past, is deflected from its telos of progress by the rhythms of hand movements that are simultaneously ancient and continually renewed.

Reminders of time are also present in Ann Newdigate's Gobelin style tapestries in which she seeks to render the spontaneity of her small collage drawings in woven form. These somewhat perverse, if beautifully rendered, exercises have the effect of magnifying, rather than diminishing, the time involved in their making, and of freezing the flux of quotidian events. The speed which characterizes modernity is arrested in its tracks, not as a nostalgic return, but rather as a therapeutic relearning of how to move more deliberately in the present. Pat Adams sums up the feeling with tongue-in-cheek humour in *Remember That Sunset We Saw from Here One Time?* 1984 (cat. 2). The mise-en-abyme of a landscape within a landscape renders the ephemeral beauty of a Prairie sunset, the subject of untold paintings, as an even more ephemeral and ubiquitous snapshot. But the "snapshot" is itself a representation of a weaving, an earlier work titled *Prairie Sunset*, 1983 (cat. 1), now held within a weaving of the same landscape in the full light of day. At the end of the day (pardon the pun), the unhurried medium of weaving extracts its small revenge by snaring within its literal and temporal frame both painting and photography.

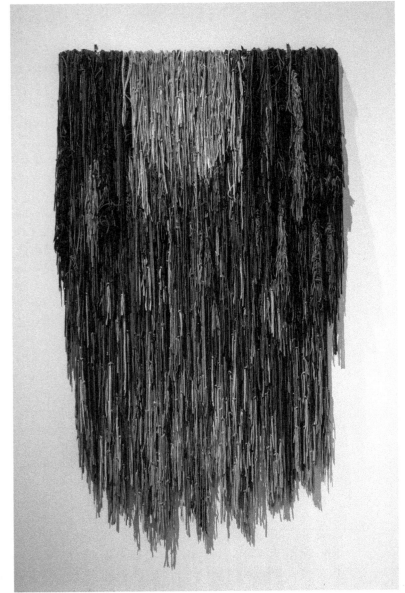

Ilse Anysas-Šalkauskas,
Rising from the Ashes, 1988
(cat. 3)

Ilse Anysas-Šalkauskas, *Rising from the Ashes*
(detail), 1988 (cat. 3)

Imagine the body of a dancer in an art gallery. She moves slowly, pressed against the wall, as if seeking the condition of a painting. At last, she arrives at a large canvas tondo roughly tacked to the wall. Her body slips behind the painting and disappears from sight, buried beneath the circular patchwork of exposed canvas and paint. Moments pass, and then in a sudden burst her head appears through a slit in the centre of the canvas. Her body pushes into space, tearing the canvas from the wall. The dancer begins to spin, the canvas flowing like a cape, as she recites with a loud voice a poem that speaks the uncontrollable forces of nature.

This was the scene in 1993 at the Musée national des beaux-arts du Québec in the debut of *Je parle*, choreographed by the Québec multi-disciplinary artist Françoise Sullivan and performed by Ginette Boutin.[33] While perhaps not its intended meaning, audiences may see in this extraordinary performative

Ginette Boutin's performance of the Françoise Sullivan choreography *Je parle*, presented at the MacKenzie Art Gallery with New Dance Horizons on January 28, 2016. Photo courtesy of Daniel Paquet.

gesture the transformation of canvas from painting to garment, its life as cloth suddenly restored through the action of a human spindle.[34] The violence of the gesture, however, reveals the extreme exertion required for painting to be reborn as textile—even when the frame is reduced to its bare minimum as an unstretched, roughly cut canvas held loosely to the wall by a few staples. Given a frame any more robust and the transformation could not take place. But Sullivan's choreography not only reveals the textile nature of painting; it shows in dramatic fashion the hidden body of the art object. At the moment when the head of the dancer penetrates the canvas, it is optically severed from the world in what might be called a virtual amputation: the head is framed as a kind of phantom limb, a dismembered part of the social body whose absence is felt as

an ache that we call aesthetic presence.[35] At the same time, we are aware that in reality the head is in contact with the rough edge of canvas, held in a cloth embrace.

Sullivan's performance offers three revelations that are useful for thinking through the relationship of weaving to the body. First, whenever the reality of weaving meets the virtuality of the frame, two bodies appear: the phantom limb of art and the umbilical body of woven fibre. Second, if the artwork is a phantom limb, then weaving offers the potential to therapeutically touch and support that limb, to provide refuge to it, and restore it to the social fabric. In weaving, corporeality and social context are umbilically bound. Third, the contact of weaving with the phantom limb erodes the binary relationship of craft and art and allows the hidden body of the scapegoat not only to return but to break silence. In Sullivan's performance, it is the forces of nature and the land that are spoken: "I speak the pine, the fir, the poplar . . . I speak the path of dawn . . . I speak the hand of the wind . . . I speak the night made with the raven."[36] This is the voice of alterity which weaving, in its involvement with the social order, also speaks when it aligns with the position of the victim.

As Sullivan's performance demonstrates, separation from the wall, even at a minimal distance, enhances the potential of textiles to serve as a refuge for the phantom limb and to restore it to the social body. At the opening of Prairie Interlace, children of Ilse Ansyas-Šalkauskas recalled using the long leather strips of Rising from the Ashes, 1988, as a hiding place during games of hide-and-seek (cat. 3). Their playful actions belie more serious events in the family's

history related to their escape from Nazi-occupied Lithuania during the Second World War, a history alluded to in the work's title. That same evening, Katharine Dickerson told the story of an Australian couple she had seen the night before the World Crafts Council General Assembly resting inside her West Coast Tree Stump, 1972, during the exhibition Textiles into 3-D at the Art Gallery of Ontario in 1974 (cat. 11).[37] The idea of shelter was in Dickerson's mind from the outset when working on the piece, which she wove outdoors using Coast Salish techniques.[38] After attaching the warp to the top part of the structure, she gradually raised the work as she wove; if it rained, she took shelter inside and continue weaving around her. Dickerson's umbilical relationship to the Tree Stump was further strengthened by fact that she was pregnant at the time.

After it is turned into clothing, weaving holds the trace of the body in its shape and form, a characteristic which further enhances its ability to interact with the phantom limb of art. Aganetha Dyck uses these traces to hold family memories in her series of shrunken woolen clothes, From Sizes 8–46. In Close Knit, 1976, Dyck gives expression to a story she heard from her Mennonite grandmother of how she and her community fled war in Europe wearing all the clothes they could put on in order to stay warm;[39] the interwoven arms of the recycled shrunken sweaters are a reminder of the tight weave of mutual support which the community relied on to escape violence and oppression (cat. 13). Traces of the body are also held in several of the hooked rugs in the exhibition. Margaret Harrison's Margaret's Rug, c. 2005, is composed of strips of fabric taken from

secondhand clothes (cat. 22). This memory map of the Métis community where Harrison grew up unites body and place in every knot, a reminder of the intimate relationship of Métis people to their homeland. A clothing reference is also found in the latch-hooked rugs of the Sioux Handcraft Co-operative. Called *Ta-hah-sheena*, the rugs were named after the ornamented robes traditionally worn by Dakota/Lakota/Nakota peoples.[40] Whenever their rugs are displayed, whether on the wall or on the floor, the sheltering space of a hide is invoked. One of the few works to reference the male body in the exhibition is found in a hooked rug made of blue and pink condoms (now degraded to brittle caramel shells) that spell the word "welcome" (cat. 9). *Threshold: No Laughing Matter*, 1991, was created by Nancy Crites at the height of the AIDS epidemic. In it she aligns the threshold of the frame, with its elusive proffer of welcome, with a hooked weave of condoms that signal the need for intimate protection.

Many second-wave feminist artists were attracted by the alignment of the phantom limb of art and the umbilical body of weaving to give expression to female embodied experience. Emblematic of this desire is Margreet van Walsem's gynocentric weaving *Birth*, 1971, which depicts the prostrate naked form of a mother in childbirth, with the baby's head crowning like the head of the dancer in Sullivan's performance (cat. 56). In this striking image, the umbilicus of women's power and agency is asserted through image and fibre. The womb itself is given a densely layered form in Jane Sartorelli's *Cerridwen*, c. 1975 (cat. 50), a free-form macramé wall hanging named after the Celtic goddess

of rebirth, while Phyllis Green's *Boob Tree*, 1975 (cat. 18) asserts female presence in a many-breasted celebration of women's bodies. In the era of bra burning, Green's knit sculpture stands as a defiant act of resistance to patriarchy.

Moving from second to third-wave feminism, questions of embodiment are also probed in *Imago, (viii) "translatable" «Is That Which Denies»* 1988, by Mary Scott (cat. 52). Like Newdigate's tapestries, Scott's work is a meditation on the relationship of painting to weaving, though, in her case, she considers this subject from the perspective of a painter. For her floor-to-ceiling installation, Scott embroidered onto a length of blue silk fabric Leonardo da Vinci's cross-sectional drawing of a heterosexual couple engaged in intercourse. For Scott, the use of the language of fibre arts constitutes a kind of "thinking through craft"—just as in her early paintings she translated acrylic paint into a kind of thread that she applied to canvas in thin skeins using a hypodermic needle, here drawing is applied via an embroiderer's needle onto silk, a technique that echoes the sexual activity depicted in the drawing. Moving to the level of representation, Leonardo's removal of half a body to render visible the hidden coupling of sexual organs is subverted in Scott's uncoupling, thread by thread, of the horizontal weft below the image, and the vertical warp above it, thereby reframing the image within deconstructed fabric. Ironically, the sagging loops above and tangled locks below speak more to disruptive bodily pleasures than Leonardo's detached anatomical observations.[41] Through this intervention into the very fabric of painting, Scott shows the

Mary Scott, *Imago, (viii)*
"translatable" «Is That
Which Denies», 1988
(cat. 52)

Image courtesy Art Gallery
of Alberta, Photo: Charles
Cousins.

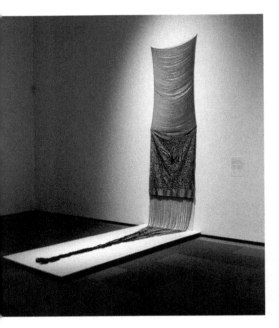

Mary Scott, *Imago, (viii)*
"translatable" «Is That
Which Denies», 1988
(cat. 52).

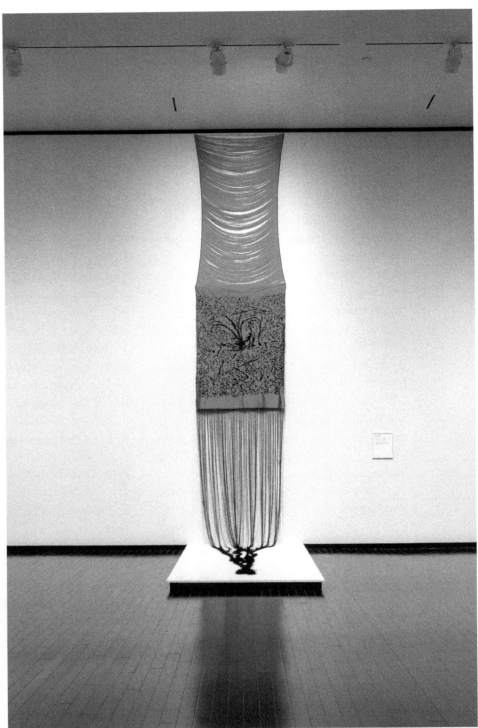

excisional violence of the frame, the scopic violence of the cross-section, and the construction of gender binaries to be imbricated within the prior order of weaving. Whether her deconstructed fabric is viewed as a representation of the Semiotic (Kristeva) or the de-differentiation which precipitates the sacrificial crisis (Girard), thread is a means to think through a number of fundamental questions. If Sullivan restores to painting the condition of a textile by bodily removing it from the frame, Scott pushes one step further to question what painting's condition as textile means for our understanding of the relationship between representation and the social order. The answer to that question hovers between material lineages and the order of the image, between the umbilical body of weaving and the phantom limb of art. In this ambivalence, perhaps we can understand Newdigate's enigmatic statement that tapestry is located "everywhere and nowhere, is everything and nothing."

If Scott brings into question the binary construction of art and weaving, Julia Bryan-Wilson, using the metaphor of the "fray", dismantles it altogether. She has argued how non-professional artists, in particular women of colour, have dismantled false binaries and made "vital interventions regarding how textiles bring together corporeality, materiality, community building, history making, race, class, and gender."[42] In terms of this essay, the loose edges of the "fray" are none other than the multitude of umbilical connections which each new intervention brings into play. These umbilical points of reference help undo the hierarchies that have structured Western aesthetics while opening the possibility of explorations of alterity and

creating new, more flexible, architectures of belonging.

Another Year, Another Party (cat. 40) offers a homespun Prairie example of those umbilical connections at work.[43] The project was the inspired idea of Ann Newdigate who received from her friend Kate Waterhouse, a pioneer in the development of Prairie plant dyes, her stock of dyed wool in 1992. In thinking about how to honour this gift, she conferred with Annabel Taylor, coordinator of the weaving program at the Woodlands Campus of the Saskatchewan Institute of Applied Science and Technology in Prince Albert. Taylor herself had inherited yarn from artist Margreet van Walsem after her passing in 1979—an artist who had been a mentor to Dyck, Newdigate, Taylor, and Waterhouse. Together they invited the Prince Albert Weavers and Spinners Guild to create a tapestry using this special yarn to honour the many contributions of Waterhouse and van Walsem. The project had multiple umbilical dimensions that brought together material, social, and temporal strands. Produced collaboratively with locally sourced yarns dyed with Prairie plants, the tapestry was the product of threads that had been spun over the course of three decades, going back to a workshop in 1971 when van Walsem and Newdigate first encouraged Waterhouse to record her knowledge of native Saskatchewan dye plants in a book.[44] As Newdigate observes:

> *Another Year, Another Party* had begun, not simply when Kate Waterhouse gave me her yarn, or when Margreet van Walsem invited Annabel Taylor to her weekly investigations into the possibilities for

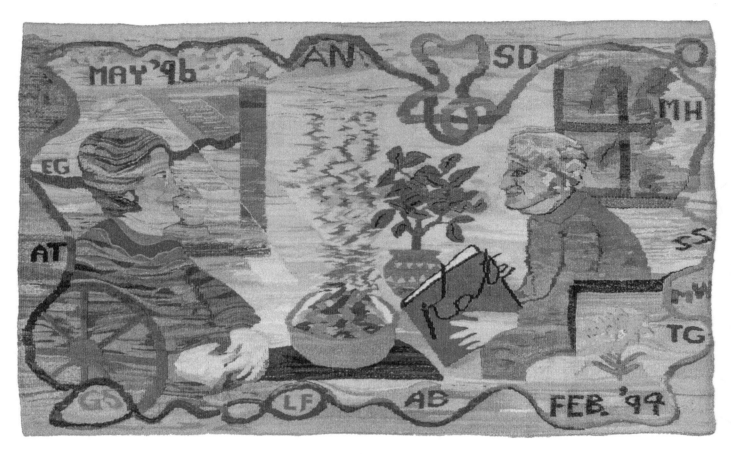

Ann Newdigate with members of the Prince Albert Spinners and
Weavers Guild and the Saskatchewan Institute of Applied Science
and Technology Weaving Program, *Another Year, Another Party*,
1994–1996 (cat. 40).

Image courtesy Mann Art Gallery.

textile arts, nor perhaps at the pot-luck feast at Thérèse Gaudet's home, or even when we workshopped the cartoon in Prince Albert, but possibly at the beginning of time when the art of weaving was discovered to be an integral part of the fabric of society.[45]

Appropriately, what appears to be an umbilical cord unites the initials of all the participants along the outer edge of the tapestry, which was finished in 1996. The work is emblematic of Newdigate's concerns for the marginalization of tapestry practices connected with women's work and imagery—"the low end of the Low Art sphere"—as Newdigate wrote in her essay "Kinda Art, Sorta Tapestry" one year earlier. Newdigate concludes, "there was no institution, benefactor, patron, or funding to dictate the imagery. Instead, the imagery and construction developed compatibly, spontaneously, and pragmatically, out of a group collaborative negotiation."[46] Though not a tapestry, Prairie Barnacles (cat. 32) was similarly produced through a collaborative process by members of the Crafts Guild of Manitoba to celebrate their fiftieth anniversary. This is the supplement of the amateur as described by Adamson, and the creation of an architecture of belonging.

A more current articulation of umbilical connections is signaled in Cindy Baker's latch-hooked rugs, which are represented in the exhibition by I know people are stealing my things, 1998 (cat. 4). Baker is a fat activist and queer rights advocate who frequently uses craft to skew ideals concerning beauty, gender and sexuality, art, and value. Her series Welcome Mats, 1997–2007, employs latch

hooking—an artistic medium used primarily by amateurs—for its subversive potential. In her words, she creates "welcome mats for the not necessarily welcome. Just as actual welcome mats cannot be taken to mean that anyone standing upon the doorstep is welcome within, my welcome mats should not be taken to mean literally what they say."[47] Baker exploits the ambiguity of what artist and cultural theorist Allyson Mitchell has referred to as "abandoned craft" to express and explore alterity.[48] Baker sees the hastily scrawled handwritten messages that she translates into yarn as a revealing kind of "body language," an affective form of communication which she unites umbilically to the grid of the rug. For her and other artists of the new millennium, an architecture of belonging begins with a queering and cripping of discourse that registers the voices of alterity on their own terms.[49]

Beyond the Umbilical Frame

Imagine a house in a wide Prairie valley. On the table is a hooked rug too large for it to hold. A young woman, working by the light of a lamp, hooks a geometric design in pink, green, and orange. She has talked about the design with the Elders. They call the rugs Ta-hah-sheena for the decorated robes worn by Tatanka Oyate, the Buffalo People. She works with her family, her community.

They are making tapestries for the great hall of a library in a new university. Their designs will welcome a community of learning with Dakota intelligence and beauty.

In 1970, the University of Regina commissioned three monumental hooked rugs for its new library, a graceful modernist edifice designed by World Trade Centre architect Minoru Yamasaki. It was a high-water point for the Sioux Handcraft Co-operative, a collective of women from Standing Buffalo Dakota First Nation in the Qu'Appelle Valley of southern Saskatchewan. Between 1967 and 1972, they produced hundreds of hooked rugs based on new and traditional Dakota designs as part of a government-sponsored economic-development project. Marge Yuzicappi's tall vertical design of two intersecting pink triangles on a green and orange field (cat. 60), along with those produced by Martha Tawiyaka and Bernice Runns, are outstanding examples of the ongoing vitality of artmaking among the Dakota, Lakota, and Nakota nations that make up the Sioux peoples of Saskatchewan.

The Ta-hah-sheena rugs, however, raise questions about works that do not neatly fit the categories of art and craft that we have discussed to this point. The Dakota word for the latch-hooked rugs, *Ta-hah-sheena*, signals this issue. The identification of the rugs with a type of ceremonial robe that could also be hung on the inside of tipis and other structures for decoration and warmth, places them firmly within a Sioux frame of reference.[50] The connection to a garment is significant here. Art historian Janet C. Berlo notes that among the Sioux "a handmade garment is never simply utilitarian. Its functionality extends into metaphysics. . . . In the Lakota language, *saiciye* is the term for adorning oneself in traditional fashion in a way that is pleasing to denizens of both the spirit world and the human world."[51] While the rugs were not made for ceremonial use, nor were the designs necessarily traditional, they point to a Sioux understanding of artistry that does not distinguish a separate class of objects called "art". Bea Medicine, in her seminal essay "Lakota Views of 'Art' and Artistic Expression," underlines this point, observing that "the integrative aspect of art in a Native perspective appears to negate segmentalized thinking in realms of arts and crafts."[52]

If the frames of art and craft represent an imposition on these tapestries, what frame is appropriate? One possible approach would be to consider how the original Ta-hah-sheena were made.[53] Could the cut which separated hide from animal be considered an aesthetic frame? Certainly, the act of skinning defines the surface and edges of the hide, which preserves in its form and substance the presence of the animal whether worn or displayed. If this cut is integral to the meaning of the Ta-hah-sheena, and at work within the remediated form of the latch-hooked rug, then the Sioux Handcraft Co-operative tapestries could be viewed within three distinct frames: as modernist abstractions created in the tradition of fine art tapestries for architectural spaces; as Indigenous craft produced according to a government economic development model; and as Ta-hah-sheena,

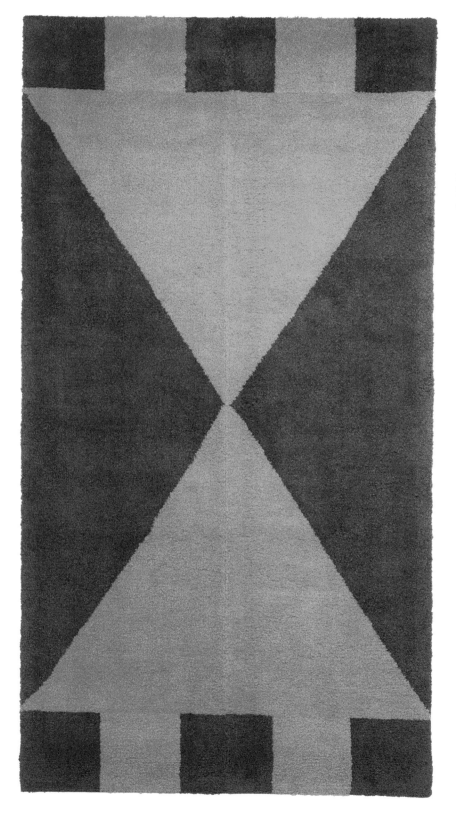

Marge Yuzicappi,
Tapestry (Ta-hah-sheena),
c. 1970 (cat. 60)

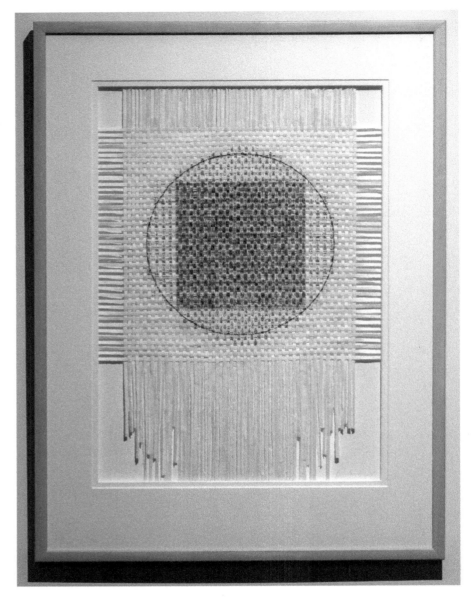

Amy Loewan, *A Mandala "The Circle and the Square,"* 1996 (cat. 30)

Amy Loewan, *A Mandala "The Circle and the Square"* (detail), 1996 (cat. 30)

a traditional Dakota art form. Those frames represent three distinct cuts: excisional, umbilical, and what might be called integumental, the broader term pertaining to the skin, hair, hooves, and feathers of animals. If this approach is valid, no one frame can be considered to the exclusion of the others; the work of theory is rather to uncover occluded frames, understand their interaction with the so-called dominant cultural forms, and ultimately come to terms with how the creators worked within or against these frames. In the case of the Ta-hah-sheena rugs, their integumental grounding—their identity as wrappings carrying the physical trace and memory of plains bison—reinforces the connection to the bodies, culture, language (oral and visual), and land of the Tatanka Oyate. As we have seen, these connections have a sympathetic resonance with the umbilical frame of weaving, which contains within its very fibres ties to animal, land, and body. Moreover, in their journey from a communal kitchen table in the Qu'Appelle Valley to an urban university campus, these works offer a quietly effective critique of the elitist frame of high art creation and transmission.

Another work that is useful for articulating the edges of the umbilical metaphor and which sheds light on the question of non-Western frames is the paper weaving of Amy Loewan. Born in Hong Kong, Loewan brought to her artmaking in Canada a perspective steeped in Chinese traditions of paper and ink rather than oil and canvas. Her forays as a graduate student at the University of Alberta in 1994 saw her translate Chinese calligraphy into the frame of modernist abstraction, using oversized brushes that required her entire body to inscribe characters on large sheets of paper laid on the floor. In subsequent works, calligraphy was applied to surfaces stained with a grid of dripped paint resembling weaving. In 1996, she began to integrate calligraphy with her own method of paper weaving,[54] creating works such as *A Mandala "The Circle and the Square,"* 1996 (cat. 30). As she describes it:

> This is an important piece of work in my artistic career. It is one of my very early rice paper weavings, a seminal work, which later on evolves into my major large rice paper weaving installations known collectively as "The Peace Projects." I begin this work with the tactile process of transforming sheets of large rice paper into long weaving strips. They are then delicately woven to form an integrated whole. In this work, the theme of "kindness" is the subject for exploration. Handwritten calligraphy of the word "kindness" in standard and ancient Chinese scripts are interwoven with computer-generated text of the English word "kindness" in a variety of fonts. The words and the calligraphy (English from left to right and Chinese from top to bottom, east and west intersecting naturally with the weaving of the paper) symbolize all languages. Circle and Square are universal symbols from many cultures and belief systems. According to the Chinese tradition (my personal heritage), Circle refers to the "sky" and Square refers to the "earth", together it signifies the universe. My art aims to evoke

contemplation and to serve as a vehicle for personal transformation.[55]

While a full theory of the relationship of Eastern and Western art practices is impossible in this short space, it is instructive to note the conditions out of which Chinese painting evolved. In China, visual art develops out of a relationship to the written word, rather than the icon.[56] In fact, it was only when painting became allied with calligraphy in the Song Dynasty that it was considered a fine art rather than a craft. The relationship of the written word to the sacred is foundational to Chinese culture; the earliest pictograms and ideographs are found on objects associated with ritual, divination, and contracts. In Taoist ritual, sacred writings were sacrificed in place of live victims.[57] In art, the relationship to the sacred is located in the written character rather than the Western excisional frame. How, then, should we describe the frame of Chinese painting and calligraphy? One possible approach would be to consider the cut or break involved with each individual brushstroke, the basic unit of calligraphy. These "bones," which when combined into a character make up a "body," hold the expressive presence of ideas and concepts. Seen in this light, the underlying logic of the cut in Chinese art is segmental, rather than excisional, umbilical, or integumental. It is the relation of the part to the whole, of the individual to society, that is essential to the conceptualization of this frame.

Loewan deploys the framing power of the written word in *A Mandala "The Circle and the Square."* By inscribing the word "Kindness" multiple times, in different scripts, fonts, and languages, onto each individual strip of paper, she points to the need for widely distributed expressions of caring rather than centralized assertions of dominance to create a harmonious relationship between the individual and society. As in the Ta-hah-sheena hooked rugs, a third frame creates expressive energies that are amplified by the frames of craft and art. Weaving, with its metaphorical connection to the social order, echoes the tension between individual—symbolized by the fringe of loose strips along the edges—and the interwoven whole. In her subsequent "Peace Project" installations, the place of the viewer is triply engaged as a place of viewing, writing, and weaving, an example of the potential to be found in exploiting multiple aesthetic frames.[58]

This essay began with a call for an expanded frame of weaving, one that would allow it to breathe, to operate on its own terms, without the confining edge of frame or plinth. As we have seen, weaving's umbilical cut establishes a relationship to the sacred quite different from the excisional cut of painting and sculpture. While art invokes the sacrificial victim through the phantom limb of aesthetic presence, weaving carries the potential to touch and clothe that limb. When weaving becomes art, the touchless frame meets the frame of touch. This connection defines the expanded frame of weaving, a frame that allows for contacts to extend along the many deterministic threads upon which society hangs—the "bad habits of the West," as Newdigate trenchantly calls

them. Weaving's ties to its conditions of production—material, corporeal, temporal, geographical, and social—long held to be a hindrance in its search for elevated status, provide the means for an effective connection to be formed. In countless works, of which *Prairie Interlace* represents but a small sample, weaving embraces what is marginalized, dispossessed, and devalued and restores it to the social body.

Prairie Interlace is but one part of the much larger story of how the flexibility of thread met the conceptual power of the frame in the post-Second World War era and unleashed a worldwide phenomenon the effects of which are still being felt. Developments on the Canadian Prairies reflect movements in Europe and the United States, but always with a local inflection, an umbilical tie to regional geographies, histories, identities, and cultures. In the epochal transition that marked the breakup of Modernism over the past half century, weavers and other interlace practitioners proved extraordinarily resilient as they adapted themselves to shifting imperatives.

Post-colonial dialogues are increasingly oriented toward global aesthetic practices with origins in non-Western and Indigenous cultures. The analysis of the umbilical cut of weaving and its interaction with the excisional frame of art prepares the way for an understanding of interactions with these alternative frames. Kirsty Bell writing in *Tate etc.* magazine notes: "Textiles seems to be uniquely positioned to perform a subtle interfacing between culture and civilization: through an angle towards broader cultural and socio-historical hegemonies."[59] These "cross-cultural entanglements" (Checinska and Watson)[60] point to the urgent need for a critical apparatus that can account for the interface of cultural perspectives without subsuming one frame within another. The need is even more pressing given the migration of weaving into digital frames.[61] *Prairie Interlace* provides an extraordinary range of examples of what an expanded frame of weaving might look like: its potential for critical insights, its ability to traverse different material and cultural terrains, and its engagement with diverse communities. In these works, and the umbilical histories they reveal, lie the threads of new futures.

NOTES

1 Throughout this essay I will use the term "weaving" to refer to a constellation of interlace practices, including tapestry, woven sculpture, rug hooking, knitting, and macramé, in which woven and knotted filaments are integral to the object's structure. While overlaps in form and intention exist with needle-based practices, such as sewing, embroidery, and quilting, as well as with other textile and fibre arts, this approach allows for a concentrated analysis of the material and historical lineages that are specific to interlace practices. It also resists a premature assimilation of these practices into the frame of art.

2 Janis Jefferies, Diana Wood Conroy and Hazel Clark, eds., *The Handbook of Textile Culture* (London: Bloomsbury Publishing, 2016).

3 Christine Checinska and Grant Watson, "Textiles, Art, Society and Politics," in *Handbook of Textile Culture*, 280.

4 This portrait of the artist in her studio is based on: "A Conversation with Ann Newdigate—Prairie Interlace," interview by Mireille Perron, Nickle Galleries, September 9, 2022, https://youtu.be/WTdrG0xKds4; and MacKenzie Art Gallery Artist's Questionnaire for *National Identity, Borders and the Time Factor, or, Wee Mannie*, 1982-015, undated.

5 Ann Newdigate, "Kinda art, sorta tapestry: tapestry as shorthand access to the definitions, languages, institutions, attitudes, hierarchies, ideologies, constructions, classifications, histories, prejudices and other bad habits of the West," in *New Feminist Art Criticism: Critical Strategies*, ed. Katy Deepwell (Manchester: Manchester University Press, 1995): 174–181.

6 Newdigate, "Kinda art," 174.

7 Mary Scott, email correspondence to the curators, October 7, 2022.

8 Newdigate, "Kinda art," 174.

9 Sarat Maharaj, "Textile Art—Who Are You?" in *Distant Lives/Shared Voices*, ed. Sharon Marcus et al., trans. Marysia Lewandowska (Łódź, Poland: 1992); reprinted in *World Wide Weaving—Atlas: Weaving Globally, Metaphorically and Locally*, ed. Dorothee Albrecht (Oslo: Oslo National Academy of the Arts, 2017), 7. Derrida's concept of the "undecidable" is from Jacques Derrida, "Living on/borderlines" in *Deconstruction and Criticism* (New York: Seabury Press, 1979), 75–176.

10 Glenn Adamson, *Thinking Through Craft* (Oxford: Berg, 2007). See in particular Chapter 5 "Amateur," 139–63, which includes a discussion of the work of Ann Newdigate.

11 Adamson, *Thinking Through Craft*, 12.

12 Adamson's references to fibre art in *Thinking Through Craft* consider the fabric collages of Miriam Shapiro and Faith Ringgold, the weaving of Magdalena Abakanowicz, Ann Newdigate, and Faith Wilding, and the more recent craft deployments of Mike Kelley and Tracey Emin. A fuller account of the critical potential of fibre art is provided in his contemporaneous article, "The Fiber Game," *Textile: The Journal of Cloth and Culture* 5, no. 2 (2007): 154–77.

13 Jacques Derrida, *The Truth in Painting*, trans. Geoff Bennington and Ian McLeod (Chicago: University of Chicago Press, 1987), 61; cited in Adamson, 13.

14 The following argument is condensed from my essay in *Theatroclasm: Mirrors, Mimesis and the Place of the Viewer*, ed. Timothy Long (Regina: MacKenzie Art Gallery, 2009). For more on René Girard's theory of the scapegoat, see: *Violence and the Sacred*, trans. Patrick Gregory (Baltimore: Johns Hopkins University Press, 1977); and *The Scapegoat*, trans. Yvonne Freccero (Baltimore: Johns Hopkins University Press, 1986).

15 Andrew J. McKenna, in his comparison of Girard and Derrida's theoretical frameworks, makes this equivalency explicit: "The victim occupies the place—within and without the community—in Girard's view of cultural origins that writing occupies in Derrida's critique of the origins of original presence, of which language is but the representation and writing the secondary representation, the forlorn and occluded trace. The victim, like writing, is a supplement of a supplement (speech), a stand in, an arbitrary substitute for any and all members of a community that does not exist prior to the victim's expulsion." Andrew J. McKenna, *Violence and Difference: Girard, Derrida, and Deconstruction* (Urbana, IL: University of Illinois Press, 1992), 16.

16 McKenna, *Violence and Difference*, 16.

17 Hans Belting, *Likeness and Presence: A History of the Image before the Era of Art*, trans. Edmund Jephcott (Chicago: University of Chicago Press, 1994).

18 See Long, *Theatroclasm*.

19 See Timothy Long, *The Limits of Life: Arnulf Rainer and Georges Rouault* (Regina: MacKenzie Art Gallery, 2004).

20 Girard, *Scapegoat*, 176–77.

21 This is a term coined by Canadian artist Liz Magor to describe those works which incorporate everyday objects (tables, blankets, ashtrays, etc.) and generate an effect which hovers between objecthood and representation. See Timothy Long, *Double or Nothing: Problems of Presence in Contemporary Art* (Regina: MacKenzie Art Gallery, 2013), 40.

22 Aside from Greek deities, one might mention those found in the cosmologies of the Romans (Parcae), Norse (Norns), Egyptians (Isis), Japanese (Ameratsu), Indians (Draupadi), and Anasazi-Hopi and Navajo peoples (Spider Woman). The Greek conception of weaving as fundamental to the establishment of social order is an idea which finds parallels in many of these cultures. For more on the relationship of weaving to myth, see Elizabeth Wayland Barber, *Women's Work: The First 20,000 Years: Women Cloth and Society in Early Times* (New York: W. W. Norton & Company, 1994), 232ff. A sample of feminist and post-colonial readings of weaving in myth include: Ruth Scheuing, "Penelope and the Unravelling of History," in *New Feminist Art Criticism*, 188–196; "The Unravelling of History: Penelope and Other Stories," in *Material Matters: The Art and Culture of Contemporary Textiles*, ed. Ingrid Bachmann and Ruth Scheuing (Toronto: YYZ Books, 1998), 201–13; Sarat Maharaj, "Arachne's Genre: Towards Intercultural Studies in Textiles," *Journal of Design History*, Vol. 4, No. 2 (1991), 75–96; and Kiku Hawkes, "Skanda," in *Material Matters*, 233–38.

23 "According to some authors Zeus is supreme and controls all, but others portray a universe in which even the great and powerful Zeus must bow to the inevitability of Fate's decrees. The depth of this feeling of the Greeks for the working of Moira or the Moirae cannot be overemphasized." Mark P. O. Morford and Robert J. Lenardon, *Classical Mythology*, 2nd ed. (New York: Longman, 1971), 162. For example, the final dialogue of Plato's *Republic* describes how the Moirai turn the great spindle of Necessity that holds heaven and earth together. See Morford and Lenardon, 247–48.

24 M. L. West, *Indo-European Poetry and Myth* (Oxford: Oxford University Press, 2007), 382.

25 The sacrificial nature of the work of the Moirai is evident in thinly veiled scapegoating narratives such as the tale of Admetus and Alcestis. When Apollo asked the Fates to extend the life of Admetus, King of Thessaly, the request was granted on the condition that someone else must die in his place. The only "volunteer" who could be found was the king's wife, Alcestis.

26 In ceramics, artists have responded by using the medium's historical forms to question the frame of art by bending, with a deft twist, optical appreciation via plinth and frame back to tactile appropriation as vessel and tile. See Timothy Long, "Which Way is Up? Jack Sures and the Art/Craft Debate," in *Tactile Desires: The Work of Jack Sures*, ed. Virginia Eichhorn (Regina, SK: MacKenzie Art Gallery, 2012), 61–69.

27 Animal bodies are also materially invoked in several of the weavings, whether sheep's wool (Annabel Taylor), dog's hair (Susan Barton-Tait), or rabbit skin (Anne Ratt). Ethel Schwass' abstracted weavings are based on the form of a horse blanket. Ultimately, weaving contains the body of the land, whether through the intermediary of an animal, through plants fibres and dyes, or directly through mineral pigments.

28 *Charlotte Lindgren: Fibre Structures*, exhibition catalogue (Halifax: Art Gallery of Nova Scotia, 1980), n.p.

29 "Mural and Spatial: How the Lausanne Biennials 1962–1969 Transformed the World of Tapestry," Centre Culturel et Artistique Jean Lurcat, Aubusson, France, 2019, https://www.cite-tapisserie.fr/sites/default/files/DP-ENGL-Mural-and_Spatial-v3_0.pdf.

30 See Adamson, *Thinking Through Craft*, 58–65.

31 See Adamson, *Thinking Through Craft*, 103–37.

32 Within the frame of modernist art production, time is a disputed term. Michael Fried's essays contrasting the gracelessness of "objecthood" to the transcendent presentness or absorption of "art" is one of the more hotly debated formulations of the debate. Objecthood implies the lack of a frame, to be left in ordinary (and thus boring) space and time, while art implies the activity of a frame which secures the quasi-divine state of presence/presentness. Weaving can be seen as one of the antidotes to this conundrum, by manifesting the time, registered in the trace of labour, that produces the final work.

33 See Anne Gérin, "Importance et question essentielles" in *Françoise Sullivan: sa vie et son œuvre*, Art Canada Institute/Institut de l'art canadien, https://www.aci-iac.ca/fr/livres-dart/francoise-sullivan/importance-et-questions-essentielles/. I had the opportunity to see this extraordinary performance in 2016 at the MacKenzie Art Gallery with Françoise Sullivan in attendance as part of *MAGDANCE: Art + Dance*, an exhibition-residency with New Dance Horizons.

34 The work of Brazilian artist Helio Oiticica performs a similar transformation and was one of the touchstones for the 2012 exhibition *Social Fabric* at the Institute of International Visual Art, London. See Checinska and Watson, "Textiles, Art, Society and Politics," 279.

35 This insight was sparked by Kader Attia's video installation *Reflecting Memory* (2016), which was presented at the MacKenzie Art Gallery in 2019 as part of the exhibition *Re: Celebrating the Body*.

36 Gérin, "Importance et question."

37 Additional details were provided by Dickerson in a telephone interview with the author, November 30, 2022.

38 For more on Dickerson's engagement with Coast Salish weaving see: Katharine Dickerson, "Classic Salish Twined Robes," *BC Studies*, no. 189 (Spring 2016): 101–27; and Sandra Alfoldy, "'Homage to Salish Weavers,'" in *The Allied Arts: Architecture and Craft in*

Postwar Canada (Montreal: McGill-Queens University Press, 2012), 155–57.

39 See "A Conversation with Aganetha Dyck—Prairie Interlace," interview by Alison Calder, Nickle Galleries, September 9, 2022, https://www.youtube.com/watch?v=etwp7l8e2gc.

40 See Sherry Farrell Racette's essay in this volume.

41 Scott has Kristeva's psychoanalytic theory in mind here, playing off the disruptive dynamism of Semiotic (imago) against the social constraints of the Symbolic. See Bruce Grenville's discussion of the Imagos series in the exhibition catalogue, Mary Scott (Lethbridge, AB: Southern Alberta Art Gallery, 1989), 8.

42 See Julia Bryan-Wilson, Fray: Art and Textile Politics (Chicago: University of Chicago Press, 2017), 14.

43 Other works in Prairie Interlace that might be mentioned here include Prairie Barnacles, a work produced collaboratively by sixteen members of the Crafts Guild of Manitoba to mark their 50th anniversary, and the hooked rugs of the Sioux Handcraft Co-operative.

44 Kate Waterhouse, Saskatchewan Dyes: A Personal Adventure with Plants and Colours (Prince Albert, SK: Write Way Printing, 1977).

45 Ann Newdigate, "The Particular History of a Saskatchewan Community Tapestry," The Craft Factor (Saskatoon, SK) (Spring/Summer 1997): 8.

46 Newdigate, "Particular History," 8.

47 Cindy Baker, "'Welcome' Mats," artist's website, https://www.cindy-baker.ca/work-2013/welcome-mats-2f93t.

48 Baker, "'Welcome Mats.'" See also "Interview: Susanne Luhmann talks with Allyson Mitchell," Atlantis (Mount Saint Vincent University, Halifax) 31, no. 2 (2007): 103–4.

49 Weaving metaphors have evolved in recent years as witnessed by the naming of the Toronto-based group Tangled Art + Disability. Eliza Chandler, the organization's first Disability-identified Artistic Director writes: "A tangle is not a knot—it can be undone or remain happily tangled. Tangles are messy and imperfect, but they are also complex, intricate, organic, even deliberate. Tangles represent what this organization does: we bring together all kinds of people and practices." https://tangledarts.org/about-us/our-history/.

50 See Susan Probe, Ta-Ha-Sheena: Sioux Rugs from Standing Buffalo Reserve, exhibition brochure (Regina: Dunlop Art Gallery, 1988), 8.

51 Janet Catherine Berlo, "Beauty, Abundance, Generosity, and Performance: Sioux Aesthetics in Historical Context," in The Sioux Project—Tatanka Oyate, ed. Dana Claxton (Regina, SK: MacKenzie Art Gallery and Information Office, 2020), 43

52 Bea Medicine, "Lakota Views of 'Art' and Artistic Expression," in Sioux Project, 55.

53 This insight came from a year-long encounter with Sitting Bull's decorated robe which was loaned to the MacKenzie Art Gallery from the North Dakota State Historical Society for the exhibition Walking with Saskatchewan in 2019–2020. I am indebted to conversations with artists Wayne Goodwill from Standing Buffalo Dakota First Nation and Dana Claxton, a member of Wood Mountain Lakota First Nation, for a deeper understanding of its significance.

54 Although painting on woven paper is practiced in parts of China, Loewen's method of paper weaving is a personal innovation and does not refer to a tradition or genre in Chinese art. Amy Loewan, email communication to the author, December 12, 2022.

55 Amy Loewan, artist's statement for Prairie Interlace information form, 2021.

56 See Dawn Delbanco, "Chinese Calligraphy," Heilbrunn Timeline of Art History, Metropolitan Museum of Art, April 2008, https://www.metmuseum.org/toah/hd/chcl/hd_chcl.htm; and Maxwell K. Hearn, How to Read Chinese Paintings (New York: Metropolitan Museum of Art, 2008).

57 Kristofer Schipper, The Taoist Body, trans. Karen C. Duval (Berkeley: University of California Press, 1993), 90. Amy Loewan notes, "Practicing Chinese Calligraphy can be considered as a sacred act. Each stroke, each brush work, one puts down with ink on the absorbent Shuen paper with intention has power. An experienced calligrapher can notice if the writing is done with intention (also refer to as bones). I have been told that there is some instrument that can measure the energy and power of the brushwork. This explains why calligraphy, the written word, can be employed as healing device, as talisman in the Taoist tradition." Amy Loewan, email to the author, December 14, 2022.

58 See Amy Loewan: Illuminating Peace, ed. Robert Freeman and Linda Jansma (Mississauga: Art Gallery of Mississauga, 2009). Amy Loewan notes, "The House Project is inspired by Lao Tzu, the ancient Chinese sage, who wisely addressed the forming of a better society this way: 'If there is to be peace in the world, ultimately there must be peace in the home and peace in the heart.' Cultivation of individual character becomes the foundation for a better society. This quote is handwritten in English and posted across the inside of the House. These eight values: compassion, kindness, respect, understanding, patience, tolerance, gentleness, and forgiveness are repeatedly written in all my paper weave projects. Public participation component is an important aspect of my installation. For example, in the House Project, I provided viewers with colourful post-it

notes and invited them to write 'What would you do to make this world a better place.'" Loewan, email.

59 Cited in Janis Jefferies, "Introduction," in *From Tapestry to Fiber Art*, 19.

60 Checinska and Watson, "Textiles, Art, Society and Politics," 279.

61 For example, see Sara Diamond, "The Fabric of Memory: Towards the Ontology of Contemporary Textiles," in *Handbook of Textile Culture*, 367–85.

LIST OF WORKS

Catalogue 1

Pat Adams

b. 1943, Tisdale, Saskatchewan, Canada

Prairie Sunset, 1983

77.5 x 148 cm

rug weaving, pick on pick technique; wool, linen

MacKenzie Art Gallery, University of Regina Collection, 1983–8

"The Prairie shaped my weaving." This simple statement by Saskatchewan artist and weaver Pat Adams makes clear the motivation behind works such as *Prairie Sunset*. Subtle colour gradations, brought to life using multiple shuttles on his large Glimakra loom, define a vibrant, uninterrupted space. Like the Métis sashes he later produced, these landscape weavings speak to an identity closely bound to the land.

Reproduced page 122.

Catalogue 2

Pat Adams

b. 1943, Tisdale, Saskatchewan, Canada

Remember That Sunset We Saw from Here One Time?, 1984

79 x 147 cm

rug weaving, pick on pick technique; wool, linen

Collection of Julia and Yolande Krueger

Pat Adams has described his weaving process as beginning with an image in his mind's eye. Every step is planned in advance, from the sequence of shading to dyeing his own yarn. The end product is like a memory, an artifact of the original image in his mind, a reality humorously illustrated in this landscape-within-a-landscape.

Reproduced cover, page 134.

Catalogue 3

Ilse Anysas-Šalkauskas

b. 1942, Berlin, Germany to Lithuanian refugees

Rising from the Ashes, 1988

203 x 120 cm

pieced and knotted; leather

Collection of the Artist

A student at the Alberta College of Art (1976–1980), Ilse Anysas-Šalkauskas credits Katharine Dickerson for teaching her how to weave and instilling an experimental approach. After graduation she began investigating the use of locally sourced leather scraps—upcycling and thrift a part of her family ethos. *Rising from the Ashes* is the second leather tapestry she created. It represents healing and survival against all odds—as Lithuanian refugees in Germany and later as immigrants to the U.S. and Canada. It also references her deep appreciation for the undulating landscape of the foothills in western Alberta with their cycles of growth and decay. Ilse Anysas-Šalkauskas continues to work with fibre, most often quilting and appliqué, and is teaching her granddaughter how to weave.

Reproduced pages xviii, 129, 198.

Catalogue 4

Cindy Baker

b. 1975, Leduc, Alberta, Canada

I know people are stealing my things, 1998

42 x 108 x 4 cm

latch-hooked; acrylic, wool, cotton

Collection of the Alberta Foundation for the Arts

Cindy Baker is a fat activist and queer rights advocate based in Western Canada who frequently uses craft to skew ideals concerning beauty, gender and sexuality, art, and value. Her series *Welcome Mats* (1997–2007) employs latch hooking—an artistic medium used primarily by amateurs—for its subversive potential. In her words, she creates "welcome mats for the not necessarily welcome. Just as actual welcome mats cannot be taken to mean that anyone standing upon the doorstep is welcome within, my welcome mats should not be taken to mean literally what they say." Baker exploits the ambiguity of what artist and cultural theorist Allyson Mitchell has referred to as "abandoned craft" to express and explore alterity.

Reproduced page 154.

Catalogue 5

Susan Barton-Tait

b. 1948, Campbellton, New Brunswick, Canada

Nepenthe, c. 1977

110 x 209 cm

free-form weaving; dog hair, wool, assorted fibres

Collection of the Artist

After arriving in Winnipeg from the U.S.A. in 1974, Susan Barton-Tait found little encouragement for her off-loom explorations until the arrival of Aganetha Dyck in 1976. The two soon became friends with Barton-Tait assisting Dyck with felting experiments in her studio. Barton-Tait's own unconventional approach to materials is evident in this loom-based work. Using yarn spun from dog's hair which she and her friends collected, Barton-Tait's weaving evokes the long-corded coat of Nepenthe, her Hungarian Puli dog, after whom this work is named.

Reproduced pages xv, 191.

Catalogue 6

Inese Birstins

b. 1942, Madona, Latvia

Mindscape, 1978

177.8 x 96.5 x 17.8 cm

free-form weaving, hand-dyed; jute, sisal, mixed fibres

Collection of Surrey Art Gallery, Gift of Bruce Ambrose

In 1978, with only a few years of weaving instruction under her belt, Inese Birstins conducted two residencies at the Banff Centre for the Arts: *Sculptural Weaving* and *Fibre in Architectural Space*. *Mindscape*, which dates to this period, suggests Birstins' command of her medium and commitment to pushing the limits of weaving through an exploration of natural materials and textures, an expansion into three dimensions, and references to inner thoughts and landscapes. Birstins was one of a handful of Canadians included in Constantine and Larsen's groundbreaking book, *The Art Fabric: Mainstream* (1981) with her felted work *Interchange II* (1979)—possibly created during the Banff Fibre Interchange residency of 1979.

Reproduced pages 69, 77.

Catalogue 7

Rose Buffalo

d. 1988, Standing Buffalo First Nation, Saskatchewan, Canada

Ta-Hah ʻ Sheena, 1968

Sioux Handcraft Co-operative

110 x 36.5 cm

latch-hooked; wool, cotton

SK Arts Permanent Collection

Reproduced page 48.

Catalogue 8

Brenda Campbell

b. 1942, Moose Jaw, Saskatchewan, Canada

Woodlands Undercover, 1975

298 x 360.5 x 8 cm

weaving, wrapped coils, rya; natural wool, cotton, fleece

Collection of the Alberta Foundation for the Arts, 1977.042.001

Considering Brenda Campbell's Pop-inspired weavings of the same era, *Woodlands Undercover*'s lack of colour is startling. Rather than overwhelm the senses with bursts of greens, pinks, and purples, Campbell challenges viewers to be present, to carefully consider and respond to what is in front of them. Technically sophisticated— Campbell studied at the Alberta College of Art and worked with Douglas Motter and Associates—*Woodlands Undercover* exploits numerous techniques in one piece: tapestry, wrapping, and rya (knotting used in shag rugs). However, the title hints at something more—pockets of woodlands filled with hidden drop-offs and tucked-away animals, secrets only revealed to those who slow down.

Reproduced page 182.

Catalogue 9

Nancy Crites

b. 1951, Toronto, Ontario, Canada

Threshold: No Laughing Matter, 1991

41 x 65 x 4 cm

hooked rug technique; latex condoms, cotton

SK Arts Permanent Collection, C92-93.01a

Pink and blue condoms—hardened over time to a caramel brown— spell out the word "WELCOME" in Calgary artist Nancy Crites' unconventional hooked rug, a work created during her early years in Prince Albert, SK. According to the artist: "This mat is a reflection of my concern with the AIDS epidemic and demystifying the condom to ensure safety and protection. [It] is a statement about crossing the line into private space, be it physically, sexually, or otherwise—respect, permission, and safety for all involved must be considered."

Reproduced pages 150, 151.

Catalogue 10

Nancy Crites

b. 1951, Toronto, Ontario, Canada

Threshold: No Laughing Matter II, 2022

53 x 71 cm

hooked rug technique; hand dyed felted wool, sari silk, cotton

SK Arts Permanent Collection, C92-93.01b

The pink and blue fibres of this hooked rug recall the colourful condoms used to create the first version of *Threshold: No Laughing*

Matter thirty years earlier. While the original mat spoke to the role of condoms in ensuring "safety and protection" during the AIDS epidemic, her updated version "expresses concern for the role and implications of the Welcome Mat during a global pandemic. Who crosses the threshold into your private space, your home, studio, etc.?"

Reproduced page 155.

Catalogue 11

Katharine Dickerson

b. 1947, Duluth, Minnesota, United States

West Coast Tree Stump, 1972

226 x 297 x 267 cm

twined, supplemental weft; jute, spindle spun wool, burlap

Collection of the Canada Council Art Bank, 74/5-0968

Katharine Dickerson was already a celebrated artist and weaver when she moved to Calgary to teach weaving at the Alberta College of Art (ACA) in 1977. She had studied at the celebrated Haystack Mountain School of Crafts with Jean Stamsta and at the School of the Art Institute of Chicago alongside Claire Zeisler, before moving to a farm on Vancouver Island. Here she set aside precise technical weaving for a more experimental approach, one informed by her study of Indigenous textile techniques. Her work grew in scale and complexity resulting in the monumental work, *West Coast Tree Stump*. This was created off-loom in her outdoor studio surrounded by living trees. She created several other large-scale commissions including the immersive *West Coast Forest* for the Department of Public Works (Douglas Building) in Victoria, 1974–75. Taking over from the retired F. Douglas Motter at ACA, Dickerson's approach to weaving was compared to the explosive rock of Jimi Hendrix.

Reproduced pages xviii, 78, 129.

Catalogue 12

Aganetha Dyck

b. 1937, Winnipeg, Manitoba, Canada

Rope Dance, c. 1974

293 x 37.5 x 30 cm

crochet; jute

SK Arts Permanent Collection, 1976-305

As a child growing up in rural Manitoba, Aganetha Dyck was fascinated by the crocheted doilies and baskets of her Mennonite grandmother. After a move to Prince Albert in 1972, Dyck began to create imaginative forms using this technique, including a pig and piglets crocheted out of copper wire. These works caught the attention of George Glenn, Director of the Prince Albert Art Centre, leading to an invitation to move into the Centre's studio. There Dyck would be introduced to Saskatchewan's vibrant weaving community, including Margreet van Walsem, Annabel Taylor, Kaija Sanelma Harris, and Ann Newdigate, among others.

Reproduced page 190.

Catalogue 13

Aganetha Dyck

b. 1937, Winnipeg, Manitoba, Canada

Close Knit, 1976

35 x 89 x 391 cm

felting via wringer washing machine; wool

SK Arts Permanent Collection, 2022-074

As a student of master weaver Margreet van Walsem in the mid-1970s, Aganetha Dyck soon became impatient with the demands of loom-based work. After accidently discovering the beauty of shrunken wool, Dyck's preferred art-making apparatus became a washing machine, rather than a loom, and discarded woolen goods her favoured medium, rather than yarn. *Close Knit*, created after her move from Prince Albert to Winnipeg in 1976, belongs to her signature series *Sizes 8 to 46*. The shrunken wool sweaters in this work form a tight, cohesive group, asserting a feminist perspective on the value of domestic life and work.

Reproduced page 118.

Catalogue 14

Murray Gibson

b. 1960, Victoria, British Columbia, Canada

Prairie Carpet, 1990

tapestry; wool, silk, cotton

Imperial Oil Limited Collection

Over his distinguished career, Murray Gibson has often paid respect to weaving's long history and global reach by referencing textile patterns inspired by cultures from around the world. *Prairie Carpet* was commissioned by Esso Resources Canada for the Esso Research Centre on the University of Calgary campus. The tapestry is meant to evoke a "magic carpet ride" over the Prairies and mountains and through the aurora borealis, and to echo the inquisitive journeys of researchers as they explore the universe. Unusually, the top section of the carpet is woven front-to-back so that it can only be read properly when it is folded over—a reference to how knowledge can flip our understanding of reality. Gibson, a graduate of the Alberta College of Art, is currently based in Antigonish, Nova Scotia.

Reproduced pages 97, 114.

Catalogue 15

Nancy Goodpipe

1928–2006, Standing Buffalo First Nation, Saskatchewan, Canada

Rug, 1968

Sioux Handcraft Co-operative

76.2 x 68.6 cm

latch-hooked; wool, cotton

SK Arts Permanent Collection

Reproduced page 42.

Catalogue 16

Evelyn Goodtrack

b. 1950, Fort Qu'Appelle, Saskatchewan, Canada

Dakota Rug, c. 1968

Sioux Handcraft Co-operative

174.5 x 113.5 cm

latch-hooked; wool, cotton

SK Arts Permanent Collection

As a teenager, Evelyn Dale Goodtrack (nee Yuzicappi) was one of the junior members of the Sioux Handcraft Co-operative. She attributes the design of *Dakota Rug*—the only one in this grouping with floral motifs—to a "grandmother from Prince Albert." Goodtrack enjoyed the community aspects of the project—how everyone chipped in and helped one another—and appreciated how it brought everyone closer to the Elders. This rug was hooked mainly in the evening under lamplight as Goodtrack's house did not have electricity at the time. Today, she lives with her husband, Hartland Goodtrack,

in Standing Buffalo First Nation. The two serve as Elders for the Saskatchewan Indigenous Cultural Centre and are dedicated to educating Dakota and Lakota youth.

Reproduced page 36.

Catalogue 17

Jessie Goodwill

Rug, 1967

Sioux Handcraft Co-operative

65 x 76 cm

latch-hooked; wool, cotton

SK Arts Permanent Collection

Reproduced page 41.

Catalogue 18

Phyllis Green

b. 1950, Minneapolis, Minnesota, United States

Boob Tree, 1975

109.2 x 55.9 x 50.8 cm

crochet; yarn, wood

Collection of the Winnipeg Art Gallery, Acquired with funds from the Estate of Mr. and Mrs. Bernard Naylor, funds administered by The Winnipeg Foundation, 2014-128

As poster image for the 1975 exhibition *Woman as Viewer*, Phyllis Green's *Boob Tree* was an instant hit. The Winnipeg Art Gallery's exhibition for International Women's Year celebrated a "women's view of herself and her world" (Zenith Corne, 1978), but also challenged a concurrent exhibition which mainly featured images of women created by men. Whether it was *Boob Tree*'s humour, punchy colour, use of crochet (a stereotypical female craft), or archetypical resonance, it proved irresistible. As writer Doug Harvey later confessed, "The poster was popular and controversial and seemed to be everywhere in the city—until it became a thing to steal them; a criminal trend in which I confess I myself participated" (Harvey, 2018).

Reproduced pages xix, 146, 168.

Catalogue 19

Ann Hamilton

b. 1956, Lima, Ohio, United States

Untitled, 1979

262 x 250 cm

weaving; cotton, sisal, wool

Collection of Walter Phillips Gallery, Banff Centre for Arts and Creativity

Ann Hamilton is a major American artist best known for her immersive multimedia installations that respond to architectural settings and social history. Less well-known are her roots in fibre. After learning to weave with Cynthia Schira at the University of Kansas (BFA 1979), Hamilton spent the following year weaving at the Banff School of Fine Arts. "When I was first in Banff, I was doing work that was very much like [Schira's]. I still feel a lot of my work comes out of a textile sensibility." After Banff, she moved to Montréal before pursuing a graduate degree in sculpture at Yale (MFA 1985). Subsequent work has displayed a concern for the "relations of cloth, sound, touch, motion and human gesture" and a "dense materiality."

Reproduced pages 64, 188.

Catalogue 20

Kaija Sanelma Harris

1939, Turku, Finland–2022, Saskatoon, Saskatchewan, Canada

Stubble Field, 1984

161 x 142 cm

double weave tapestry; wool

Collection of the Canada Council Art Bank, 87/8-0276

For Finnish-trained artist and weaver Kaija Sanelma Harris, experimentation with weaving techniques has been linked to her desire to transmit sensory experiences of the Prairies through woven structures. Between 1981 and 1987, she created a series of double woven tapestry landscapes "with a major emphasis on color and relief" (Harris in Moppett, 1993). In *Stubble Field* the rolling countryside around Saskatoon, pricked with straw after harvest, is imaginatively captured through looped elements and a rich palette of earthen tones.

Reproduced page xvii.

Catalogue 21

Kaija Sanelma Harris

1939, Turku, Finland–2022, Saskatoon, Saskatchewan, Canada

Sun Ascending, 1985

396.2 x 86.2 cm (each of 24 components)

tapestry; wool, linen

Collection of the MacKenzie Art Gallery, gift of Cadillac Fairview Corporation Ltd., 2014-12

In 1984, Saskatoon artist and weaver Kaija Sanelma Harris was one of a select group of Canadian artists invited by Cadillac Fairview Corporation to produce textiles to warm the austere modernist interiors of the TD Centre, a complex of buildings designed by architect Mies van der Rohe. *Sun Ascending*, her largest work and most important architectural commission, is a modular, geometric landscape that recalls in abstracted form the sun rising above an aspen grove, a landscape typical of both her native Finland and her adopted home. The two sets of panels create the sense of a clearing within a thicket.

Reproduced pages xvii, xx, 82, 98.

Catalogue 22

Margaret Harrison

b. 1941, Katepwa Lake, Saskatchewan, Canada

Margaret's Rug, c. 2005

55.8 x 99.1 cm

hooked rug technique; recycled wool sweaters, tee shirts, silk on burlap

Private Collection

In *Margaret's Rug*, Margaret Harrison departs from traditional Métis floral designs to depict a specific place—her home in the Katepwa Lake road allowance community in southern Saskatchewan's Qu'Appelle Valley. Each element refers to a specific place, story, or women's task from Harrison's youth. According to Métis academic Cheryl Troupe, the rug is "a contemporary mnemonic device that allows her [Harrison] to remember and share." With her mother, Adeline Pelletier dit Racette, Harrison has worked tirelessly to preserve and energize the traditional Métis art forms of rug hooking and silk embroidery. Their efforts are highlighted in the Gabriel Dumont Institute (GDI) films *Aen Kroshay aen tapee avec mi gineey: Métis Hooked Rugs* and

Mashnikwawchikun avec la sway di fil: Métis Silk Embroidery (see the GDI YouTube page).

Reproduced pages 14, 15, 54, 60.

Catalogue 23

Eva Heller

b. 1946, Łódź, Poland

Heat, 1983

Panel A: 227.5 x 95 x 3 cm

Panel B: 231 x 92 x 3 cm

Panel C: 228 x 95 x 4 cm

Panel D: 231 x 97 x 3 cm

shaped tapestry; wool, cotton

Collection of the Alberta Foundation for the Arts, 1985.001.001.A-D

"Sunshine, grass of the Prairies, summer heat. . . . Every winter I was waiting for a Chinook and the first signs of spring." Eva Heller's description of the inspiration for *Heat* points to her interest in translating impressions of nature into magnificent abstracted Gobelin tapestries. Heller received her training at the State Higher School of Fine Arts in Łódź, Poland where guest lecturers included Janina Tworek-Pierzgalska, Anna Sledziewska, and the influential Magdalena Abakanowicz. Produced two years after arriving in Canada, *Heat* proved challenging for Heller, who lacked a large studio space in her Lethbridge home. Instead, she wove it on a simple frame in a small bedroom and dyed the wool in a large pot in her kitchen.

Reproduced page pages 96, 129.

Catalogue 24

Theresa Isnana Sr.

d. 1977, Standing Buffalo First Nation, Saskatchewan, Canada

Rug, 1967

Sioux Handcraft Co-operative

86.3 x 55.9 cm

latch-hooked; wool, cotton

SK Arts Permanent Collection

Reproduced page 41.

Catalogue 25

Pirkko Karvonen

b. 1935, Forssa, Finland

Rapeseed Fields, 1974

230 x 97 x 6 cm

weaving, rya, plant dyed; wool

Collection of the Alberta Foundation for the Arts, 1974.100.001

Pirkko Karvonen was taught to weave by her stepmother in Finland in response to the postwar shortage of utilitarian objects like rugs, towels, and tablecloths. After coming to Canada in 1951, she established a studio practice in Edmonton where she taught weaving to scores of students across the province through the Edmonton School Board's Extension Services and Alberta Culture. *Rapeseed Fields*, 1974, offers an abstracted rendering of a canola field and illustrates her masterly combination of design, technique, and dyeing skills. It also recalls the significant efforts of Prairie agricultural researchers in the 1970s to create canola (formerly known as rapeseed), an oilseed crop whose brilliant yellow flowers illuminate the Prairie landscape in July and August.

Reproduced page 128.

Catalogue 26

Jane Kidd

b. 1952, Victoria, British Columbia, Canada

Landslice #1, 1988

54 x 53 cm

slit woven tapestry with pulled warp; wool, cotton, rayon, linen, silk

Landslice #1 and *Landslice #3* are part of a series Jane Kidd wove after joining the faculty of the Alberta College of Art, where she taught from 1980 to 2011. Smaller and more intimately scaled than her large architectural commissions, the works explore woven structure and form. Kidd created the rich texture by pulling on the warp threads, gathering them into a compressed low-relief sculpture reminiscent of geological stratification. Her subsequent tapestries have been more figurative in nature and exploit a rich personal iconography that draws on her research into the history of textiles, the natural world, and the phenomenon of collecting. Kidd was awarded the prestigious Saidye Bronfman Award for fine craft in 2016.

Collection of the artist

Reproduced pages 104, 105, 131.

Catalogue 27

Jane Kidd

b. 1952, Victoria, British Columbia, Canada

Landslice #3, 1989

54 x 53 cm

slit woven tapestry with pulled warp; wool, cotton, rayon, linen, silk

Collection of the artist

Reproduced pages 164, 179.

Catalogue 28

Charlotte Lindgren

b. 1931, Toronto, Ontario, Canada

Winter Tree, 1965

148.3 x 73 cm

weaving; wool, wire

Collection of Confederation Centre Art Gallery, CM 67.1.36

Charlotte Lindgren's *Winter Tree* was featured in the acclaimed *Canadian Fine Crafts* exhibition at Expo 67 and reflects the artist's ongoing interest in architecture. Woven flat on a loom in purple wool—a colour chosen for its clarity, weightlessness, and timelessness—the weaving's three-dimensional form was not realized until hung. Although by this time based in Halifax, Lindgren's Winnipeg years (1956–1963) played a pivotal role in her development. While working as a design lecturer in the Home Economics department at the University of Manitoba, Lindgren took instruction in weaving from her colleague Lillian Allen. A series of wall hangings created prior to her move to Halifax in 1964 drew the attention of American textiles doyen Jack Lenor Larsen, leading to an invitation to the Haystack Mountain School of Crafts in Deer Isle, Maine. Lindgren went on to represent Canada twice at the Lausanne International Tapestry Biennial (1967, 1969) and to teach at the Banff Centre in the 1970s.

Reproduced pages 117, 119.

Catalogue 29

Carol Little

1949–2015, Calgary, Alberta, Canada

Furrow, 1976

364 x 91.8 cm

twill woven, warp ikat; wool

Collection of the Alberta Foundation for the Arts, 1977.027.001

Carol Little was one of the many former Alberta College of Art students to join Douglas Motter and Associates' custom weaving business in Calgary, honing her skills from 1973 to 1978, before founding her own studio. She continued to weave throughout the 1980s, focusing mainly on works for exhibition and commission. She later went on to found Handspirits, a co-operative gallery, in 1987, shifting her practice to focus more on batik and painted silks. *Furrow* was woven during Little's tenure with Douglas Motter and Associates and bears the company label on the reverse. The subtle bands of ikat and sculptural presentation recall Prairie agricultural landscapes. Place was a recurring source of inspiration for Little.

Reproduced pages xv, 122.

Catalogue 30

Amy Loewan

b. 1945, Hong Kong

A Mandala "The Circle and the Square," 1996

66.5 x 45.8 cm

weaving, calligraphy; Shuen (rice) paper, Chinese ink, charcoal, computer printouts

Collection of the Alberta Foundation for the Arts, 1997.168.001

As a mature student in the art department at the University of Alberta, Amy Loewan began to incorporate sensibilities and materials from her Chinese heritage in calligraphic drip paintings. The grid-like woven patterns of this calligraphy led her to explore the process of physically weaving strips of rice paper. The horizontal and vertical strokes of the character for "kindness" were particularly evocative for her and became the impetus for her *Project Kindness* series. In *A Mandala "The Circle and the Square"* the word kindness is printed in various fonts from left to right in English and calligraphically written in Chinese from top to bottom. Together with symbols for earth (square) and sky (circle), the work weaves an optimistic cross-cultural statement about the power of kindness to create a better world.

Reproduced page 208.

Catalogue 31

Amy Loewan

b. 1945, Hong Kong

A Peace Project, 2000

95 x 68 cm

weaving, calligraphy; Shuen (rice) paper, Chinese ink, charcoal, computer print outs

Collection of the Alberta Foundation for the Arts, 2000.068.001

A Peace Project is an early example of Loewan's woven rice paper works which today have evolved into a series of large installations collectively known as *The Peace Projects*. Appearing geometric and abstract from a distance, the work reveals upon closer inspection a series of words that have been integrated into the rice paper weave: compassion, kindness, respect, understanding, patience, tolerance, gentleness, and forgiveness. In 1998, art historian David Silcox

wrote about this series: "Her materials remind us of how fragile human rights are. This simple, powerful, but gently moving work is made of soft white rice paper and ink . . . and these reverberating words invoke ideas, which are the most powerful weapons in the world-wide battle for human dignity."

Reproduced pages 172, 173.

Catalogue 32

Crafts Guild of Manitoba

Prairie Barnacles, 1979

approx. 175 cm wide

rep weave; wool, wood

Collection of Manitoba Crafts Museum and Library, 581.00

Prairie Barnacles is a collaborative project which points to the strong communities associated with weaving across the Prairies. Created to celebrate the fiftieth anniversary of the Crafts Guild of Manitoba, it was based on a workshop led by Ken Weaver (an apprentice of the noted American author and textiles promoter Jack Lenor Larsen), directed by Anne Ayre, and installed by Gordon Ayre. Participating artists included: Lee Anderson, Shirley Anderson, George Baldwin, Janet Baldwin, Wynn Buchanan, Andrea Burchard, B. Renton Goodwyn, Chris Grossman, Ruth Johnston, Catherine MacLean, Jean McMurray, Ruby Monds, Henrietta Mullin, Ivy Rollo, Carol Romanyk, and Roberta York. The barnacles were woven on the floor of the Guild in Winnipeg using a technique called warp-faced rep weave (warp rep) in which the warp threads are set closely together and alternating thick and thin weft threads are used to create a ribbed texture. Similar to Jane Kidd's *Landslice* series, a strong warp thread on one side of each barnacle was pulled to form the three-dimensional shape.

Reproduced pages 112, 129, 192.

Catalogue 33

Florence Maple

1922–2000

Rug, 1969

Sioux Handcraft Co-operative

113.5 x 93 cm

latch-hooked; wool, cotton

SK Arts Permanent Collection

Marie Florence Maple (née Perreault) was a Métis woman who initially made hooked rugs in the traditional Métis style. After moving with her family to Standing Buffalo First Nation, one of the few First Nations to accept citizens without treaty status, Maple helped manage the Sioux Handcraft Co-operative and taught rug-making skills to the young women of the community. Later in life, she moved to Winnipeg, Manitoba.

Reproduced pages 13, 48.

Catalogue 34

Florence Maple

1922–2000

Tipi Mat, 1967

Sioux Handcraft Co-operative

68.6 x 68.6 cm

latch-hooked; wool, cotton

SK Arts Permanent Collection

Reproduced pages 13, 42.

Catalogue 35

Cathryn Miller

b. 1950, Toronto, Ontario, Canada

Winter Sun, c. 1977

88 x 120 cm

tapestry; wool, cotton

SK Arts Permanent Collection, C77.5

Toronto-born artist Cathryn Miller began weaving in 1974 after setting up a studio in Grasswood, a small community near Saskatoon. Self-taught, Miller's textiles were regularly chosen for the Saskatchewan Handcraft Festival Juried Exhibition, from which this work was purchased by the Saskatchewan Arts Board (now SK Arts). The complex interplay of geometric forms, whether in weaving or in paper, have interested Miller throughout their career.

Reproduced page 174.

Catalogue 36

F. Douglas Motter

1913, Chicago, Illinois, United States–1993, Calgary, Alberta, Canada

This Bright Land, 1976

216 x 350 cm

plain weave; wool, copper, steel

City of Calgary Public Art Collection, Gift of the Calgary Allied Arts Foundation, 1983 990072 A-F

It was a twist of fate that saw F. Douglas Motter take up weaving. Trained as a painter, in 1945 he bought a loom for his wife, Jeanette. "We started weaving as a hobby, but somewhere along the line things got out of hand." Motter occupied the family loom and eventually founded Douglas Motter and Associates in 1961, a weaving company that produced hand-woven goods, custom yardage, and commissioned hangings. His weavings were highly celebrated and were selected for inclusion in the Brussels World Fair of 1958 and Expo 67. Major commissions included tapestries designed for the Legislative Building in Edmonton as well as *This Bright Land*, commissioned for the entrance to the Calgary Convention Centre. Motter was the first weaving instructor at the Alberta College of Art (1967–1977) and mentor to Carol Little, who likely wove this work.

Reproduced pages 94, 113.

Catalogue 37

Ann Newdigate

b. 1934, Makhanda (also known as Grahamstown), South Africa

Collage Preparatory Sketch for Wee Mannie, 1980

41 x 39.5 cm

collage; pastel, crayon, watercolour, pencil crayon, ink on paper

MacKenzie Art Gallery, University of Regina Collection, purchased with the assistance of the Canada Council Art Bank, 1982-16

Drawings are often the basis for Ann Newdigate's tapestries. Setting two paradigms in dialogue, her work incorporates "the tension between the systematic quality of the tapestry process and the apparent freedom of marks made by pencil or paint in the drawings" (Newdigate, 1982).

Reproduced page 132.

Catalogue 38

Ann Newdigate

b. 1934, Makhanda (also known as Grahamstown), South Africa

National Identity, Borders and the Time Factor, or, Wee Mannie, 1982

99 x 109.2 cm

tapestry; cotton, silk, wool, synthetic fibre

MacKenzie Art Gallery, University of Regina Collection, purchased with the assistance of the Canada Council Art Bank, 1982-15

As a recent immigrant from South Africa to Saskatoon, Ann Newdigate was drawn to weaving in the 1970s thanks to the influence of Prince Albert weaver Margreet van Walsem. Continuing her studies at the Edinburgh College of Art, Newdigate created this Gobelin-style tapestry using a famous photograph of Métis leader Louis Riel that was taken after his capture at Batoche in 1885. According to Newdigate, "the tapestry has an autobiographical element because the date of the photo compares almost exactly with the date of one of the Boer Wars in South Africa when my grandfather was killed at Faber's Puts." As the title suggests, her interweaving of colonial narratives crosses borders, and raises complex questions about the erasures and appropriations by which national identities are constructed.

Reproduced pages 133, 185.

Catalogue 39

Ann Newdigate

b. 1934, Makhanda (also known as Grahamstown), South Africa

Then there was Mrs. Rorschach's dream/ You are what you see, 1988

181 x 87 cm

tapestry; linen, silk, synthetic fibres, wool, cotton

Collection of the Canada Council Art Bank, 90/1-0261

"With the figure of Mrs. Rorschach, the artist points to historians' neglect of both women and tapestry. Although Mrs. Rorschach was a practising psychologist, her presence has been hidden from history, overshadowed by her more famous husband, just as tapestry has been neglected by art history, overshadowed by the more prestigious fine arts" (Bell, 1988).

Reproduced pages xix, 129, 158, 159, 180, 181.

Catalogue 40

Ann Newdigate with members of the Prince Albert Spinners and Weavers Guild and the Saskatchewan Institute of Applied Science and Technology Weaving Program

Another Year, Another Party, 1994–1996

114 x 162 cm

tapestry; wool

Mann Art Gallery Permanent Collection

This wonderful tapestry was woven with threads spun over the course of three decades. It was inspired by Ann Newdigate and Annabel Taylor, both of whom received gifts of yarn from their friends and mentors: Margreet van Walsem and Kate Waterhouse, pictured here. *Another Year, Another Party* commemorates a dynamic community of weavers, spinners and dyers based in Prince Albert, SK, their connections and shared histories. They include: Ann Newdigate, Alice Bergquist, Jill Couch, Sheila Devine, Lorraine Farish, Thérèse Gaudet, Elaine Greve, Mary Hunt, Gail Sheard, Shirley Spidla, Madelaine Walker, Melanie Wiens, Annabel Taylor, and Noella Thompson. The wool was coloured with dyes from local plants by Kate Waterhouse.

Reproduced page 204.

Catalogue 41

Maija Peeples-Bright

b. 1942, Riga, Latvia

Sunny Snail Woofish, c. 1970

35 x 81 x 0.5 cm

crochet; wool, fabric, paint, buttons

Collection of the MacKenzie Art Gallery, gift of Veronica and David Thauberger, 1999-167

The work of California artist Maija Peeples-Bright offers one of the few Prairie intersections of textiles and ceramics, another medium with ambitions to overturn modernist assumptions about art and craft. Peeples-Bright's sojourn in Regina overlapped with that of her former teacher, the noted Funk ceramist David Gilhooly. From 1970 to 1971, she created a wide range of Funk-inspired works in ceramic and textile, including crocheted "Woofishes," a play on the word "fetish" and the name of her Dachshund, Woof W. Woof. During this period, she also produced crocheted, woven, and sewn "beast" curtains for the Art Building at the University of California, Davis.

Reproduced page 152.

Catalogue 42

William Perehudoff

1918–2013, Saskatoon, Saskatchewan, Canada

Untitled Tapestry (Loeb Commission), 1976

120.7 x 160 cm

punch-hooked; acrylic, cotton, latex

Collection of Confederation Centre Art Gallery, Gift of Mr. and Mrs. Jules Loeb, 1980, CM 80.6.5

In 1975, Toronto collector and philanthropist Fay Loeb initiated a project that would see twenty-three leading artists from across Canada produce designs for a series of limited edition tapestries. The tapestries were conceived as a way to warm the often-uninviting common areas of public and commercial buildings. William Perehudoff from Saskatoon was one of five Prairie artists selected. His tapestry, which is based on a small collage, took advantage of the vibrant hues of acrylic yarn that were used in the tapestry workshop in Mexico. Artisans accentuated the colour edges in his design by hand-carving a deep "V" in the punch-hooked pile, thereby replicating the cut elements of the original collage.

Reproduced page 96.

Catalogue 43

Gayle Platz

b. Toronto, Ontario, Canada

Large Tapestry Weave, c. 1974

190 x 66 cm

slit-woven, free-form tapestry; bouclé, chenille, wood

Collection of the Winnipeg Art Gallery, Acquired with funds from The Winnipeg Foundation, G-74-12

In the early 1970s, two young experimental weavers, Gayle Platz and Marilyn Foubert, established a shop-studio in Winnipeg whimsically named "Frolicking Fantasy." The weavers, who had met at Sheridan College in Ontario, were given an exhibition of the same name at the Winnipeg Art Gallery in 1974. It highlighted their interest in structure, material, tactility, and an expanded understanding of what fibre arts could be. In *Large Tapestry Weave*, Platz combines wood, bouclé, and chenille into an organic shape with a prominent negative space—a work that demonstrates a myriad of tactile and formal possibilities.

Reproduced page 95.

Catalogue 44

Anne Ratt

d. 1970s Saskatchewan, Canada

Mat (cross pattern), c. 1971

53 x 47 cm

looped; rabbit fur

SK Arts Permanent Collection, N73.5

Anne Ratt was from the Lac La Ronge Indian Band and a citizen of Sucker River First Nation in northern Saskatchewan. For her rabbit fur mats, Ratt employed traditional northern Cree techniques that were used to make lightweight, warm, and breathable garments and blankets. Lengths of rabbit fur were cut and dried, then rubbed and worked to make them pliable, and finally looped in a manner similar to crochet using the index finger as a hook. According to Sherry Farrell Racette, an Algonquin/Métis academic, the small scale of these rabbit fur mats and their sale through La Ronge's Northern Handicraft Co-operative Centre (an alternative to the trading post system), indicates they were possibly a "test product" for tourists or a southern market.

Reproduced page 39.

Catalogue 45

Anne Ratt

d. 1970s Saskatchewan, Canada

Mat (radiating circle pattern), c. 1971

51 x 44 cm

looped; rabbit fur

SK Arts Permanent Collection, N73.6

Reproduced page 39.

Catalogue 46

Elaine Rounds

b. 1943, Harvard, Illinois, United States

Prairie Twill Seasons (Ode to Spring, Summer, Fall and Winter), 1985

104 x 104 cm (each)

twill woven; wool, acrylic, cotton, linen

Collection of the Artist

This suite of four weavings is a celebratory ode to the dramatic change of seasons on the Prairies. When Rounds first moved to Brandon, Manitoba from Colorado in 1970, the landscape did not appeal to her. However, she eventually fell in love with its subtle and sublime beauty and began weaving her appreciation into wall hangings with strong horizontal lines. In addition to the twill weave of this work, Rounds is also known for her use of the Swedish inlay technique. *Prairie Twill Seasons (Ode to Spring, Summer, Fall and Winter)*, has hung in the land titles office in Brandon and in the office of the director of the Rural Development Institute at Brandon University, and it was included in the 1989 exhibition *Urban/Rural Landscape* at the Art Gallery of Southwestern Manitoba.

Reproduced page 135.

Catalogue 47

Mariette Rousseau-Vermette

1926, Trois-Pistoles, Québec, Canada–2006, Montréal, Québec, Canada

Anne-Marie, 1976

183 x183 cm

weaving, boutonné technique; wool, cotton

Collection of Walter Phillips Gallery, Banff Centre for Arts and Creativity

When Mariette Rousseau-Vermette arrived in Alberta to head the Fibre program at The Banff Centre for the Arts (1979–1985) she was already established internationally as a leading tapestry artist, appearing four times at the influential Tapestry Biennial in Lausanne, Switzerland (1962, 1965, 1967, 1971). Along with her Canadian contemporaries, she forged a new awareness and appreciation for tapestry—a "Fibre Revolution" that would see textile artists experiment with new materials and push the limits of traditional weaving off the wall. One of a series of almost monochromatic works, *Anne-Marie* embodies modernist restraint and quiet contemplation. Similar works were exhibited as part of major 1976 exhibition at the Winnipeg Art Gallery, examples of which are found today in the collection of the Metropolitan Museum of Art in New York.

Reproduced pages xviii, 70.

Catalogue 48

Florence Ryder

c. 1935–2005 Standing Buffalo First Nation, Saskatchewan, Canada

Untitled (lilac ground), no date

45.7 x 95.3 cm

Hooked rug technique; wool, mixed fabrics on burlap

Private Collection

Florence Ryder was a citizen of the Standing Buffalo Dakota First Nation located in the Qu'Appelle Valley of southern Saskatchewan. She learned to make rugs when she was ten years old from her mother, Elizabeth Ryder. Ryder's designs were floral based until a brief stint with the Sioux Handcraft Co-operative encouraged her to adopt geometrical Dakota designs. Unlike the latch-hooked Ta-hah-sheena wool rugs of the Co-operative, Ryder's hooked rugs are made with used clothing (mostly polyester pants) acquired from the Friendship Centre in the nearby town of Fort Qu'Appelle, resulting in colours that reflect the fashion trends of the recent past. Inspiration for her designs came from a variety of sources, including books, magazines, television, and powwows.

Reproduced pages 13, 176.

Catalogue 49

Florence Ryder

c. 1935–2005 Standing Buffalo First Nation, Saskatchewan, Canada

Untitled (pink ground), no date

48 x 91 cm

Hooked rug technique; wool, mixed fabrics on burlap

Collection of Jack Severson

Reproduced page 49.

Catalogue 50

Jane Sartorelli

1924, Toronto, Ontario, Canada–2006 Edmonton, Alberta, Canada

Cerridwen, c. 1975

231 x 139.7 x 12.7 cm

free-form macramé; wool, acrylic, mixed fibres

Collection of Nick and Annette Radujko

The 1970s saw the proliferation of feminist art practices—works that sought to recuperate "feminine" techniques, subjects, and bodies in order to challenge patriarchy. It is unlikely Jane Sartorelli travelled

to see Judy Chicago's *The Dinner Party* when it was launched in Brooklyn in 1974, however, *Cerridwen* shares much of its boldness, strength, and abstracted feminine forms. Sartorelli began working with textiles in the mid-1960s combining techniques to create her own idiosyncratic style of low-relief tapestry. Her work was shown and collected extensively in Edmonton allowing Sartorelli to support her five children as a single mother. Her subjects were most often figurative, although she experimented with abstraction. Cerridwen is the name of an ancient Welsh goddess associated with rebirth and inspiration.

Reproduced page 153.

Catalogue 51

Hazel Schwass

1925, Wadena, Saskatchewan, Canada–2011, Calgary, Alberta, Canada

Untitled, 1974

160 x 80 x 8 cm

free-form tapestry; wool, sheep fleece, bones, wooden beads

Collection of the Alberta Foundation for the Arts, 1974.022.001

In 1943, 18-year-old Saskatchewan born artist and weaver Hazel Schwass devoted 210 hours to the Searle Grain Company's concentrated weaving study program. Building on this foundation, she continued studies with Margreet van Walsem and Kate Waterhouse at the Saskatchewan Summer School for the Arts in Fort Qu'Appelle, SK, and with Mary Snyder at Banff. Known in Lethbridge as an influential teacher and "the lady who made saddle blankets," Schwass also produced more experimental works that incorporate elements of her blankets—juicy padding, rectangular shape, and a single fringe—in novel and expressive forms. She was an influential teacher at Lethbridge Community College and active member of the Lethbridge Handicraft Guild; the Handspinners, Weavers and Dyers of Alberta; the Handweavers, Spinners and Dyers of America; and the Lethbridge Allied Arts Council.

Reproduced page 16.

Catalogue 52

Mary Scott

b. 1948, Calgary, Alberta, Canada

Imago, (viii) "translatable" «Is That Which Denies», 1988

739 x 99.1 cm

embroidery, deconstructed fabric; silk

Art Gallery of Alberta Collection, gift of Mr. Joseph Pierzchalski, 95.36

As a painter, Mary Scott has consistently pushed the boundaries of what painting is. In the mid-1980s, after working as Assistant Head of Visual Arts at the Banff Centre (1982–1984), Scott's work began to consider the relationship between surface and ground, image and text, disruption and order. Her series *Imago*, from the Latin word for "image", explores Lacan's idea of the idealized image or archetype—and the phallocentrism which French feminists sought to subvert. *Imago, (viii) translatable «Is That Which Denies»* is a length of deconstructed silk cloth—not woven but un-woven. The central panel is embroidered with the abstracted image of a Leonardo da Vinci drawing showing the cross-section of a man and women engaged in coitus.

Reproduced pages xix, 202.

Catalogue 53

Margaret Sutherland

1922, Calgary, Alberta, Canada–2017

The Seed, c. 1984

162.6 x 58.4 cm

Theo Moorman inlay technique; wool

Collection of Red Deer Museum + Art Gallery, Gift of Dr. Kathleen A. Swallow

Margaret Sutherland first learned to weave at the Banff School of Fine Arts, taking courses with Mary Snyder (1973) and F. Douglas Motter (1974). In 1980/81, Sutherland was included in *Fibrations*, "the province's first juried contemporary fibre art exhibition," juried by Glen Allison, Ann Lambert and Mariette Rousseau-Vermette for the University of Alberta (later travelling to The Nickle Arts Museum, now known as Nickle Galleries). Throughout the 1980s, Sutherland undertook numerous large-scale architectural weaving commissions in Alberta, including tapestries for Sun Life Place in Edmonton and Sun Life Plaza in Calgary. Sutherland, who lived for a time in the bush outside Rocky Mountain House, nurtured a deep appreciation of nature, a sensibility reflected in *The Seed*.

Reproduced page 171.

Catalogue 54

Martha Tawiyaka

c. 1877–1979, Standing Buffalo First Nation, Saskatchewan, Canada

Tipi Mat, 1967

Sioux Handcraft Co-operative

76.2 x 61 cm

latch-hooked; wool, cotton

SK Arts Permanent Collection

Martha Tawiyaka, a descendant of Chief Standing Buffalo, was a Sisseton Dakota woman, midwife, and medicine woman. As a founding member of the Sioux Handcraft Co-operative and its "spiritual head," Tawiyaka worked with other Elders from the community to provide traditional Dakota designs for the young women in the co-operative. Her work was presented to dignitaries and collected by several institutions, the most significant being a large tapestry made for the University of Regina that remains on display in the Dr. John Archer Library. In 1969, she was noted as one of the "Canadians You Should Know" by *Maclean's* magazine.

Reproduced page 40.

Catalogue 55

Annabel Taylor

1937, Lucky Lake, Saskatchewan, Canada–2006, Deep River, Ontario, Canada

Ten Shades of Sheep, 1983

133 x 86 cm

rug weaving technique, weft-faced; handspun wool, linen

SK Arts Permanent Collection, Donated by the Saskatchewan Craft Council, 2020-059

Annabel Taylor was a founding member of the Prince Albert Spinners and Weavers Guild and a former student of Margreet van Walsem and Ann Newdigate. *Ten Shades of Sheep* is a prize-winning example of her interest in natural dyeing and spinning, techniques which she often taught. "The challenge of using a simple structure, a limited palette of colour, pure materials and classic elements of carpet design," Taylor writes, "have involved me in a process which is simple and direct, a process which has been very satisfying."

Reproduced page 116.

Catalogue 56

Margreet van Walsem

1923, Zutphen, The Netherlands–1979, Prince Albert, Saskatchewan, Canada

Birth, 1971

86.4 x 35.6 cm

tapestry; wool

Collection of Mann Art Gallery, 2005.07.010

Dutch-born artist Margreet van Walsem was introduced to natural dyed wool and weaving by Anton Skerbinc at the Saskatchewan Summer School of the Arts in Fort Qu'Appelle in 1969. Her work harmonizes a deep feeling for nature with a use of natural materials, an interest in ancient and Indigenous weaving techniques, and a choice of subject matter that "involves being surprised with and wondering about familiar things: birth, death, dance, giving, taking, justice and injustice" (Jasper, 1974). These interests converge in *Birth*, an image which fuses the moment of birth with the creation of a tapestry.

Reproduced page 157.

Catalogue 57

Margreet van Walsem

1923, Zutphen, The Netherlands–1979, Prince Albert, Saskatchewan, Canada

Inside Out, 1977

254 x 127 x 10 cm

slit-woven tapestry with additions; wool

Collection of Mann Art Gallery, 2017.08.016

The later works of influential Prince Albert weaver Margreet van Walsem bring together a deep commitment to carding, spinning, and dyeing with an evolving interest in innovative weaving techniques. Van Walsem became more interested "in the possibilities of structure" (Robertson, 1976) after encountering sculptural weaving approaches at the Sixth Lausanne International Tapestry Biennial in 1973, and through workshops with Jagoda Buić (Yugoslavia) and Ritzi Jacobi (Germany) in 1974. *Inside Out* is a virtuosic tapestry in which changing loom tensions allows the creation of a multi-form landscape of slits and channels, twists, and folds.

Reproduced pages xix, 130.

Catalogue 58

Kate Waterhouse

1899–1995, Kerrobert, Saskatchewan, Canada

Kate Waterhouse Archives, 1977

Sample Card: 25 x 38.5 cm

Opened Book: 22 x 30 cm

paper, wool

SK Arts Permanent Collection, Gift of Ann Newdigate, 1998-028

The publication in 1977 of *Saskatchewan Dyes: A Personal Adventure with Plants and Colours* summarized a decade of intensive research and experimentation by the Saskatchewan dyer and weaver Kate Waterhouse. Assisted by the Saskatchewan Arts Board and classes at the Saskatchewan Summer School of the Arts, she developed an impressive body of knowledge about the dyes produced by Prairie plants—knowledge that has enriched the work of many weavers in this exhibition (Margreet van Walsem, Ann Newdigate, Annabel Taylor, *et al.*).

Reproduced pages 175, 228.

Catalogue 59

Whynona Yates

1926 Leicester, England–1998, Canada

Hanging, 1974

237 x 132 x 20 cm

weaving, twining, rya; wool

Collection of the Alberta Foundation for the Arts, 1997.085.001

British-born Whynona Yates was a prolific weaver whose large-scale textile sculptures and wall hangings were shown across Canada and internationally, including in the Canadian Pavilion at Expo 67 and the National Gallery of Canada in 1973. Based in Edmonton, Yates spun, dyed, and created her works using a variety of woven and off-loom techniques, reflecting an interest in weaving traditions from around the world. *Hanging* features dense, thatch-like rows of raw fleece fringe as well as fine warp threads and a narrow band of weaving at the top. While recalling a landscape, the fringes may also reference a *mino*, a type of Japanese outer garment made of water-repellent straw.

Reproduced pages xv, 117.

Catalogue 60

Marge Yuzicappi

b. 1948, Fort Qu'Appelle, Saskatchewan, Canada

Tapestry (Ta-hah-sheena), c. 1970

Sioux Handcraft Co-operative

365 x 183 cm

latch-hooked; wool, linen

Collection of University of Regina President's Art Collection, pc.1971.3

Marge (Marjorie) Yuzicappi was one of the younger members of the Sioux Handcraft Co-operative and hooked some of its largest rugs, an activity which she continues today. One of her most significant works, *Tapestry (Ta-hah-sheena)*, was made for the University of Regina where it remains on display in the Dr. John Archer Library. Because the rug was too large to lay out in her home, Yuzicappi had to roll it up and work on it in sections. As Algonquin/Métis academic Sherry Farrell Racette notes regarding this piece, her "geometric patterns are both subtle and dynamic, serving the ancient purpose of beautifying a shared communal space."

Reproduced pages 13, 207.

Catalogue 61

Yvonne Yuzicappi

1942 Wolseley, Saskatchewan–2009 Standing Buffalo First Nation, Saskatchewan, Canada

Rug, 1968

Sioux Handcraft Co-operative

111 x 36.5 cm

latch-hooked; wool, cotton

SK Arts Permanent Collection

Reproduced pages 13, 48.

CONTRIBUTORS

Alison Calder

Alison Calder, an award-winning poet, has published widely on Canadian prairie literature and culture for more than two decades, She teaches Canadian literature and creative writing at the University of Manitoba.

Michele Hardy

Michele Hardy studied textiles and craft at Sheridan College School of Crafts and Design (Dip. 1984), Nova Scotia College of Art and Design (BFA 1985) and the University of Alberta (MA 1995) before turning to cultural anthropology at the University of British Columbia (PhD 2003). Joining Nickle Galleries at the University of Calgary in 2005, she has curated more than three dozen exhibitions with a particular emphasis on Alberta craft and textiles. Highlights include *Sandra Sawatzky: The Age of Uncertainty*, 2022; *Shona Rae: Re-Imagined Narratives*, 2018; *Laura Vickerson: The Between*, 2016, and *John Chalke: Surface Tension*, 2015. Hardy is an Adjunct Associate Professor with the Department of Art and Art History, University of Calgary and teaches courses related to art and museum studies. Hardy regularly offers conference presentations and is the author of numerous book chapters, articles and exhibition catalogues. Recent publications include: *Richard Boulet: Stitching Between the Lines and Against the Grain* (2022); *Embroidering Development: The Mutwa and Rann Utsav in Kutch, India* (2020); and *Radical Access: Textiles and Museums* (with Joanne Schmidt), Proceedings of the 16th TSA Symposium (2018).

Mackenzie Kelly-Frère

Mackenzie Kelly-Frère is an artist, educator and academic. His research focuses on textile structures; computer-aided weaving; the social history of textiles; craft theory; and craft-based pedagogy. He is currently Associate Professor at the Alberta University of the Arts in the BFA Fibre and MFA Craft Media programs. Over the past twenty years Mackenzie has exhibited in Canada, China, Japan, Korea and the United States. He has contributed texts to publications including *Craft Perception and Practice: A Canadian Resource, Volume III* and *Textile: The Journal of Cloth and Culture*. Mackenzie lives in Calgary, Canada with his husband Kristofer and daughter Elizabeth.

Julia Krueger

Julia Krueger studied art history (BA 2002) and Canadian art history (MA 2006) at Carleton University in Ottawa, ON and ceramics (BFA 2010) at the Alberta College of Art + Design (ACAD, now AUArts) in Calgary, AB. In 2020, she completed a PhD in visual culture at the University of Western Ontario in London, ON and is currently the Permanent Collection Registrar with SK Arts. In addition to her studies, Julia has maintained an active teaching, writing, curatorial and research practice grounded in material culture and craft theory with a focus on Canadian prairie craft. She has taught art history courses at the University of Western Ontario, Luther College, University of Regina and ACAD. Her writing has been included in *Cahiers métiers d'art ::: Craft Journal*; *Crafting New Traditions: Canadian Innovators and Influence*; *The Encyclopedia of Saskatchewan*; and *Studio Magazine*. She has curated or conducted research for exhibitions such as *Hansen-Ross Pottery: Pioneering Fine Craft on the Canadian Prairies*; *Keepsakes of Conflict: Trench Art and Other Canadian War-Related Craft*; *Tactile Desires: The Work of Jack Sures;* and *Victor Cicansky: The Gardener's Universe*.

Mary-Beth Laviolette

As an independent art curator, writer and public speaker, Mary-Beth Laviolette pays particular attention to the world fine craft in Canada. Most recently, she worked with fourteen artists in fibre and Indigenous beading to create commissions for Calgary's YW Hub. In 2017, she curated for the Glenbow Museum (Calgary AB) a major exhibition: *Eye of the Needle—Beading, Embroidery and Needlework*. She has been on the board of the Alberta Craft Council since 2009.

Timothy Long

Timothy Long studied art history at the University of Regina (BA Hons 1986) and the State University of New York at Stony Brook (MA 1990). He has over thirty years of curatorial experience at the MacKenzie Art Gallery where he is Head Curator and Adjunct Professor at the University of Regina. Writing regional art histories and assessing their impacts has driven several of his collaborative investigations, including: *Regina Clay: Worlds in the Making; Superscreen: The Making of an*

Artist-Run Counterculture and the Grand Western Canadian Screen Shop (with Alex King); and nationally touring retrospectives of David Thauberger (with Sandra Fraser) and Victor Cicansky (with Julia Krueger). Other projects, including *Atom Egoyan: Steenbeckett* (with Christine Ramsay and Elizabeth Matheson) and the *MAGDANCE* series of exhibition/dance residencies with New Dance Horizons, are the result of his interest in interdisciplinary dialogues between art, sound, film, and contemporary dance. His application of the cultural anthropology of René Girard has resulted in a number MacKenzie publications, including: *The Limits of Life: Arnulf Rainer and Georges Rouault* and *Theatroclasm: Mirrors, Mimesis and the Place of the Viewer.*

Sherry Farrell Racette

Sherry Farrell Racette is an interdisciplinary scholar with an active artistic and curatorial practice. Her work is grounded in extensive work in archives and museum collections with an emphasis on Indigenous women and recovering aesthetic knowledge. Beadwork and stitch-based work is important to her artistic practice, creative research, and pedagogy. In 2016 Farrell Racette was the Distinguished Visiting Indigenous Faculty Fellow at the Jackman Humanities Institute, University of Toronto and in 2021 received a Lifetime Achievement Award from the University Art Association of Canada (UAAC-AAUC). She was born in Manitoba and is a member of Timiskaming First Nation in Quebec.

Mireille Perron

Mireille Perron is an artist, educator, and writer. Since 1989 she has been living and working in Moh-kins-tsis/Calgary, Alberta. Perron is the founder of the Laboratory of Feminist Pataphysics (2000–), a social experiment that masquerades as collaborative works of art/craft, and events. She taught at the Alberta University of the Arts until 2018 when she received the title of Professor Emerita.

Jennifer E. Salahub

Jennifer E. Salahub, PhD is Professor Emerita of Art, Craft, and Design History, Alberta University of the Arts (AUArts) and sits on the Board of the Alberta Craft Council. Her interest in textiles and craft is long standing, reflecting her professional and personal life. She continues to be fascinated by the unexplored (neglected and lost) early history of craft and craft education in Alberta. In other words, she sees the world through "craft-coloured" glasses. Most recently she published "'A Lot of Heifer-Dust': Alberta Maverick Marion Nicoll and Abstract Art" in *Bucking Conservatism: Alternative Stories of Alberta from the 1960s and 1970s* (2022).

Susan Surette

Susan Surette has a PhD from Concordia University, Montreal, where she lectures in craft, textile, and ceramic theory and history. She is a co-editor of *Sloppy Craft: Postdisciplinarity and the Crafts* (Bloomsbury, 2015), "Special Edition on Craft" *Journal of Canadian Art History* (2018/19), and *Craft and Heritage: Intersections in Critical Studies and Practice* (Bloomsbury, 2021). She has written essays about Canadian craft for exhibition catalogues, contributed chapters to books and journals, and acted as a consultant for Canadian craft projects. As a former weaver and basket maker, she continues to be passionate about all aspects of textiles.

Cheryl Troupe

Cheryl Troupe, PhD is an Assistant Professor in History at the University of Saskatchewan. She is a community-engaged researcher whose work centres Métis voices and perspectives in examining on Métis road allowance communities in Western Canada. Merging oral histories, family genealogies and mapping, her work focuses on the intersections of land, gender, kinship and how stories are connected to specific places. She is a citizen of the Métis Nation – Saskatchewan.

CALIOPSIS
(COREOPSIS)

ALUM + TIN

ALUM + AMMONIA
ALUM + VINEGAR
ALUM
ALUM + BAKING SODA
NO MORDANT
CHROME
ALUM + ALUMINUM
 KETTLE

FLEABANE
NO MORDANT

CHROME ADDED

UMBILICARIA (NORTHERN
 LICHEN
3RD BATH
3RD BATH + VINEGAR

> DIFFERENT STAGE

BIRCH (OUTER BARK
 FROM LOGS)
TIN